# the best
# tables · chairs · lights

Introduction by Clive Grinyer

Research by Cinzia Anguissola d'Altoé and Brice d'Antras

Drawings by Marvin Klein

A RotoVision Book

# the best
# tables · chairs · lights

## Innovation and invention in design products for the home

## Mel Byars

RotoVision

# Contents

RotoVision

A RotoVision Book
Published and distributed by
RotoVision SA
Route Suisse 9
CH-1295 Mies
Switzerland

RotoVision SA
Sales & Editorial Office
Sheridan House
114 Western Road
Hove, BN3 IDD
UK
Tel: +44 (0)1273 7272 68
Fax: +44 (0)1273 7272 69
E-mail: sales@rotovision.com
Web: www.rotovision.com

ISBN 2-88046-832-9

Printed in Singapore
Production and separation in Singapore
by ProVision Pte. Ltd.,

Tel: +65 6334 7720
Fax: +65 6334 7721

# lights

# index

Designed for RotoVision by
Becky Willis at
Design Revolution, Brighton, UK.
Project Editor: Nicola Hodgson

Front Cover: Marc Harrison's "ANTic" center table in
wood, resin, and steel tubing; Ron Arad's "Well
Tempered" armchair in steel; Jonathan Goldman's
"Urchin" light in thin rip-stop nylon fabric

Back cover: Fernando Campana and Humberto
Campana's "Inflating Table" in PVC and aluminum

Front flap: The swivel pedestal version of Paolo
Rizzatto's "Dakota" armchair in cast-aluminum with
saddle leather upholstery

Back flap: The floor version of Alberto Meda and
Paolo Rizzatto's "Titania" lamp that features
interchangeable, variously colored polycarbonate filters

# foreword

Artistic expression in the 20th and 21st centuries is no longer the preserve of fine artists and sculptors. Design has contributed many of the great icons of this and the last century, in areas such as graphics, automobiles, products and furniture. The progress brought about by developments in technology, materials and manufacturing has allowed designers opportunities to introduce innovation and beauty to the everyday objects in our lives.

Design, as opposed to art, is the urge to bring vision, innovation, surprise and invention to objects of function that we interact with directly. The purpose of a table or a chair is not to be placed in a museum or art gallery. A table is not primarily a work of art, but the collection of functional, intellectual and emotional decisions that culminate in its design become of artistic value and provide satisfaction above and beyond the functional intention. The design trinity of lights, tables and chairs collected in this book has come to represent, better than any other objects around us, the stage for intellectual and creative experimentation. These objects continuously capture and fascinate the minds of designers and create the canvas on which to explore the connections between the physical and the emotional.

Creating a suspended surface, supporting our own body, or providing a source of light can be done in an infinite number of ways. Any solution is therefore a unique combination of materials and geometry to create an object that is structurally sound, physically comfortable and usable. Further than this, any design creates emotional responses, which, as this book shows, can range from surprise and shock to adoration and apathy. The joy of design lies in contemplating the myriad of possibilities – the certainty that there is no one empirically correct chair, light or table – so that these objects are the subject of

marvelous intellectual exploration and experimentation that frequently result in grand statements.

These statements may often come to represent a whole area of design philosophy, above and beyond the legacy of the original designer. Occasionally they become cultural icons that represent a shift in values within our wider society. From the Bauhaus to Ron Arad, the chair, for example, has become an icon that communicates something fundamental about how society values different materials, the skills of the craftsman or the possibilities of manufacturing and its aesthetic tastes. These can reflect wider social and political trends, from the mass-produced utilitarianism of the 1930s to the self-made self-expression of the 1980s and beyond.

That such simple objects can do this is remarkable, yet in this book you will find many examples of iconic objects that say much about how we view the world. If life were only about function, we would have little to marvel at. The exuberance and sheer joy of solving functional problems in surprising and thought-provoking ways might be seen as the ultimate height (or the ultimate decadence of civilization), but each object in this book is a singular vision, a representation of a unique set of decisions as complex as a work of art or a poem.

Tables, Chairs and Lights is about design, materials, craftsmanship and manufacturing technology. It is about the enormous palette of possibilities open to any designer who approaches these objects. In each example, we can study and understand the combination of materials and structure and judge the beauty or intellectual statement that is created. More than that, the underlying principles are exposed, the covers taken off, to show the components of the ideas, the materials and the processes that

culminate in the finished design. This is where conventional definitions of art and design separate, for any piece of design is a huge collaboration, from light bulb manufacturer to metal supplier, from glass technologist to plastic injection moulder. In these pages we can see the ingredients that come together and begin to understand where individual or collective decisions make the difference between mediocrity and greatness. So although design is about aesthetic content, this is not just brought about by manipulation of surface. The objects in this book explain that design is the culmination of many decisions, tempered and twisted by a desire to find beauty, surprise and delight at every opportunity. Great designs grow, sometimes from trial and error, sometimes from a moment of vision, and play in the boundaries between physical reality and material possibility. Great designs are those that find the possibilities for delight and beauty in the bringing together of these activities, the result of which is art that we can sit on, eat at and read by.

This book unpacks the ways that some of the greatest and most interesting designs have crossed those boundaries. Each example takes us on a journey, via the inherent qualities of materials, the ways in which they can be manipulated, the structural possibilities and a constant probing and questioning of the concept of beauty. It is a broad and rich journey to make and is a testament to the designer's endeavour to enrich our lives at every level and create moments of inspiration, intrigue, enjoyment and delight in the objects that share our space and the world around us.

**Clive Grinyer**
**Director – Design and Innovation**
**Design Council, London**

This profile of 50 tables will serve as an effective force in changing the reputation of the table as a merely utilitarian object into one of a fascinating, but still highly functional, tool for living. Here, you will find the harvest of some of the most imaginative minds in the design world today. In minute detail, this innovative collection reveals the panorama of types, shapes, sizes, colors and materials used in the best contemporary furniture design.

During the last 20 years, a shift has occurred from the manipulation of traditional materials through traditional means to the experimentation with, and exploration of, advanced materials through advanced means. However, the use of established media (such as wood, metals, stone and others) has certainly not been abandoned, merely rethought and reconfigured with great imagination.

The tables featured here range from the highly engineered, intricate and expensive to the practical, simple, and cheap. They inflate, extend, flip, rise, lower, or for storage and transport, fold or come apart. Some are deadly serious designs, while others are amusingly outlandish. And there are even tables sold only as legs for which you furnish the top surface.

# tables

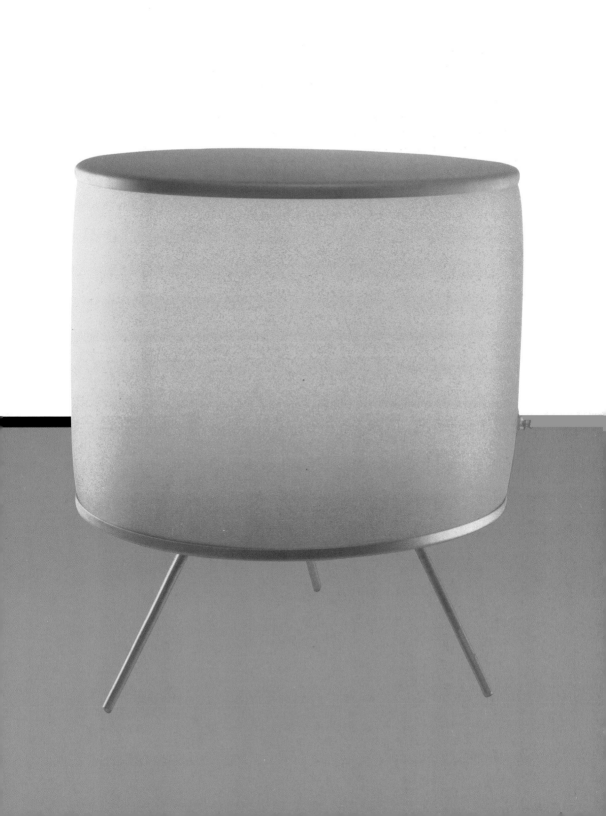

# tables: guest introduction

The table, as well as the chair, has become an irreducible part of the history of furniture production and likewise of our daily lives. In order to have some insight into the role and form of the table, let's contrast it with the chair, which, besides being a highly functional object, has manifestations corollary to those of its users—human beings—and even to society as a whole. The less-demonstrative table plays a secondary role to the chair, but is no less significant.

When we look at tables and chairs as archetypes (or ideal forms), their individual differences are obvious. The centuries-long continuity of their forms has made it possible for us to isolate the ideas we have developed for each one—a relatively readable schema engraved in our thoughts and variously incarnated in the production of different models through the ages.

Essentially the archetype that the chair embodies is a fundamental contradiction: the front legs reach only to seat level while the rear ones rise higher to become the back rest. This disparity gives rise to an essential ambiguity and, in another sense, the impurity of all chairs to which a great many designers have responded with varying levels of mastery and virtuosity. Attempting to diminish the problem, increase efficiency, and lessen the ambiguity, Modernists have attempted to resolve the contradiction by making chairs with stool-like characteristics: the seat and the back form a single unit, held aloft by a configuration of legs or a base of some kind. That chairs are an essential index through which an interpretation of society may be conjured is precisely based on this confrontation with their ambiguity—an archetypal ambiguity that is a manifestation of life itself, in all its complexity.

Contrarily, tables present an altogether different order. The archetype of a table is obvious and simple: a surface is supported by a leg or legs or other device to raise it from the ground. There is no ambiguity here. The history of the table, past and present, may be read as infinite variations on a very simple theme to which all tables more or less refer.

Variations of tables have primarily been informed by the technology called upon to make tables and devise their forms. The entire history of classical styles was bound to an unchanging tradition in skills, mainly in woodworking. The technology employed to produce a table for a king was the same as that used by, for example, the Shakers. Exponents of the Modern Movement—motivated by extreme, utopian leanings—have tended to identify with the archetype, as attested by the work of Mies van der Rohe and the group Archizoom. Today, however, the Modern Movement is as much behind us as before us.

In the wake of the healthy confusion encouraged by Postmodernism, few people today are attempting to bring an element of clear-sightedness to bear on new, emerging products.

Keep in mind that since the recent advent of the microprocessor, tables and chairs no longer have quite the same meaning as before. Electronics has irreversibly invaded our daily lives with increasingly efficient and ever-smaller objects. While virtuality has imperceptibly evolved into reality, tables and chairs still present their same, immutable characteristics: heights of 46cm for chairs and 75cm for tables continue to be unalterably linked to their use and to the body sizes and shapes of the users.

We might even think of the present as the age of confrontation between objects that originated as archetypes (like board games) and objects that originated in dematerialized forms (like computer games). To the extent that dematerialization follows technology's vertiginous progress, archetypes are beginning to look more and more archaic. And, as the real is erased and we are swept into the virtual, our need for the presence of the archaic is becoming more urgent.

A desire to re-establish a balance between the two has created the need for a tangible validation of our existence in the world we live in. And the more technology and communication contribute to making virtuality a worldwide phenomenon, the better we are able to appreciate the reality, for example, in the technical inventiveness of the tables shown here. Could it be that the creation of variety is a reaction to the prevailing proliferation of dematerialization?

**Sylvain Dubuisson**
**Paris**

# tables: author introduction

It was with some trepidation that I chose to include tables in this book, regardless of their ubiquity. My initial reticence was based on the unfounded judgment that tables in general, especially new tables, would not be interesting – indeed, might be particularly boring. Yet I discovered that I had been naïve, or probably just ignorant.

Much to my delight, I found a wide range of tables that had been created by imaginative designers who, when put to the task, whether self- or manufacturer-assigned, had conjured a number of fascinating examples, including those that express the surreal if not impractical, those that voice serious and highly functional concerns, those that address green matters, and those that feature ingeniously manipulated materials.

A distinct effort was made to include examples by both male and female designers from around the world whose work transcends the merely utilitarian use of new and traditional materials, resulting in the remarkable and the intelligent.

There are five basic kinds of tables: for dining, for work, for playing games, for handy convenience (like the coffee table and small side table), and for use while standing (like the buffet/hunt table and the console). They serve as evidence that the study of design must always focus on sociological, anthropological, political, and financial concerns, rather than primarily aesthetic ones. The tables in this book that fold or break down speak of the scarcity of environmental space; ones in inexpensive materials concern frugality; ones featuring multiple functions illustrate the single service of one utilitarian object for many; and ones that appear to be simple may be essentially quite intricate, while others that appear to be simple are indeed quite simple. And all of them have sprung forth, whether easily or arduously, from the constantly probing minds of designers, not always serious nor solely playful.

The choices here are my personal ones, limited by the images and documentation that I and my assistants were able to collect from the generous manufacturers and designers who accepted our invitation to participate. But, we were able to satisfy the quota of 50 examples, including some intriguing ones suggested by my assistants and hitherto unknown to me.

I admit to having mixed feelings about the approach I have taken: I am uneasy on the one hand and prideful on the other that it emphasizes the clever and artful exploitation of new and traditional materials, methodologies, and technologies rather than aesthetics. My discomfort stems from the backlash against the adulation of science generally and of technology specifically. The indictment alleges that the unharnessed pursuit of technological development for profit is incompatible with respect for the planet. Thus, in part,

the cries are that an ecological catastrophe has already happened. The reproach includes the romantic assertion that, while focusing on science, the enjoyment of nature is lessened.

As a response and not a pardon, I share an apocryphal story about Hermann Helmholtz, the 19th-century German physicist and anatomist. He was traveling in the mountains of Switzerland with some friends when a great storm arose. Helmholtz, being of a scientific disposition, assiduously began to scribble observational notes. His friends asked him if this rationalization of one of nature's great dramatic moments did not distract from its beauty, to which he rejoined that, on the contrary, the phenomenon became all the more dramatic and moving.

But, even so, this book does not concern the value of the Earth-helping or Earth-harming production and processes employed in the creation of the objects featured here, but rather is offered as a report, and not a thorough one, on a narrow slice of our material culture as expressed during the last decade or so. But be warned; some of the materials used to make furniture, furnishings, and products, especially right now, may indeed be both harmful to the makers and to the users. In the production of fine art, sculptor Niki de Saint Phalle, for example, can attest to the the life-threatening effects of certain substances that give off toxic gases. The emission occurs not only when the substances are being manufacturered but also up to four and five years after. A single case in point: particle board, which many of us have considered harmless, gives off highly toxic fumes.

There are no assertions here to suggest that anyone needs to purchase, own, or use the tables discussed. Probably no one does. And the choice of tables here is not intended as an advertisement for the products; favoritism was punctiliously avoided, although I and my assistants are friendly with some of the designers and the representatives of the manufacturers. I thought hard and long before including the "Corinthia" table system by the husband of one of my assistants. She merely presented the table to me along with many others without any special comment or urging. I could have omitted it without a reprisal. Neither she nor the designer knew of its inclusion until after publication.

The final selection of tables, numbered from one to 50, is arbitrarily grouped according to materials or some other distinguishing characteristics. While there is a rainbow of examples, the group is not necessarily representative of the state of the table today, only somewhat exemplary and then not widely so.

If the examples serve to amuse, enlighten, delight, provoke, or infuriate you, then we have done our job well. But be assured that bore you they will not.

wood

# Table

**Designer:** Axel Kufus (German, b. 1958)
**Manufacturer:** the designer
**Date of design:** 1987

The most notable feature of this table is the elimination of blocks for reinforcement that would normally be added to the underside of a sparsely built, thin-framed table such as this one. The simplicity of its construction is complemented by the simplicity of the design itself: four leg-sides and a top. To decrease waste, the large pieces of wood removed to form the legs are used by the designer to make his "Stöck" chairs.

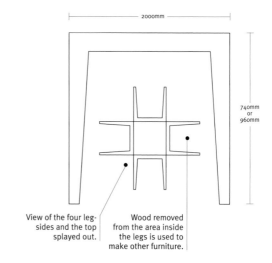

2000mm

740mm
or
960mm

View of the four leg-sides and the top splayed out.

Wood removed from the area inside the legs is used to make other furniture.

Plan view of the corners.

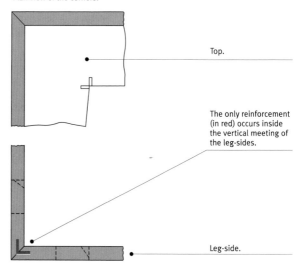

Top.

The only reinforcement (in red) occurs inside the vertical meeting of the leg-sides.

Leg-side.

tables

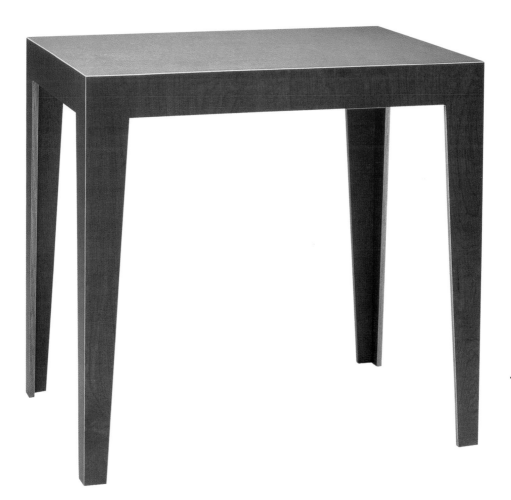

wood

**Table**

The five film-coated plywood sections (four leg-
sides and the top) are cut using templates.
After gluing, the edges are given a fine edge.

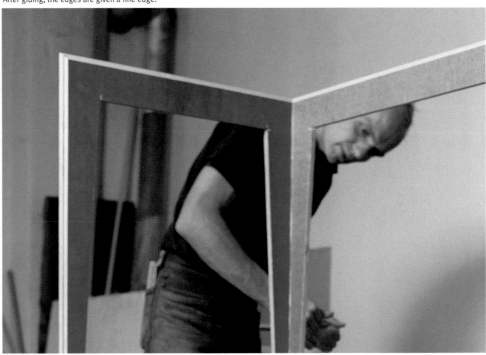

The raked angle of the thick plywood, the one-piece leg-side, and the special glue all contribute to the elimination of underside block reinforcement.

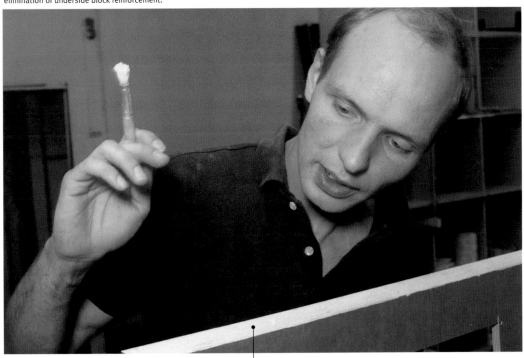

The mitered (45°) 12mm- or 15mm-thick plywood (shown here at the top of the leg-side) is being coated with glue by the designer-maker.

# "Herr Zock" table

**Designer:** André Haarscheidt
(Swiss, b. 1966)
**Manufacturer:** the designer
**Date of design:** 1995

This table is exemplary of standard type-furniture, extreme in its use of plain materials whose natural features are revealed. The raw edges of the wood are left to view; the details of the construction are exposed.

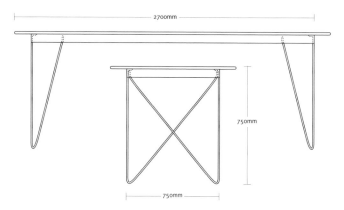

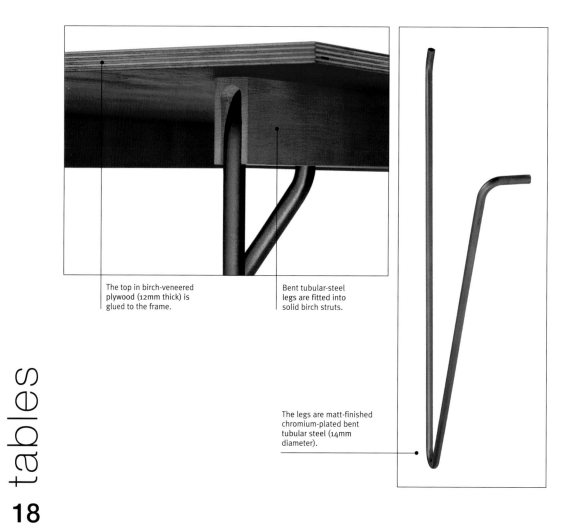

The top in birch-veneered plywood (12mm thick) is glued to the frame.

Bent tubular-steel legs are fitted into solid birch struts.

The legs are matt-finished chromium-plated bent tubular steel (14mm diameter).

tables

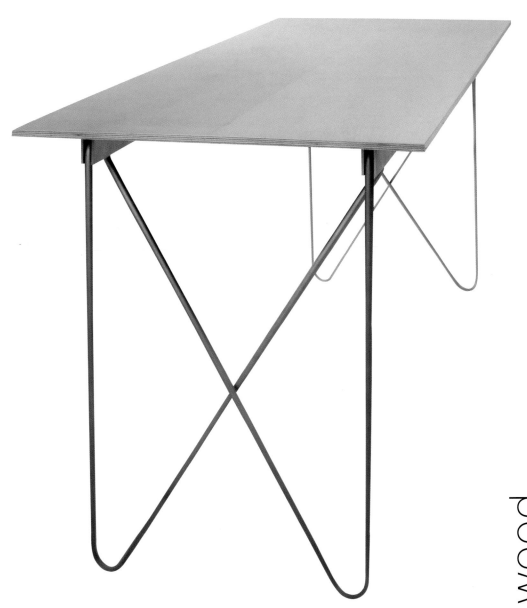

wood

# "Chromosome" side table

**Designer:** Essaime (né Stéphane Millet, French, b. 1949)
**Manufacturer:** Quart de Poil', Paris, France
**Date of design:** 1996

In limited production, this table was commissioned to mark the centenary of the French magazine, Art et Décoration. Deceptively complicated and pivoting along two different axes, the legs must be positioned correctly (held to the top by magnets) for the table to function properly.

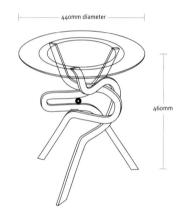

440mm diameter

460mm

The legs are folded by rotating them around two different axes. The base and glass top can be displayed on a wall like a bas-relief sculpture or hung on a wall merely to store it out of the way. Weighing 4Kg, the size when folded is 450mm x 450mm x 30mm.

Three steel disks are U. (ultraviolet) glued to the etched circle on the Sécurit tempered glass top, indicating the position of the legs; otherwise the legs will not function properly.

Iron magnets (3Kg each) are attached to the tops of the three legs to adhere them to the steel disks glued under the glass top.

Two iron axles and bolts are inserted through two areas of each of the three legs.

Three legs of MDF (medium density fiberboard) compressed wood are stained and varnished.

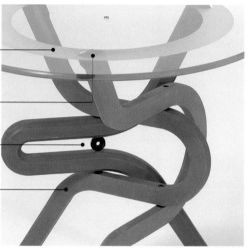

# "Oh! Marie-Laure" table

**Designer:** Christian Ghion (French, b. 1958) and Patrick Nadeau (French, b. 1955)
**Manufacturer:** G.N. Éditions, Paris, France
**Date of design:** 1996

A new approach to the manipulation of plywood, the sheets (from which the four sections of this table are cut) are bent before the cutting is performed. The designers, employing the kind of technological innovation made possible by computers, have successfully incorporated a pleasing, flowing aesthetic flair into an object that might have been mundane in the hands of others.

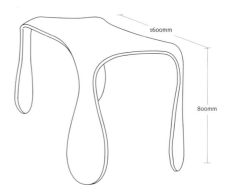

Plywood (27mm thick) is steam-bent prior to its being cut into four pieces (or two matching shapes) by digital-numeric instructions from a computer.

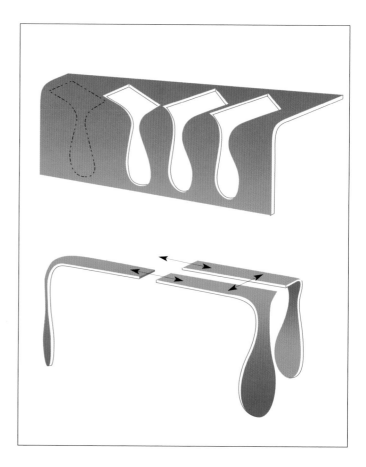

The four sections of the table (two separate shapes) are glued together.

(Only three of the four sections are shown here, awaiting the fourth to be cut from the steam-curved section shown above.)

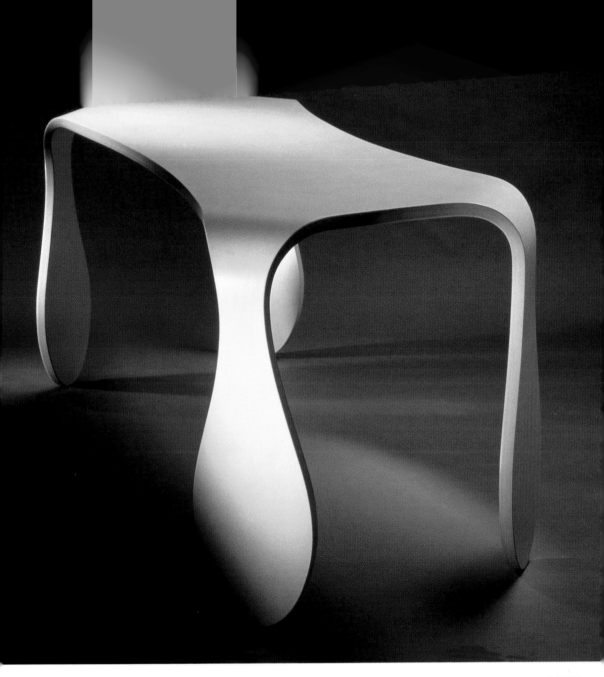

wood

# "Max" table

**Designer:** Ruud Ekstrand (Swedish, b. 1943)
**Manufacturer:** Inredningsform AB, Malmö, Sweden
**Date of design:** 1992

A relatively simple, traditional approach, this table combines the simplicity and material (wood) one has come to expect from Scandinavian craftspeople. The top is an unattached component available in a choice of three materials. The object has no secrets; all the joints and hardware are left naked.

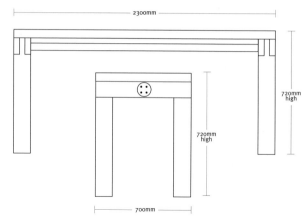

2300mm

720mm high

720mm high

700mm

Available in a range of sizes and heights, measurements of only the basic model (MAX HB 701) are given here.

Exploded view of the stainless-steel hardware and stretcher.

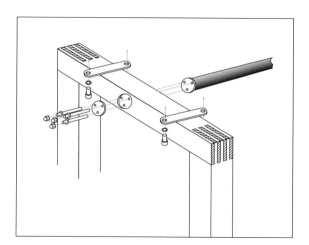

Tops available in solid beech (30mm thick), gray-brown limestone (30mm thick), or clear glass with a polished edge.

Solid beech.

Stainless-steel hardware.

Exposed mortise work.

Stainless-steel stretcher.

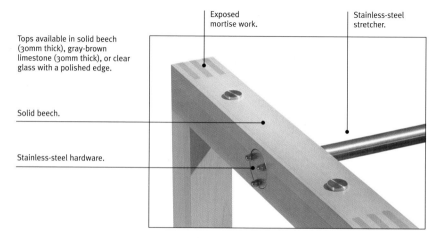

tables

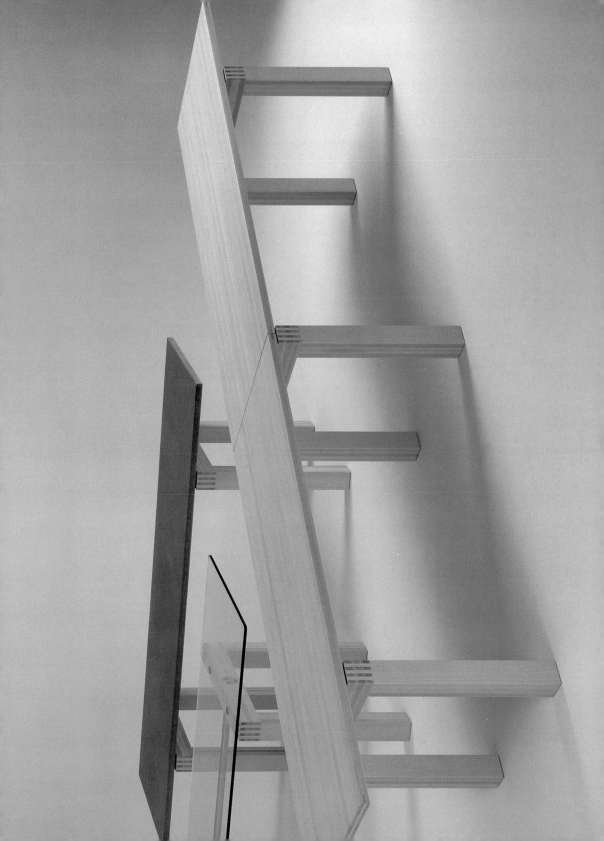

# "Arquà" table

**Designer:** Carlo Bimbi (Italian, b. 1944)
and Paolo Romoli (Italian, b. 1941)
**Manufacturer:** Diber, Tavernelle di
Serrungarina (PS), Italy
**Date of design:** 1995

A simple solution was employed for a vexing
problem. This ambitious table features
tubing for the legs that is inserted into round
holes in a wooden block. The tubes are held
in place by a cylindrical tensioning technique
that creates a sturdy structure to be
assembled by the user.

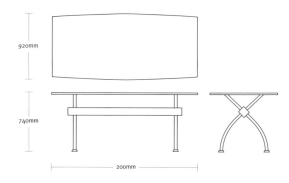

920mm

740mm

200mm

The glass top is 15mm thick with beaked
edges or with 45°-angle edges. The glides
(at the ends of the legs) are turned
aluminum, hand polished and painted
with acrylic varnish.

Solvent stained, acrylic painted, or
natural stained/waxed solid cherrywood.

Electrowelded aluminum (45mm diameter),
polished and coated with acrylic varnish.

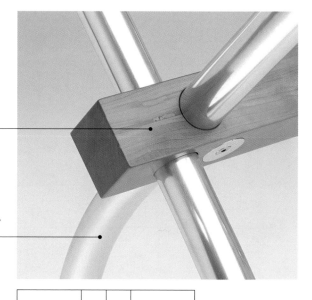

A blocking expansion system holds the
aluminum legs in place by a hex screw
that is tensioned by a hex screwdriver
provided to the user who assembles
the table himself.

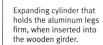

Expanding cylinder that
holds the aluminum legs
firm, when inserted into
the wooden girder.

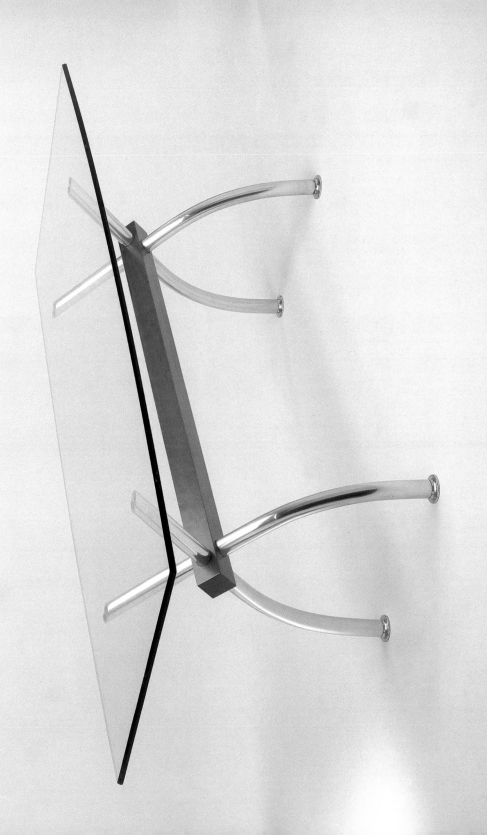

# "Legs" center table

**Designer:** Laura Agnoletto (Italian,
b. 1963) and Marzio Rusconi Clerici
(Italian, b. 1960)
**Manufacturer:** Adedei Tre S.r.l., Milano, Italy
**Date of design:** 1990

With a complexity that far exceeds its function,
this fascinating table's design elements are
based on zoomorphic elements: the spider, the
crab, and the tortoise. These sections are held by
a tension structure that employs cable that can
be tightened. The glass top, shown rectangular
here, can be almost any shape or size.
Surprisingly, the legs are of wood, not metal.

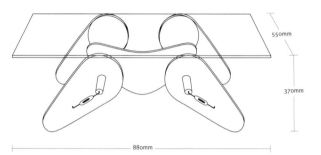

550mm

370mm

880mm

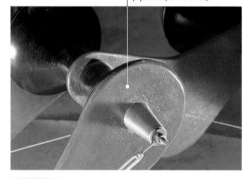

Hand-painted birch-veneered
plywood (10mm thick).

Aluminum
shaft cone.

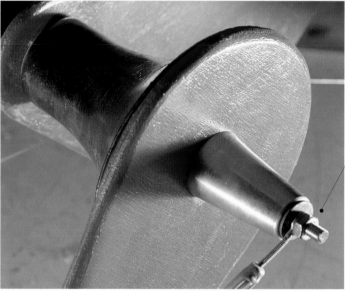

A tension cable holds
together the different
sections (a rubber piece
intended for a boat draft
and a steel tie-beam).

Threaded steel rod (with
tension cable attached to
the end) is inserted into
the aluminum shaft cone.

wood

# "TV Stage" unit

**Designer:** Katsushi Nagumo (Japanese, b. 1956)
**Manufacturer:** Tokyo Mitoya Co. Ltd.,
Tokyo, Japan, and Project Candy-Milano,
Milano, Italy
**Date of design:** 1994

Cabinets that house remote-controlled
high-fidelity equipment and audio-visual
components require that closed doors be
"transparent" enough to permit beams of UV
(ultraviolet) to pass through. Most cabinets
have incorporated doors made of smoked
translucent glass or plastic, although the
equipment remains somewhat visible. The
unit here offers an interesting design solution
to the problem: solid wood-composition
doors with slit piercing.

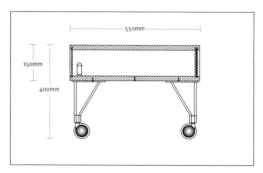

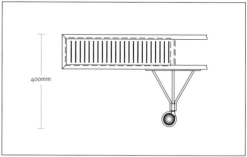

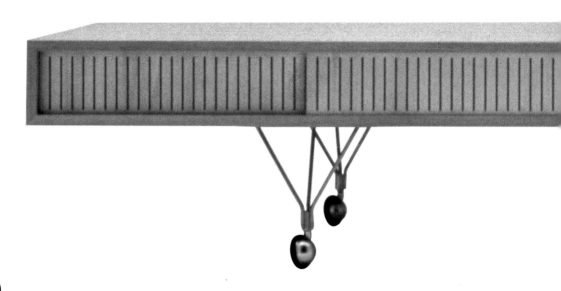

2000mm

Televsion set.

Cut-outs in the cabinet's backside permit connector and electrical wires from the audio-visual equipment housed inside to be fed through to the outside.

Cabinet made of MDF (medium density fiber) board.

Very narrow vertical openings in the sliding cabinet doors allow the UV beam emitted by remote-control devices to signal the electronic and audio-visual equipment inside.

Legs in bent-steel rods.

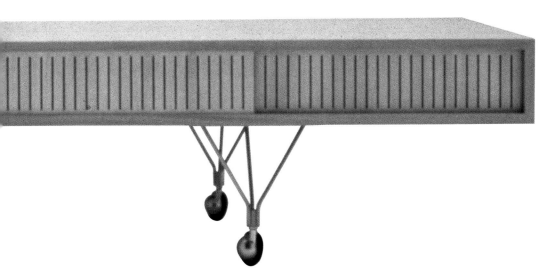

wood

**31**

# "Ply" table

**Designer:** Jasper Morrison (British, b. 1959)
**Manufacturer:** Vitra AG, Weil am Rhein, Germany
**Date of design:** 1990

Even though mass-produced, this table is made with great care by craftspeople in a large factory using advanced machinery technology. Designed by a British person for a German firm, the table is very simple and made with a relatively small number of pieces. But, unlike the table (pages 14–17) by Axel Kufus, which is made with thicker wood, this table requires underside blocking for reinforcement.

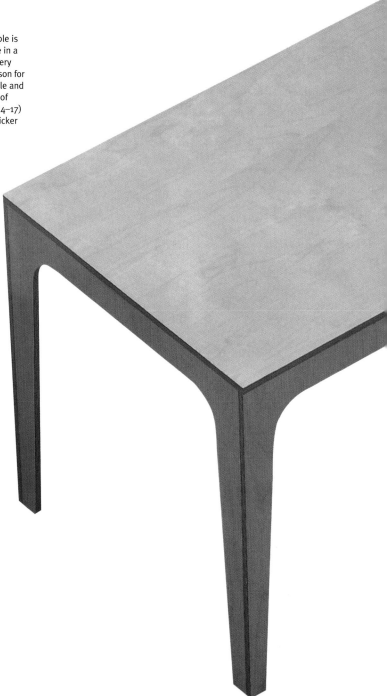

tables

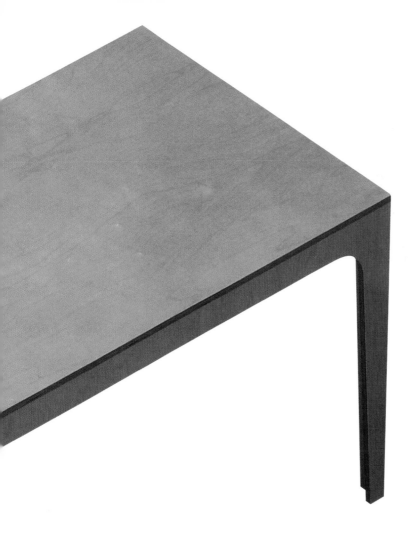

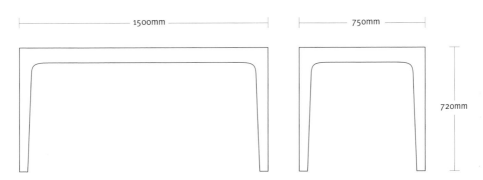

1500mm     750mm     720mm

**"Ply" table**

Sequential images illustrate the production sequence.

1500mm x 3000mm x 15mm birch-veneer plywood.

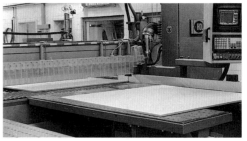

Full plywood sheets being cut into sections.

Leg templates.

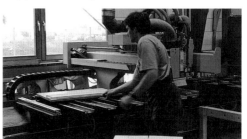

A CNC (computer) program guides the templates.

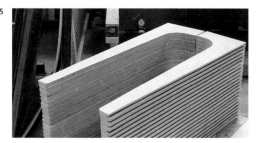

Stacks of leg parts await attachment.

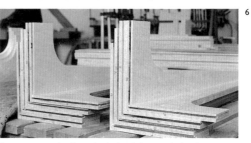

Leg corners are glued together before being attached to the top.

tables

The production sequence continues.

7

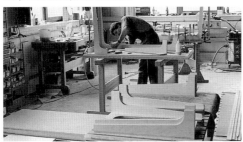

A craftsperson carefully attaches the legs to the top.

8

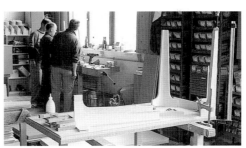

Leg corners are held in place by clamps.

9

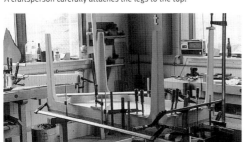

While the glue sets, a baroque collection of clamps holds all parts.

10

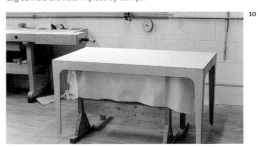

A completed table is sanded and cleaned.

11

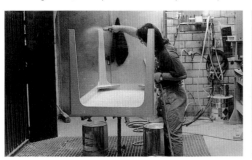

12

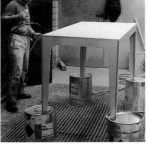

A table, elevated from the floor, is spray-painted on all sides, including beneath. The paint is a clear DD solution known as Pur varnish, with additives that provide a high resistance to UV (ultraviolet) light.

WOOD

# "Spanoto" table

**Designer:** Jakob Gebert (German, b. 1965)
**Manufacturer:** Nels Holger Moormann, Aschau im Chiemgau, Germany
**Date of design:** 1996

The very definition of type furniture, this unadorned table can be shipped and stored flat; the top is used as the container. No special tools are required for its quick assembly, which is realized with the use of a wooden paddle that separates the tops of the legs before they are slid into side tracks on the underside of the top. However, this table does appear to be somewhat unstable.

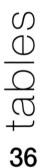

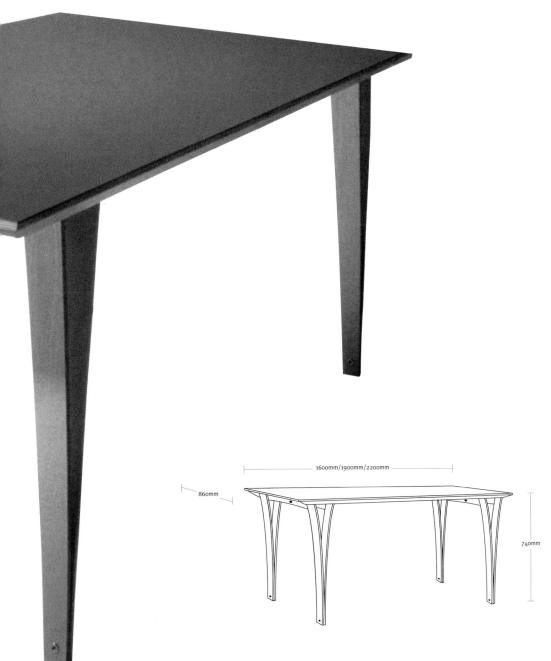

1600mm/1900mm/2200mm

860mm

740mm

# "Spanoto" table

| Frame: | Oiled birch |
|---|---|
| | Untreated birch |
| Top: | Red, blue, or black linoleum laminate |
| | Varnished birch |
| | Untreated birch |
| | Varnished maple |
| | Varnished apple |

Step 4: The legs, now firmly held in place, can be moved to another place along the underside of the table top when the paddle is used to spread the legs again.

Step 3: When the spreading paddle is removed, the construction is locked into place.

Step 2: After the legs are spread, they are slid into the guiding grooves at the sides of the underside of the table top.

Step 1: Assembly requires no fasteners or adhesives. A wooden paddle (in red) is twisted to spread the legs apart at their top ends.

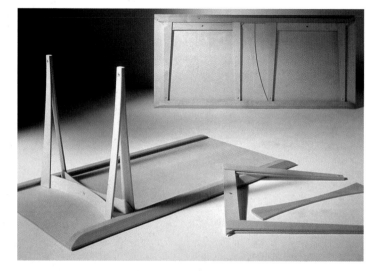

tables

# metal

# "Wounded Knee" adjustable table

**Designer:** Jonas Lindvall
(Swedish, b. 1963)
**Manufacturer:** David design ab, Malmö, Sweden
**Date of design:** 1992

This table employs simple materials – wood and metal. A screw element in the stem is adjustable by the sitter's knee, permitting the table top to be turned for height adjustment, much like some office chair bases.

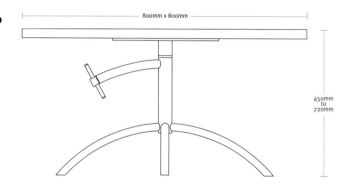

800mm x 800mm

450mm to 720mm

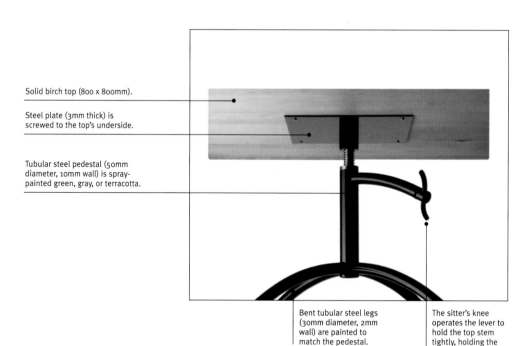

Solid birch top (800 x 800mm).

Steel plate (3mm thick) is screwed to the top's underside.

Tubular steel pedestal (50mm diameter, 10mm wall) is spray-painted green, gray, or terracotta.

Bent tubular steel legs (30mm diameter, 2mm wall) are painted to match the pedestal.

The sitter's knee operates the lever to hold the top stem tightly, holding the height firm.

# "Manthis" adjustable table

**Designer:** Alberto Liévore (Argentine, b. 1948)
**Manufacturer:** Perobell, Sabadell, Spain
**Date of design:** 1990

This table is highly functional, intelligently mechanical, and well conceived while featuring a curious angular form, which announces its insect namesake. The pitched stem, which adjusts vertically, holds the top tray in a horizontal position.

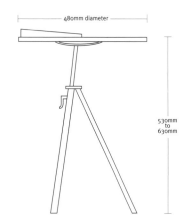

480mm diameter

530mm
to
630mm

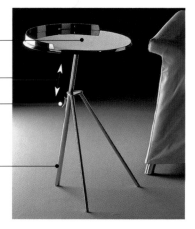

Top tray is available in stainless steel or a chromed-black finish like the base, or in cherrywood-stained ash with a metal base.

The top is raised and lowered by the stem inserted into the tubular back leg.

Release lever to adjust the tray height.

The three-leg frame is soldered together.

A developmental drawing reveals the designer's interest in creating a vertically adjusting table.

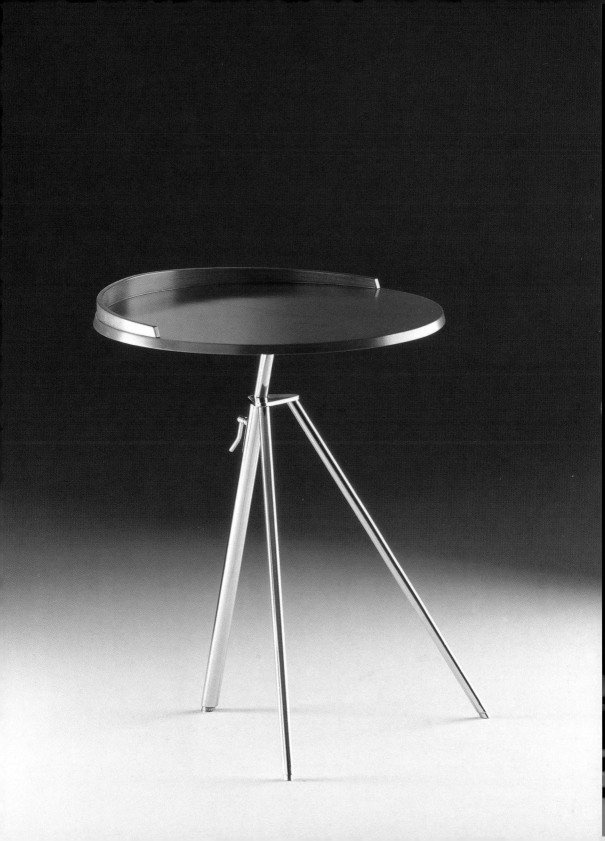

# "High Func" table legs

**Designer:** Olof Kolte (Swedish, b. 1963)
**Manufacturer:** David design ab, Malmö, Sweden
**Date of design:** 1991

Produced by an aluminum foundry, the legs are steel-shot blasted after casting. Available in two heights, the legs are to be attached by the end user to a table top in almost any kind of wood. While not particularly inexpensive, the use of recycled aluminum is admirable.

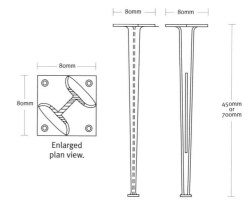

80mm
80mm
80mm

80mm

Enlarged plan view.

450mm or 700mm

The user adds any wooden top of his choosing.

The legs are attached to a wooden top with four counter-sunken screws through pre-drilled holes.

Recycled cast aluminum with a steel shot-blasted finish.

Available in a center-table height (450mm) or a dining-table height (700mm).

tables

# "Dumbo" side table

**Designer:** Piero Gaeta (Italian, b. 1961)
**Manufacturer:** Steel, divisione della Molteni & Molteni S.p.A., Giussano (MI), Italy
**Date of design:** 1994

Part of the manufacturer's Domestic Zoo group of furniture, this table is essentially a fatuous object—a 'folie' with high technological standards, a fine finish, and great attention paid to detail. In featuring an animal form, the design rejects the total abstraction found in most tables and may be favorably compared to the robust animal forms found in 19th-century Black Forest furniture. Evidently popular, 800 examples of this table were produced.

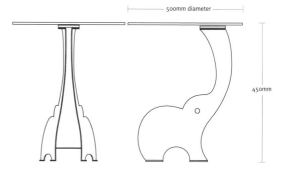

500mm diameter

450mm

Clear glass top (450mm diameter, 80mm thick) with polished edges.

Steel disk is screwed to the base and epoxy glued to the glass.

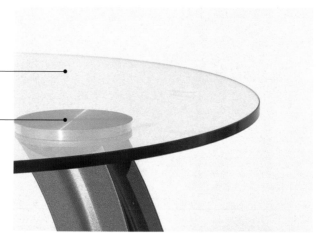

Steel plate FE37 is folded, welded, and spray-painted with steel stove enamel in green, blue, metallic gray, or black.

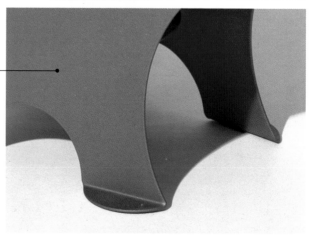

tables

46

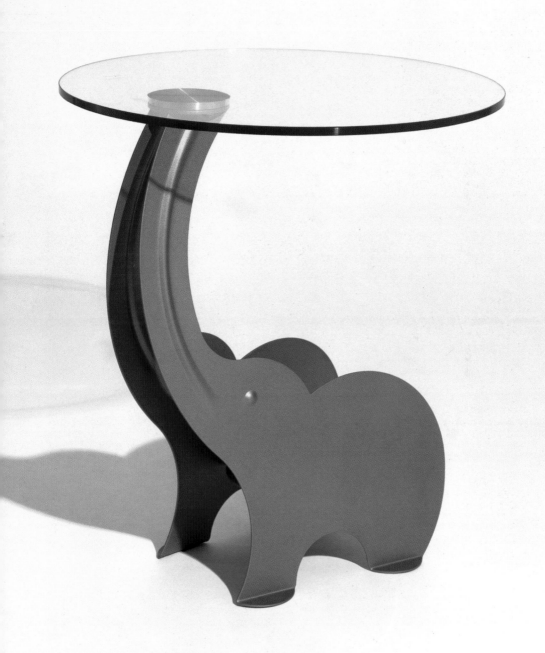

# "Nomos" table system

**Designer:** Norman Foster (British, b. 1935)
**Manufacturer:** Tecno S.p.A., Milano, Italy
**Date of design:** 1986

In this highly flexible system, a wide range of table configurations are made possible by the large inventory of available parts and pieces. For example, tops can be had in rectangular or round shapes and flat or, for drafting use, tiltable. The design, while appropriate for domestic use, provides the kind of flexibility today's office environment demands, including the addition of lighting fixtures, storage units, and other components. Perhaps arguably, the concept is supposed to be simple enough to allow easy assembly and manufacture worldwide.

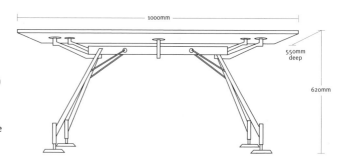

Of the seven sizes available, including those with round tops, only the no. T1016 is shown above and right.

Foot design.

The parts, steel fused onto aluminum, are finished in polished chromium plating or powder painted in metal gray or shiny black colors.

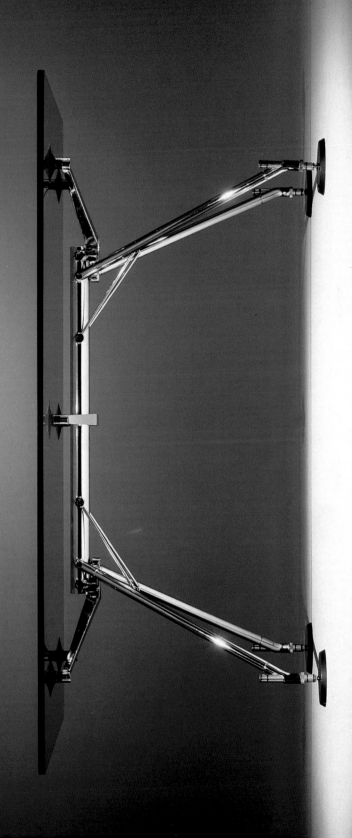

# "Nomos" table system

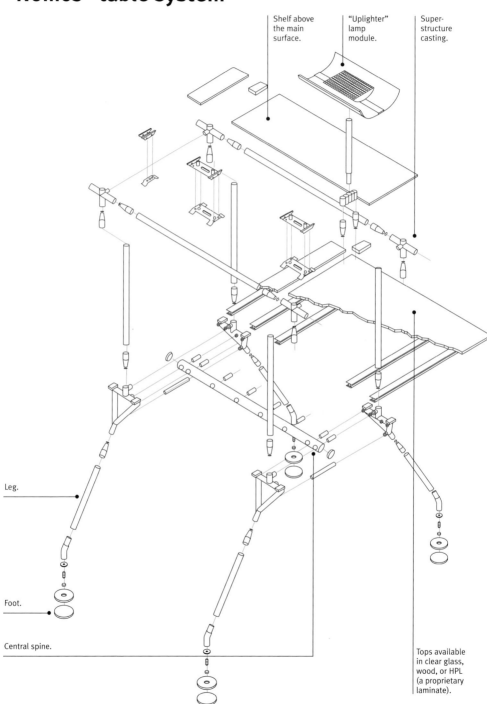

Shelf above the main surface.

"Uplighter" lamp module.

Super-structure casting.

Leg.

Foot.

Central spine.

Tops available in clear glass, wood, or HPL (a proprietary laminate).

metals

# "Chincheta" center table

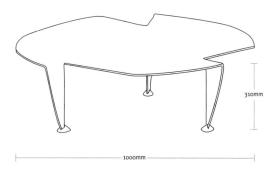

310mm

1000mm

**Designer:** Sergi Devesa i Bajet
(Spanish, b. 1961) and Oscar Devesa i Bajet
(Spanish, b. 1963)
**Manufacturer:** Disform S.A., Barcelona, Spain
**Date of design:** 1987

The essential design principle of this table
is based on very simple geometry. A circle of
sheet aluminum is cut with only a straight line
in three places equally spaced along the
perimeter and bent downward.

Available in gray or black
epoxy spray-painted
aluminum.

The leg section is created by
one straight line sawn into
the 1000mm-diameter top
and bent down at 90°.

Leg tips in cast aluminum
L-2560-60.

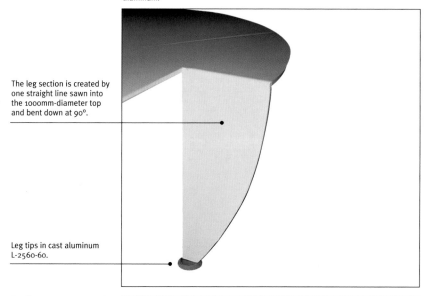

Small maquettes were made
prior to production.

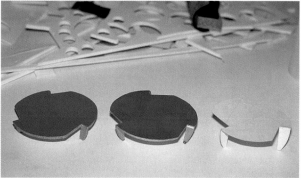

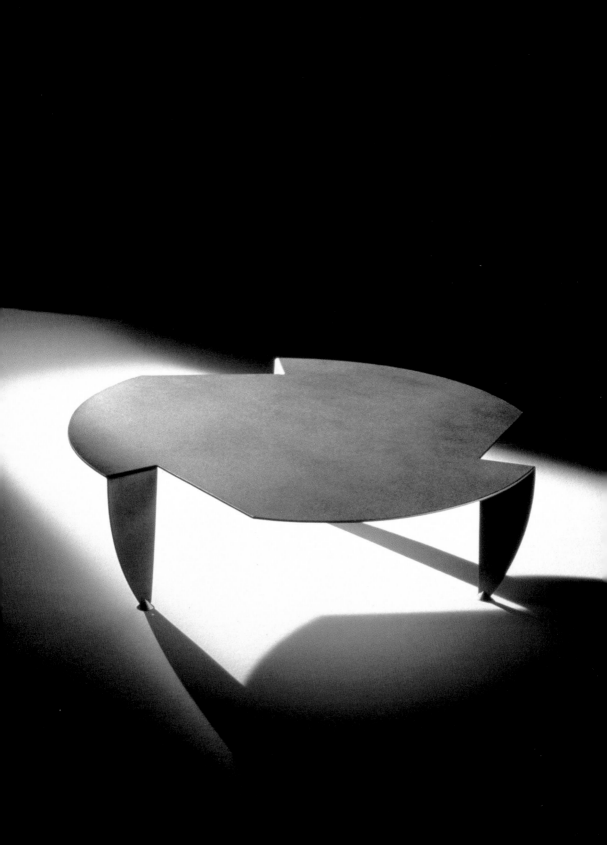

# "Corinthia" table system

**Designer:** Luca Scacchetti (Italian, b. 1952)
**Manufacturer:** Poltrona Frau, Tolentino (MC), Italy
**Date of design:** 1995–96

Intended for executive office and conference room use, numerous configurations are made possible through the use of various parts, sections, and fittings—all part of this ambitious system. In the suite, there are matching cabinets, bookcases, shelf units, a low center table, and lighting (none shown here). Based on Postmodern principles, the aesthetic reflects classical forms—thus the abstracted Corinthian capital at the top of the leg.

The support system is made of polished extruded aluminum.

A light metal frame is fitted with turned chromium-plated steel columns.

tables

**"Corinthia" table system**

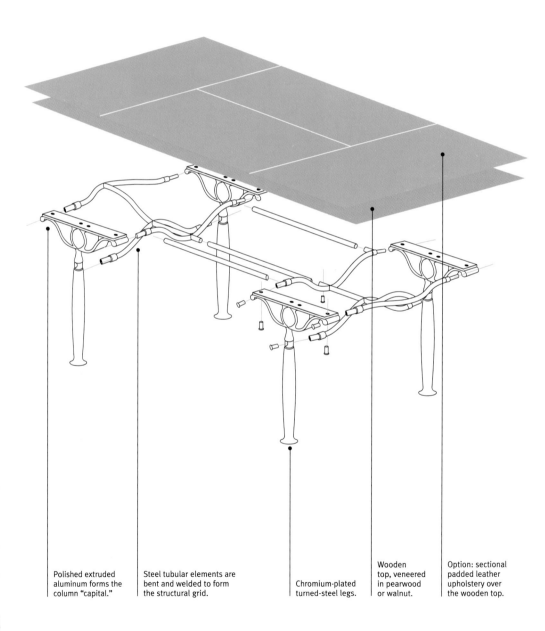

Polished extruded aluminum forms the column "capital."

Steel tubular elements are bent and welded to form the structural grid.

Chromium-plated turned-steel legs.

Wooden top, veneered in pearwood or walnut.

Option: sectional padded leather upholstery over the wooden top.

tables

56

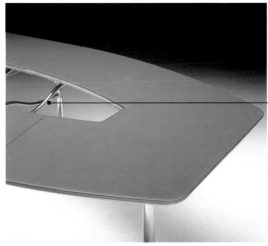

Center areas can be wired for electricity or filled in with clear glass or matching wood.

Work surface, in wood with rounded edges, can be upholstered in leather (a product for which the manufacturer has become well known) or can be veneered in pearwood or walnut.

Modularity facilitates a wide range of sizes and configurations.

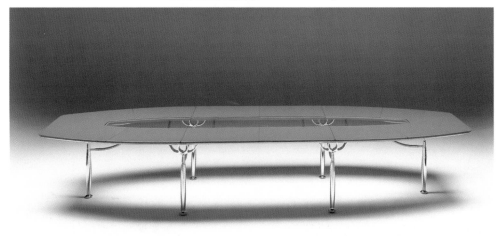

metals

# "Less" table system

**Designer:** Jean Nouvel (French, b. 1945)
**Manufacturer:** Unifor S.p.A., Turate (CO), Italy
**Date of design:** 1993

In general, tables with very thin tops tend to sink greatly in the center part of the top, even when only a light-weight object is placed on it. Though very thin, the "Less" top gives the illusion of being much thinner than it really is. A group of four counter-reinforcing triangles, fitted together under the top plane, are longitudinally reinforced by welded-on steel strips. Even though the table top slopes down to a thickness of 40mm at the center beneath the flat surface, the overall thickness of the top appears to be only as thick as its supernarrow edge.

tables

metals

# "Less" table system

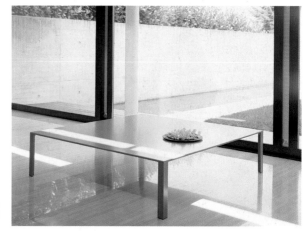

A center table version is placed in the interior space of the Fondation Cartier, Paris, for which the system was originally created.

View of the superstructure beneath the sheet-steel flat top. All surfaces are polyurethane painted and then polyacrylic coated.

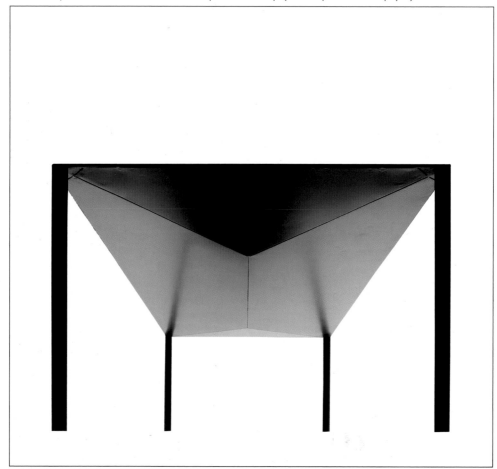

# glass

# "Fleur" center table

**Designer:** Vincenzo Lauriola (Italian, 1962–93)
**Manufacturer:** Porada arredi S.r.l., Cabiate (CO), Italy
**Date of design:** 1992

A prototype, this table is an exercise that illustrates how to combine engineering tension principles with pleasing aesthetic values. The high-tech materials include hole-bored plastic and steel disks and epoxy glue used to hold the disks to the underside of the glass top.

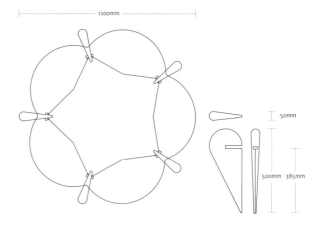

Five stainless steel disks are epoxy glued to the underside of the glass table (notice the reflection).

Taut steel cable (2mm thick) is fed through the plastic eye element of the steel disks.

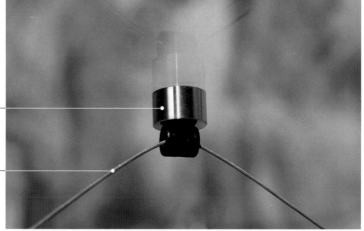

Five legs in cherrywood are rounded on all sides.

The quintafoil-shaped clear glass top (15mm thick) has a polished edge.

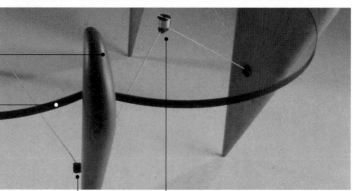

Cable is fed through plastic tubes fitted into each leg

Cable-threaded disks are glued to underside of the clear glass top.

tables

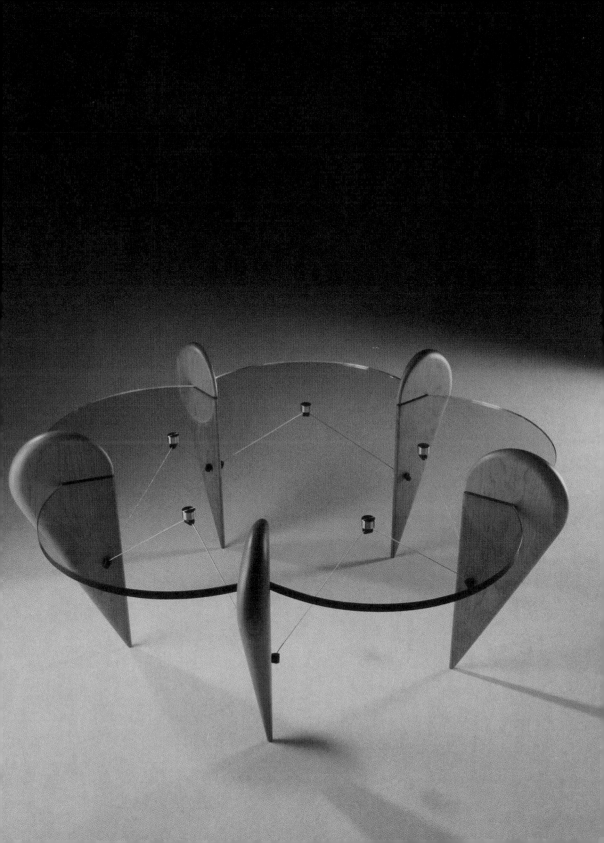

# "Table de Verre II"

**Designer:** Philippe Chaix (French, b. 1949)
and Jean-Paul Morel (French, b. 1949)
**Manufacturer:** Sté Forma, Paris
**Date of design:** 1991

The designers of this table—principally
architects—have worked in collaboration with
Woytek Sepiol to develop furniture that
explores the use of glass and new materials.
This example is made almost entirely of glass,
with the exception of steel rods running
through the legs and topped by metal disks.

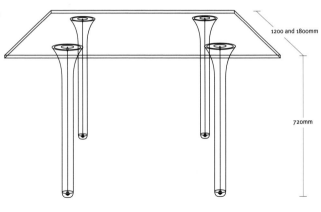

1200 and 1800mm

720mm

900 and 1200mm

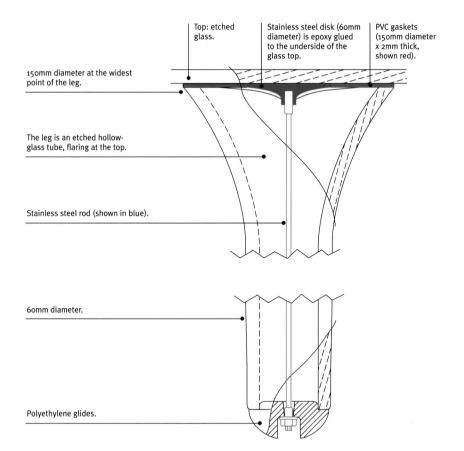

Top: etched
glass.

Stainless steel disk (60mm
diameter) is epoxy glued
to the underside of the
glass top.

PVC gaskets
(150mm diameter
x 2mm thick,
shown red).

150mm diameter at the widest
point of the leg.

The leg is an etched hollow-
glass tube, flaring at the top.

Stainless steel rod (shown in blue).

60mm diameter.

Polyethylene glides.

glass

# "Tala" table

**Designer:** Chérif (né Chérif Médjeger, French b. 1962)
**Manufacturer:** wood version Tenon et Mortaise, for VIA, Paris, France; glass version Group de Verriers Associés
**Date of design:** 1987

This side table was produced in two versions: one in wood and one in glass. The editions were 100 examples in wood and three in glass. The former version is an Old World statement employing traditional craftsmanship, while the glass version is an experimentation in the use of a fragile but efflorescent material. Both were exercises that married the efforts of artisans and designer. While not cheap, neither are the tables inordinately expensive.

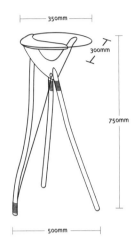

350mm
300mm
750mm
500mm

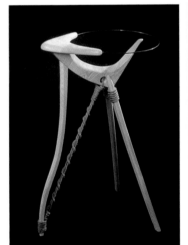

Using a binding technique and rope material, the ashwood frame was made by the artisan group, Tenon et Mortaise.

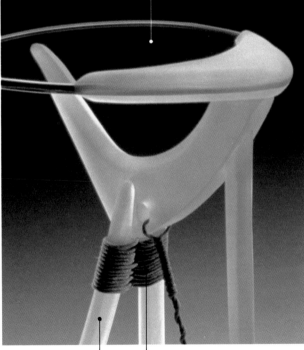

Clear-glass top surface with a polished edge.

Rope is adhered with an UV-fixed adhesive.

Acid-etched glass frame and construction produced by Group de Verriers Associés (three glassmakers).

tables

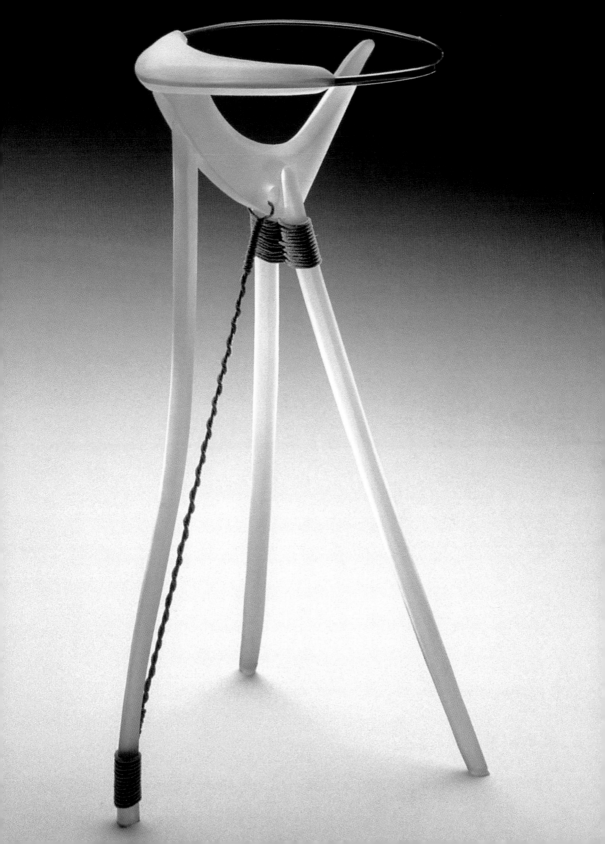

# "Ragno" table

**Designer:** Vittorio Livi (Italian, b. 1944)
**Manufacturer:** Fiam Italia S.p.A., Tavullia (PS), Italy
**Date of design:** 1984

Fiam, founded in 1972, has become known for its
daring one-piece glass furniture. This table, made
soft in an oven after being cut from one piece of flat
glass, is notable for its simplicity and conception, a
departure from the manufacturer's other, more
intricate, glass furniture.

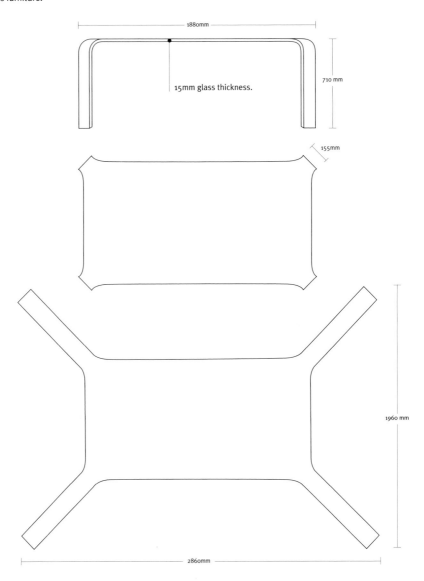

1880mm

710 mm

15mm glass thickness.

155mm

1960 mm

2860mm

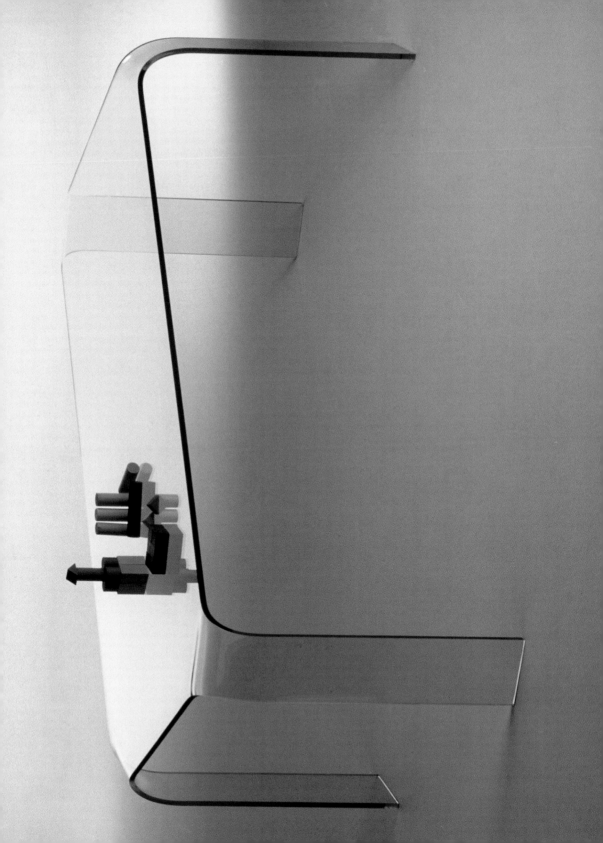

# "Ragno" table

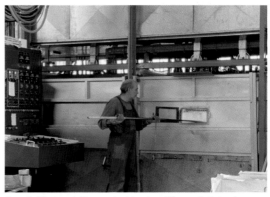

So-called float crystal is warm-bent in a tunnel furnace (exterior shown above), using an exclusive process developed by the Fiam Italia firm. A year of technology study was spent developing the "Ragno" table. (A different object is being softened in the furnace below, but a similar oven and the same process is employed.)

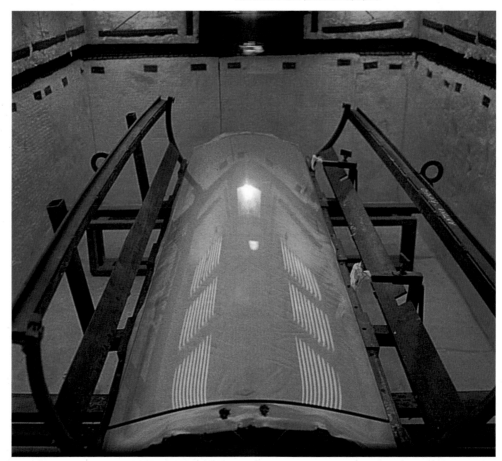

# plastics & composites

# "Hatten" side table

**Designer:** Ehlen Johansson (Swedish, b. 1958)
**Manufacturer:** Ikea, Älmhult, Sweden
**Date of design:** 1992

Typical of the inexpensive goods for which the manufacturer has become known, this table features a top that doubles as a removable tray. The tray rests on the body drum, which serves as a storage area. Assembly is performed by the user. With retail stores worldwide, Ikea sells a great many products; for example, 28,000 copies of this table have been made each year since 1993.

The tray-lid on top and basin below are of a thermoformed acrylic in transparent, blue, and red versions. (Red was replaced by orange later in the production run.)

Aluminum tubing (16mm diameter).

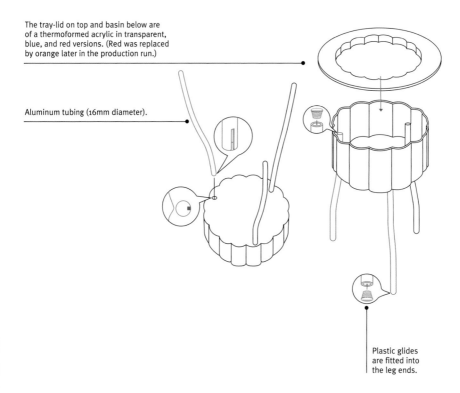

Plastic glides are fitted into the leg ends.

tables

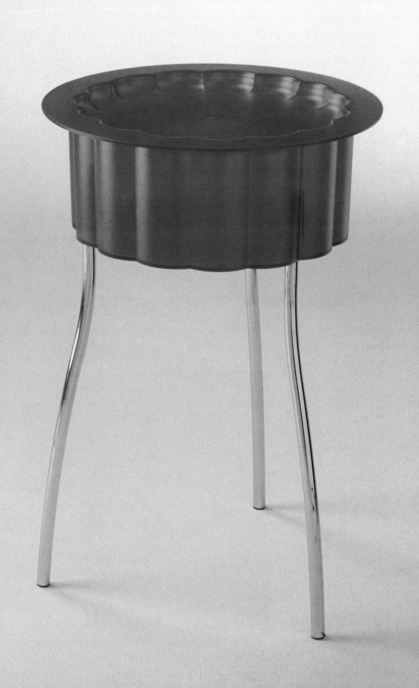

# Composite table

**Designer:** Sylvain Dubuisson
(French, b. 1946)
**Manufacturer:** Moc, Chavignon, France
**Date of design:** 1987

This very lightweight table is built with
high-tech materials in a design so refined
as to make almost no decorative statement.
Issued in an edition of five, the object, with
its super-thin top, is more of an intellectual
statement than an artistic one, although
its aesthetic values are not insignificant.

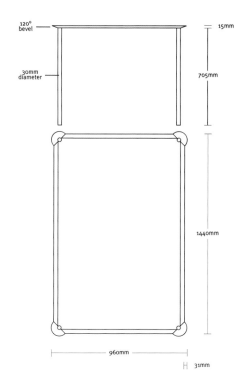

120° bevel · 15mm · 30mm diameter · 705mm · 1440mm · 960mm · 31mm

The edges are beveled from below to
make the table appear wafer thin. The
bevel is rectilinear along the sides and
ends, but conical at the four corners,
forming a 120° angle.

The constituents are in polyurethane foam
(15mm thick): the outer layer of the top is a
carbon-fiber taffeta, pre-impregnated with
epoxy resin 3000 filaments (thickness 4/10),
and the intermediate layer is a high-modulus
carbon fiber and a film of mono-component
bond in epoxy.

The seam was necessary due to the
narrow width of the carbon-fiber taffeta.

The tops of the tubular legs (30mm
diameter, in braided carbon fiber for the first
version and stainless steel for the second)
are inserted into short tube inserts that are
attached to the underside of the table top.

Neoprene glides are attached to the ends
of the legs (not shown).

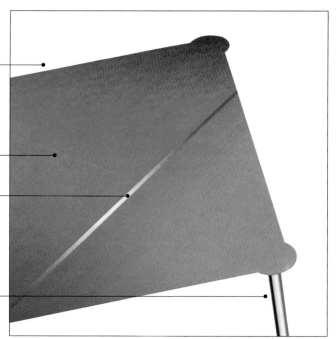

tables

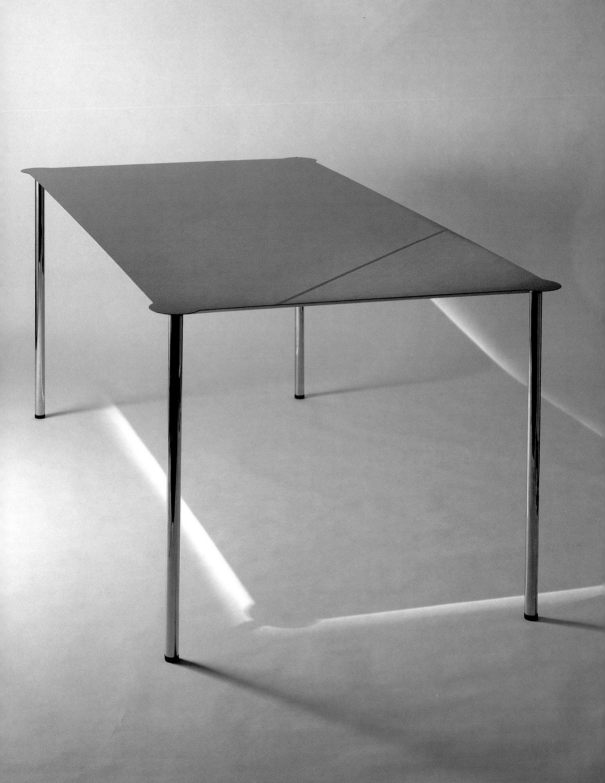

# "Plaky" side table

**Designer:** Christopher Connell (Australian, b.
1955) and Raoul Hogg (New Zealander, b. 1955)
**Manufacturer:** MAP (Merchants of Australian
Products), Victoria, Australia
**Date of design:** 1993

The top and legs of this table were produced by
molding a substance composed of recycled ABS
(acrylonitrile-butadiene-styrene) and recycled
polycarbonate materials. The table has also been
produced with cast resin (see facing page).

Revealing their first-life colors,
the reprocessed polycarbonates
and ABS, previously used in
other products, are chopped
up, re-extruded, granulated,
and molded.

The top is bolted to the
aluminum pedestal.

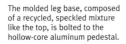

The molded leg base, composed
of a recycled, speckled mixture
like the top, is bolted to the
hollow-core aluminum pedestal.

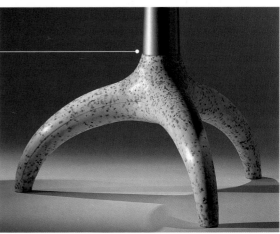

tables

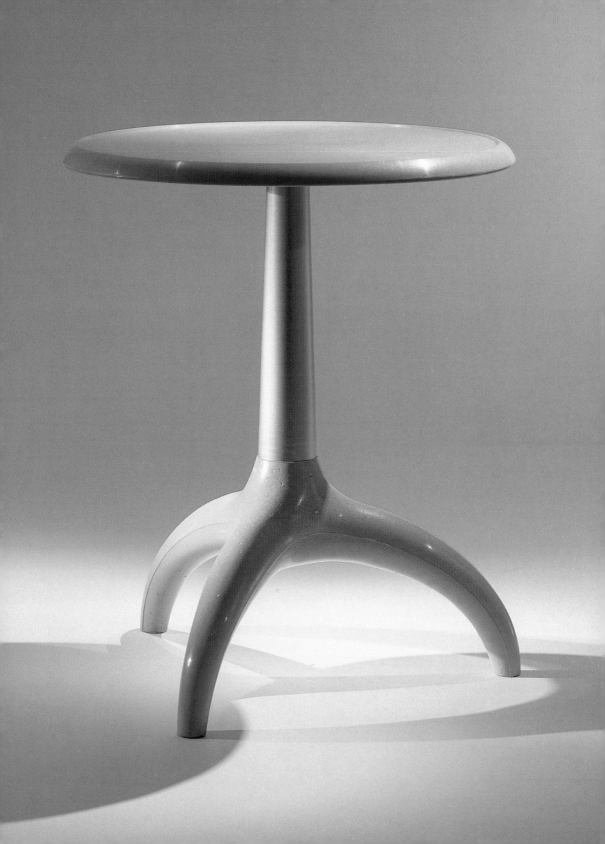

# Inflating table

**Designers:** Fernando Campana (Brazilian,
b. 1961) and Humberto Campana (Brazilian,
b. 1953)
**Manufacturer:** Campana Objetos Ltda,
São Paulo/SP, Brazil.
**Date of design:** 1996

The idea of the designers (who are brothers), was
to produce a table that was its own package. When
the bladder body is deflated, it is storable while
still attached to the top and bottom dishes. The
legs are removable. The table, appropriate for
use by the side of a chair, is inexpensive, amusing,
and surprisingly functional. The final version is
made in clear PVC.

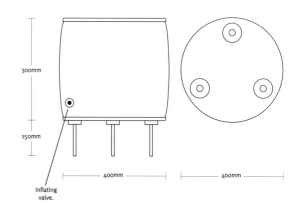

300mm

150mm

Inflating
valve.

400mm

400mm

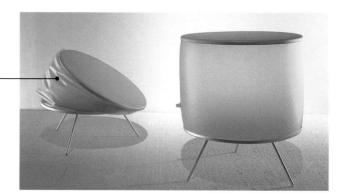

The prototype in yellow PVC
(polyvinylchloride) film illustrates the
inflatable nature of the object. The legs
on the final version are vertical.

All metal is electrostatically spray-painted.
The PVC bladder is formed by heat sealing,
and the aluminum dishes are contact glued
to the PVC.

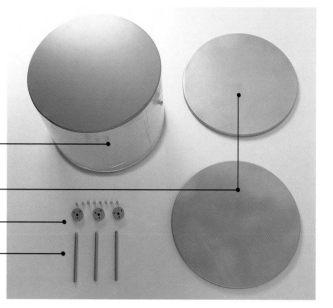

The final version of the table is realized in
0.3mm-thick clear PVC (400mm diameter x
296mm high), supplied by Lidice Brinquedos
Ltda, Diadema SP, Brazil.

Two 0.2mm thick aluminum dishes
(400mm diameter x 15mm deep).

Leg-socket disks (27mm diameter x
100m long) cut from aluminum rods.

Aluminum-rod legs (9mm diameter
x 150mm long).

tables

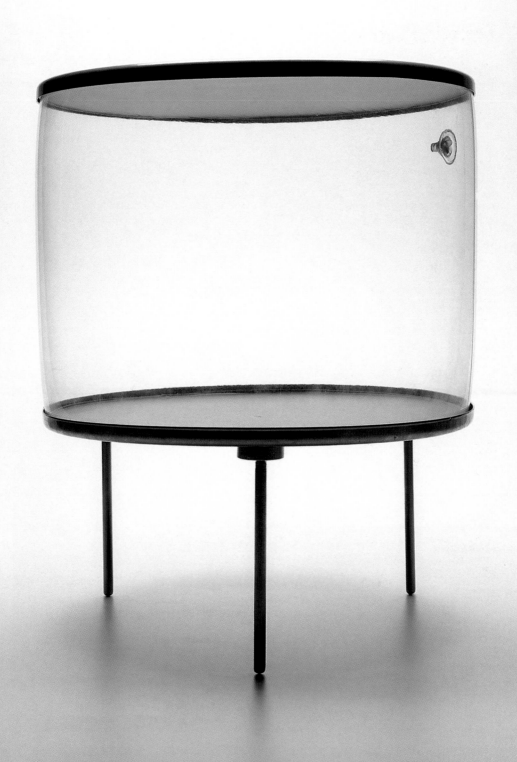

# Inflating table

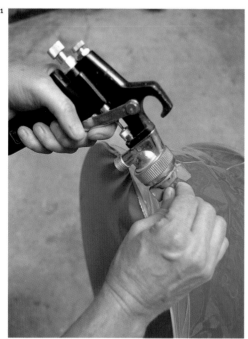

Sequential assembly procedure:

1. An air gun inflates the PVC bladder-body of the table.

2. Contact glue is painted onto the aluminum dishes used for the top and bottom.

3. The top dish is being glued onto the bladder-body.

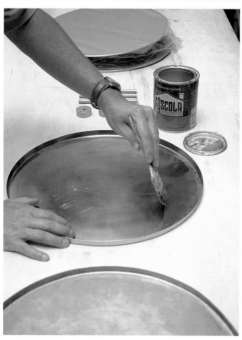

tables

4. The bottom dish is being glued onto the bladder-body.

5. The legs are screwed into the bottom dishes.

6. The completed, inflated table.

plastics...

81

# "Gello" side table

**Designer:** Marc Newson (Australian, b. 1963)
**Manufacturer:** Trois Suisse, Paris, France
**Date of design:** 1994

An ephemeral, transparent object, this table continues the designer's use of challenging materials to produce intriguing furniture forms. The table, available in one of three colors or clear and packaged flat in a cardboard box, is to be assembled by the end user.

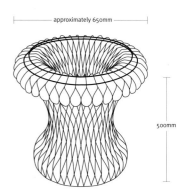

approximately 650mm

500mm

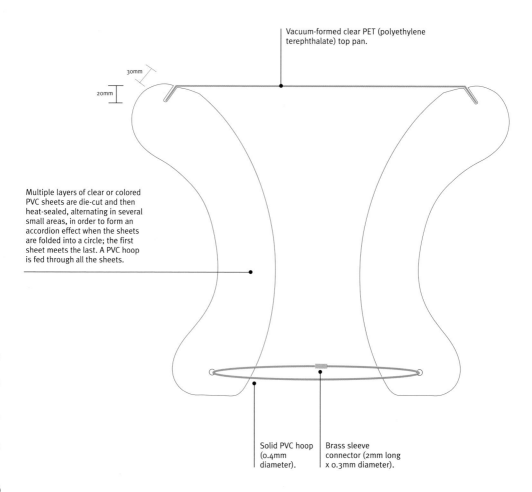

Vacuum-formed clear PET (polyethylene terephthalate) top pan.

30mm

20mm

Multiple layers of clear or colored PVC sheets are die-cut and then heat-sealed, alternating in several small areas, in order to form an accordion effect when the sheets are folded into a circle; the first sheet meets the last. A PVC hoop is fed through all the sheets.

Solid PVC hoop (0.4mm diameter).

Brass sleeve connector (2mm long x 0.3mm diameter).

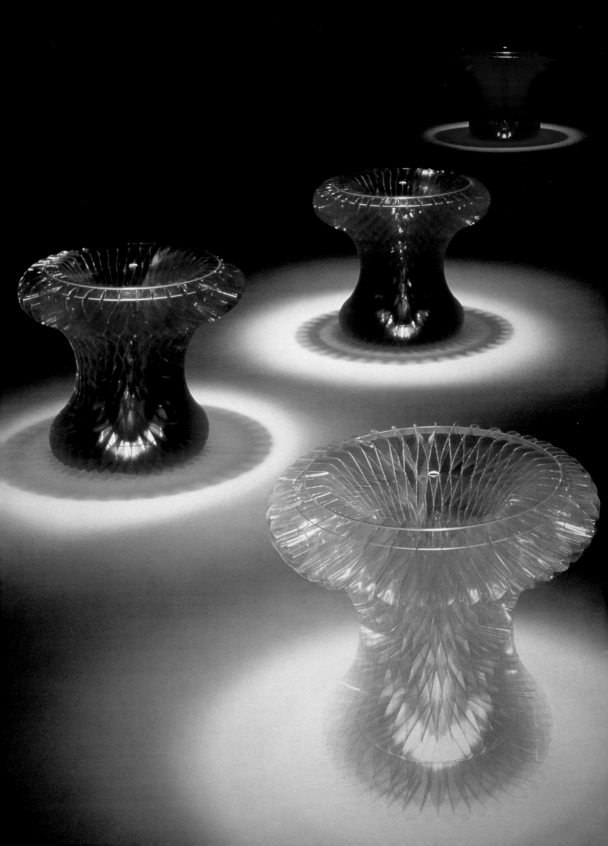

# Center table

**Designer:** Christophe Pillet (French, b. 1959)
**Manufacturer:** Limited edition for V.I.A.,
Paris, for the Carte Blanche award (1993)
**Date of design:** 1993

Active since 1988 when he designed a lamp
for Memphis, the designer here explores the
use of a heat-formed plastic material which
he combined with metal. The former, a
polycarbonate, produces a certain frosted
translucence, reminiscent of etched glass.

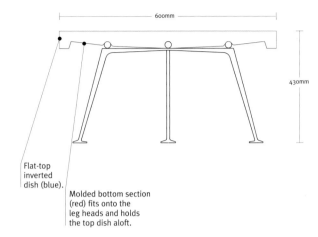

600mm

430mm

Flat-top
inverted
dish (blue).

Molded bottom section
(red) fits onto the
leg heads and holds
the top dish aloft.

The top is formed like a
round box with a flat lid
and a sculptured bottom.

Thermoformed two-part top:
The flat-top inverted dish (above)
forms a hollow box with the
molded bottom (below) that
is held stationary by the
impressed grooves.

Cast aluminum base.

tables

84

# "X-Light" table

**Designer:** Alberto Meda (Italian, b. 1945)
**Manufacturer:** Alias S.r.l., Grumello del
Monte (BG), Italy
**Date of design:** 1989

This is an example of the kind of super-light-
weight furniture for which the designer, who
began as an engineer, has become known.
Producing prototypes himself, he employed
machinery necessary to make a sandwich of
glass and carbon fibers in an epoxy resin
matrix. The external edge is aluminum. (For
a similar leg form, see René Herbst's 1935
stainless steel table in Yvonne Brunhammer,
Le Mobilier 1930-1960, Paris: Éditions
Massin, 1997, p. 66.)

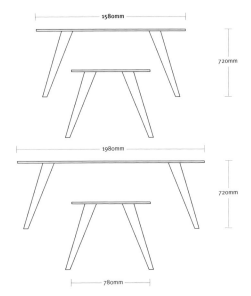

1580mm

720mm

1980mm

720mm

780mm

All the components used
in the table's construction.

Aluminum
profile.

Glass-fiber
fabric.

Aluminum
honeycomb.

Carbon-fiber
fabric.

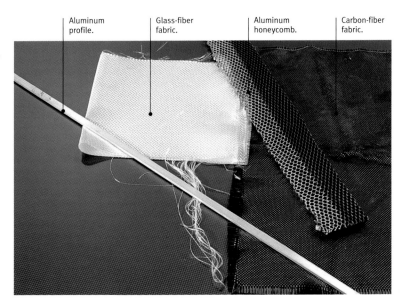

# "ANTic"
# center table

**Designer:** Marc Harrison (New Zealander, b. 1970)
**Manufacturer:** ANTworks, Moorooka, Australia
**Date of design:** 1996

The components of this distinctive table, which looks more like a flying saucer than an ant, are connected by only four screws. Local Australian wood (for the top) is combined with a resin (for the superstructure) and steel tubing (for the legs) to form a relatively simple but stylish structure produced in a small edition.

The only fasteners: four screws.

The semi-spherical superstructure into which the legs are inserted is an injection-molded resin.

Four stainless steel tubular legs (25mm diameter).

Chamfered edge of Australian wood (600mm diameter x 40mm thick) is cut with a CNC router.

tables

# "4300" table

**Designer:** Anna Castelli Ferrieri (Italian, b. 1918)
**Manufacturer:** Kartell S.p.A., Noviglio (MI), Italy
**Date of design:** 1982

Not a new table, its advanced technology reveals its having been produced by Kartell, the far-sighted 50-year-old firm that made plastics respectable for domestic use. Composed of only nine pieces (the top, four legs, and four leg cones), the table is easily shipped and assembled. No screws are necessary since all elements are force fitted by the end user.

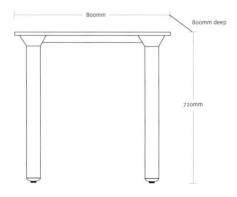

800mm

800mm deep

720mm

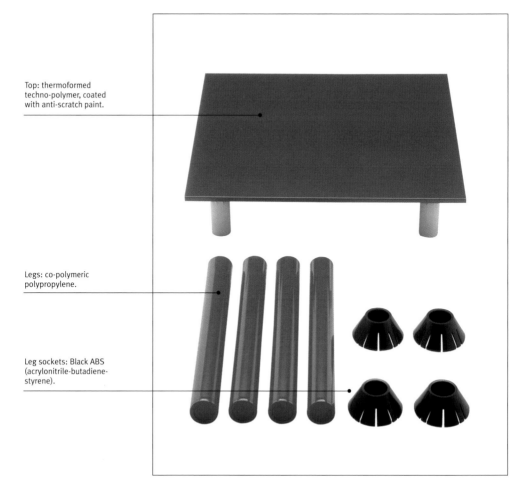

Top: thermoformed techno-polymer, coated with anti-scratch paint.

Legs: co-polymeric polypropylene.

Leg sockets: Black ABS (acrylonitrile-butadiene-styrene).

tables

# "4300" table

Available in white, yellow, green, red, brown, or black.

Underside view of the top.

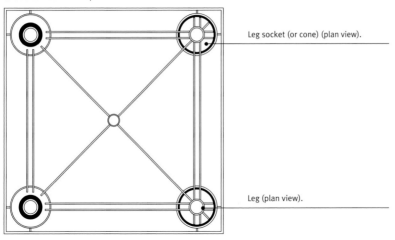

Leg socket (or cone) (plan view).

Leg (plan view).

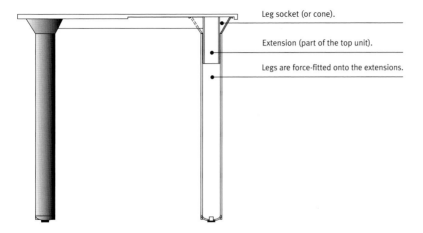

Leg socket (or cone).

Extension (part of the top unit).

Legs are force-fitted onto the extensions.

# "Le misanthrope" console

**Designer:** Vincent Bécheau (French, b. 1955) and Marie-Laure Bourgeois (French, b. 1955)
**Manufacturer:** the designers
**Date of design:** 1985

Made primarily of synthetic materials, this table's main feature, as with the other furniture pieces in the same series, is the use of a particular type of corrugated polyester sheeting that is also used for architectural roofing.

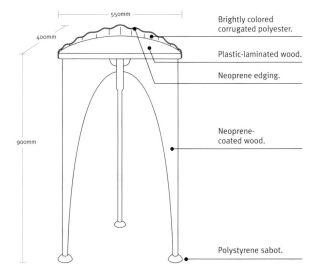

550mm

400mm

900mm

Brightly colored corrugated polyester.

Plastic-laminated wood.

Neoprene edging.

Neoprene-coated wood.

Polystyrene sabot.

The corrugated polyester top rail is connected with screws and washers. All other parts are glued together.

The "Misanthrope" table is part of a system that includes shelving and other furniture units. A catalogue page is shown below.

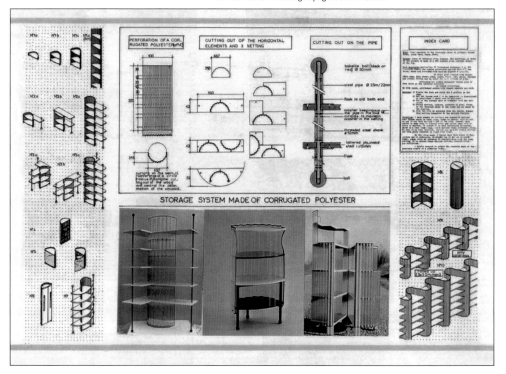

STORAGE SYSTEM MADE OF CORRUGATED POLYESTER

plastics....

# "So" side table

**Designer:** Andrew Tye (British, b. 1968)
**Manufacturer:** the designer
**Date of design:** 1996

The body of this table is composed of flat and bent acrylic sheeting. Since certain plastic materials, such as acrylics, have a shape memory, a heat-bending device is used to set the form of the bottom portion of the body and to retain rigidly vertical and flat planes. To eliminate hard, sharp edges, they are flame flashed.

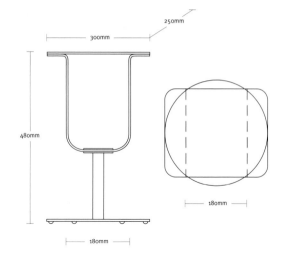

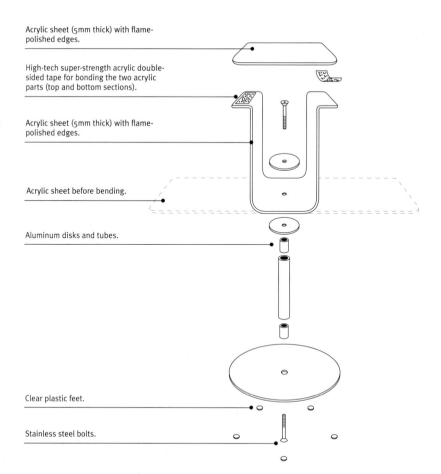

Acrylic sheet (5mm thick) with flame-polished edges.

High-tech super-strength acrylic double-sided tape for bonding the two acrylic parts (top and bottom sections).

Acrylic sheet (5mm thick) with flame-polished edges.

Acrylic sheet before bending.

Aluminum disks and tubes.

Clear plastic feet.

Stainless steel bolts.

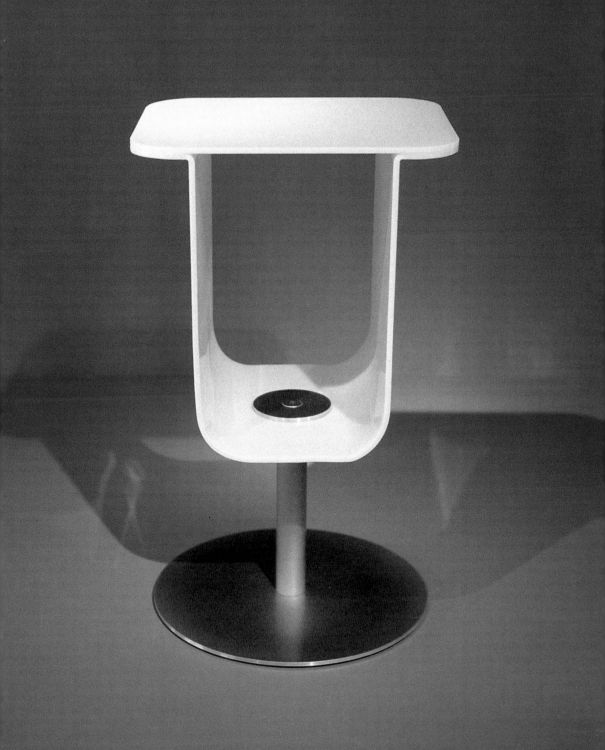

# "A" table

**Designer:** Maarten van Severen
(Belgian, b. 1956)
**Manufacturer:** the designer
**Date of design:** 1992

This sleek, highly engineered table
features the unusual use of what
some might consider an old-fashioned
material, Bakelite, which is glued to
the superstructure. To complete the
effect of the already sleek surfaces, the
table is polished and waxed after being
fully assembled by welding, screwing,
and gluing. Compare this table with the
"Less" table on pages 58–60.

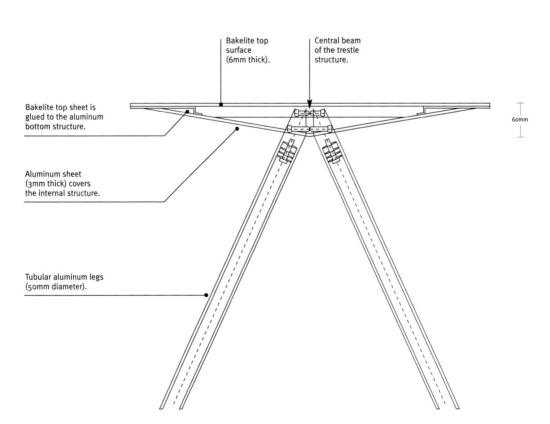

2700mm

720mm

Bakelite top
surface
(6mm thick).

Central beam
of the trestle
structure.

Bakelite top sheet is
glued to the aluminum
bottom structure.

60mm

Aluminum sheet
(3mm thick) covers
the internal structure.

Tubular aluminum legs
(50mm diameter).

tables

# "Triangle" side table

**Designer:** Hannu Kähönen (Finnish, b. 1948)
**Manufacturer:** Moform OY, Helsinki, Finland
**Date of design:** 1986

This collapsible table employs all high-tech, newly developed materials—a surprising departure and non-traditional approach since it was designed and produced in a country known primarily for its use of wood and wood products.

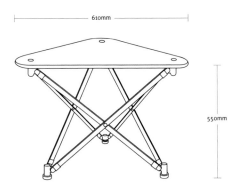

610mm

550mm

Fiberglass legs.

Table-top connectors, foot joints, and plugs are in polypropylene.

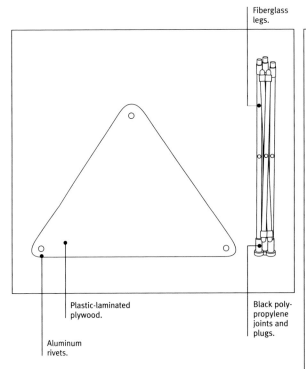

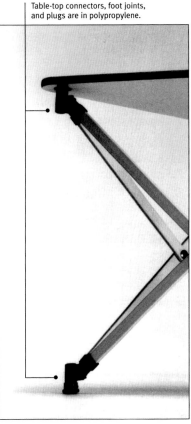

Plastic-laminated plywood.

Black polypropylene joints and plugs.

Aluminum rivets.

tables

100

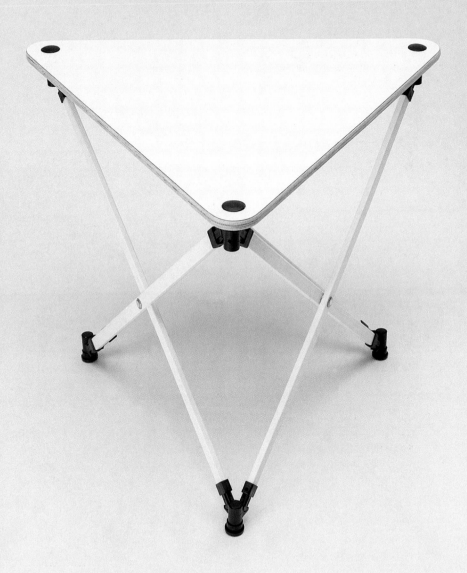

# "Triangle" side table

The "Triangle" table is part of a suite that includes the "Moform" chair. This uses the same materials, with the addition of a textile for the arms and seat.

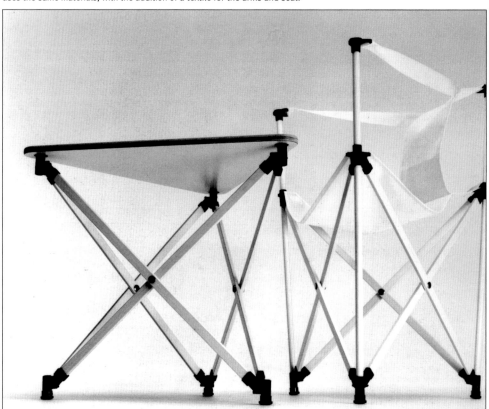

# various
# materials

# "Zébulon" desk

**Designer:** Jérôme Gauthier (French, b. 1970)
**Manufacturer:** the designer
**Date of design:** 1995

This one-of-a-kind object may appear peculiar at first view, but, when compared to narrow-use French furniture of the 18th century, the rationale of the design becomes apparent. The eclectic combination of materials (industrial metal, unfinished wood, and natural color leather) is distinctive in the treatment of the bellows pockets.

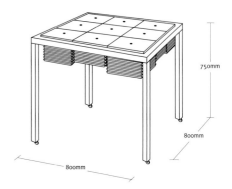

750mm

800mm

800mm

A drawing by the designer reveals his studies for the bellows in sheep leather, including the corner solution (lower right).

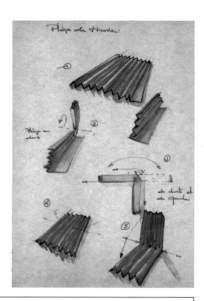

Nine square lids veneered in pearwood with finger holes for removal.

Square sanded and varnished extruded steel (40mm x 40mm).

Bellows pockets in tan sheep leather are supported on steel shelves suspended by metal rods at each corner.

Covered casters.

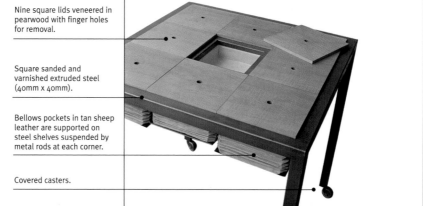

tables

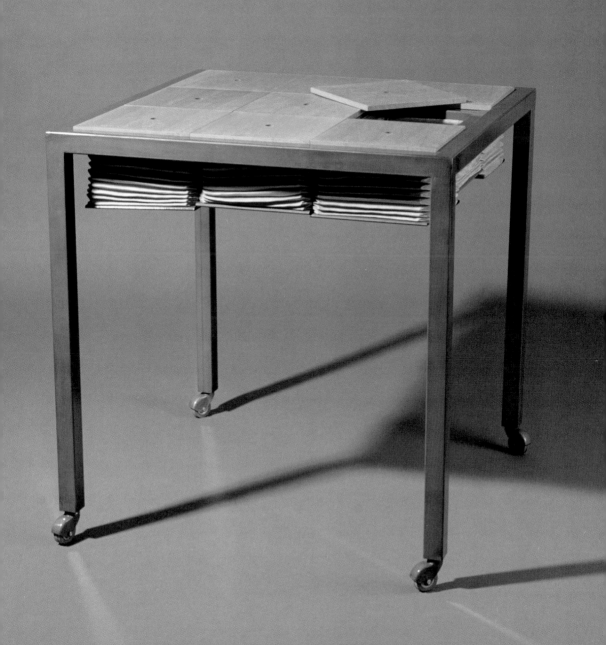

# Desk-table

**Designer:** Olivier Leblois (French, b. 1947)
**Manufacturer:** Quart de Poil', Paris, France
**Date of design:** 1995

Die cut from the same standard cardboard used to make packing boxes, this very inexpensive table is sold flat, and the end user assembles it at home. Simply by using a sharp knife or fine saw, its height can be changed from high, as a desk, to low, as a center table.

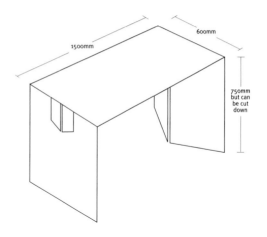

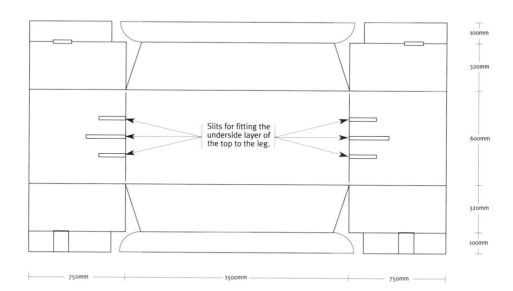

Slits for fitting the underside layer of the top to the leg.

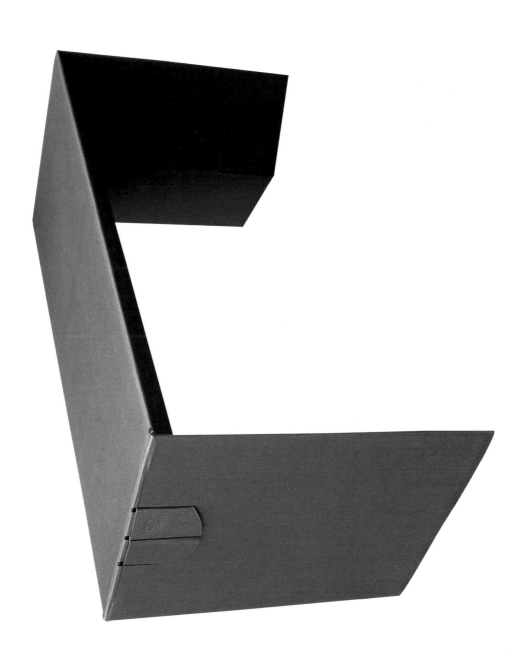

# Desk-table

From one piece of corrugated cardboard the table is
built by folding only—no fasteners or glue required.

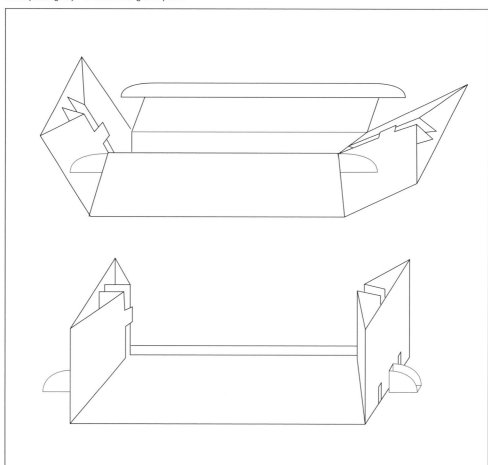

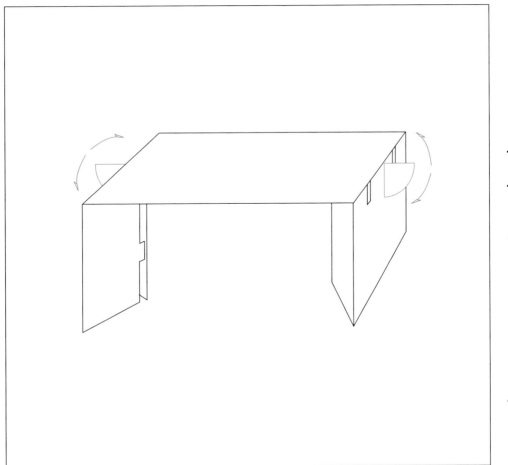

# "Table cruelle pour jeune fille au pair" table

**Designer:** Rashdar Coll-Part
(Monégasque, b. 1912)
**Manufacturer:** the designer
**Date of design:** 1991

This is a surreal one-of-a-kind piece. The designer's name is a pseudonym and his date of birth and nationality are probably untrue. Its title means "a cruel table for a young nanny." The glass-covered maze simulates a laboratory experiment, and the designer suggests the inclusion of two live mice.

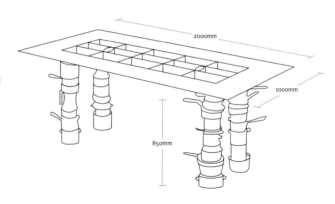

Ordinary used pots and pans retaining their original, if tattered, finishes.

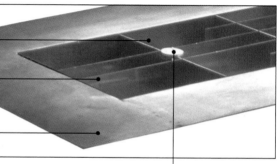

The maze is composed of vertically placed sections of aluminum sheeting.

Sécurit (tempered) glass (6mm thick) covers the maze.

Oxidized aluminum top surface (2mm thick).

Polyurethane pads separate the glass top from the maze partitions.

tables

110

# "Teppich-Tisch" (rug table)

**Designer:** Konstantin Grcic (German, b. 1965)
**Manufacturer:** Authentics, artipresent GmbH, Holzgerlingen, Germany
**Date of design:** 1993

Produced by a firm known for its products in inexpensive plastics, this table is very odd indeed but possesses an intriguing sense of humor. It is an amalgam of worldwide production elements: rug from India, top from Germany, metalwork from Taiwan, and conception by a designer whose origins are Yugoslavian. The rug table, available in two versions, is purchased by the consumer in three pieces which must be assembled by them.

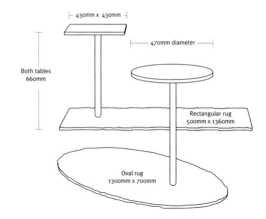

430mm x 430mm

470mm diameter

Both tables 660mm

Rectangular rug 500mm x 1360mm

Oval rug 1300mm x 700mm

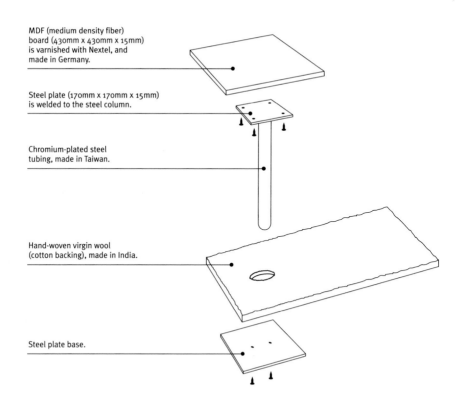

MDF (medium density fiber) board (430mm x 430mm x 15mm) is varnished with Nextel, and made in Germany.

Steel plate (170mm x 170mm x 15mm) is welded to the steel column.

Chromium-plated steel tubing, made in Taiwan.

Hand-woven virgin wool (cotton backing), made in India.

Steel plate base.

tables

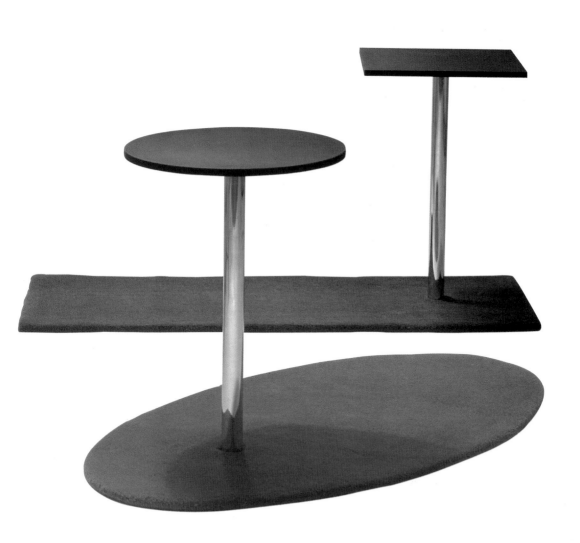

# "Pigmento" center table

**Designer:** Luciana Martins (Brazilian, b. 1967) and Gerson de Oliveira (Brazilian, b. 1970)
**Manufacturer:** the designers
**Date of design:** 1995

According to the designers, this table was conceived as a tribute to materials, making little other statement – hence the simple form (the square) and the use of a raw pigment. They suggest that the object may only exist for someone to sit and gaze at it; the intensity of color is mesmerizing.

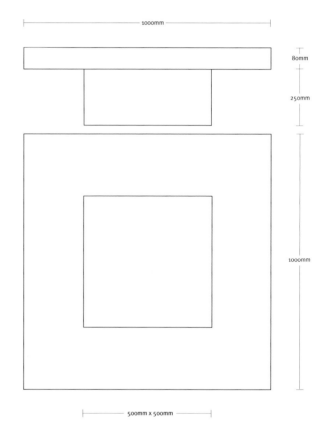

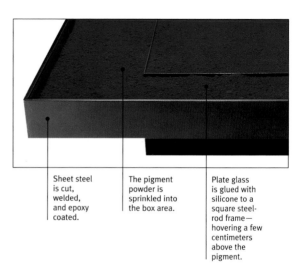

Sheet steel is cut, welded, and epoxy coated.

The pigment powder is sprinkled into the box area.

Plate glass is glued with silicone to a square steel-rod frame—hovering a few centimeters above the pigment.

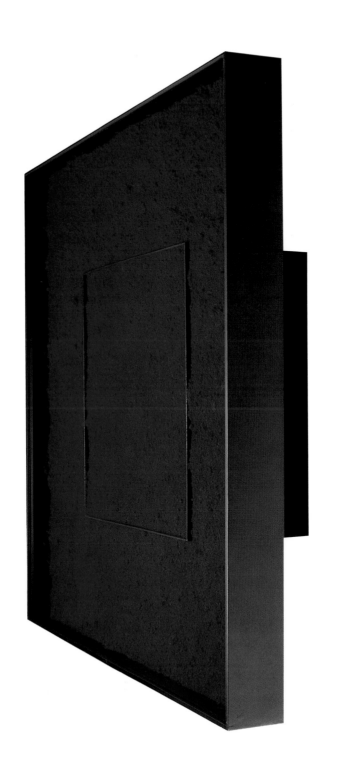

various materials

# "Pigmento" center table

The pigment powder, deposited into the box area of
the table, is like that for tinting plastics, dyes, and paints.

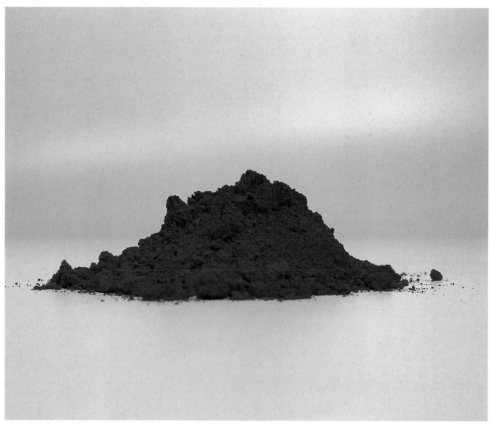

tables

# articulation

# "Clack" table

**Designer:** Michele De Lucchi
(Italian, b. 1951)
**Manufacturer:** Bieffe di Bruno Ferrarese
S.p.A., Caselle di Selvazzano (PD), Italy
**Date of design:** 1989

This version of the tilt-top table, popularized
in the 18th century, is appropriate for saving
space in small environments. The top folds
downward, and the legs collapse inward,
like an umbrella. Made in metal, it gives the
appearance of wood. There are two sizes of
tops available, named the "Big Clack" and
"Little Clack" tables.

The rectangular hollow metal legs
are attached by the end user to the
folding mechanism at the base of the
short pedestal by means of a hex
screwdriver, provided
with the table.

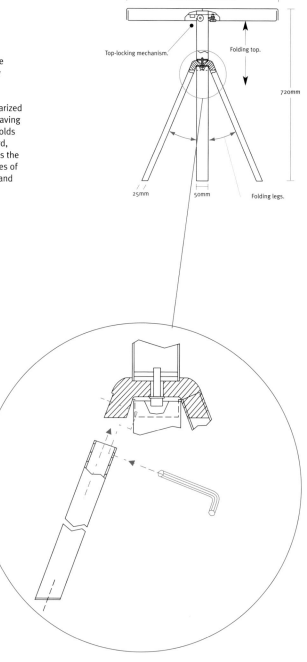

80 x 80mm or 80 x 120mm

Top-locking mechanism.

Folding top.

720mm

25mm

50mm

Folding legs.

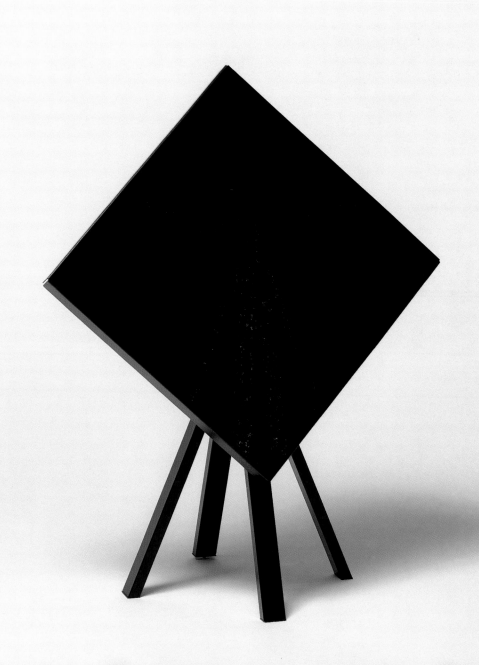

# "Clack" table

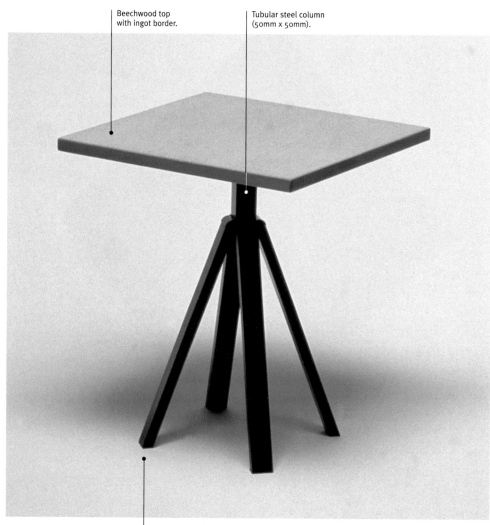

Beechwood top
with ingot border.

Tubular steel column
(50mm x 50mm).

Four rectangular hollow metal
legs (50mm x 25mm x 532mm)
are attached to the central
column mechanism with a small
screwdriver provided to the end
user for assembly.

tables

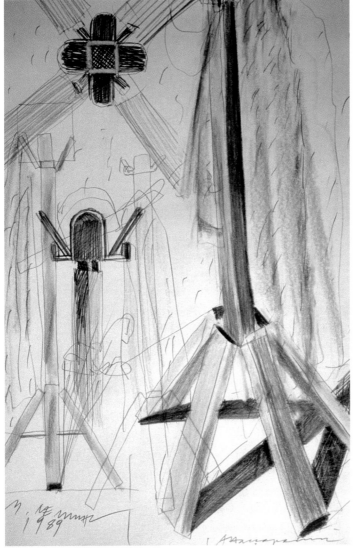

A drawing by the designer discloses the same leg-folding conception, here for a coat rack.

# "S 1080" side table

**Designer:** Alfredo Walter Häberli
(Argentine, b. 1964) and
Christophe Marchand (Swiss, b. 1965)
**Manufacturer:** Gebrüder Thonet GmbH,
Frankenberg, Germany
**Date of design:** 1996

While a stacking chair is quite ordinary
in the history of 20th-century furniture,
a stacking table is unusual. However,
nesting tables have existed for some time.
Available with two slightly different frame
configurations, only one is shown here. The
plastic for the parts alone attests to the
employment of sophisticated technology in
producing this piece: polyamid, poly-acetal,
polypropylene, and thermo-plastic rubber.

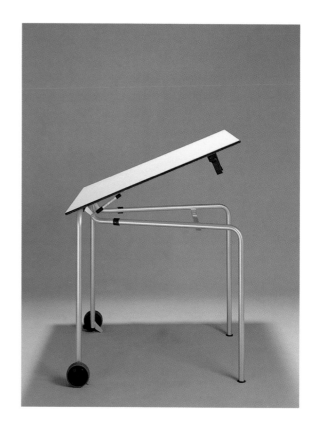

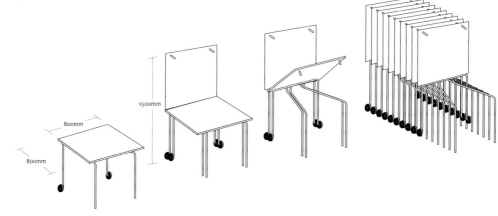

800mm

1500mm

800mm

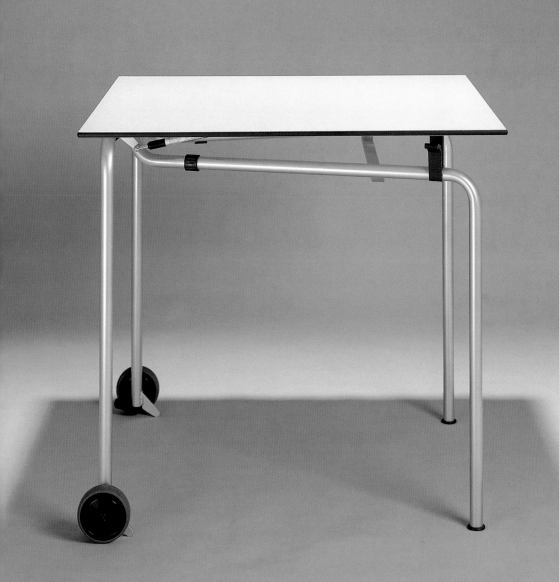

# "S 1080" side table

The tops are liftable, thus exposing the frames that permit the units to be compressed one over the other. Since there is no downward weight as with stacking chairs, an infinite number of tables can be nested.

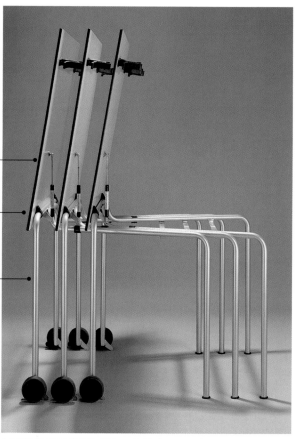

Lid of the table is plastic-laminated on the top and on the bottom.

A gas-spring (400N) holds the lid aloft.

High-gloss powder-epoxy coated steel tube (25mm diameter, 2.5mm wall) is bent with a Pulzer type HD35 Matic F machine and soldered.

Assembly is accomplished with ten cylindrical screws and Loctite 454 instant adhesive. Black plastic parts made of polyamid, polyacetal, polypropylene, or thermoplastic rubber.

tables

One of two of Thonet's production facilities in
Frankenberg, Germany, where the table is made.

articulation

# "Rotterdam" side table

**Designer:** Alexander Gelman (Russian, b. 1967)
**Manufacturer:** Nina Sue Nusywowitz, New York, NY, U.S.A.
**Date of design:** 1997

The top open spaces between the nine folding panels of this metal table can be made narrow in order to eliminate the necessity of a traditional top surface. Shapes, formed by folding, can be any one of a vast number of configurations. The geometry is simpler even than the forms of origami.

Capable of assuming an almost endless number of shapes and of supporting objects, a separate flat top surface is not needed.

Each section in white-galvanized sheet aluminum (18 gauge) is punched along the sides and fitted with full, vertical Royal hinges (13mm knuckles, 13mm leaves), attached by stainless-steel screws (.08 with round heads) to the edges of the sections.

610mm

| 508mm | 558 | 508 | 457 | 406 | 355 | 305 | 254 | 204 |

Flat elevation view

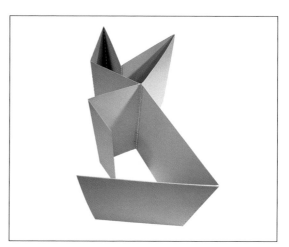

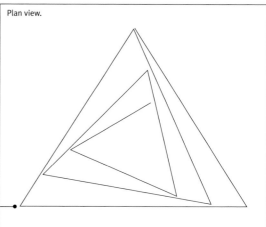

Plan view.

tables

## 126

# "Tabula Rasa" table-seat

**Designer:** Uwe Fischer (German, b. 1958)
and Klaus-Achim Hein, German, b. 1955)
**Manufacturer:** Vitra AG, Weil am Rhein, Germany
**Date of design:** 1987

This structure is a highly practical, though fantastic, unit that combines seating, table top, and sideboard. It may be a simple matter to conjure this concept on the drawing board or by computer, but to have it actually realized in an edition of 20 is quite another. The seating and table top extend up to 5000mm, as if by magic, from the small cabinet.

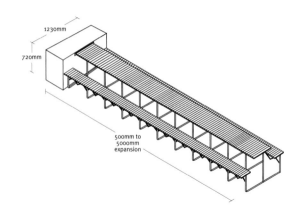

1230mm
720mm
500mm to 5000mm expansion

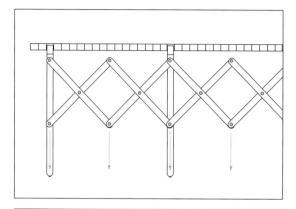

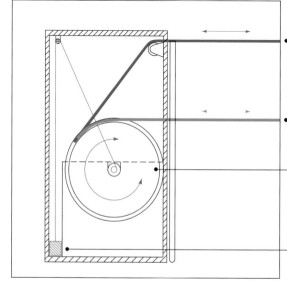

Plywood slats for the table top (blue) and the seat (green) are adhered to a fabric belt.

The seating and table top slats are wound around the drum, and the leg-supports fold up in front of the cabinet.

A heavy weight attached to a cable (red) counterbalances the winding force and the release of of the slats around the drum.

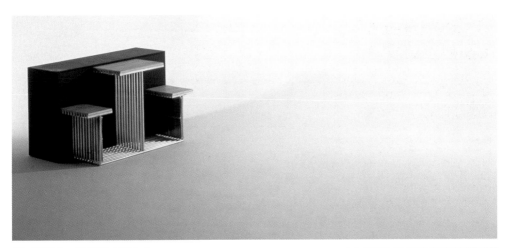

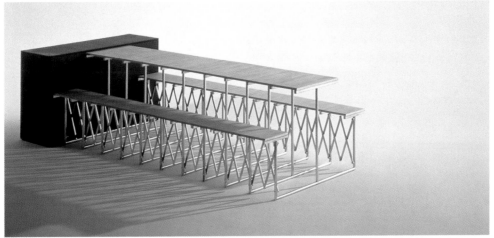

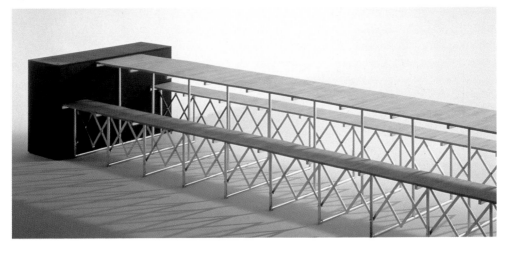

# "T Four 4" folding trolley

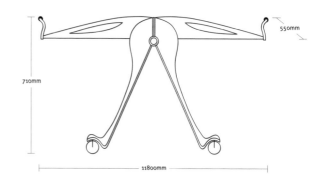

**Designer:** Ron Arad (Israeli, b. 1951)
**Manufacturer:** Driade S.p.A., Fossadello di Caorso, Italy
**Date of design:** 1993

A clever folding frame, for easy storage, was invented to support the plywood tray. This is a highly refined product by a designer whose earlier work was much more rough-hewn with obvious, if not brutal, features revealing handmade construction.

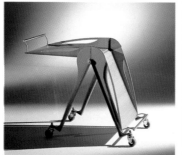
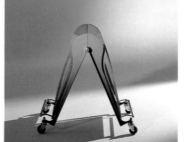
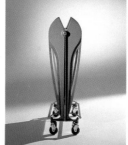

The trolly folds into an upright position for storage.

View inside the fully opened tray: light-color molded walnut-stained plywood.

Frame in cast aluminum on casters.

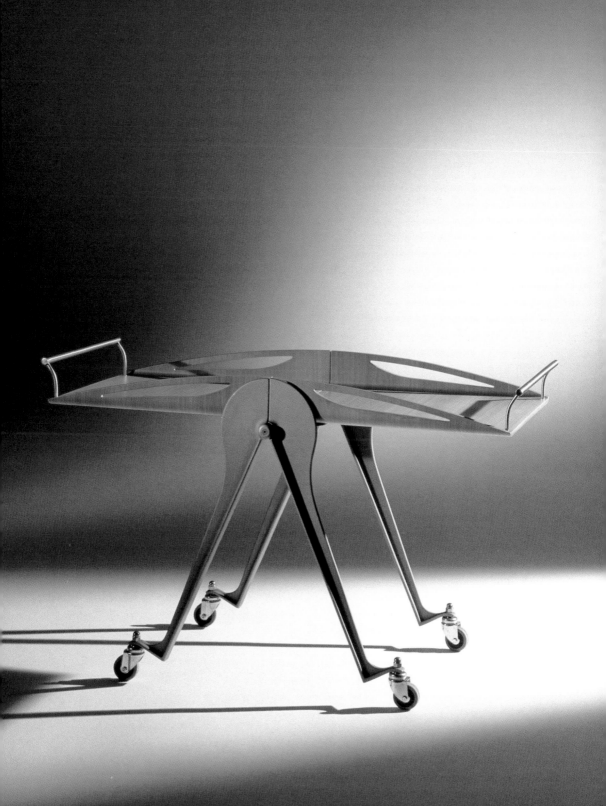

# "Last Minute" table

**Designer:** Hauke Murken (German, b. 1963)
**Manufacturer:** Nels Holger Moormann,
Aschau im Chiemgau, Germany
**Date of design:** 1992

In the tradition of using fabric hinges like
those employed by Charles and Ray Eames in
their screen of 1946, the hinges are the only
elements that hold this table together and make
articulation possible. Easily stowed away, the
almost cube-shaped table can be folded and
then hung on the wall to save space.

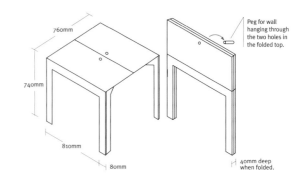

760mm

740mm

810mm

80mm

Peg for wall
hanging through
the two holes in
the folded top.

40mm deep
when folded.

Partially folded, completely
open, and hanging stages.

Partially
raised
top.

Hole (36mm diameter) for wall hanging
when the two linen-hinged sections of
the top are folded flat.

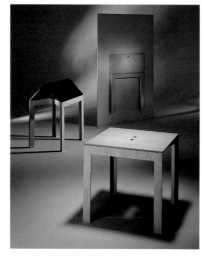

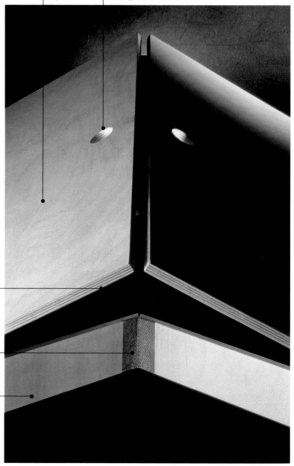

12mm-thick plywood
throughout.

Linen hinge here (at the
center of two opposite aprons)
and at each of the four leg
corners—no other connectors.

Inward-folding apron
(80mm high).

# "Scalandrino" table/étagère

**Designer:** Achille Castiglioni (Italian, b. 1918)
**Manufacturer:** Zanotta S.p.A., Nova Milanese (MI), Italy
**Date of design:** 1983

This table can be easily transformed from a flat, horizontal surface into a vertical shelving unit through the use of a releasing-and-locking lever. The kind of tour-de-force object one has come to expect from this venerable designer, this object may be more of an oddity than a practical piece of furniture.

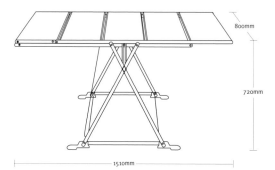

800mm

720mm

1510mm

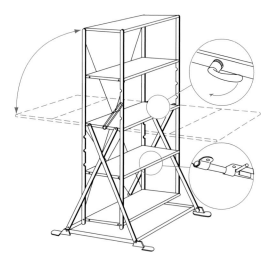

Configuration can be flat as a table, vertical as a bookcase/shelving unit (above), or angled as a bookcase/shelving unit (right).

Natural beechwood shelves with gray-brown or gray-green linoleum inserts.

Silver-painted steel structure.

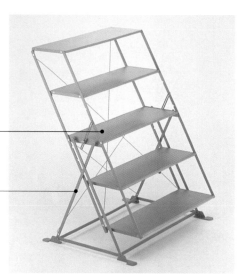

tables

**134**

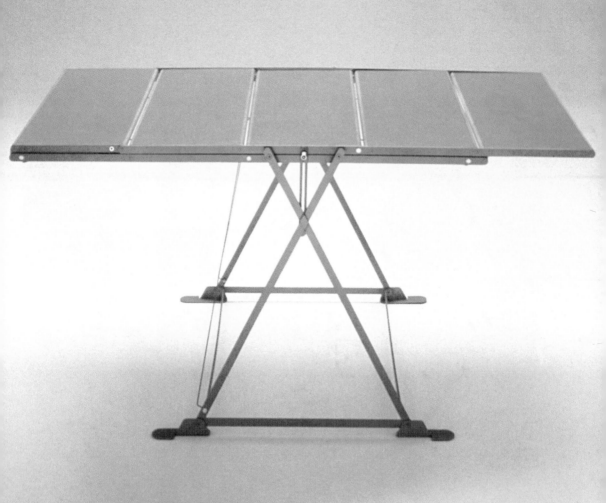

# "Table à bascule"

**Designer:** Jean-Pierre Caillères
(French, b. 1941)
**Manufacturer:** Papyrus, Paris, France
**Date of design:** 1985

This two-position table may be used at a
dining or desk height or at a center table
height. The red spring-buttons at the sides
of the weighted base hold the arms in one
of two positions.

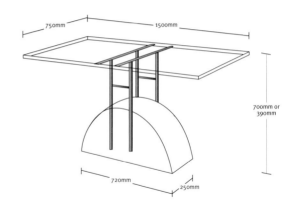

750mm · 1500mm · 700mm or 390mm · 720mm · 250mm

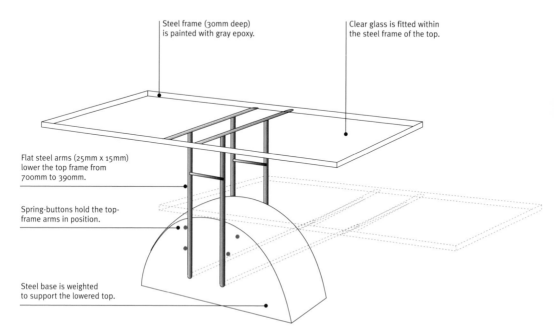

Steel frame (30mm deep)
is painted with gray epoxy.

Clear glass is fitted within
the steel frame of the top.

Flat steel arms (25mm x 15mm)
lower the top frame from
700mm to 390mm.

Spring-buttons hold the top-
frame arms in position.

Steel base is weighted
to support the lowered top.

tables

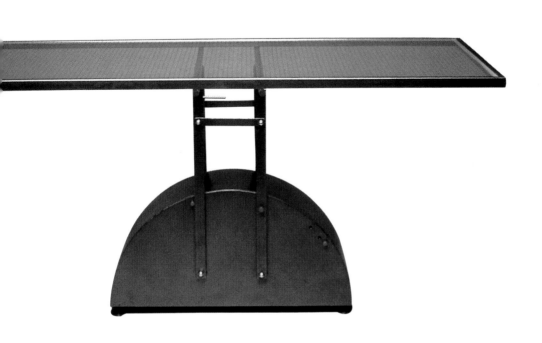

# "Unitisch" system

**Designer:** Ueli Biesenkamp (German, b. 1941)
**Manufacturer:** Atelier Alinea, Basel, Switzerland
**Date of design:** 1995

This system was designed so that any one of a number of possible conditions could be created with varying heights and user-specified top lengths. Configurations include small side tables adjacent to those that tilt for drafting, as well as a desk version (shown here). One top-surface option features a hand-size slit that is cut into the top, making transportation easier.

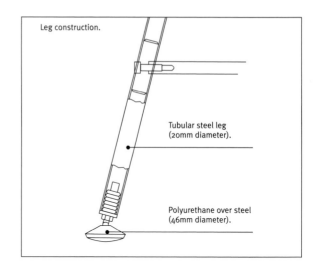

Leg construction.

Tubular steel leg (20mm diameter).

Polyurethane over steel (46mm diameter).

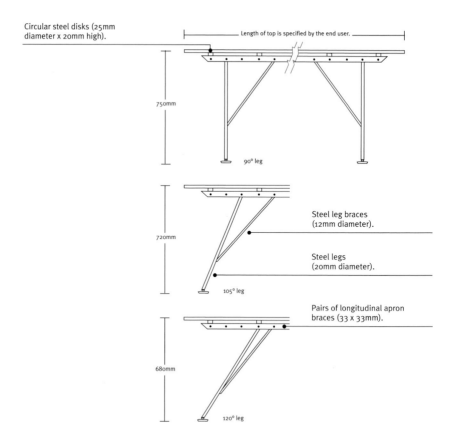

Circular steel disks (25mm diameter x 20mm high).

Length of top is specified by the end user.

750mm

90° leg

720mm

Steel leg braces (12mm diameter).

Steel legs (20mm diameter).

105° leg

Pairs of longitudinal apron braces (33 x 33mm).

680mm

120° leg

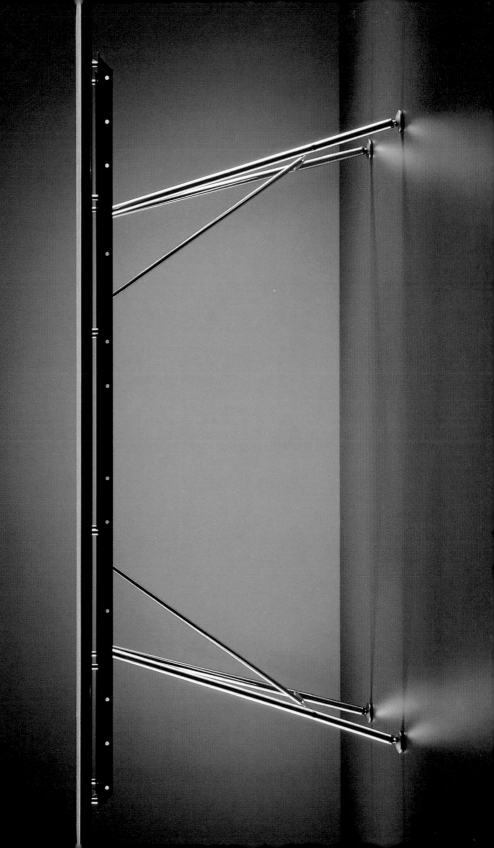

**"Unitisch" system**

Table may be stowed away. The hole in the top
is for hand insertion to facilitate moving.

 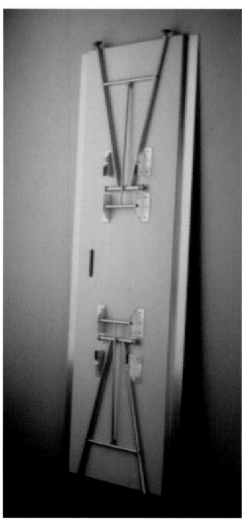

tables

Top materials and three available designs.

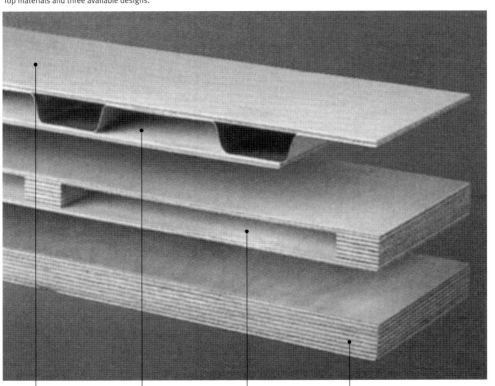

Top surface is available in beechwood, birchwood, or plastic laminate.

"Aluwelle": Two layers of plywood separated by aluminum struts.

"Multi-Steg": Two layers of plywood separated by eight-plywood struts.

"Multiplex": Single layer of plywood (10 plies thick).

articulation

# "Pari" table

**Designer:** William Sawaya (Lebanese, b. 1948)
**Manufacturer:** Sawaya & Moroni S.p.A.,
Milano (MI), Italy
**Date of Design:** 1986

This table, by an experienced, prolific furniture designer and manufacturer of his own work and that of others, features a height-altering ability. An easily deployable leg-folding mechanism allows for two heights, to accommodate various social functions.

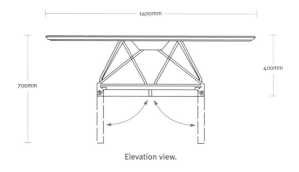

1400mm

700mm

400mm

Elevation view.

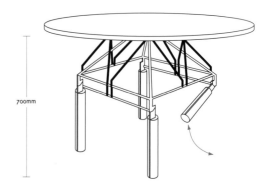

700mm

Plan view.

In the high position, the table is appropriate for dining or games.

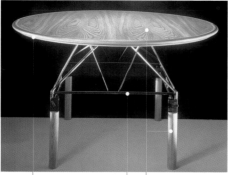

The chamfered edge creates the illusion of an edge thinner than it is.

Beechwood veneer (top) and solid beechwood legs.

Black-painted steel folding mechanism permits two heights.

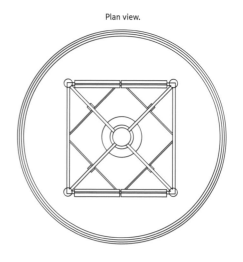

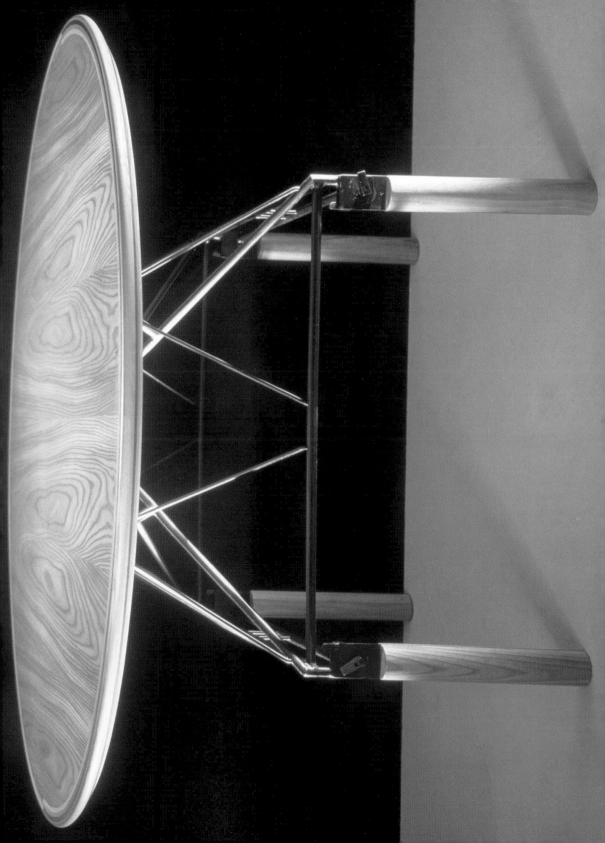

When the legs are folded, a center table is created.

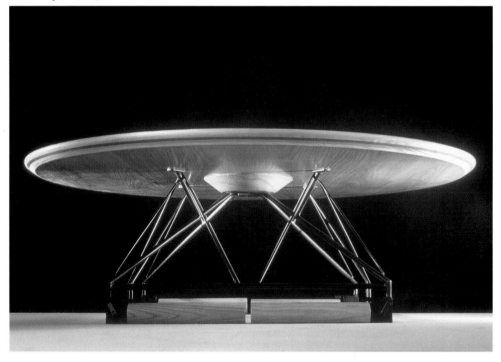

tables

144

This section describes the recent shift in design aesthetics, reflecting the use of new technology and advanced materials.

It is no longer possible to know the construction of a piece of furniture merely by looking at a picture of the finished product. For example, the chair shown here appears to be cut from a piece of foam rubber, but, on the contrary, it is made by combining two pieces of plywood for the sides with layers of Pirelli rubber strips, reconstituted foam, and dacron wadding for the seating surface, which is in turn covered over with fabric. The inside is hollow.

In this section, you will find the details of the red chair together with other highly diverse examples of the work of 56 designers who are active worldwide. Their production runs range from one-of-a-kind seating, or a handful of examples, to those of over a hundred thousand, and even an automobile seat that has reached 700,000.

You will find here the results of some of the most imaginative minds at work in the design world today. There are chairs made directly into finished products without the use of preliminary drawing, while others are the result of years of experimentation, development, and large sums of money.

# chairs

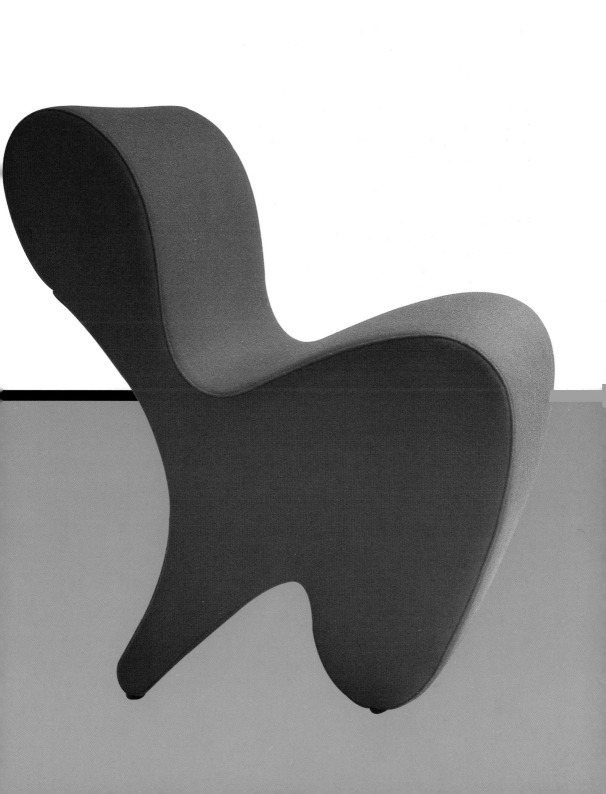

# chairs: guest introduction

While the basic function of chairs remains constant, technical developments have created an incredible variety of new possibilities for change in the construction and design of this furniture. Thus, seen throughout history, chairs offer a shimmering, revealing image of society, including the anachronisms for which they were created.

Chairs are objects with a soul, not only because they correspond to our physiology with their legs, seats, and backs, or because they nurture us with their form and comfort, but also because they possess an inner, well-conceived technology. However, we rarely recognize the fact that this technical construction is also a component conspicuously related to the design itself.

This section concentrates on the material and constructional aspect of chairs. But, while the author's approach is a technical one, his choices belie curiosity and subjectivity and are thus well suited to achieving his goal of reaching a broad audience. The spate of richly illustrated coffee table books that define today's generally superficial understanding of design identifies the quality of design only with the outer form and usually casts a blind eye to the technical achievements that characterize the form.

Here, Mel Byars sheds light on the incredible breadth of technological and thus often aesthetic innovations in furniture design. Hence, his profile of chairs takes its place in what is, unfortunately, an all too rarely cultivated tradition of publications that create a broader understanding of furniture construction: Gustav Haßenpflug's Stahlmöbel, Karl Nothelfer's Möbel, Gerd Hatje's New Furniture series, and Mario Dal Fabbro's Modern Furniture, which defined the technical aspects of furniture design as early as the 1950s and 1960s and served as eloquent testimonies to the Modern Movement. They explored a range of technology, from the Windsor chair in turned and bent wood, and Thonet's chairs in bent wood to furniture in tin and armchairs in tubing, whether hollow bamboo from the Philippines or extruded steel from Mannesmann.

A pioneering effort in this publishing tradition is Heinz and Bado Rasch's book, Der Stuhl, published in 1929, in which both authors clearly sublimated the issues of construction to those of function and ergonometry. At that time, the authors were successors to a new generation of architects who, after World War I, were engaged in the social aspects of building and simultaneously in redefining furniture's tasks.

Experiments continue to this day. When design does not merely follow fashionable trends, industrial developments are utilized in the most varied ways—from High Tech to recycling. Thus, the optimal armchair, office chair, or car seat is again and again reinvented following the needs and possibilities of its time. The post-modern and, by now, post-industrial worlds offer us specialization and rich individualism; in the choice of chairs in this section, Mel Byars consciously pays tribute to both.

**Alexander von Vegesack**
**Director, Vitra Design Museum**
**Weil am Rhein, Germany**

# chairs: author introduction

Sigfried Gideon argued in his book Mechanization Takes Command (1948) that the industrial world's material culture is continuously being affected by scientific and industrial progress. In his book, which offers an encompassing approach to design, he was first to claim that the anonymous contributions to science are as important as the history of individuals and design. Today, even though few of us know the inventors of new materials (for example, at Du Pont, Roy Plunkett discovered Teflon and Stephanie Kwolek, Kevlar), they are not anonymous, merely little known.

In the mid-20th century, when Gideon was discussing the contributions of science to design, designers remained, as in previous centuries, committed to the "truth" of materials. More recently, Paola Antonelli, the associate curator of design at The Museum of Modern Art in New York City, became one of the first to recognize that designers today are turning from a devotion to the "truth" of materials as a traditional absolute value and an ideal standard. Her landmark exhibition in America and Japan— "Mutant Materials in Contemporary Design" (1995–96)— included examples, some in this volume, by contemporary designers who have customized, extended, or modified the physical universe of materials, quite differently so than in the past.

As a result of the use of new materials (like plastics, compounds and glues) as well as traditional ones (like wood and glass), the range of recent chair design has been remarkable, provoking the question, "Just how much can one chair vary from another?" The answer is, "Very much," encouraged by the essential structure of a chair, which need include only a seating surface and a back; the stool, with only a seating surface, is a variant. These minimal criteria for a chair's construction favor infinite possibilities for chair configuration.

The 50 examples here were drawn from the plethora of the last decade and a half. In most cases, they were chosen for their innovative characteristics and the manipulation of materials, often for recycling purposes. A conscious effort was made to include the work of designers worldwide. However, most are male and European, particularly Italian, although there are also those from North and South America, Asia and Australia. Yet, in attempting to represent the best of design today, an imbalance in the number of Italian designers and manufacturers was inevitable. In Italy, possibly uniquely among all countries, the climate created by the symbiotic, if not always amicable, relationships among manufacturers, schools, publishers, the government, and native and immigrant designers has fostered the circumstances under which innovation, imagination, experimentation, and production have become fecund. Nevertheless, a global balance was assiduously attempted.

The chairs here, chosen as much for the use of materials as for the manipulation of them, are far from fully representative of the past 15 years. Rather, they were chosen for their variety. In selecting the objects, there was no assumption that anyone, in any culture or country, would wish to use any one of them at home or in the office. After all, most of us are still held in the fond embrace of things past, and the objects here very much represent the present. Unfortunately, Modernism—the 20th-century rejection of the restraining conservatism of prior centuries—has never adequately served the more nurturing aspects of the domestic environment that most of us desire. Modernism has frequently failed to cater to our physical needs (through softness and warmth) and our appetite for visual and intellectual stimulation (through surface variety and intricate images). And indeed, most of the chairs here do not serve these basic demands; the cerebral stimulation provided by the examples is of an entirely different character.

Some of the objects may appear to be sheer folly. However, those that superficially seem to be merely comic often have great depth. The efforts are conjured by trained designers not only seriously aware of their responsibilities but also harbingers of inherited, nationally indigenous senses of humor, which vary from country to country.

The categories into which the chairs are divided (see the Contents page) are arbitrary in that more than one material (for example, metal with wood) has more often than not been married to make them.

Design books, publications, and exhibitions rarely show us the details of how a piece of furniture is constructed; Domus magazine serves as an exception, but not a consistent one, even then. On the following pages, you will discover how the chairs were built and, with the skin removed in some examples, how their skeletons look. Examples include not only one-of-a-kind designs and short runs of 80 or fewer pieces, but also larger editions, such as the 700,000 or so seats produced from 1989–96 for the Mazda MX-5 "Miata" automobile (pages 292–295) and the 500,000 folding chairs designed by Gastone Rinaldi manufactured by Fly Line since 1980 (pages 282–285). The small editions as well as the maquettes for larger runs are testament to the Arts and Crafts tradition and approach, still practiced worldwide, having not yet fully been replaced by computer preproduction techniques. And, happily, the mass-produced work serves as proof that imagination and design excellence is permitted and even encouraged by some large-scale manufacturers.

The selections were based on my preferences, my personal guidelines for aesthetic and technological criteria, the availability of images that would fully illustrate an object, and the generosity and cooperation of designers and

manufacturers, some providing photographs taken especially for the book.

The intention at the outset was to feature no more than one chair by each designer represented, but, due to the rich output of Philippe Starck and Alberto Meda and the imagination of the Campana brothers, the parameter was excused in these three cases.

This profile of 50 chairs will hopefully tweak your imagination, reveal the genius of certain trained designers, offer insights into the possible manipulation of new and traditional materials, question the boundary line, if there is one, between fine art and design, and, if nothing else, amuse and entertain.

# wood

# "Puzzle" armchair

**Designer:** David Kawecki (American, b. 1949)
**Manufacturer:** 3D: Interiors, San Francisco, California, U.S.A.
**Date of design:** 1991

This chair is laser-cut in discrete sections, economically shipped flat, and assembled by the customer. It may be a bit of a problem discovering the proper sections to fit together, hence the name. Compare Kawecki's chair to Rietveld's "Armchair 'First Model' " (Gerrit Th. Rietveld, The Complete Works, Utrecht: Centraal Museum, 1992, no. 120).

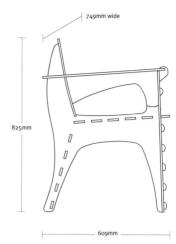

749mm wide

825mm

609mm

Laser-cutting head.

Viewed through a protective glass (left), the laser head cuts out the various parts of the chair from a sheet of 5-ply Baltic birch plywood (6mm thick). Instructions for the cutting pattern are provided by a computer program that directs the laser-cutting head, resulting in precisely fitting chair sections.

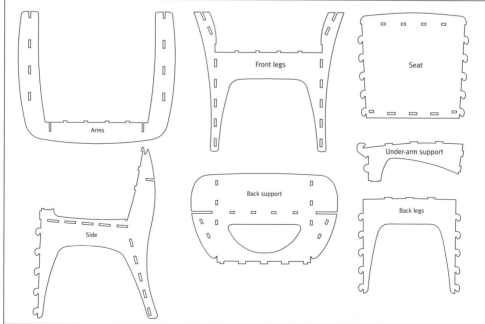

Arms

Front legs

Seat

Side

Back support

Under-arm support

Back legs

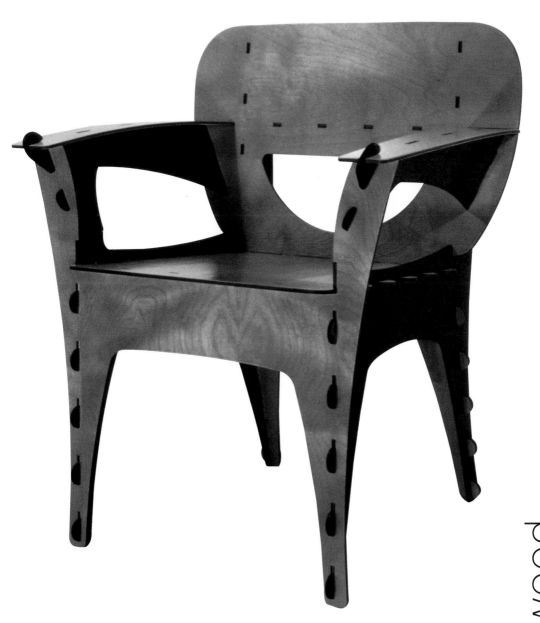

# "Dry" side chair

**Designer:** Massimo Morozzi (Italian, b. 1941)
**Manufacturer:** Matrix, divisione della
Giorgetti S.p.A., Meda, Italy
**Date of design:** 1987

For economical shipment and possibly even experimental purposes, the chair's assembly and disassembly is accomplished by a single winged bolt—no adhesives are required. Available in polished or lacquered natural or in multi-color aniline-dyed beechwood with or without a seat cushion, the chair is composed of elements sawn with hand tools.

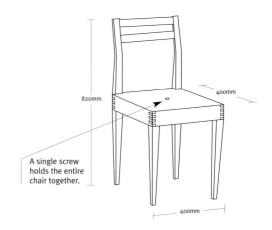

820mm

400mm

400mm

A single screw holds the entire chair together.

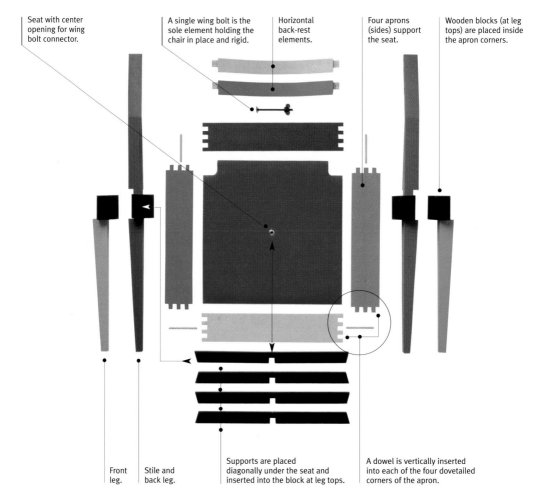

Seat with center opening for wing bolt connector.

A single wing bolt is the sole element holding the chair in place and rigid.

Horizontal back-rest elements.

Four aprons (sides) support the seat.

Wooden blocks (at leg tops) are placed inside the apron corners.

Front leg.

Stile and back leg.

Supports are placed diagonally under the seat and inserted into the block at leg tops.

A dowel is vertically inserted into each of the four dovetailed corners of the apron.

chairs

154

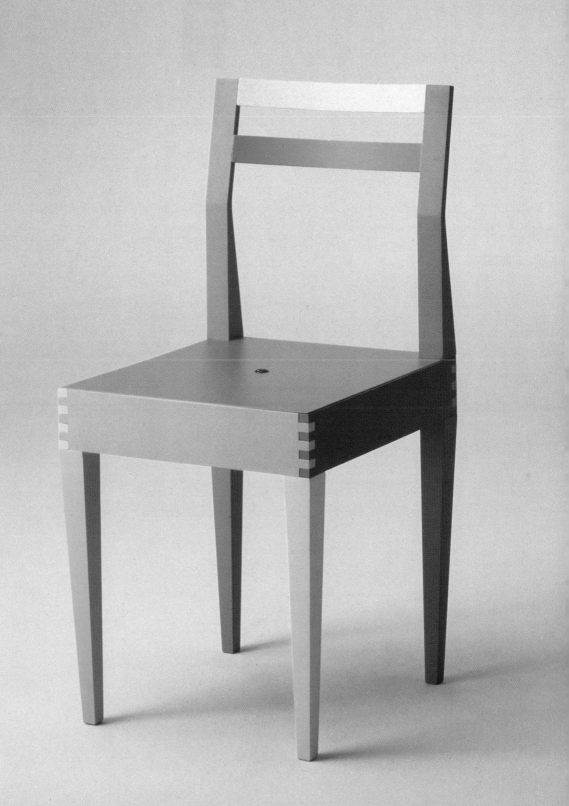

# "Puzzle" stacking chair

**Designer:** Essaime (né Stéphane Millet, French, b. 1949)
**Manufacturer:** Quart de Poil', Paris, France
**Date of design:** 1994

For domestic, office, or public use, the chair can be ganged at the sides for multiple use side-by-side and at the floor for multiple use in rows. It is designed in side-chair and armchair versions and exhibits a bit more aestheic flair than most public seating.

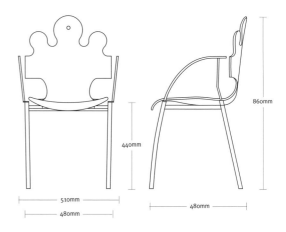

860mm

440mm

510mm

480mm

480mm

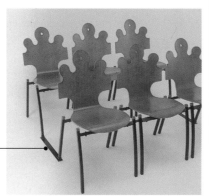

Floor links for the ganged configuration are available colored to match the floor covering.

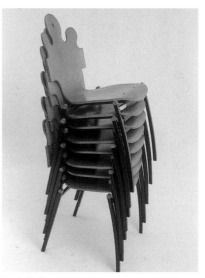

Stackable for storage.

Two-way bent stained and varnished beechwood-veneered plywood.

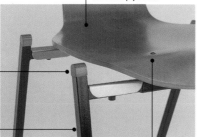

Matching, stained beechwood tips fill in the tops of the extruded steel legs.

Extruded steel legs and horizontal supports (2mm x 2mm) are varnished black.

Seat/back is screwed onto the frame in three places: two onto the front, one in the back.

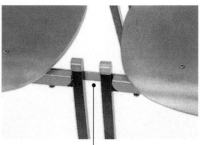

A simple, hand-insertable steel plate links the chairs sideways.

chairs

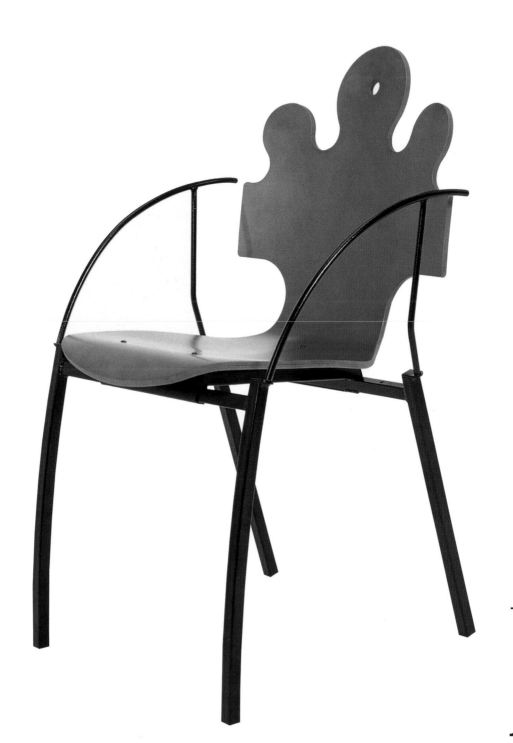

wood

# "Chair 9"

**Designers:** James Davis (British, b. 1965)
and David Walley (Australian, b. 1960)
**Manufacturer:** Yellow Diva, London, Great Britain
**Date of design:** 1994

With the outward appearance of being hot-wire-cut from a piece of synthetic foam, the chair is actually quite intricate and hollow inside with Pirelli rubber webbing providing springy support. The webbing is in turn covered over with a layer of reconstituted foam and then by dacron. Finally, over both layers of padding, is the upholstery material.

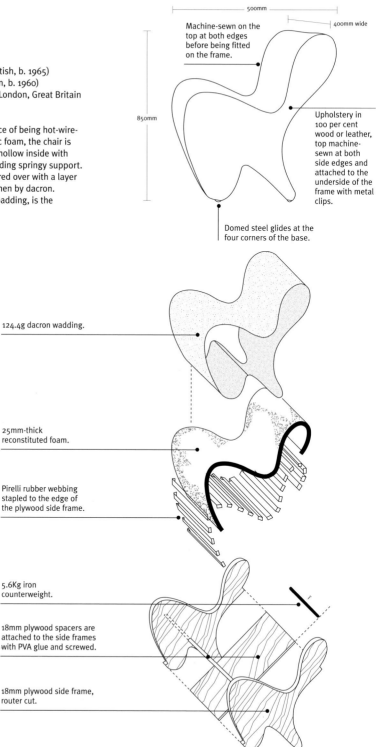

500mm

400mm wide

Machine-sewn on the top at both edges before being fitted on the frame.

850mm

Upholstery in 100 per cent wood or leather, top machine-sewn at both side edges and attached to the underside of the frame with metal clips.

Domed steel glides at the four corners of the base.

124.4g dacron wadding.

25mm-thick reconstituted foam.

Pirelli rubber webbing stapled to the edge of the plywood side frame.

5.6Kg iron counterweight.

18mm plywood spacers are attached to the side frames with PVA glue and screwed.

18mm plywood side frame, router cut.

chairs

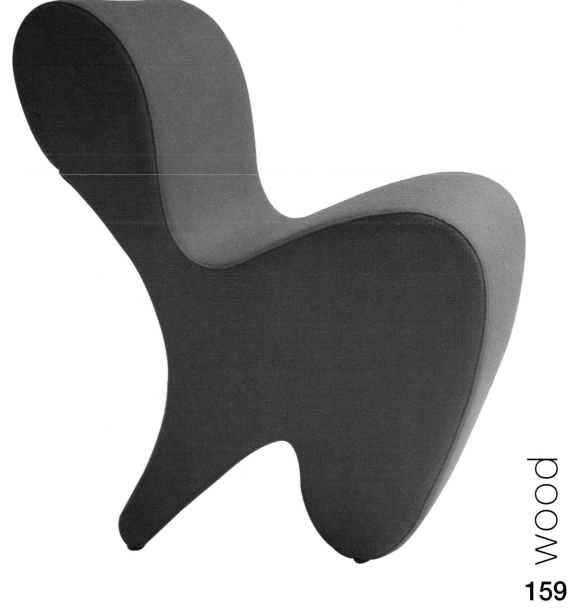

wood

# Cantilevered stacking chair

**Designers:** Peter Steinmann (Swiss, b. 1961) and Herbert Schmid (Swiss, b. 1960)
**Manufacturer:** Atelier Alinea, Basel, Switzerland
**Date of design:** 1995

Plywood is bent into an extremely narrow radius (a full 90°) and then attached only at the leading edge, appearing to be wound around the metal drum that is invisibly attached to the one-piece legs.

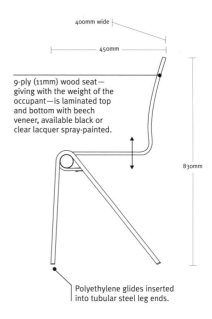

400mm wide

450mm

9-ply (11mm) wood seat— giving with the weight of the occupant—is laminated top and bottom with beech veneer, available black or clear lacquer spray-painted.

830mm

Polyethylene glides inserted into tubular steel leg ends.

Tubular steel (18mm diameter, 2mm wall) is chromium-plated

Plywood seat wraps around the drum.

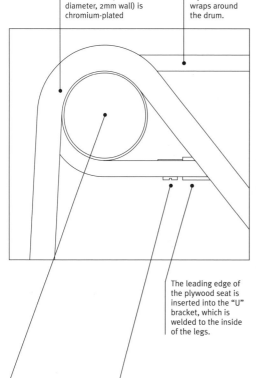

The leading edge of the plywood seat is inserted into the "U" bracket, which is welded to the inside of the legs.

Stacking configuration.

Plastic discs (55mm diameter) cover open ends of the tubular metal drum that is welded to the inner elbow of the "V"-bent legs.

Stainless steel screws clear the "U" bracket to prevent scratching of the seating surface of the stacked chair below.

chairs

160

wood

# "Cross Check" armchair

**Designer:** Frank Gehry (Canadian, b. 1929)
**Manufacturer:** The Knoll Group, East Greenville, Pennsylvania
**Date of design:** 1992

The architect/designer, with project designer Daniel Sachs and design technician Tom MacMichael, spent more than 24 months and a large sum of the manufacturer's money on the development of a group of bentwood furniture. The chair uses a newly developed glue, which eliminates the necessity of metal fasteners. The "Cross Check" armchair is one in a group of chairs, two tables, and an ottoman, available in clear or ebonized finishes.

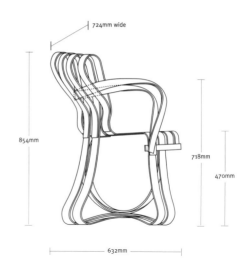

724mm wide
854mm
718mm
470mm
632mm

The design concept was inspired by the wood-strip bushel basket made popular by fruit growers in the 19th and 20th centuries.

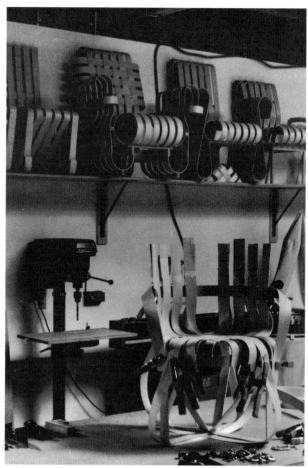

In a workshop near the architect/designer's office in Venice, California, 115 prototypes were produced over a period of about two years.

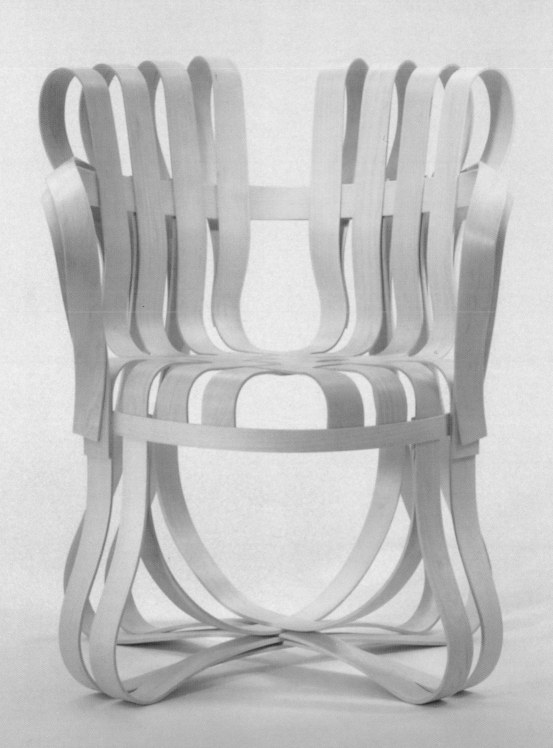

# "Cross Check" armchair

The lengthy experimentation time resulted in five chairs, an ottoman, and two tables being placed into production.

The strips (50mm wide x 2mm thick) are made of 6-, 7-, or 8-ply hard white maplewood, bonded with high-bonding urea glue. For resilience, the wood grain runs lengthwise.

No assembly glues are used on the woven seat, facilitating a springy flex.

Newly developed thermoset assembly glue provides structural rigidity and eliminates the need for metal fasteners.

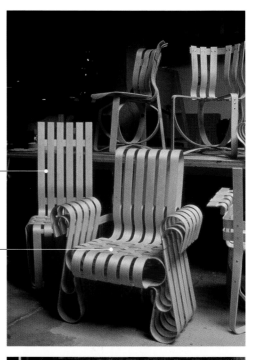

A prototype bending form illustrates how the wooden strips were folded in place.

An early version of the "Hat Trick" side chair (1991).

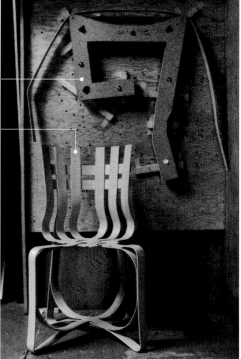

chairs

The designer's study (1990) for the "Cross Check" armchair.

The designer's earliest (1989) experiment in manipulating maplewood strips.

Ca. 1989, the designer holds a maquette of the "High Sticking" side chair (1991).

wood

# "Less" stacking side chair and stool

**Designer:** Marco Ferreri (Italian, b. 1958)
**Manufacturer:** BPA International, Cabiate (CO), Italy
**Date of design:** 1993

The use of advanced technology in this chair lies not in its minimal form but rather in the construction of the "upholstery" on the seat and the back rest. A layer of Softwood™, placed over the padding, behaves like upholstery fabric.

Stacking configuration of the chair, available with a beechwood frame, clear or black painted. Seat and backrest are clear, medium gray, blue, orange, or green.

Plan view of the stacking configuration of the stool. Five examples shown here.

The top surface of the seat (Softwood) is soft and pliable, almost like fabric.

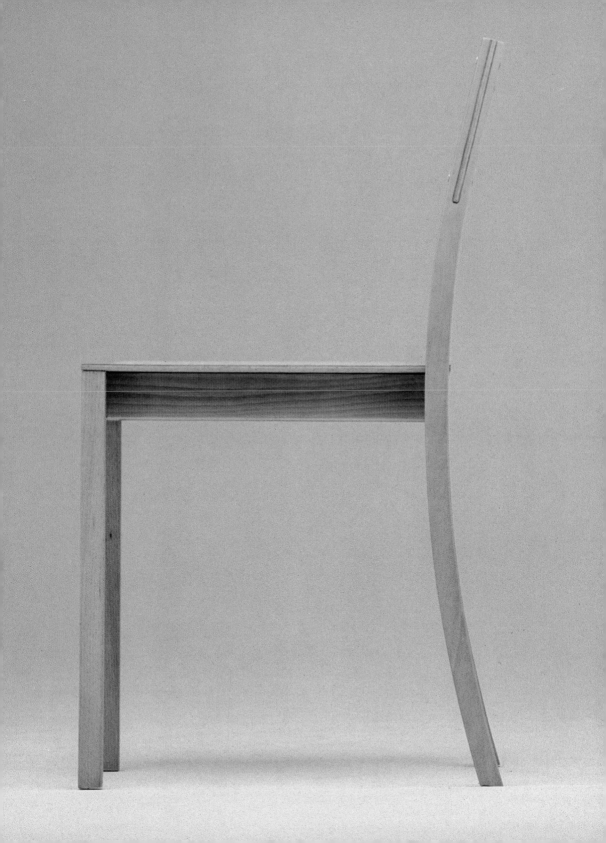

# "Less" stacking side chair and stool

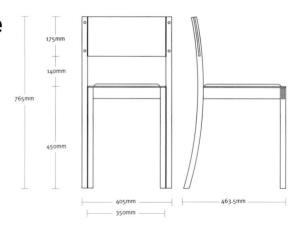

175mm
140mm
765mm
450mm

405mm
350mm
463.5mm

| Base wood surface. | Inner layer of fabric, combined with a layer of polyurethane foam, is bonded by high heat and pressure to the Softwood surface. | Softwood (top layer) acts as a soft upholstery material much like fabric. | The backrest is fitted into the stiles through slots (6mm wide) and riveted. | Parts of the superstructure are glued together, and the seat and backrest are held by eight bolts and eight screw rivets. |

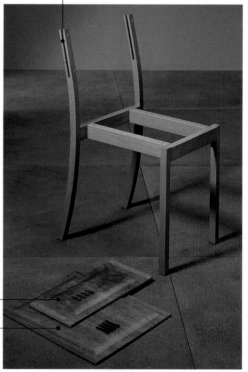

Back.

Seat.

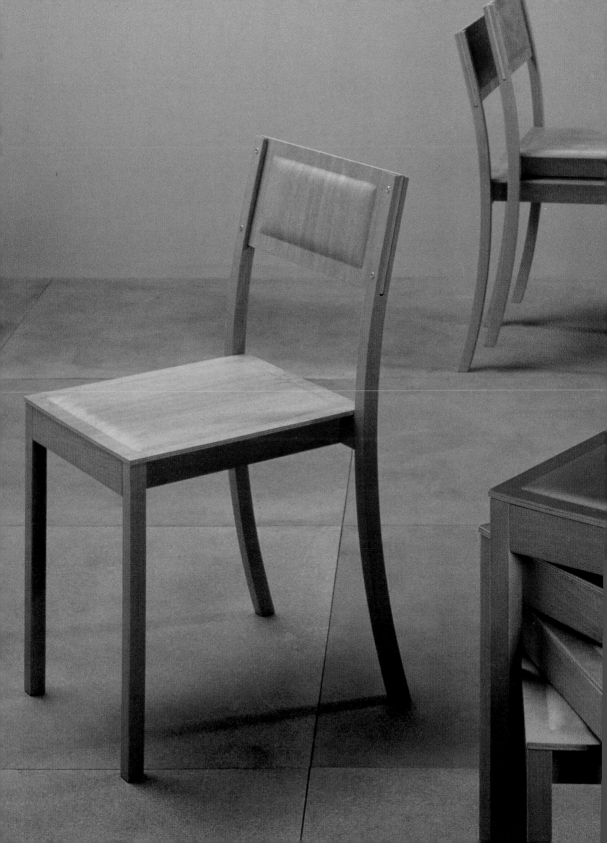

# "NXT" Stacking Chair

**Designer:** Peter Karpf (Danish, b. 1940)
**Manufacturer:** Swedese, Vaggeryd, Sweden (to 1996);
Inredningsform, Malmô, Sweden (from 1996)
**Date of design:** 1991

Development of a patented process through intense
research has resulted in the achievement of great
strength and little weight in this chair through the
fusion of very thin layers of a natural material—
wood—at alternating grain angles. Weighing just
3.5Kg, the chair is available in a natural-wood finish
and red, blue, yellow, and green lacquer colors.

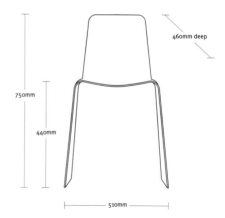

Back view of the "NXT"
chair, which is capable
of being ganged through
the use of a metal rod
inserted through the legs
and of being numbered
with small discs.

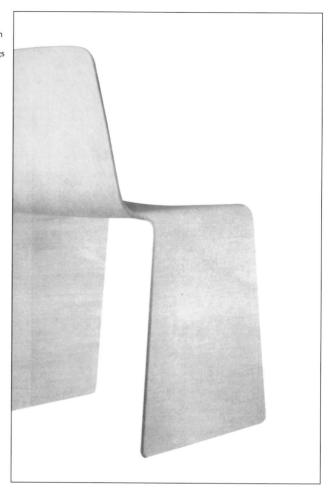

# "NXT"
# Stacking Chair

The radiating directional lines indicate the distribution of the occupant's weight, which results from the four alternating grain layers on eight fused plywood sheets.

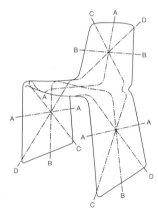

Arrows indicate grain direction of the A and B layers of veneer (see layer drawing below).

Flat sheets (above, left and right), before gluing, cutting, and heat-and-high-pressure bending.

Dotted lines (above) indicate grain direction of the C and D layers of veneer (see below).

Tan shapes indicate the flat cut-out shape before bending.

The eight alternating grain directions in the lamination sequence of one chair:

A: Top to bottom (180°)
B: Left to right (90°)
C: Diagonally left (45°)
D: Diagonally right (45°)
C: Diagonally left (45°)
D: Diagonally right (45°)
B: Left to right (90°)
A: To to bottom (180°)

chairs

172

metal

# "Ota Otanek" chair

**Designer:** Borek Sípek (Czechoslovakian, b. 1949)
**Manufacturer:** Vitra GmbH, Weil am Rhein, Germany
**Date of design:** 1988

Combining many of the qualities of fine traditional furniture of the past with modern techniques, the materials in this chair include beaten copper, partially hand-worked wood, and steel. The manufacturer assembles the parts (made to the designer's specifications) fabricated by various outside suppliers. Perhaps the challenge assumed by the designer, as well as the manufacturer, was to produce an industrial object with the appearance of being hand-hewn; however, the chair is neither truly industrial nor fully handmade.

650mm deep

750mm

550mm

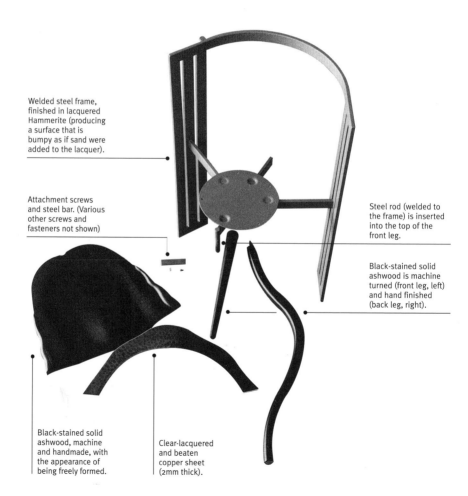

Welded steel frame, finished in lacquered Hammerite (producing a surface that is bumpy as if sand were added to the lacquer).

Attachment screws and steel bar. (Various other screws and fasteners not shown)

Steel rod (welded to the frame) is inserted into the top of the front leg.

Black-stained solid ashwood is machine turned (front leg, left) and hand finished (back leg, right).

Black-stained solid ashwood, machine and handmade, with the appearance of being freely formed.

Clear-lacquered and beaten copper sheet (2mm thick).

chairs

174

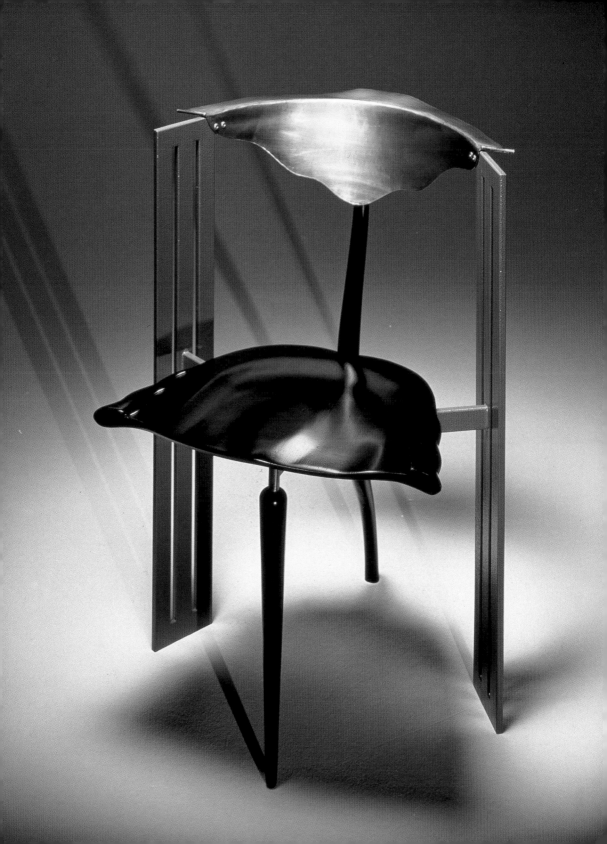

# "Mirandolina" stacking chair

**Designer:** Pietro Arosio (Italian, b. 1946)
**Manufacturer:** Zanotta S.p.A.,
Nova Milanese (MI), Italy.
**Date of design:** 1992

Like Marcel Breuer's aluminum chair of 1932-34, this is a one-piece chair, with no cross slats for the seat as in the Breuer version. Unlike Breuer's chair, this is inexpensive and lightweight. This design reveals a successful symbiotic relationship among designer, manufacturer, and materials supplier.

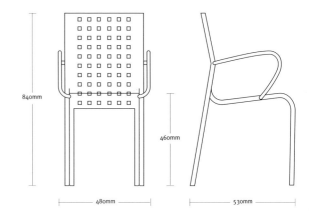

840mm
460mm
480mm
530mm

The armchair version features solid, extruded, square, bent aluminum arms, bolted to the seat and the back.

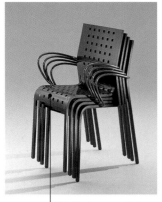

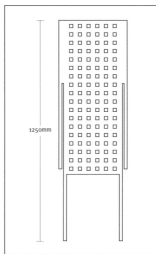

1250mm

Metallic stove-enameled aluminum alloy (3mm thick) for outdoor use, in metallic clear, black, green, light blue, or custom colors.

Production process:

1. Only one firm in Italy can supply a 400mm-width extruded aluminum-alloy sheet (3mm thick).

2. The flat sheet is cut to size, including notching for the legs. The front and back legs are integral to the body; there is no welding.

3. The holes are punched out of the flat sheet to create a lighter weight and appearance.

4. Bending and shaping occurs in a hydraulic press.

5. The aluminum is painted in a small range of colors.

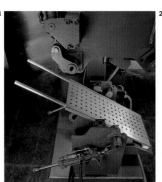

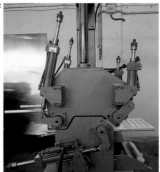

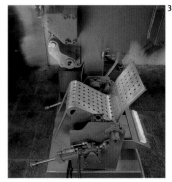

Sequential images show the pre-trimmed sheet (with the grid pattern already stamped out) being shaped by the hydraulic press.

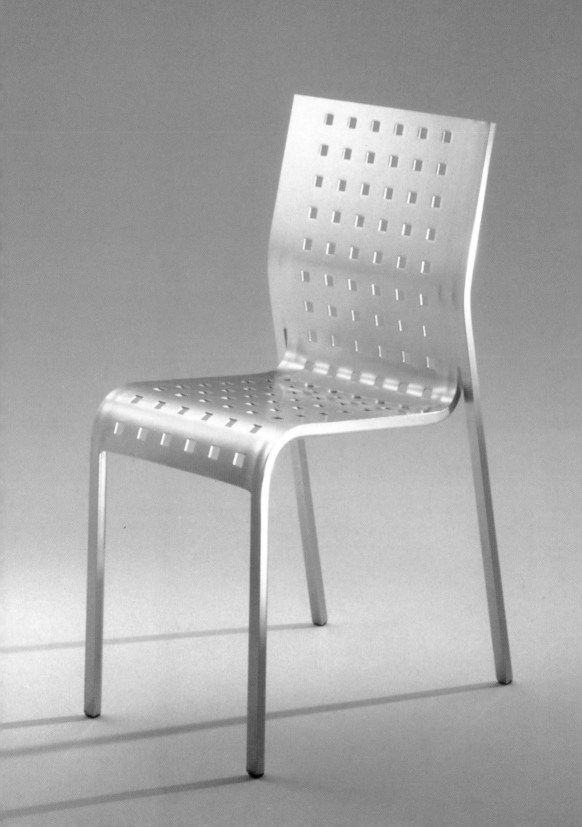

# "Mirò" chair

**Designer:** Carlo Forcolini (Italian, b. 1947)
**Manufacturer:** Alias S.r.l., Grumello del Monte (BG),
Italy
**Date of design:** 1989

Exploiting the flexible nature of tempered steel, this
spare, imaginative chair is painted in a Calder
palette: the primary colors, black, white, and also
silver. The structure eliminates traditional metal
joinery. When viewed at a raked angle, the seat
appears to have the silhouette of lips.

724mm wide

310mm

540mm

The drawing includes the backrest.

Seat is laser-cut malleable steel
sheeting (2mm thick).

Steel tubular frame is 18mm diameter
(1.5mm wall thickness) with glides at
the floor connected to the tubular leg
by thin metal rods.

Hollow
tubular frame
extension is
capped
closed.

Frame is
assembled
with stainless
steel nuts and
bolts.

Shock absorber under
the seat is expanded
polyurethane (30Kg/m²
density) and glued to
the frame's end finial.

The malleable steel seat is sprung from its
leading edge beneath the front of the frame.

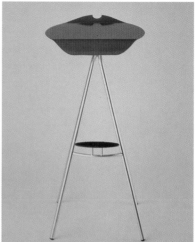

A bar stool version is available with a foot-rest
stretcher to stabilize the long, thin legs.

chairs

178

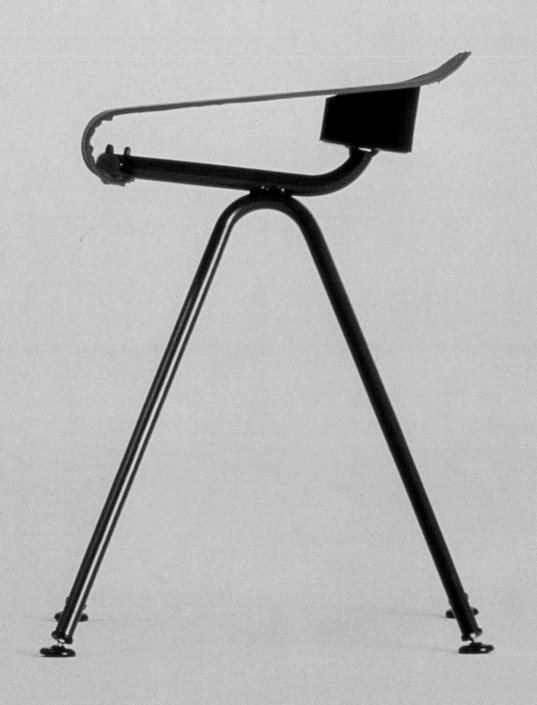

# "Utility" side chair

**Designer:** Stephen Povey (British, b. 1951)
**Manufacturer:** Diametrics, London, England
**Date of design:** 1986

This chair is formed of standard tubular steel for the frame and legs and rubber-like suction cups for the ferrules. Assigning an everyday, ordinary product to a new use, the seat and back are dustbin (trash can) lids purchased by the designer-manufacturer directly from a dustbin producer in England. Excluding the suction cups, the chair is composed of only four pieces.

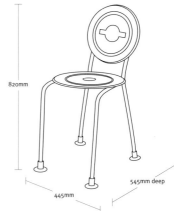

820mm

445mm

545mm deep

The designer arc-welds the frame to the seat—a very simple assembly.

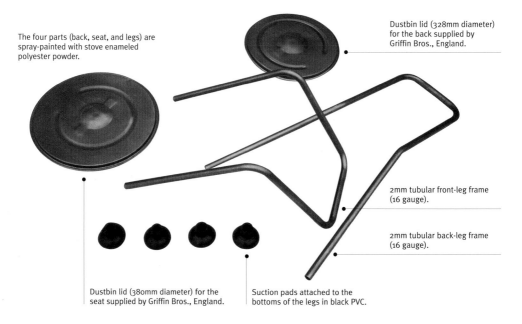

The four parts (back, seat, and legs) are spray-painted with stove enameled polyester powder.

Dustbin lid (328mm diameter) for the back supplied by Griffin Bros., England.

2mm tubular front-leg frame (16 gauge).

2mm tubular back-leg frame (16 gauge).

Dustbin lid (380mm diameter) for the seat supplied by Griffin Bros., England.

Suction pads attached to the bottoms of the legs in black PVC.

chairs

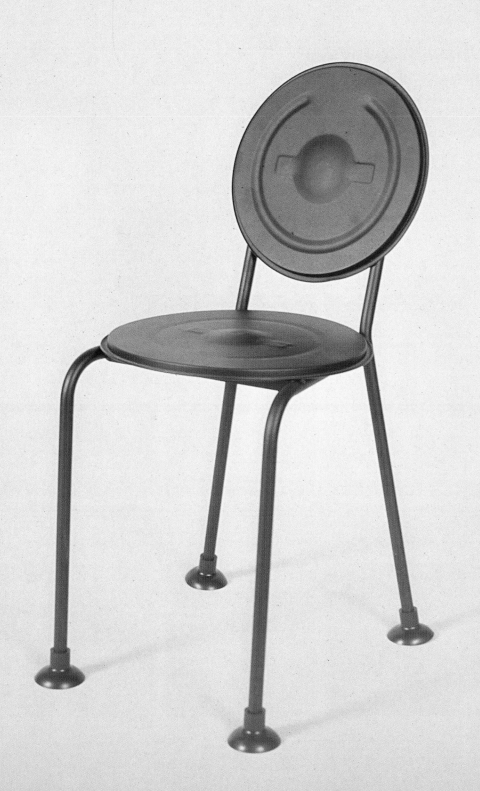

# "How High the Moon" armchair

**Designer:** Shiro Kuramata (Japanese, 1934-1991)
**Manufacturer:** Vitra GmbH, Weil am Rhein, Germany
**Date of design:** 1986-87

The leading representative of minimalism in design at the time of his death, Kuramata produced this chair as an artistic rather than a functional composition, in punctured, stretched steel. It is claimed by its manufacturer to be the lightest large chair ever designed.

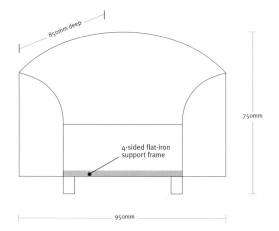

850mm deep

750mm

4-sided flat-iron support frame

950mm

Solid steel templates are used to cut the specially treated steel mesh into nine sections (plus the legs) and the thin four-sided frame.

Parts of the chair are clamped and fixed into place.

With sections of the chair touching at the edges, the workman solders the sections at the intersecting points of the mesh.

Sections of the chair are steadied using a steel matrix.

A workman solders the top of the right front to the tops of the arm and side.

About 2,300 soldering connections are made on each chair before it is tuned to eliminate twisting, then plated with 15μ of nickel and, finally, coated with an epoxy resin.

chairs

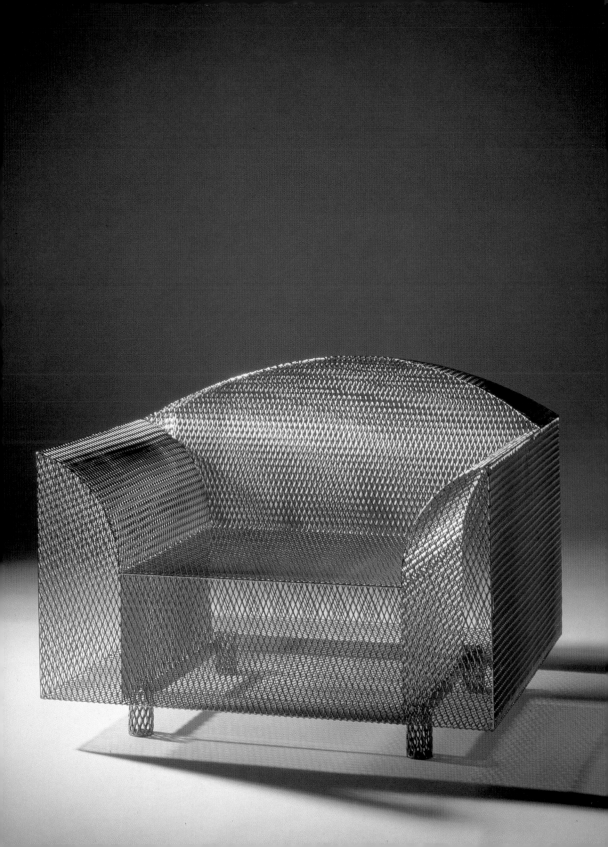

# "Billboard" chair

**Designer:** Maurizio Favetta (Italian, b. 1959)
**Manufacturer:** King Size by Lasar, Milano, Italy
**Date of design:** 1993

Far more serious than a quick glance may reveal,
the design accommodates photographs, sections of
posters, fabrics, colored paper, graphics, or other thin
flat images, which should be trimmed to the precise
size of the back section for best effect.

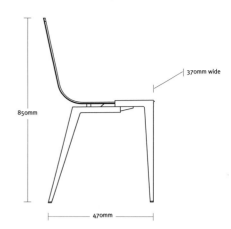

850mm

370mm wide

470mm

A snap-on leather padded
section (not shown) covers
the screws that hold the leg-
frame sections together and
also the leading edge (point
A) of the sloping back.

Leg-frame sections in cast
aluminum, enamel-painted
in black, silver, red, or blue.
The two sections are inserted
into one another and held by
hex-headed screws.

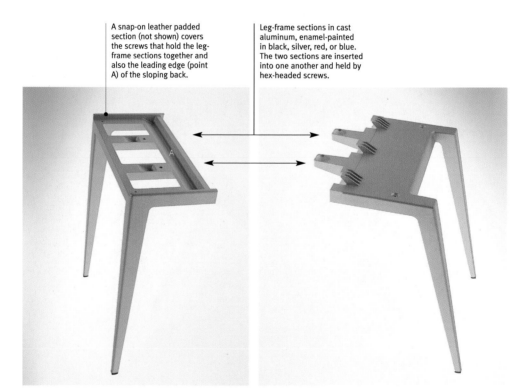

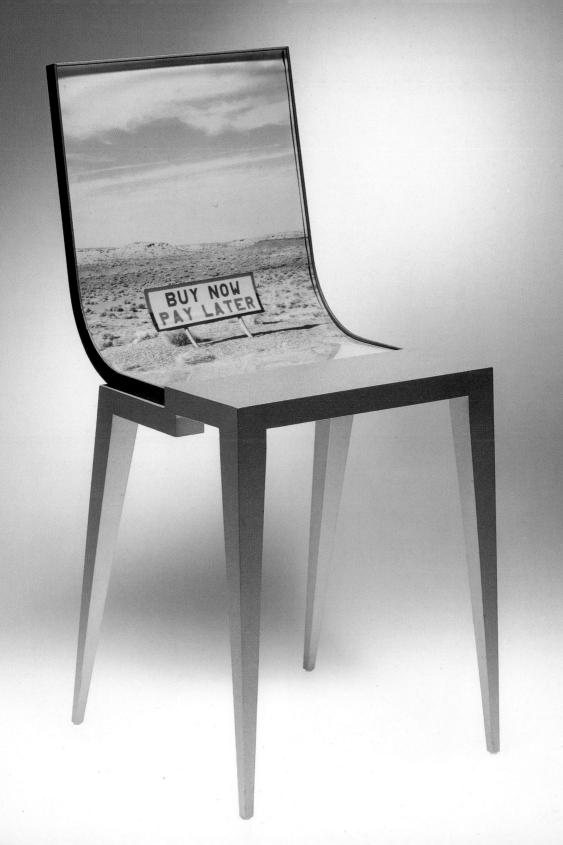

# "Billboard" chair

Three angled
elements, as
part of the top of
the front-leg
unit, elevate the
curved seat
from the base,
creating an airy
effect when seen
from the side.

Two polyvinyl
disks, placed on
the top of the
back-leg unit,
elevate the back
of the seat from
the base.

An image or flat material (trimmed
to 370 x 640mm) is sandwiched
between a sheet of clear acrylic
and the bent aluminum back and
flows downward onto the back of
the seat.

Polyvinyl glides are inserted into
a key opening through the side of
the cast aluminum legs (rather than
the traditional method of insertion
through the ends where the glides
may fall out and become lost).

chairs

The clear acrylic sheet covering the aluminum back rest is removed with the hex screwdriver provided with the chair.

The head rail is removed so that the artwork can be slid between the aluminum back rest and the clear acrylic covering.

The aluminum back rest.

The artwork, trimmed to 370 x 61mm and no thicker than 1mm, is sandwiched between the clear acrylic sheet and the aluminum back.

The clear acrylic sheet fits into the back edge of the leather-covered seat and is screwed into the top of the aluminum back rest.

# Discs chair

**Designers:** Fernando Campana (Brazilian, b. 1961)
and Humberto Campana (Brazilian, b. 1953)
**Manufacturer:** Campana Objetos Ltda,
São Paulo/SP, Brazil
**Date of design:** 1992

A freely formed seat that questions the standard
approach to chair design. Neither the technology
(sawing, welding, metal bending) nor the materials
(wood and steel) are particularly advanced, but the
depth of imagination is undeniable. The chair is one
of a kind, but, even so, additional copies would all
be somehow varied.

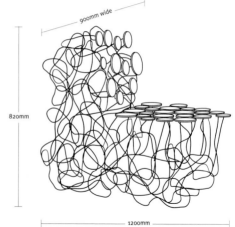

900mm wide

820mm

1200mm

Since the chair is handmade, dimensions are approximate.

Steel rod (10 cm diameter) is bent by hand in a free-form manner.

11 disks in pinewood in two sizes for the backrest and 22 others for the seat.

Steel discs (50 cm diameter, welded to the ends of the bent steel rods) are screwed to the backsides of the pinewood disk.

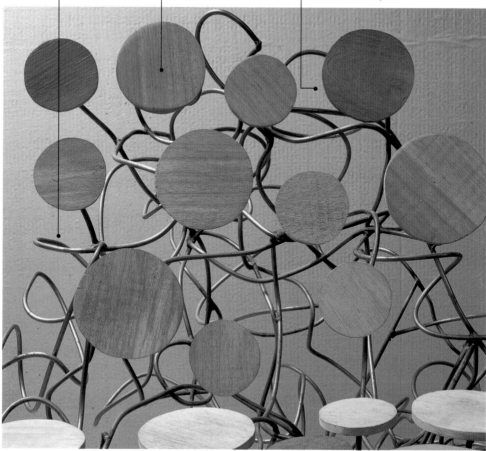

# "Well Tempered" armchair

**Designers:** Ron Arad (Israeli, b. 1951)
**Manufacturer:** Vitra GmbH, Weil am Rhein, Germany
**Date of design:** 1986-87

Known for his one-of-a-kind chairs in beaten metal, this design in tempered steel (hence the title) is an example of a simple, more rational form. Very elegant and with a delightful springiness, the chair is composed of only four pieces.

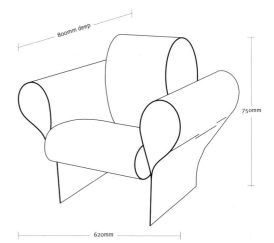

800mm deep

750mm

620mm

High-grade steel (1mm thick).

Wing nuts hold the sections together. No welding or adhesives are employed.

An outline pattern (right) was entered into a computer, which controlled the tracking of a laser-burning machine. The holes (for the wing nuts for assembly) were drilled by hand using a template.

To prevent scratching of the shiny surface, a protective white plastic foil is left on the steel sheet until it reaches the customer.

The side sections are crimped (indicated by the broken lines, right) by a bending machine at a 90° angle.

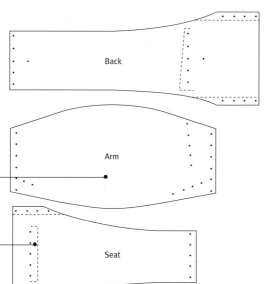

Back

Arm

Arm

Seat

chairs

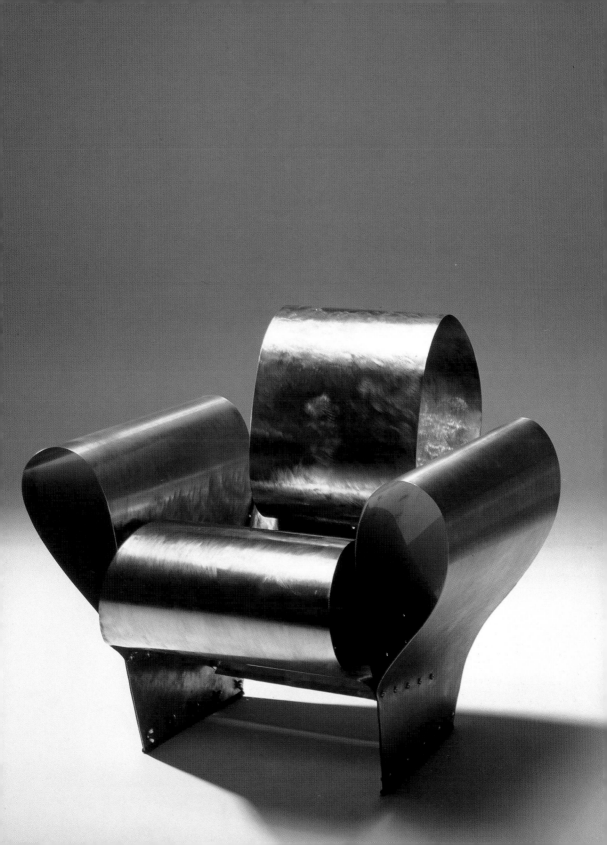

# Aluminum stacking chair and stool

**Designers:** Piet Hein Eek (Dutch, b. 1967) and Nob Ruijgrok (Dutch, b. 1966)
**Manufacturer:** Eek en Ruijgrok vof, Geldrop, The Netherlands
**Date of design:** 1994

A practical, inexpensive, and very lightweight seat, produced with computer punching and bending machines, this was also designed in a stacking-stool version. Made solely of bent aluminum sheeting, with the exception of self-sealing plastic pop-nails for assembly.

Composed of seven sections, the anodized aluminum sheet is 2mm thick.

Section 1:
Front side of back rest.

Section 2:
Seat.

Section 7:
Back side of the back rest, which extends from the seat.

Sections 3-6:
Four legs (center and at the right and bottom).

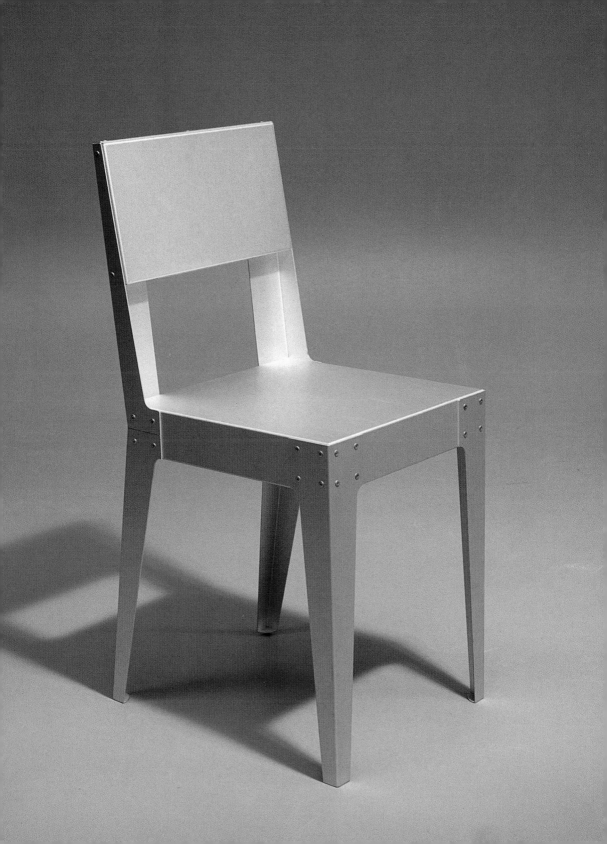

# Aluminum chair and stool

845mm

480mm

360mm

Stacking configuration of the stools.

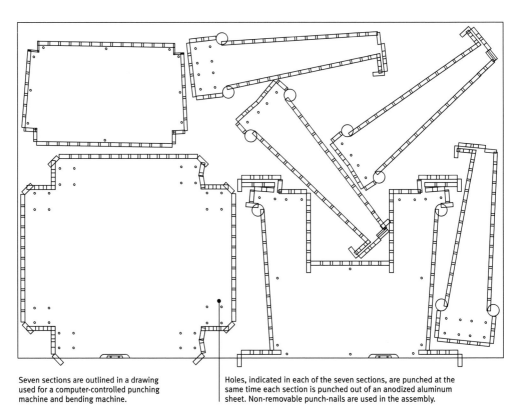

Seven sections are outlined in a drawing used for a computer-controlled punching machine and bending machine.

Holes, indicated in each of the seven sections, are punched at the same time each section is punched out of an anodized aluminum sheet. Non-removable punch-nails are used in the assembly.

chairs

Acetate templates are created
for each of the seven sections.

metals

# "L'Aube et le temp qu'elle dure" stacking chair

**Designer:** Sylvain Dubuisson (French, b. 1946)
**Manufacturer:** L.C.S.D., Le Pin, France
**Date of design:** 1987

A departure from the archetypal four-legged chair, this example was designed in two sheet-aluminum sections. The chair—produced in an edition of three for the exhibition "Tandem," held in Romans-sur-Isère, France—was named after an essay by art historian François Barré. The title translates as "Dawn and the Time it Lasts".

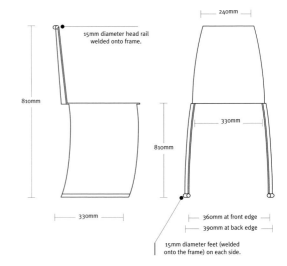

15mm diameter head rail welded onto frame.

810mm

330mm

240mm

330mm

810mm

360mm at front edge
390mm at back edge

15mm diameter feet (welded onto the frame) on each side.

Projection drawing by the designer.

Aluminum AG3 (4 mm thick) is cut, rolled, folded, and, on the back side, polished.

Green-dyed leather is glued to the surface of the aluminum on one side.

The chair is made in two parts: the back is welded to the seat-legs unit.

chairs

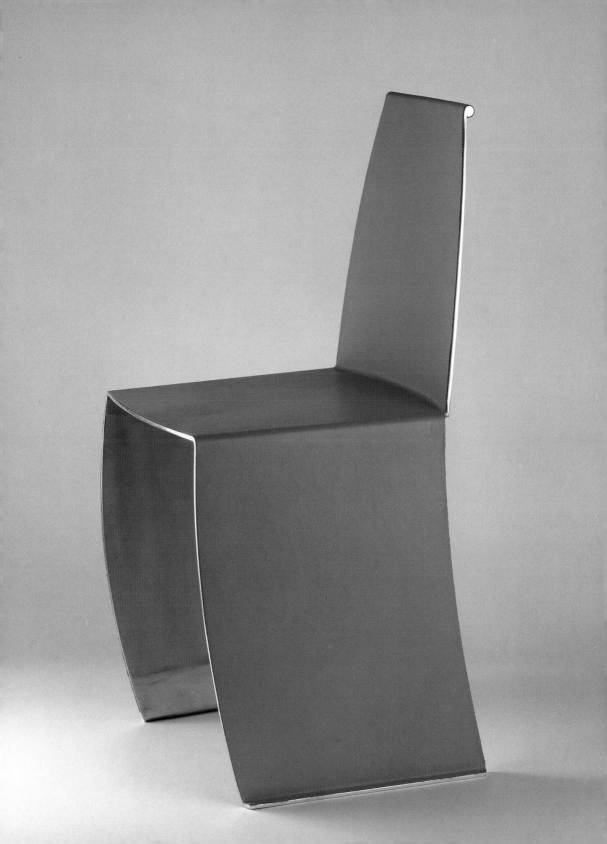

# "Armonica" side chair

**Designers:** Herbert Ohl (German, b. 1926)
and Jutta Ohl (German, b. 1938)
**Manufacturer:** Matteograssi S.p.A.,
Mariano Comense (CO), Italy
**Date of design:** 1991

Herbert Ohl claims that most chairs have "health-endangering" effects on their occupants. This chair, called a "seating tool" by its ambitious creators, purportedly offers free, "harmonic" movement, which in turn lends "rhythmic dynamics" to one's "body and life," in the designer's own words. Movement is realized through the malleability of the metal pedestal.

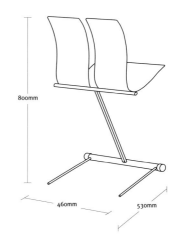

800mm

460mm

530mm

All joints are force fused. No welding and no adhesives are employed for joining. The leather covering on the metal surface of the seat and back is coated. The baked metal surfaces are finished with a choice of powdered or polyester epoxy paint in film thicknesses of 120–180 microns.

Leather-covered, molded tempered steel (2mm thickness).

Aluminum tubing (25mm diameter) with end caps in black PVC.

Leather-covered, molded tempered steel (3mm thickness).

Pedestal of two separate steel rods (12mm diameter each, 489mm high) with an elastic characteristic.

Aluminum-tube base (25mm diameter) fitted with black PVC caps.

"Donut" glides in black PVC (31mm diameter).

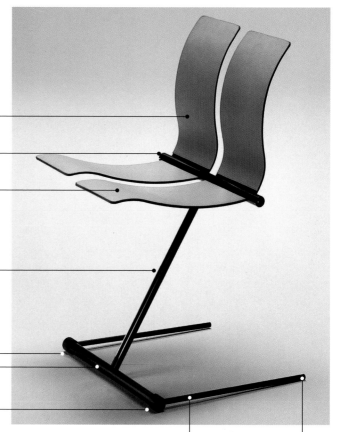

Steel rod (12mm diameter) with an elastic characteristic.

Black PVC caps.

chairs

## 198

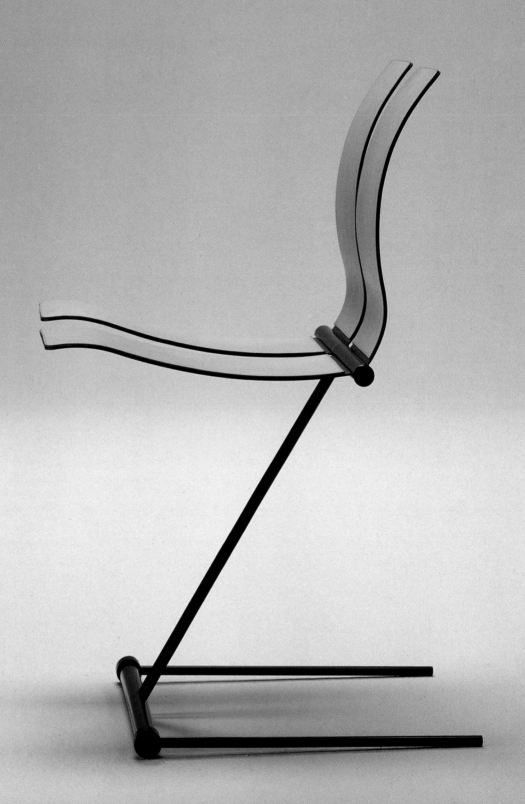

# "Dakota" armchair

**Designer:** Paolo Rizzatto (Italian, b. 1941)
**Manufacturer:** Cassina S.p.A., Meda (MI), Italy
**Date of design:** 1995

This chair features a cast-aluminum seat shell
that accommodates either four straight legs
or a swivel pedestal. The inner upholstery, with
its special design of fingers and a plastic track
attachment, is removable and replaceable.

The two versions (straight legs or pedestal)
are available as follows:
• Completely upholstered in saddle leather
and chair trim in soft leather.
• Saddle leather outside and removable
fabric cover inside with soft leather trim.
• Completely upholstered with removable
fabric cover with trim in same fabric.

# "Dakota" armchair

Inside the seat bottom, grid and spiral elevations in the molded aluminum offer rigidity. The same base accommodates either four legs or a center pedestal.

Cast aluminum underside of the seat bottom.

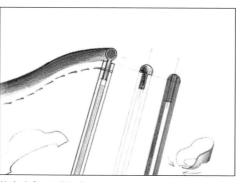

Methods for attaching the inner upholstery unit to the perimeter edge of the seat bucket.

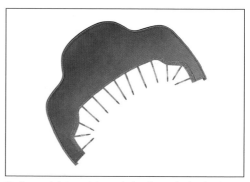

The inner upholstery unit is attached to the seat bucket rim via an extruded tube with an attached insertion feature (see facing page). The fingers are concealed by the seat cushion.

chairs

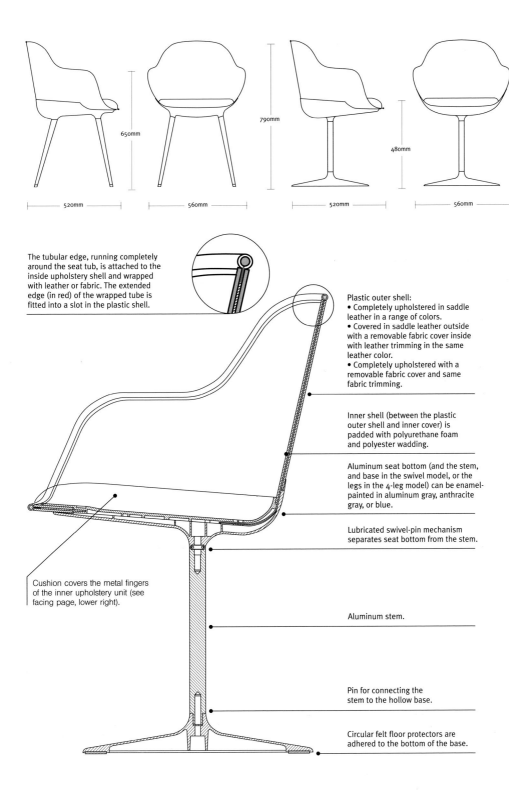

650mm

790mm

480mm

520mm

560mm

520mm

560mm

The tubular edge, running completely around the seat tub, is attached to the inside upholstery shell and wrapped with leather or fabric. The extended edge (in red) of the wrapped tube is fitted into a slot in the plastic shell.

Plastic outer shell:
• Completely upholstered in saddle leather in a range of colors.
• Covered in saddle leather outside with a removable fabric cover inside with leather trimming in the same leather color.
• Completely upholstered with a removable fabric cover and same fabric trimming.

Inner shell (between the plastic outer shell and inner cover) is padded with polyurethane foam and polyester wadding.

Aluminum seat bottom (and the stem, and base in the swivel model, or the legs in the 4-leg model) can be enamel-painted in aluminum gray, anthracite gray, or blue.

Lubricated swivel-pin mechanism separates seat bottom from the stem.

Cushion covers the metal fingers of the inner upholstery unit (see facing page, lower right).

Aluminum stem.

Pin for connecting the stem to the hollow base.

Circular felt floor protectors are adhered to the bottom of the base.

# "Longframe" chaise longue and "Armframe" easy chair

**Designer:** Alberto Meda (Italian, b. 1945)
**Manufacturer:** Alias S.r.l., Grumello del Monte (BG), Italy
**Date of design:** 1993

An amalgamation of visual and physical lightness has been incorporated into a lounge seat appropriate for indoor or outdoor use. The result may be more of an engineering accomplishment than an aesthetic one. The net upholstery is held in place by covered plastic piping, which is fed into the channel of the side frame. The Kevlar cord stretched among the legs controls the frame's twisting.

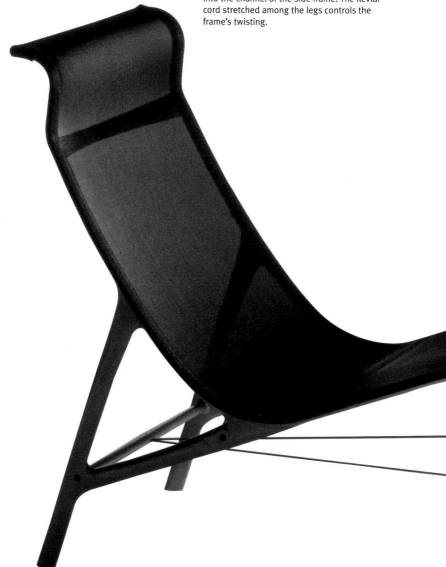

chairs

Polyester net upholstery netting.

Kevlar cord (red), which decreases the chair's twisting motion, is attached to the front legs and at a single point at the back legs.

Top brace and its mold (red).

Extruded and bent aluminum frames (for the easy chair and the chaise longue) with channels for netting insertion.

Nylon glide (not shown) is inserted into the end of all four legs.

Screw hole to secure the bottom of back stretcher, at whose center point the Kevlar cord is attached.

Mold (red) and corresponding back and foot stretcher.

Mold (red) and corresponding "Y" leg, attached to the frame by screws.

metals

# "Long-frame" chaise longue and "Armframe" easy chair

No Kevlar cord nor upper back stretcher are used in the "Armframe" version (left).The extruded aluminum frame design, into which the hem of the taut polyester netting is fed at the inside edges, eliminates the necessity of being attached at top and bottom edges.

Cross sections of two different aluminum processes:

Inside edge of longitudinal extruded frame.

Extruded section.

Die-cast section.

PVC piping, fed into extrusion channel, holds the polyester webbing tautly.

Polyester netting fabric.

Counter-sunk screw.

Longitudinal side frame of extruded aluminum houses a channel for insertion of the net-covered piping. Notch with screw hole is for attaching the top-back bar.

920mm

540mm wide

730mm

380mm

900mm

540mm wide

420mm

1460mm

chairs

# plastics

# "LAM L 1000" chair system

**Designer:** Roberto Lucci (Italian, b. 1942) and
Paolo Orlandini (Italian, b. 1941)
**Manufacturer:** Shelby Williams Industries,
Morristown, Tennessee, U.S.A.
**Date of design:** 1991

On most ergonomic chairs, the seat can be raised
and lowered. However, unlike most others, this chair
has no springs or gas pistons. A simple self-adjusting
tilt configuration makes the chair economical and
reliable. The system (of which about 60,000 a year
have been produced since 1992) includes models
with four legs, sled legs, a swivel pedestal and
ones attached to a bar for public tandem seating.

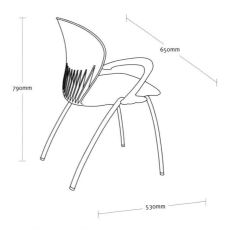

650mm

790mm

530mm

Of the numerous configurations, the 4-leg armchair
is shown in the drawing here.

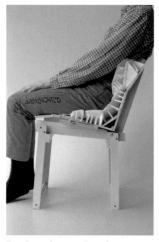

Experimental ergonomic mock-up.

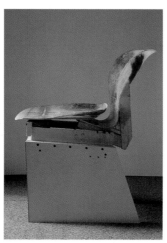

Full-size model in glass-reinforced polyester.

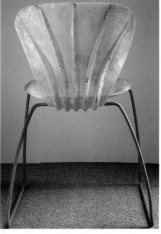

On another model in glass-reinforced
polyester, the fins (running the full height
of the back) were increased in number but
shortened in the final version.

The lever principle that synchronizes the
back and seat movement is illustrated
through a 3-dimensional model (right).

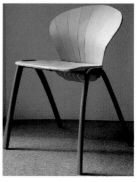

Using paper and PVC tubing in
a full-size model (right), the most
desirable proportions are sought.

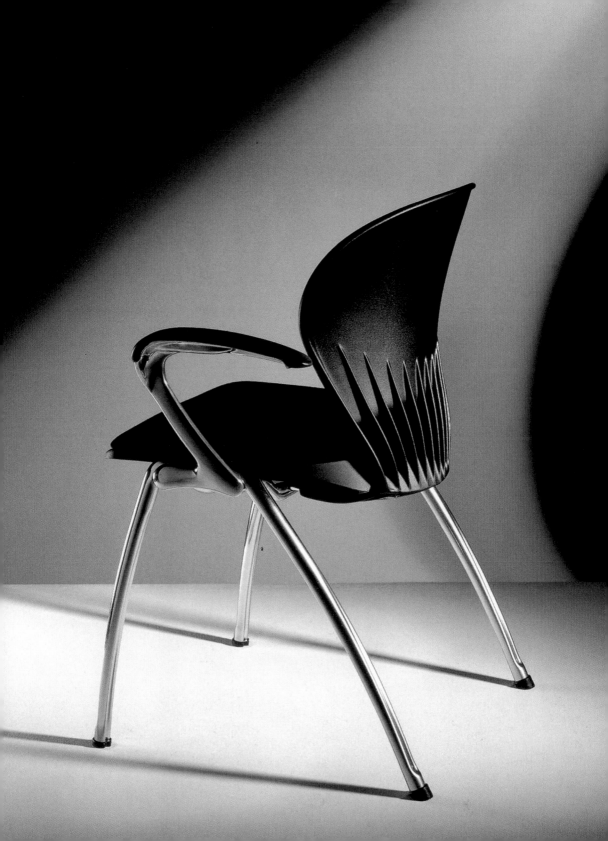

# "LAM L 1000" chair system

Models available in the seating system:

4-leg side chair.
4-leg armchair (preceding page).
Sled-base side chair (below left).
Sled-base armchair (below right).
Swivel chair.
Swivel armchair.
Modular seating.

4-leg model:
Bent and stamped
steel tubing (25mm
diameter).

Swivel model:
Bent and stamped
steel tubing
(30mm diameter).

Polyamide
roll
casters.

The fins on the back
permit self-tilting. The
material does not split
where the back meets
the seat.

Fireproof, injection-
molded, recyclable
polypropylene resin,
available in a range
of colors.

The back and seat are available
in bare plastic or with foam-
rubber and polypropylene
pads covered with fabric or
PVC material.

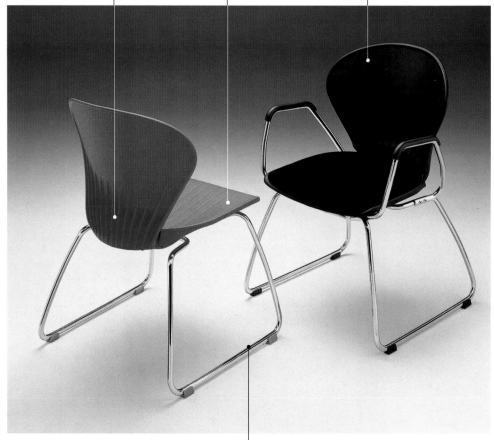

Bent and stamped steel tubing
(18mm diameter), powdered epoxy
finishes (two standard colors).

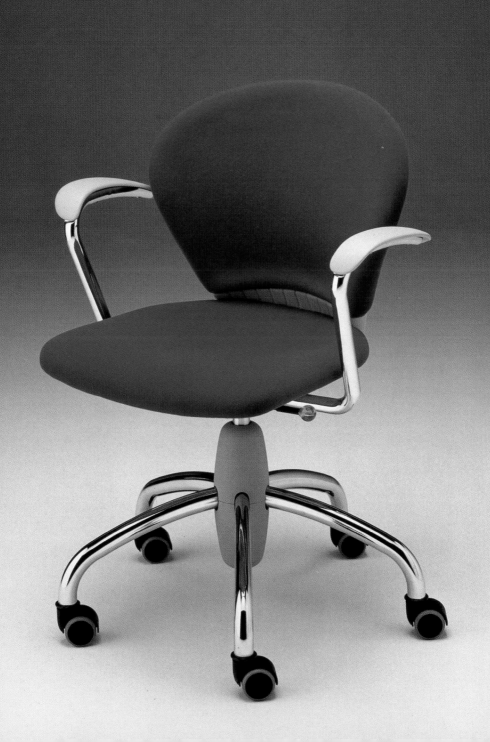

# "Drop" stool

**Designer:** Frans Van Praet (Belgian, b. 1937)
**Manufacturer:** Metcator-Orteliushuis, Antwerp, Belgium
**Date of design:** 1994-95

Combining the technologies of metal bending and plastic casting, this geometrically sophisticated form can be used both outside and indoors. Any one of eight colors is available, including different combinations for seat and base.

Geometrical configuration from which the form was derived.

Seat section in cast polyester (hollow inside)

Base section in cast polyester/concrete over a bent steel-rod armature.

475mm

345mm                415mm

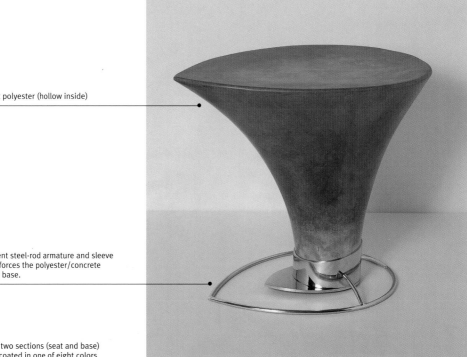

Cast polyester (hollow inside)

A bent steel-rod armature and sleeve reinforces the polyester/concrete cast base.

The two sections (seat and base) are coated in one of eight colors and glued together.

chairs

# "AC1" swivel chair

**Designer:** Antonio Citterio (Italian, b. 1950)
**Manufacturer:** Vitra GmbH, Weil am Rhein, Germany
**Date of design:** 1988

Part of a coordinated collection of office furniture, this chair adjusts to the occupant's body, following the body's movements, and flexes in a number of ways. Many of its parts, traditionally in metal, are in plastics.

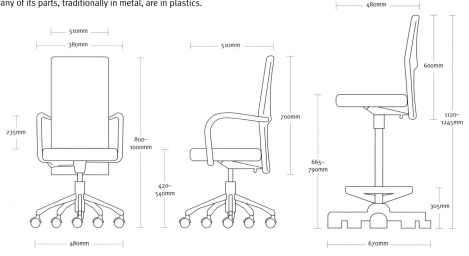

Through the use of flexible Delrin (a plastic material used for the back rest) and a synchronized mechanism beneath the seat and the flexing back rest are automatically adjusted when the occupant leans forward or pushes back.

The flexing back (covered in leather) of Paolo Deganello's "Documenta" chair (1987), also produced by Vitra, was the inspiration for the design of the flexing back of Citterio's "AC1" chair.

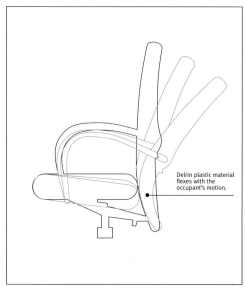

Delrin plastic material flexes with the occupant's motion.

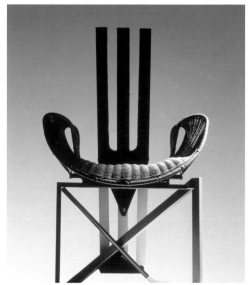

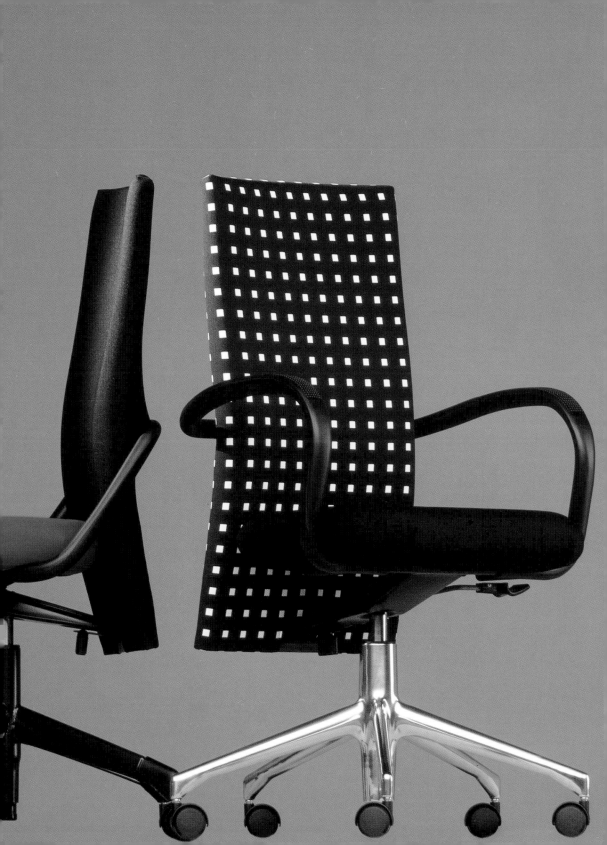

# "AC1" swivel chair

Chair parts are manufactured and supplied by various sources worldwide.

Pimpled section on the polyamide armrest.

If arm is not selected, the polyamide side connector is attached.

Special "lense" screws.

CFC-free polyurethane foam.

Front axle.

Gas-lifting pneumatic-spring mechanism

Double casters for either carpeted or hard floors.

Backrest version A: All Delrin plastics or partially covered (front side) with fabric.

Backrest version B: Delrin covered front and back with fabric.

Motion mechanism is adjustable to the height and weight of the occupant. Adjustment lever is located at the left.

Back axle.

The base:
1. Polyamide.
2. Die-cast aluminum (polished).
3. Die-cast aluminum (chromium-plated).

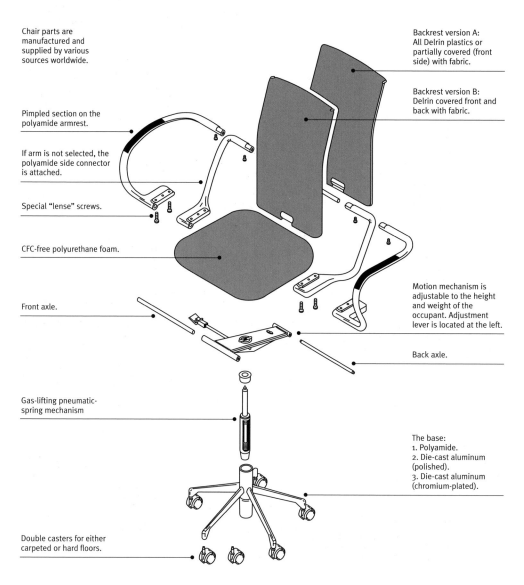

chairs

Sequential documentation illustrates a chair's assembly. The process begins with all the parts for one chair placed in a transport bin (right). The full assembly is performed by one person, who undertakes the quality control and assures that everything works properly.

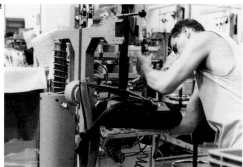

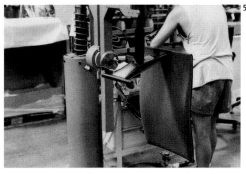

plastics

217

# "Miss Trip" side chair

**Designer:** Philippe Starck (French, b. 1949)
**Manufacturer:** Kartell S.p.A., Noviglio (MI), Italy
**Date of design:** 1995

The original of this chair, more sculpturally voluptuous, was intended to be a self-contained unit, eliminating a carton package. However, for economy of shipment, the customer buys the disassembled chair in its own take-away box. This was the first object that the manufacturer made in wood – it was known previously for its plastic production. Two-component molding of polypropylene forms the seat where it reaches considerable thickness (about 8mm) in the inner strata.

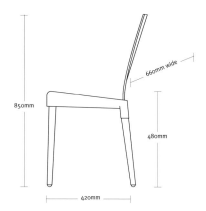

Turned solid beechwood legs are fitted at the top with plastic screws and at the bottom with plastic glides.

Polypropylene seat is molded by a two-component-forming process and includes slits on the back edge for the back's insertion.

The back is made of bent plywood with a beechwood veneer.

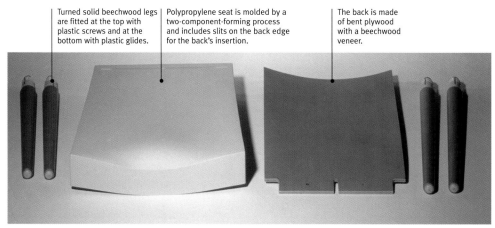

In the original concept (right), the seat and the back served as the packaging container for the legs. The wicker-effect surface was to be part of the mold die. The design was greatly modified in the final production model:

The legs were changed from being force-fitted to those with threaded plastic tops, which the customer screws into the underside of the seat.

The back was simplified with two slits that fit into the seat and are held by two screws.

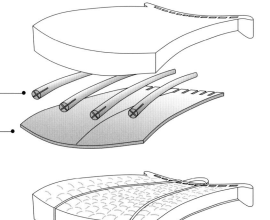

Despite plans for a self-contained unit, the chair was sold in a "cash and carry" cardboard box (450 x 150 x 500mm) (not shown). The assembly-instructions are printed on the outside of the box. The total weight of the box and the chair is 5.5Kg.

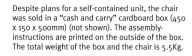

chairs

Illustration has been adapted from a sketch by the designer.

plastics

# "Alí-Babá" seat

**Designer:** Oscar Tusquets Blanca (Spanish, b. 1941)
**Manufacturer:** Casas M.s.l., Barcelona, Spain
**Date of design:** 1990

The namesake of a mythical Middle Eastern carpet-flyer, this seat was inspired by carpets used on furniture, particularly in British mansions and by Eliel Saarinen in Finland. On the model where the carpet-upholstery flows into the floor, the designer wanted to create a 2-level seat to accommodate people who watch television or read a newspaper while sitting on the floor and leaning against a sofa. The design is made possible by the use of the flexible polyurethane form housed within the upholstery bag (carpet on the top, felt on the bottom).

| Model without the carpet extension. | One of two bent-steel back legs extending from the steel-rod superstructure. | Rug is attached to the frame with velcro. |

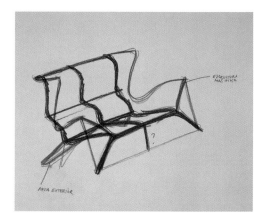

Bent-steel superstructure (in the designer's sketch here) is located inside a flexible polyurethane form that is covered by the upholstery (carpet on the top, felt underneath).

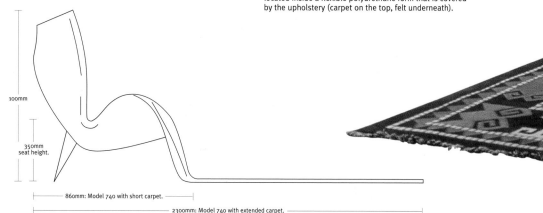

100mm

350mm
seat height.

86mm: Model 740 with short carpet.

2300mm: Model 740 with extended carpet.

chairs

Three carpet designs are available (Tibet, left; Anatolia, middle; Laberinto, right). Other fabrics or leather may also be used.

# "4822" to "4825" stools

**Designer:** Anna Castelli Ferrieri (Italian, b. 1920)
**Manufacturer:** Kartell S.p.A., Noviglio (MI), Italy
**Date of design:** 1979

Resulting from sophisticated and extensive technological research, this stool was first manufactured in structural polyurethane in order to obtain thick sections and hold the metal insertions in the molding process. However, when the polyurethane was found to have structural limitations, an engineered plastic made of slightly foamed glass-reinforced polypropylene was substituted. The stool has become the manufacturer's biggest selling product at 15,000 annually. The four model numbers refer to varying leg and back heights; otherwise, the stools are the same design.

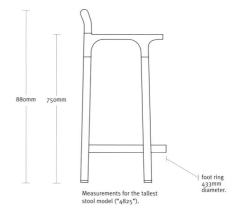

880mm    750mm

foot ring
433mm
diameter.

Measurements for the tallest
stool model ("4825").

The test result (below) of one of the many engineering studies performed on the Castelli Ferrieri seat illustrates where major stress deformation occurs (shown in red).

Expanded polyurethane backrest/handle covers and structural iron rod.

Seat in semi-expanded polypropylene, filled with glass.

Structural iron rod terminates in a threading that accommodates the screwing on of the detachable legs.

Painted iron legs.

Footrest is polypropylene (filled with a metal ring) stiffens the four slim metal legs.

Rubber plugs finish the legs and protect the floor.

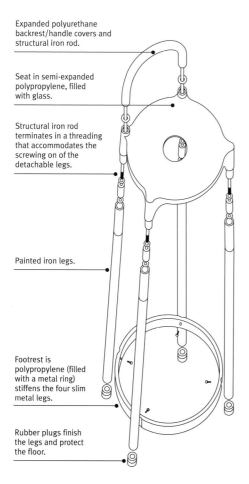

The four stool heights and two backrest/handles are available in a range of models including those below and others: seven model numbers from "4822" to "4828."

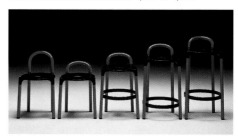

chairs

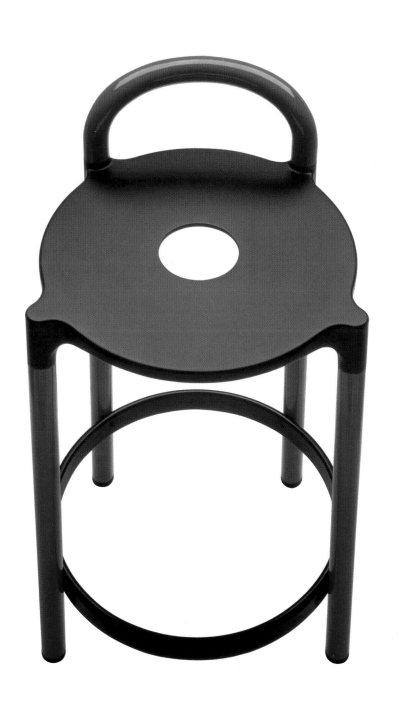

plastics

# "Hi Ho" stool

**Designer:** Aaron Lown (American, b. 1968)
**Manufacturer:** Aaron Lown—C4 Design
Laboratories, New York, NY, U.S.A.
**Date of design:** 1994

Lightweight aluminum for the base, formed
by an age-old sandcasting process, and the
fiberglass shell, shaped in a vacuum bag, are
combined to produce a springy seat in an
unusual shape. The foot pegs that support
the occupant are also used to hold the stool
sections together. Industrial materials have
been combined with a luxury one—leather.

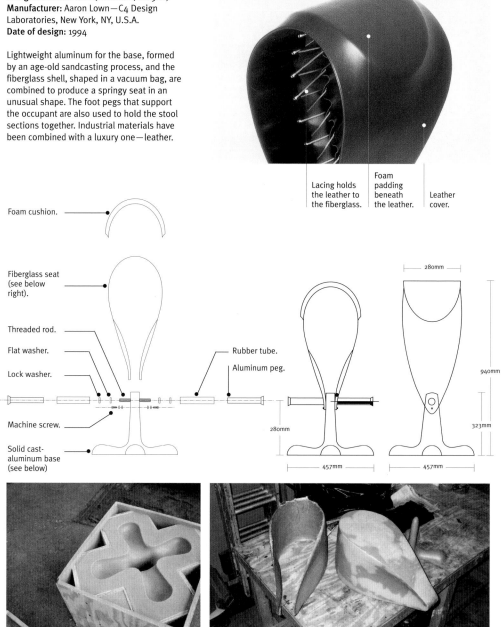

Lacing holds the leather to the fiberglass.

Foam padding beneath the leather.

Leather cover.

Foam cushion.

Fiberglass seat (see below right).

Threaded rod.

Flat washer.

Lock washer.

Rubber tube.

Aluminum peg.

Machine screw.

Solid cast-aluminum base (see below)

280mm

940mm

280mm

323mm

457mm

457mm

A traditional sand mold casts the
solid-aluminum base, shown here
before casting.

12 layers of medium-weight woven glass and woven roving are placed on a form
(right) and adhered to the form in a plastic vacuum bag. After forming, the
fiberglass section (left) is covered by a leather sleeve and laced beneath.

chairs

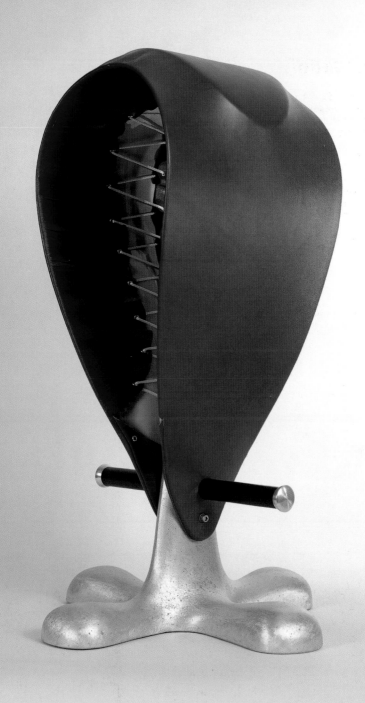

# "Pepe" chair

**Designer:** Christopher Connell (Australian, b. 1955)
and Raoul C. Hogg (New Zealander, b. 1955)
**Manufacturer:** MAP—Merchants of Australian
Product Pty. Ltd, Victoria, Australia
**Date of design:** 1992-93

This lithe, sinuous form and intricate construction
was the designers' attempt "to do the most difficult
thing we could." A lightweight tubular steel frame is
engulfed by polyurethane foam in a mold. The two
sections of the interior steel support frame are
connected by a special bracket at the waist of the
chair (where the back meets the seat) to offer
appreciable springiness to the back. The 100 per
cent wool crêpe upholstery fabric is available in a
range of colors not normally used for furniture.

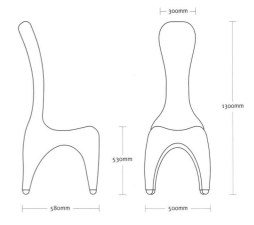

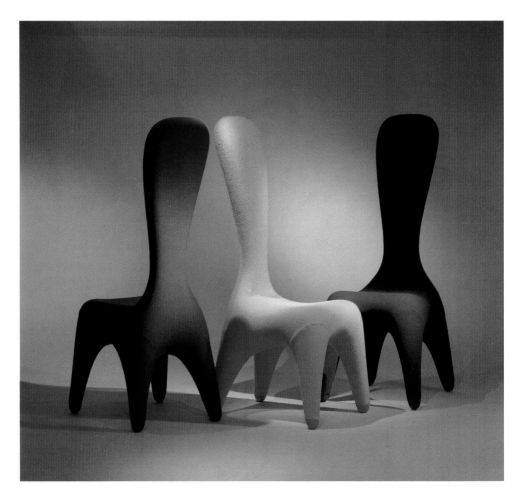

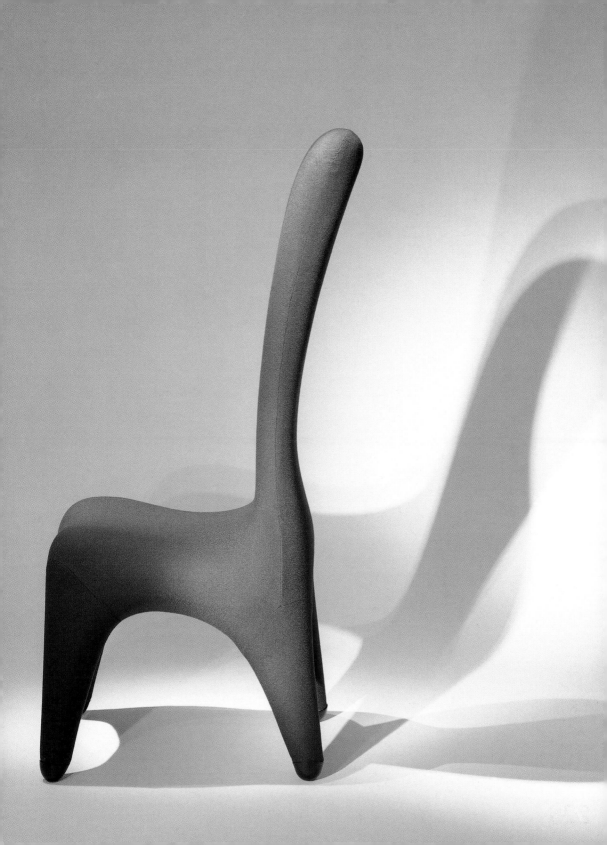

# "Pepe" chair

After the mold is injected with expanded polyurethane foam using a Heko Viking low-pressure foam-dispensing machine, the fully-formed chair with a self-skin is removed with the tubular frame inside.

Bright milled steel tubing (25mm diameter x 1.6mm wall thickness) is bent with a Pedrozzili automatic tube-bending machine and is Saf electric mig welded before being inserted into the mold in an inverted position. The die is then closed and injected with foam.

3-part hinged mold before it is injected with CFC-free expanded polyurethane with the use of a low-pressure foam-dispensing machine.

The tubular inner frame is in two parts connected by two hairpin springs that permit the back to flex backward from the seat. (Shown here in the inverted position in which it is molded.)

100 per cent wool crêpe upholstery fabric is cut to a pattern and hand sewn onto the self-skinned polyurethane body.

2X hairpin springs connect the two sections of the frame, permitting the back to flex.

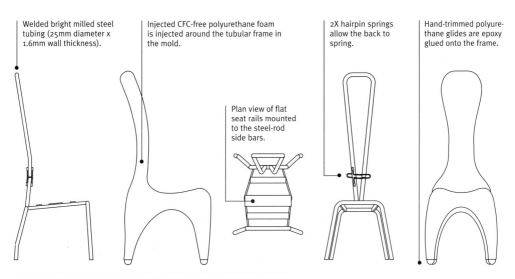

Welded bright milled steel tubing (25mm diameter x 1.6mm wall thickness).

Injected CFC-free polyurethane foam is injected around the tubular frame in the mold.

Plan view of flat seat rails mounted to the steel-rod side bars.

2X hairpin springs allow the back to spring.

Hand-trimmed polyure-thane glides are epoxy glued onto the frame.

Workman assembles the "Pepe" chairs in a factory where other chairs are produced.

# Bubble-wrap chair

**Designers:** Fernando Campana (Brazilian, b. 1961)
and Humberto Campana (Brazilian, b. 1953)
**Manufacturer:** Campana Objetos Ltda,
São Paulo/SP, Brazil
**Date of design:** 1995

While not exuding permanence, the use of a
material never intended for upholstery suggests
a direction for new fabric development—padding
and upholstery as one and the same material.
The chair was made in an edition of two.

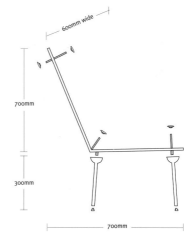

600mm wide

700mm

300mm

700mm

Sheet-metal squares are welded
into the corners of the grid of the
frame. The six bolts that hold
down the bubble wrap are in turn
welded to the metal squares.

5mm diameter
steel rods form a 70
x 70mm grid.

Upholstery: 30 sheets
of bubble wrap
(600 x 1300mm).

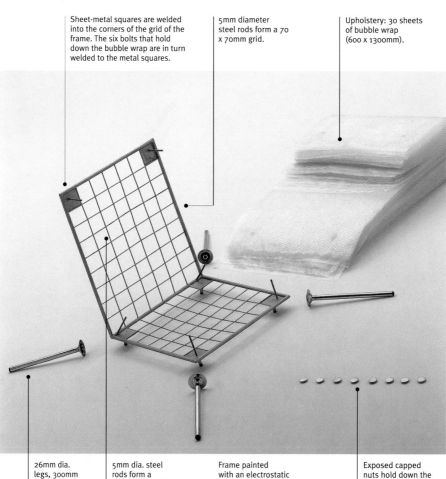

26mm dia.
legs, 300mm
long.

5mm dia. steel
rods form a
70 x 70mm grid.

Frame painted
with an electrostatic
sprayer.

Exposed capped
nuts hold down the
bubble-wrap sheets.

chairs

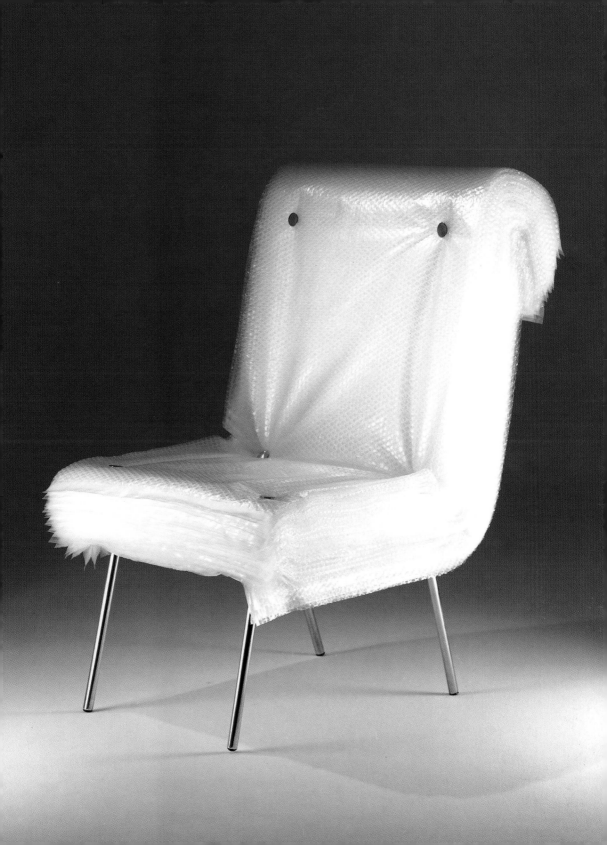

# "Sansiro" chair

**Designers:** Fabrizio Ballardini (Italian, b. 1953)
and Lucio Costanzi (Italian, b. 1957)
**Manufacturer:** Bernini S.p.A., Carate Brianza
(MI), Italy
**Date of design:** 1994

This playful, structurally innovative object
questions the boundaries of fine art, seating,
and function. Exploiting the elasticity of
rubber, the seat itself (an inflatable ball) is
essentially a separate object.

970mm

660mm

500mm

590mm

Rubber glides are
attached to the ends
of the tubular steel
upholstery support.

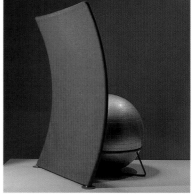

The seating ball (500mm diameter)—formed of two
layers of rubber fused with a non-toxic netting
layer—is spray-painted with an emulsion of
metallic fragments and is inflated by a valve.

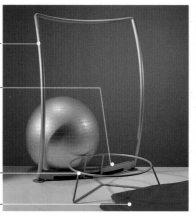

The bent steel tubular
frame (25mm diameter)
supports the upholstery
sack.

Metal cross member holds
the hoop frame in place at
the back center.

The solid steel rod frame
(8mm diameter)
supports the ball.

The upholstery sack slides
over the back frame.

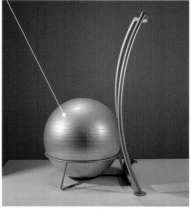

chairs

232

# "Lockheed Lounge LC2"

**Designer:** Marc Newson (Australian, b. 1962)
**Manufacturer:** Pod, Paris, France
**Date of design:** 1988

Modified from the original model (the one-of-a-kind "LC1" version), the production of this seat combines a plastic (fiberglass) with a metal (aluminum). The "LC2" is deceptively light in that it weighs only 20Kg due to the hollow fiberglass shell. Designed with only three legs, this unabashed industrial object completely rejects the idea of comfort. It was produced in an edition of ten and is very expensive.

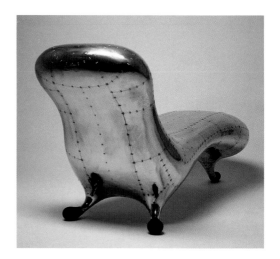

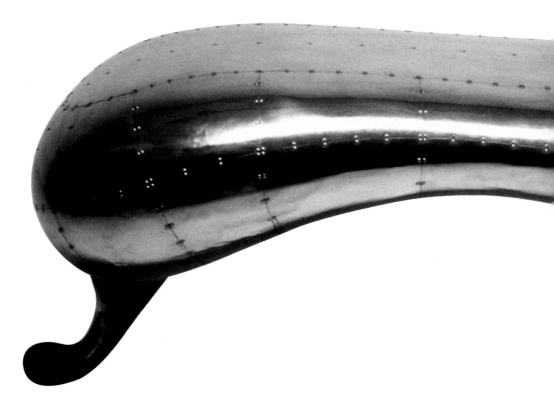

chairs

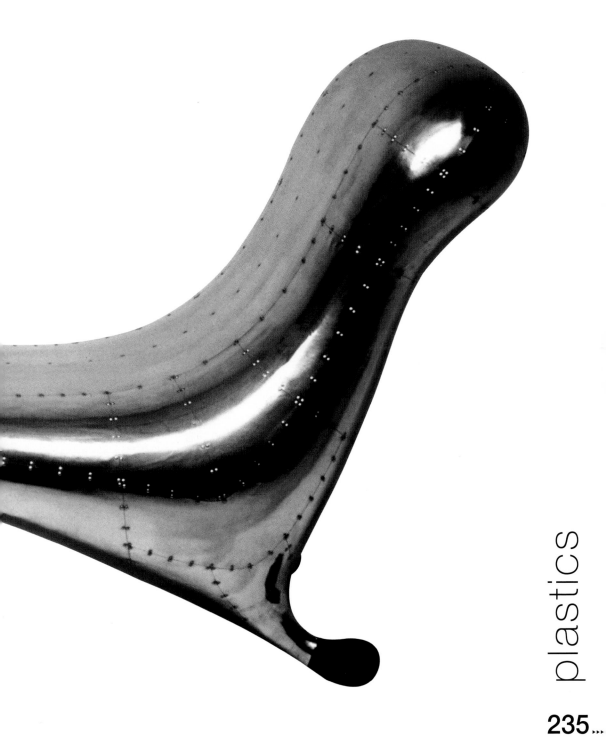

plastics

# "Lockheed Lounge LC2"

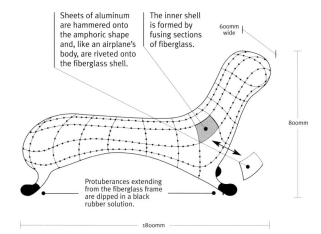

Sheets of aluminum are hammered onto the amphoric shape and, like an airplane's body, are riveted onto the fiberglass shell.

The inner shell is formed by fusing sections of fiberglass.

600mm wide

800mm

1800mm

Protuberances extending from the fiberglass frame are dipped in a black rubber solution.

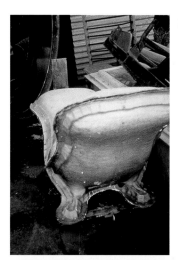

A mold is used for forming the fiberglass shell.

The fiberglass shell is shown here, assembled in one version and, before assembly, in two parts lying on their sides. The back legs are part of the mold; the front leg is attached separately.

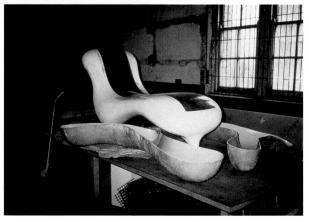

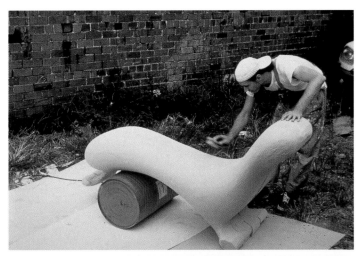

The designer and maker is sanding the finished fiberglass form, prior to its being riveted over with aluminum sheets.

A scene from Madonna's music video "Rain" (1992).

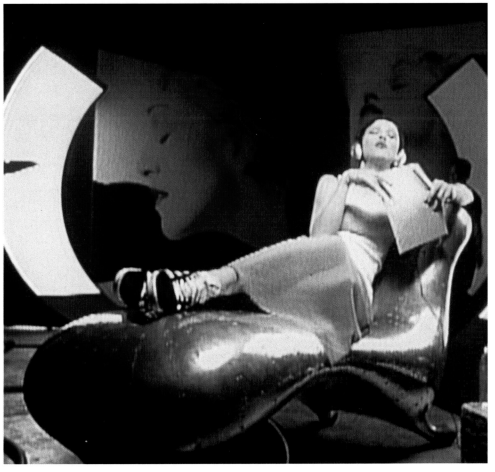

plastics

237

# "Louis 20" chair

**Designer:** Philippe Starck (French, b. 1949)
**Manufacturer:** Vitra, Weil am Rhein, Germany
**Date of design:** 1992

This chair is made from two recyclable materials: polypropylene (body and front legs) and already recycled aluminum (back legs and arms). The energy and raw material required for reprocessing polypropylene is 70 per cent less than that for polyamide. Only five screws are used to connect the back-legs bridge to the body. An optional swiveling writing tablet, attaching to one arm, is available.

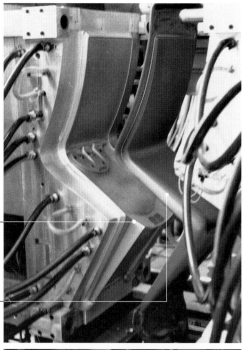

Back half of die in the blow-molding process.

Chair body is formed when a warm plastic tube is placed within the closed mold and compressed air forces it against the shape of the hot die—a technique known as blow-molding.

Chair body before the excess polypropylene is trimmed away from the top, bottom and between the front legs. Available in gray, blue, red, green, black, or blue-gray.

Connecting wire links together back legs for ganging in rows for assembly hall use.

chairs

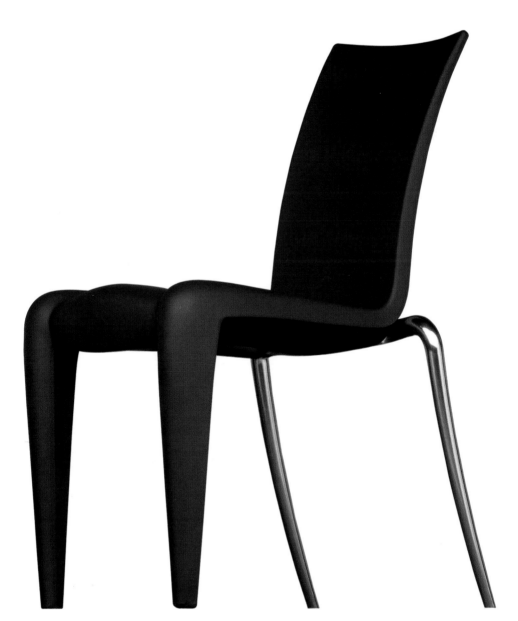

# "Louis 20" chair

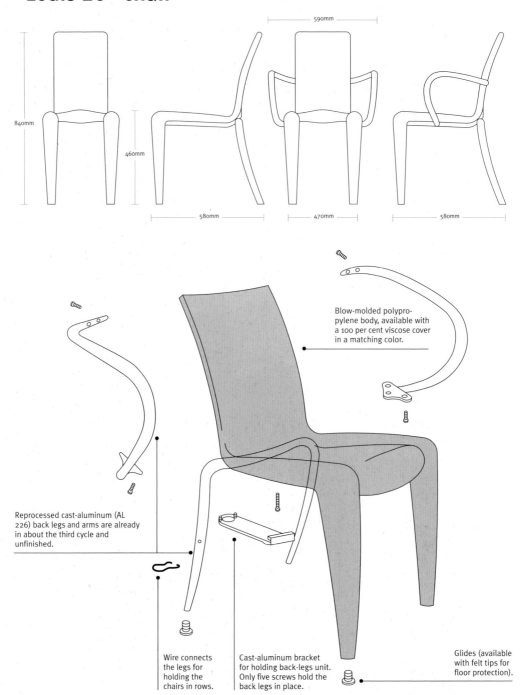

590mm

840mm

460mm

580mm

470mm

580mm

Blow-molded polypro-
pylene body, available with
a 100 per cent viscose cover
in a matching color.

Reprocessed cast-aluminum (AL
226) back legs and arms are already
in about the third cycle and
unfinished.

Wire connects
the legs for
holding the
chairs in rows.

Cast-aluminum bracket
for holding back-legs unit.
Only five screws hold the
back legs in place.

Glides (available
with felt tips for
floor protection).

chairs

# fibers & composites

# "Light Light" armchair

**Designer:** Alberto Meda (Italian, b. 1945)
**Manufacturer:** Alias, Grumello del Monte (BG), Italy
**Date of design:** 1987

The designer, who began as an engineer more than a quarter of a century ago, has created a chair that reflects his continuing commitment to pursuing fresh, new, technologically innovative approaches to traditional objects. This chair was constructed with a core of Nomex honeycomb that was covered over with carbon fiber, itself saturated with an epoxy resin before application. All of this resulted in the lightest, fully functional chair known, at 0.98g or almost 1Kg.

510mm deep

700mm

510mm

Experimental materials used in the early trials of production.

First in yellow polystyrene made by the designer.

A subsequent version in yellow polyurethane.

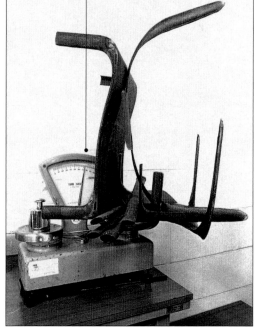

Parts and pieces of an experimental version weigh in at about 0.75Kg, before the final assembly with adhesives added.

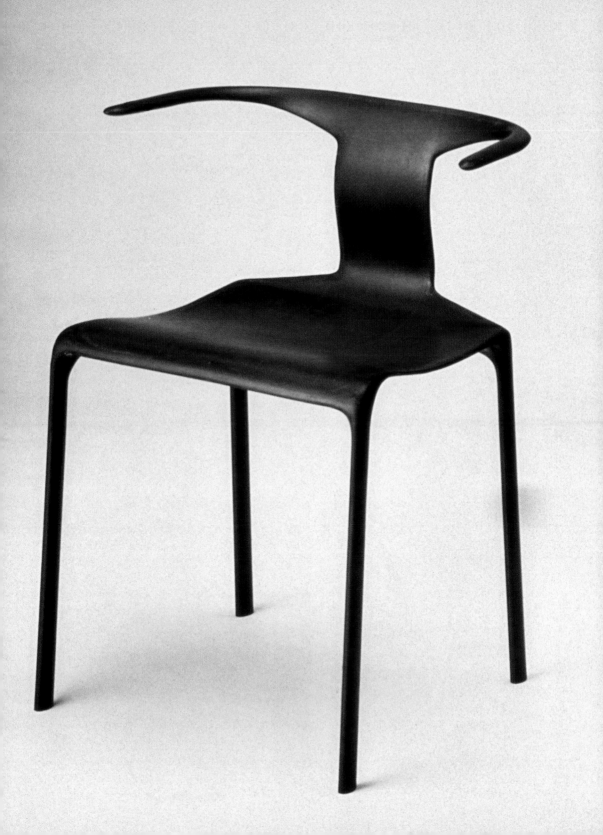

# "Light Light" armchair

Sandwich configuration is accomplished with a resin mold, "empty sack," and autoclave (or an apparatus, like that for medical sterilization, employing hyperheated steam under pressure).

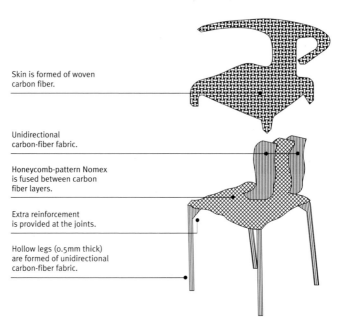

Skin is formed of woven carbon fiber.

Unidirectional carbon-fiber fabric.

Honeycomb-pattern Nomex is fused between carbon fiber layers.

Extra reinforcement is provided at the joints.

Hollow legs (0.5mm thick) are formed of unidirectional carbon-fiber fabric.

Nomex honeycomb is fused between layers of carbon fiber.

The designer works on a prototype.

chairs

244

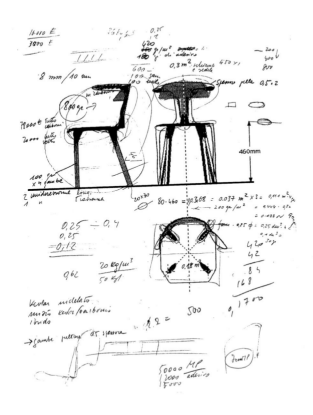

As one of the designer's drawings reveals, his "Light Light" chair was more driven by science than aesthetics, although the latter can never be absent no matter the designer's training or orientation.

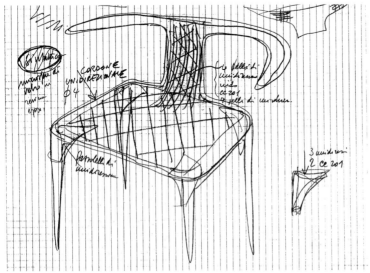

In another of the designer's drawings, he addresses fiber direction and joint reinforcement.

# "Aeron" swivel armchair

**Designer:** William "Bill" Stumpf (American, b. 1936) and Don Chadwick (American, b. 1936)
**Manufacturer:** Herman Miller, Inc., Zeeland, Michigan, U.S.A.
**Date of design:** 1992

The result of extensive testing and experimentation and based on the designers' long experience in ergonomics, this chair combines many advanced materials, including die-cast glass, reinforced polyester, polyurethane foam, flexible vinyl, recycled aluminum, Hytrel polymer, and Lycra. Its main features are a torselastic-spring device and a unique upholstery pellicle. The manufacturer unfortunately acquiesced to making the chair also available in fabric with traditional foam padding.

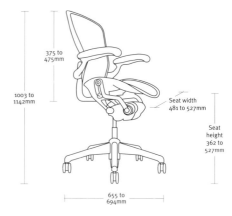

Range of dimensions for three sizes
(Models A, B, and C)

Protected by numerous patents, the "Kinemat" tilt feature (an intricate twist and free-fall tilt action at the ankle and hip known as torselastic spring) includes adjustable arms and chair heights to suit the individual occupant.

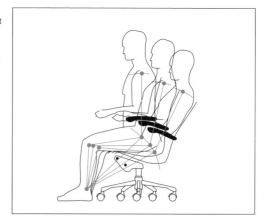

Versions are available in three sizes (Models A, B, and C) to satisfy almost the full range of male and female body sizes, and, democratically, none are the managerial or secretarial office chair designs.

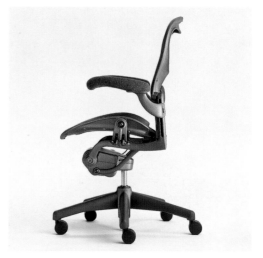

fibers...

# "Aeron" swivel armchair

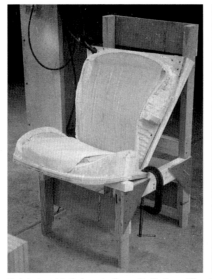

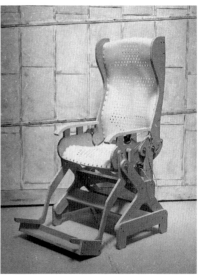

Early test models that eventually resulted in three different sizes to suit the range of human male and female sizes and proportions, up to about 112Kg.

Workman attaches the patented "Kinemat" tilting device, a 4-bar link suspension system.

Unlike Vitra's production of the "AC1" chair which is assembled by a single worker (see page 217), Herman Miller assigns different people to assemble this chair.

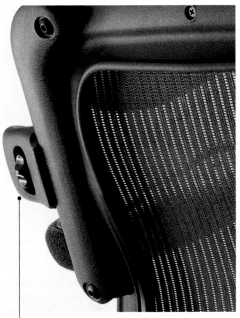

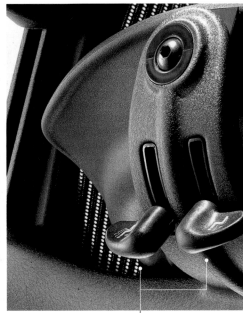

130mm height adjustment
control for the armrest.

Tilt-tension and height
adjustment knobs.

Developed particularly for this chair, the
pellicle (or upholstery sling) on the back
and on the seat is lino-woven from a
mixture of Lycra and Hytrel elastomeric
polymer. It adapts to the user's shape and
becomes typographically neutral when
vacant. The material, which aerates the
body, has been extensively tested for static
load, drop impact, memory, and abrasion
and snag.

Arm pad supports
(upholstered poly-
urethane foam or non-
upholstered molded
vinyl) and arm yokes
(die-cast aluminum)
offer 30° lateral
rotation.

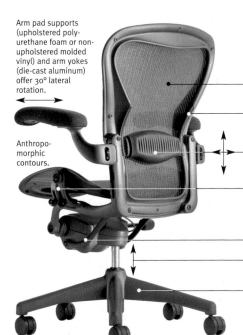

Anthropo-
morphic
contours.

Recycled reinforced polyester seat and
back frames.

Self-skinning urethane lumbar pad
(optional) offers 100mm vertical and
25mm horizontal adjustments.

Hip pivots on each side of the seat.

4-bar link suspension system (patented
"Kinemat" tilting device).

152mm-high 2-stage pneumatic (gas) lift.

Recycled cast-aluminum base with a
wrinkle-coated powder-coated epoxy finish.

fibers....

# "Cadé" armchair

**Designer:** Luciana Martins (Brazilian, b. 1957)
and Gerson de Oliveira (Brazilian, b. 1970)
**Manufacturer:** Probjeto S.A.—Produtos e Objetos
Projetados, São Paulo, Brazil
**Date of design:** 1986-87

This unorthodox black cube is not recognizable
as a chair. The stretch fabric covering the
superstructure yields easily when an occupant
sinks onto the seat. The inner structure is far
more intricate than one might suspect because,
after all, it is hidden from view. "Cadé", the name
of the armchair, is a pun on the Portuguese word
cadé, meaning, "Where is it?," and cadeira,
meaning "chair."

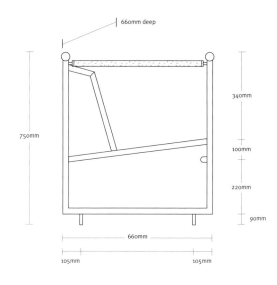

660mm deep

750mm

340mm

100mm

220mm

90mm

660mm

105mm    105mm

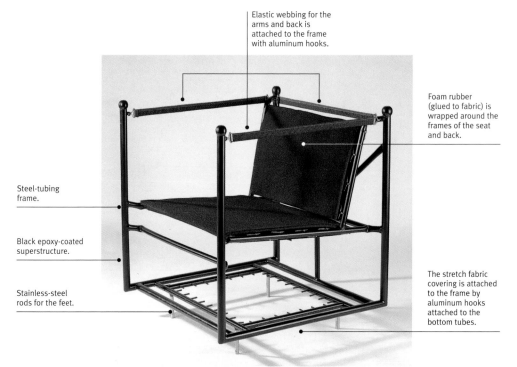

Elastic webbing for the
arms and back is
attached to the frame
with aluminum hooks.

Foam rubber
(glued to fabric) is
wrapped around the
frames of the seat
and back.

Steel-tubing
frame.

Black epoxy-coated
superstructure.

Stainless-steel
rods for the feet.

The stretch fabric
covering is attached
to the frame by
aluminum hooks
attached to the
bottom tubes.

The black stretch-fabric shroud is Elastex
(92 per cent nylon and 8 per cent Elastan fiber),
manufactured by Char-Lex Indústrias Têxteis.

fibers...

# "Quadraonda" armchair

**Designer:** Mario Cananzi (Italian, b. 1959)
**Manufacturer:** Vittorio Bonacina & C. s.n.c.,
Lurago d'Erba (CO), Italy
**Date of design:** 1991

This is an example of the high-quality vegetal-fiber production for which this manufacturer has become well-known. The chair combines a traditional natural material (rattan) and technique (weaving and metal bending) with a modern material (chromium-plated steel) and method (electrical welding).

Rattan (a climbing tropical palm) in both the natural state (top) and aniline dyed (below).

A craftsperson weaves the weft (side to side) and warp (top to bottom) arrangement of the rattan reeds onto the bent tubular-steel frame.

With a water-filled steamer, a craftsperson (see hand at extreme right, below) softens the rattan reed to facilitate more malleable weaving onto the metal seat-frame.

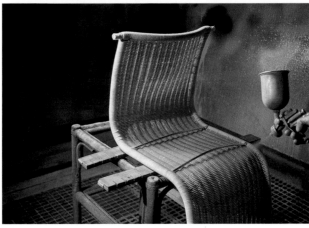

chairs

# "Quadraonda" chair

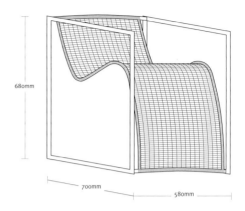

680mm

700mm

580mm

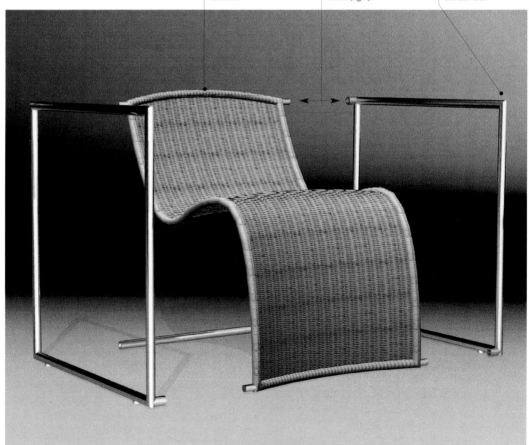

Seating frame is formed of bent-steel tubing welded at the corners.

Solid, welded steel fingers (left) are inserted into the hollow steel frame (right).

Frame sections are formed by welding the steel tubing at the corners.

chairs

Tubular extensions at the corners of the seat unit are inserted into the welded extensions on the side frames and held by self-threading screws.

An example of the possibility of multiple seating units, or ganging.

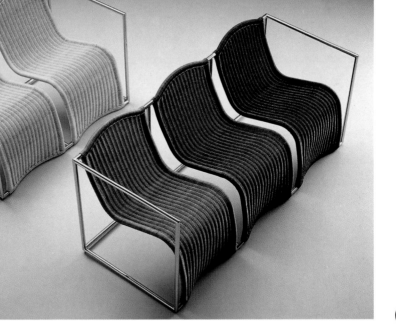

# "Feltri" armchairs

**Designer:** Gaetano Pesce (Italian, b. 1939)
**Manufacturer:** Cassina, Meda (MI), Italy
**Date of design:** 1986

In a single material that serves as both upholstery and frame while eliminating support bars and other traditional construction elements, this chair was produced from the inextricable relationship between an innovative content, novel techniques, and an unusual material. Felt, a material not normally associated with furniture making, is put to imaginative use. The resin impregnation of the bottom portion creates rigid support, and the pliable quality of the natural felt in the top portion facilitates folding, offering a womb-like space. The design is available in low- and high-back versions.

Back view reveals the folding nature of the intentionally flopped back and arm-wings.

The hemp strings hold the seat to the body.

The circular base is sliced, due to the 25mm thickness of the felt, on the periphery to permit the creation of a smooth curve.

Designer's conceptual drawing (in various media on paper) explores the use of a material that would serve to produce an essentially two-section chair.

The production model (not shown) by Cassina is fully lined on the inside of the hood with a fabric quilted with polyester wadding.

chairs

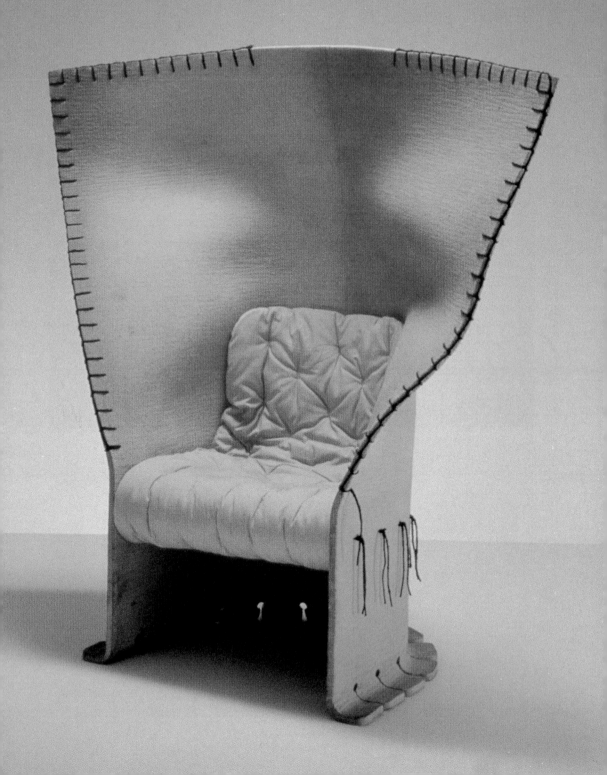

# "Feltri" armchairs

Working on a prototype, the felt is impregnated (or soaked) with polyester resin, which when dried under high heat turns the felt into a stiff material, almost like wood.

An inverted prototype chair reveals (in the darker area) the resin-soaked lower portion, beneath the seat.

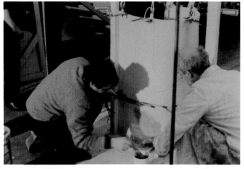

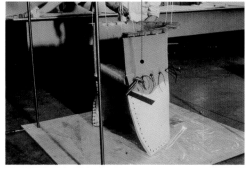

After extensive experimentation, a final production mold is made.

A fully assembled version of the chair with a panel (not used in the final version) added beneath the seat.

Heavy wool strings are stitched through the periphery to offer binding to the thick edge of the felt and also a finishing touch.

Both the barrel back and the seat are wool felt (25mm thick).

Hemp strings, like those employed for the periphery binding, are fed through puncture holes in the side to hold the hard resin-saturated seat in place.

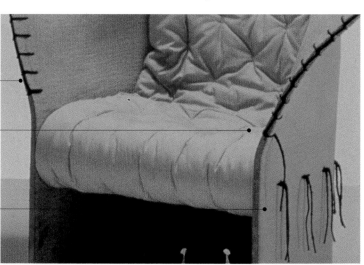

chairs

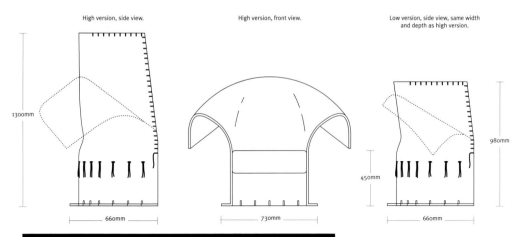

High version, side view.

High version, front view.

Low version, side view, same width and depth as high version.

1300mm

660mm

730mm

450mm

980mm

660mm

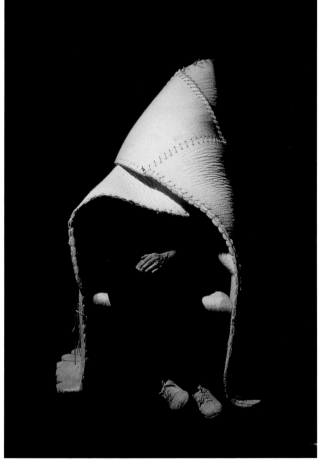

fibers...

259

# "Knotted" lounge chair

**Designer:** Marcel Wanders (Dutch, b. 1963)
**Manufacturer:** Wanders Wonders, Amsterdam,
The Netherlands
**Date of design:** 1995

Based on the traditional craft of macramé, a rope made of
carbon fiber (inside) and an aramid casing (outside sleeve)
is knotted into a limp shape, soaked in an epoxy solution,
suspended within a frame to form a chair shape, and dried
at a high temperature. It becomes very stiff and sturdy. The
processes and form were realized through a project known
as Dry Tech, sponsored by the Droog Design Foundation in
collaboration with the Laboratory for Aeronautics and
Astronautics of the T.V. Polytechnic in Delft. The designer
is a member of the ad-hoc Droog Design group; the Dutch
word Droog means "dry" or "lacking substance."

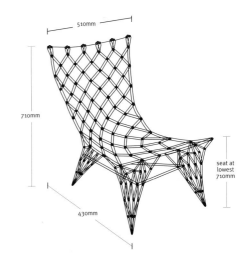

510mm

710mm

430mm

seat at
lowest
710mm

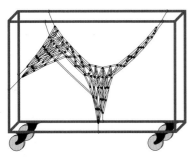

The limp braided chair is saturated
in an epoxy solution, hung within
a frame in the desired form, and
placed in a room heated to 80° C.
until the rope (silky carbon fiber
covered by a cotton-like, soft
aramid sleeve) becomes rigid
and extremely strong.

Carbon fibers
run inside the
length of the
aramid sleeve.

The woven aramid sleeve
(or bread) (4mm diameter
overall) covers the
carbon-fiber center.

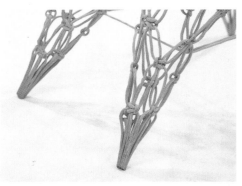

Rigidly formed by an epoxy solution,
the legs assume a strong cone shape.

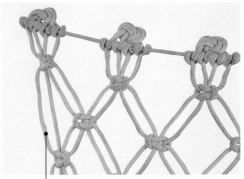

A close view of the top of the back reveals
the braided rope, frozen in place as if by magic.

chairs

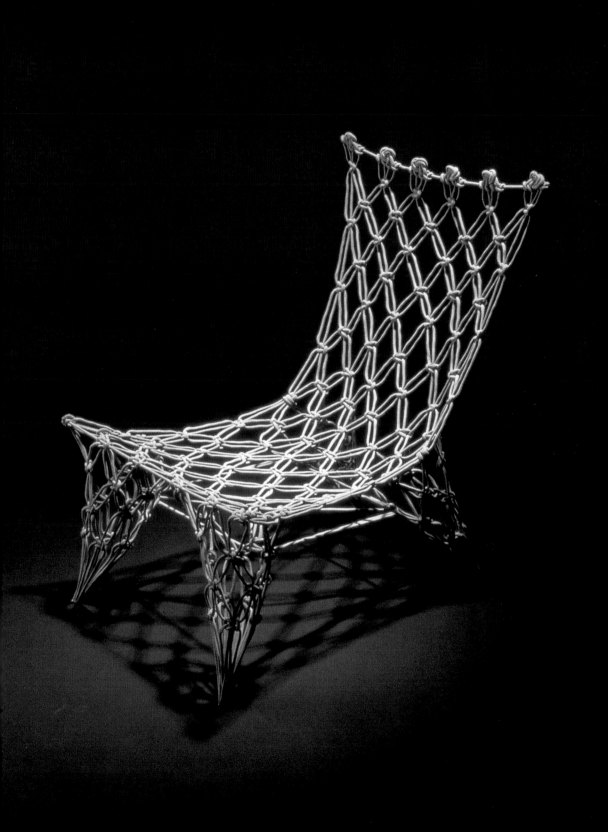

# "Husband" armchair

**Designer:** Constantin Boym
(Russian, b. 1955)
**Manufacturer:** Boym Design Studio,
New York, New York, U.S.A.
**Date of design:** 1992

Admired by Philippe Starck and
specified for installation by him in the
Teatríz restaurant in Mexico City, this
chair reflects a nostalgia for a time
past. It features a so-called "husband"
backrest, while exemplifying a kind of
banality with kitsch values. The chair
is part of a group that the designer
has named Searstyle furniture.

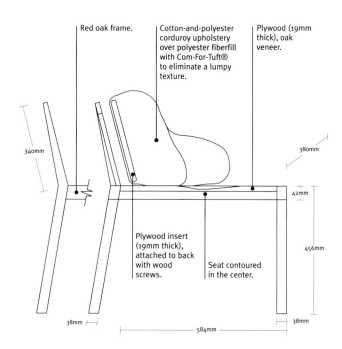

Red oak frame.

Cotton-and-polyester
corduroy upholstery
over polyester fiberfill
with Com-For-Tuft®
to eliminate a lumpy
texture.

Plywood (19mm
thick), oak
veneer.

340mm

380mm

42mm

456mm

Plywood insert
(19mm thick),
attached to back
with wood
screws.

Seat contoured
in the center.

38mm

584mm

38mm

The "husband" backrest,
normally used to prop
oneself up in bed, was
ordered directly from the
Sears, Roebuck & Co.
catalogue by the
designer. It is split open
in the back, a plywood
panel inserted (see the
drawing above), and the
back resewn closed.

The "husband" is
illustrated in the
Sears, Roebuck &
Co. catalog,
shown here in
the 1990 edition.

Specifications and
price for the bedrest,
or "husband," appear
on a subsequent page
in the Sears catalog.

Publication of the
Sears catalog
ceased in 1992.

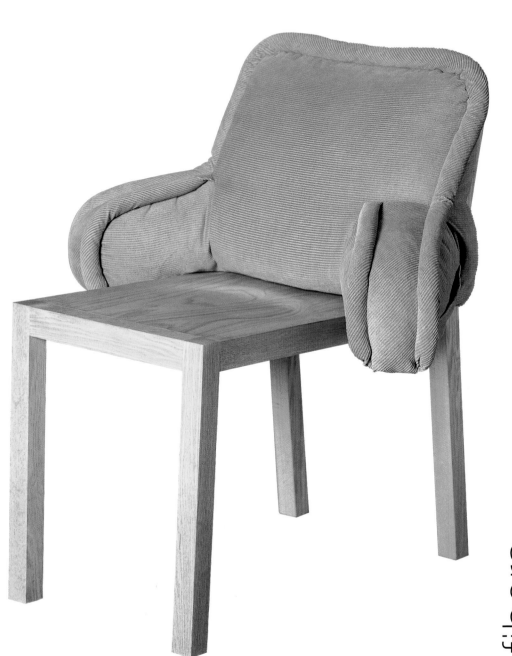

# Cotton-string armchair (blue)

**Designers:** Fernando Campana (Brazilian, b. 1961)
and Humberto Campana (Brazilian, b. 1953)
**Manufacturer:** Campana Objetos Ltda,
São Paulo/SP, Brazil
**Date of design:** 1993

The designers use no preliminary drawings but
rather work direct. Far more formally constructed
than it appears in its completed form, the metal-grid
body is composed of precisely welded steel rods
that form a screened volume. The cotton cord is
wound through the cage, like a worm traveling
through soil, until a sufficiently cushioned web is
woven. The chair was made in an edition of five.

Brightly dyed cotton cord (2000mm long x 10mm diameter).

The upholstery is created by the matting that occurs when a length
of cotton cord is fed over, under, and through the grid of the body.

chairs

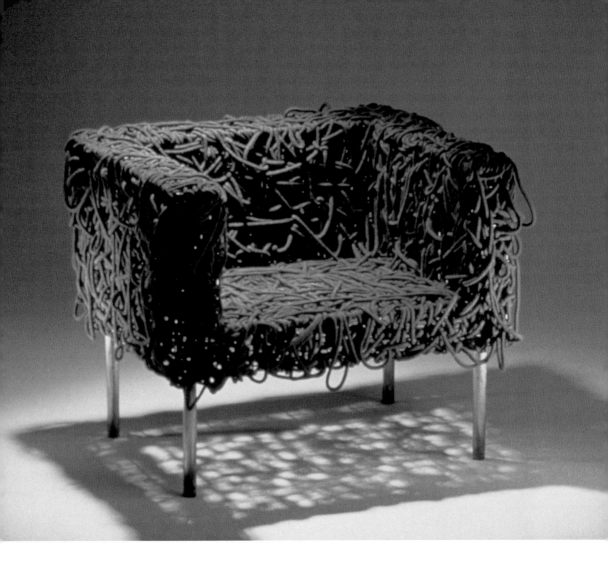

# Cotton-string armchair (blue)

750mm

620mm

450mm

300mm

920mm

Steel-tube legs
(300mm long x 25mm
diameter).

Epoxy varnish is
electrostatically applied
to the superstructure.

5mm diameter
steel rods form a
100 x 150mm grid.

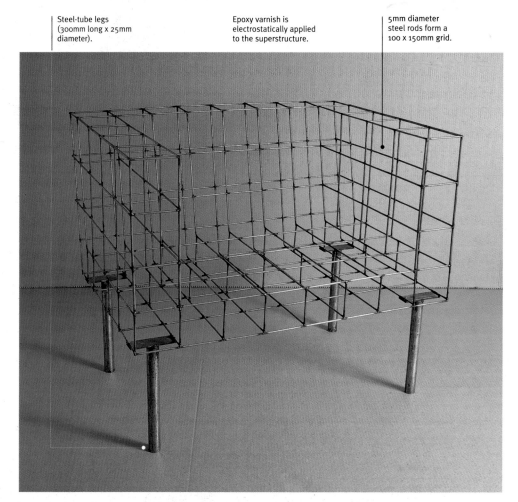

chairs

# various
# materials

# "Rothko" armchair

**Designer:** Alberto Liévore (Argentine, b. 1948)
**Manufacturer:** Indartu, Hernani (Guipúzcoa),
Spain
**Dates of design:** 1993 (plywood version),
1994 (Maderón version).

The final version of the chair was produced
from high-density Maderón, a proprietary plastic
composite material with wood-like characteristics.
This is created by mixing ground almond shells
and other lignocellulosic materials with natural
resins and formed by molding. Maderón, invented
by chemical engineer Silio Cardona, is waterproof
and can be made heat-resistant. Spain, the place
of the chair's manufacture and design, is the
second largest harvester of almonds worldwide
(the U.S.A. is the first).

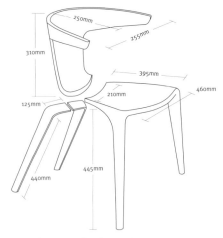

The first version (1993) of the chair
in four sections of 11 mm-thick plywood.

The original plywood prototype evolved
from the 4-section model (above) to the
final Maderón molded version (below).

Due to the high-density nature of the
composite, a very smooth surface is
achievable through sanding.

The ledge on the back frame is glued
and screwed to the underside of the
front section.

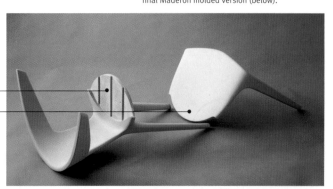

After assembly, "C" clamps hold the back
section to the front section until the glue dries.

chairs

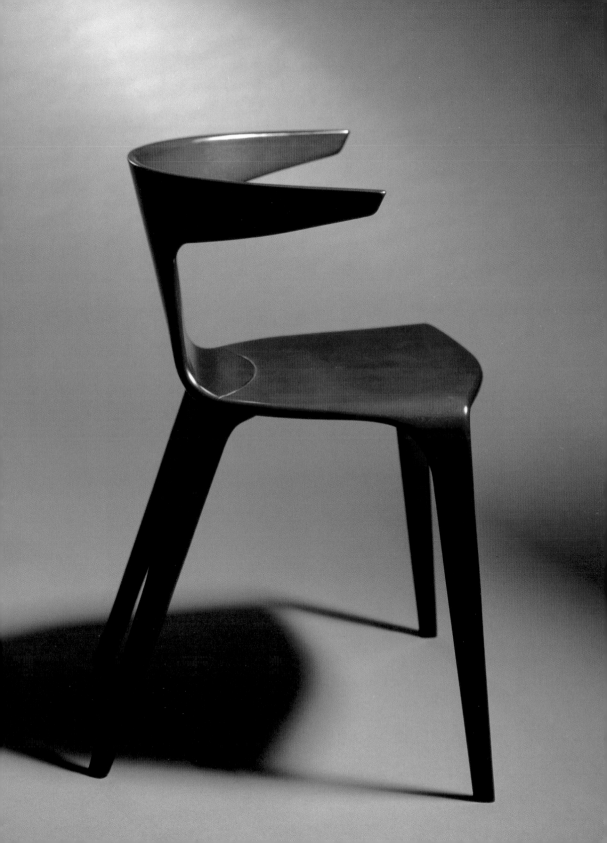

# "Rothko" armchair

Final stage of assembly; sanding is followed by coating with a white varnish and then painting.

The chair installed in its namesake, the Rothko bar in Barcelona.

Almonds used in the production of Maderón before the shells are pulverized.

Production process of Maderón:

Pulverized almond shells
or other lignocellulosic refuse

+

polymer resins

=

paste molded
into sections

=

two sections adhered
to each other with epoxy glue

=

assembly is sanded,
painted with white varnish,
and then painted over
with the final varnish color.

chairs

The designer was commissioned to design a chair for the new Rothko bar in Barcelona. His preliminary ideas (above) were derived from the traditional Spanish bar chair (right) originally produced in bentwood, which proved to be too expensive for the Rothko chair. The use of molded Maderón reduced costs by 50 per cent.

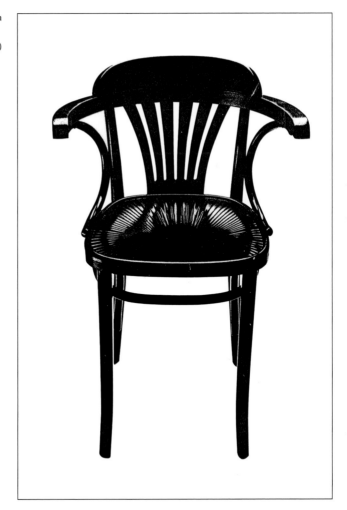

various materials

271

# "Equity" armchair

**Designer:** J.H. Pollard (French, b. 1952)
**Manufacturer:** Matteograssi S.p.A.,
Mariano Comense (CO), Italy
**Date of design:** 1987

Employing traditional leather with a
plastic inner layer stiffener, this luxurious
architectonic essay has a presence that
cannot easily be ignored and solves the
problem of shipping a very large object.

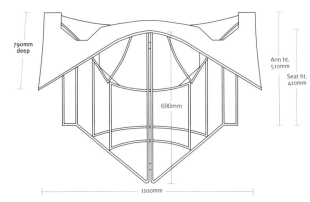

View of the chair from behind.

Leather and polyamide-film seat.

Seat support rests on the frame.

Tubular-steel stiffeners for the leather support.

The tubular steel elements are made
available either polished, chromium
plated, spray painted with a metallized
emulsion, or liquid laminated with two
layers of Softech™ (a baked-on finish
in an 80–120 micron thickness).

Serving as legs, the frame folds out from
a central point (A) serves as the back,
arm, and seat support.

Folded one-piece upholstery:
two layers of coated leather (black or
tan) are fused with an inner layer of
polyamide film. Different thicknesses of
polyamide are inserted in various areas,
depending on the stiffness required.

Inner supports for the seat area (front
edge, right; back side, left) that appear
as arcs on the floor.

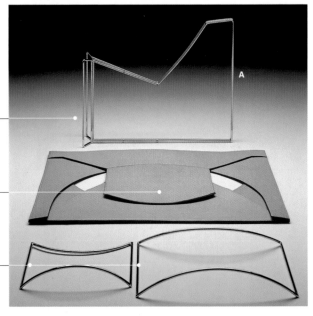

chairs

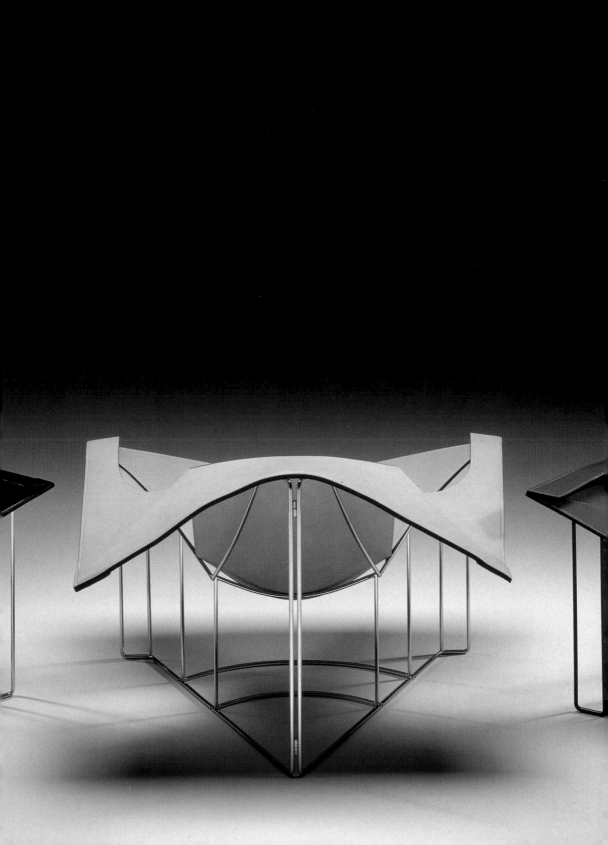

# "T. 4. 1." (Tea for One) armchair

**Designer:** Olivier Leblois (French, b. 1947)
**Manufacturer:** Quart de Poil', Paris, France
**Date of design:** 1995

This two-part cardboard armchair has been used for both domestic and public applications, including imprinted advertising messages. The chair is sold flat with assembly instructions. Perhaps surprisingly, most retail buyers have been those desiring a kind of throw-away, cheap aesthetic rather than a utilitarian, inexpensive object.

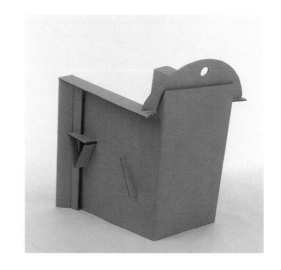

The first edition of the chair, in 3-ply cardboard, was stamped out with blades extended from a flat wooden bed. The second and present edition (in 2-ply cardboard, shown here as a simplified interpretation) is cut out by blades inset into a wooden drum which rolls over flat sheets of cardboard, like a printing press, rapidly stamping out each of the two sections.

The interpretation here, for graphic purposes, is not technically accurate.

**Back and seat section**

**(Broken lines indicate folds.)**

**Sides, arms, and back-support and arms section**

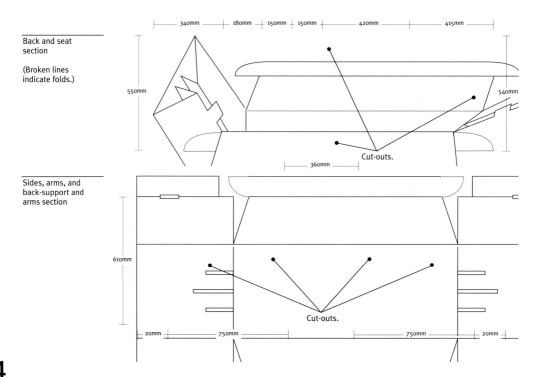

Cut-outs.

Cut-outs.

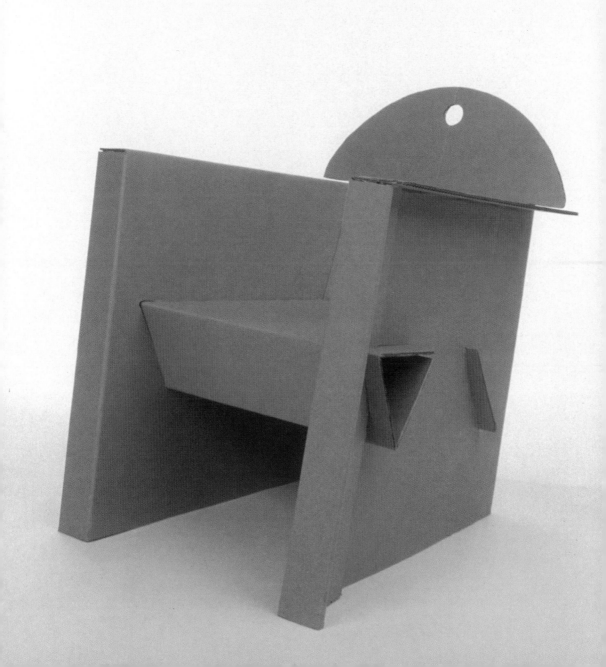

# "Collezione Pak" armchair

**Designer:** Nani Prina (Italian, b. 1938)
**Manufacturer:** Rimadesio S.p.A., Desio (MI), Italy
**Date of design:** 1984

Reminiscent of De Stijl principles, a simple interpretation marries two traditional materials— glass and wood—creating an object far less fragile than it may appear. The glass and wood never touch due to the use of an advanced special adhesive (made of acrylic resins) for connecting the black steel cylinders that separate the glass from the painted wood. The color range includes combinations of black, white, red, yellow-green, and blue.

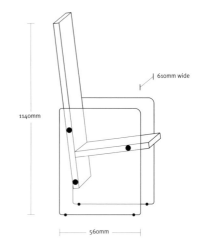

610mm wide

1140mm

560mm

Black steel joints separate the inner glass surface from the back and seat units. They are screwed into the wood and welded to the glass with a special glue (made of acrylic resins) through polymerization with black-light blue lamps—similar to the bonding techniques used in dental ceramics.

15mm thick tempered glass with rounded corners and polished edges.

The wood seat and back surfaces are lacquered.

Black PVC glides elevate the glass edge from the floor for protection.

chairs

276

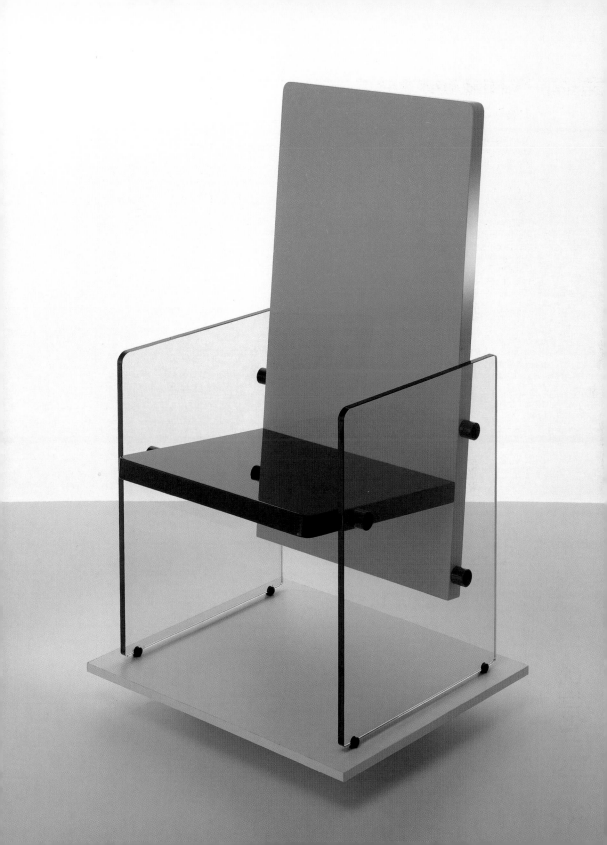

# "Ghost" armchair

**Designers:** Cini Boeri Mariani (Italian, b. 1924) and Tomu Katayanagi (Japanese, b. 1950)
**Manufacturer:** Fiam Italia S.p.A., Tavullia (PS), Italy
**Date of design:** 1987

Reforming the reputation of glass as an overly fragile material, the chair is in one piece and bent in a furnace. The technique was developed by Antonio Livi, who founded Fiam in 1972, and has since produced a wide range of deftly twisted and turned furniture.

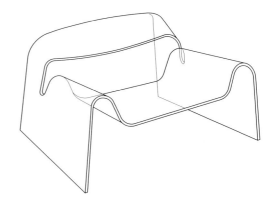

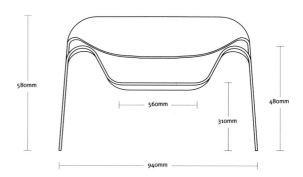

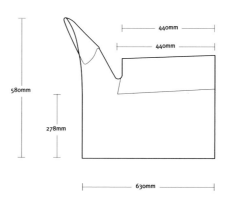

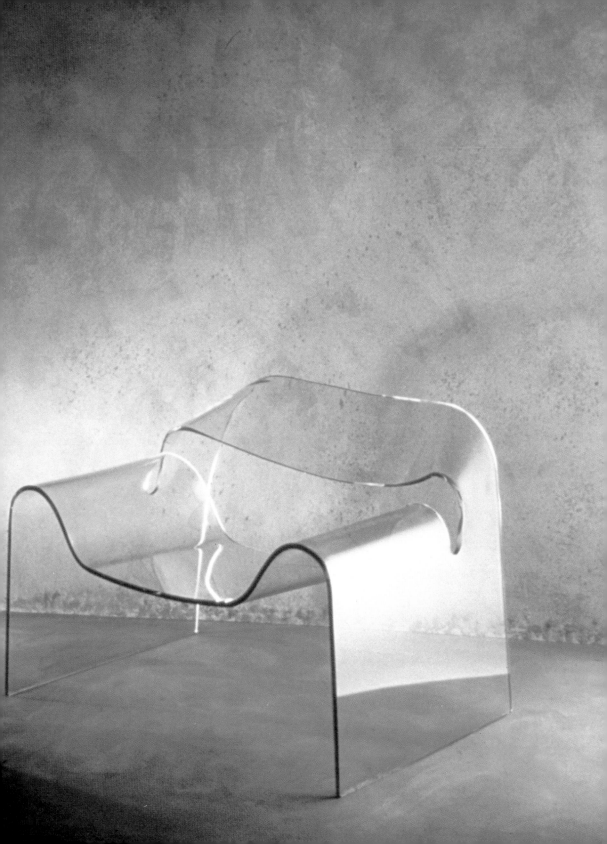

# "Ghost" armchair

The flat shape of pre-cut float crystal (12mm thick) is shown here before bending occurs. The pierced section within accommodates the upward bending of the bottom of the backrest and the downward bending of the back of the seat.

Float crystal is warm-bent in a tunnel furnace, using an exclusive process developed by Antonio Livi at Fiam Italia.

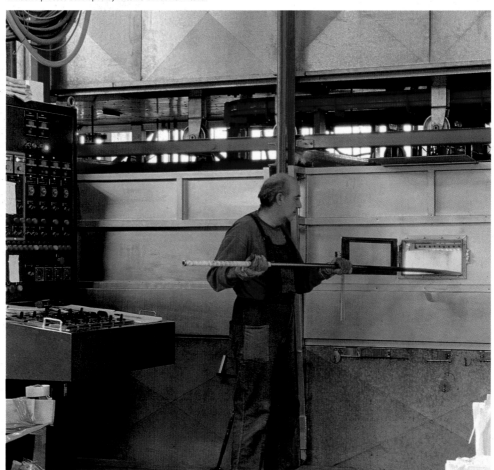

chairs

280

# articulation

# "Dafne" folding chair

**Designer:** Gastone Rinaldi (Italian, b. 1920)
**Manufacturer:** Fly Line S.r.l., Carrè (VI), Italy
**Date of design:** 1979

Economical and highly portable, about 180,000 examples of this chair have been produced during the last two decades. An array of mechanical and hydraulic presses and cutting, bending, and drilling machines are used for the production of the parts that are manually assembled. The chair is available in ten colors.

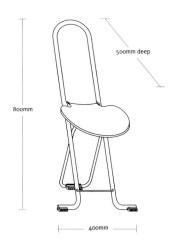

500mm deep

800mm

400mm

The range of colors available.

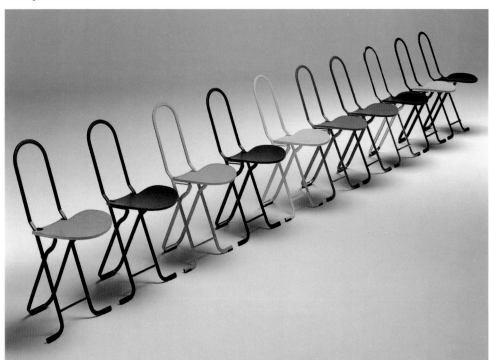

chairs

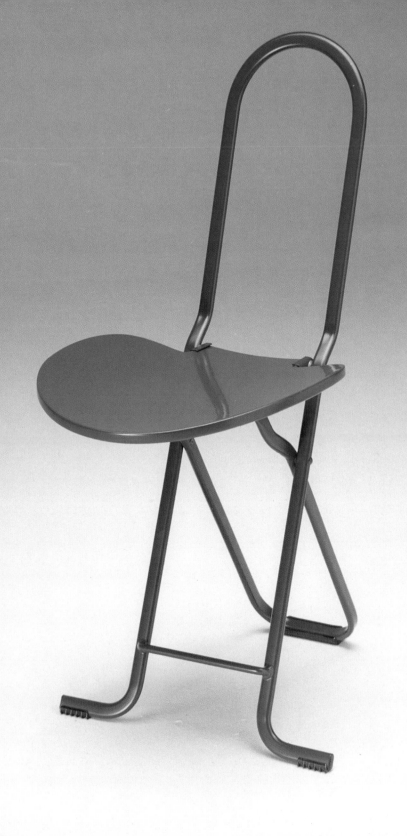

# "Dafne" folding chair

In addition to fine-wood laminated composition board, a version of the chair is available with the seat frame woven over with wicker (straw), a technique still today combined with high-tech designs in Italy.

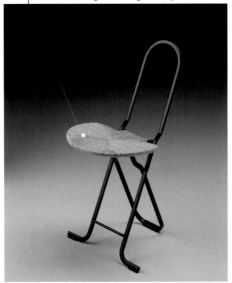

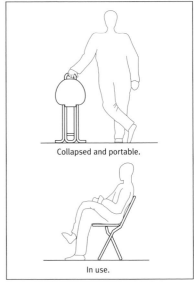

Collapsed and portable.

In use.

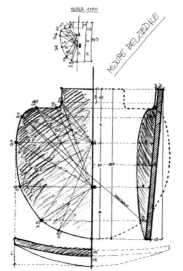

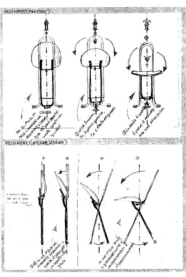

Even though the concept is a simple one, the designer performed extensive experimentation and exploration, illustrated here by three of the numerous drawings—the seat geometry (left) and the folding principle (right).

chairs

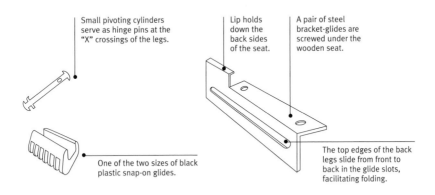

Small pivoting cylinders serve as hinge pins at the "X" crossings of the legs.

Lip holds down the back sides of the seat.

A pair of steel bracket-glides are screwed under the wooden seat.

One of the two sizes of black plastic snap-on glides.

The top edges of the back legs slide from front to back in the glide slots, facilitating folding.

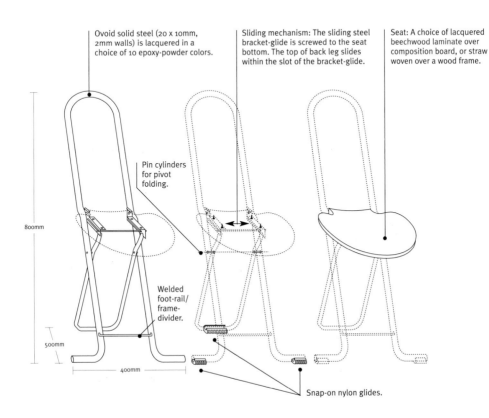

Ovoid solid steel (20 x 10mm, 2mm walls) is lacquered in a choice of 10 epoxy-powder colors.

Sliding mechanism: The sliding steel bracket-glide is screwed to the seat bottom. The top of back leg slides within the slot of the bracket-glide.

Seat: A choice of lacquered beechwood laminate over composition board, or straw woven over a wood frame.

Pin cylinders for pivot folding.

Welded foot-rail/ frame-divider.

Snap-on nylon glides.

800mm

500mm

400mm

articulation

285

# "Rocking–chaîne 1 and 2" chairs

**Designer:** Jean-Marc Mouligne (French, b. 1950)
**Manufacturer:** Quart de Poil', Paris, France
**Date of design:** 1992

Probably more comfortable than it appears, the chairs provide a new definition of the traditional concept of the rocking chair. Easily demountable, these chairs are easily shipped and may be used indoors or outside. They are available in zinc and black colors.

540mm

750mm

890mm

Font supports (10mm diameter).

Font supports (13mm diameter).

540mm

750mm

490mm

820mm

820mm footrest.

The angle and slope of the seat is adjustable by five notches on the front edge.

The sides (3.3mm) are flexing steel joints, much like a bicycle chain or those on a combine harvester.

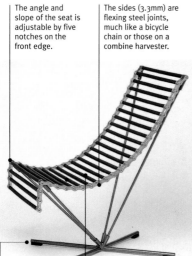

Polyvinyl glides are attached with two screws.

The cross members are neoprene rubber tubes (55mm diameter) inserted with full-width stainless steel springs, screwed into the flexing sides.

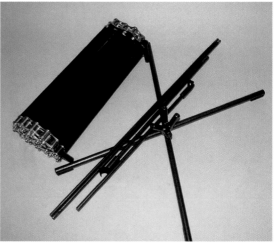

Demountable, all parts of the chairs are assembled without screws or glue. The weight of the chair and occupant holds the parts together.

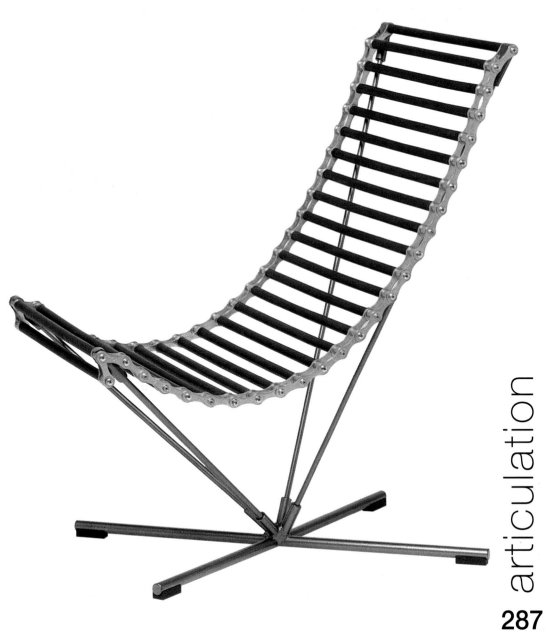

articulation

287

# "Snap" chair

**Designer:** Peter Costello (Australian, b. 1947)
**Manufacturer:** Pongrass Furniture Pty. Ltd,
Sydney, Australia
**Date of design:** 1992

Precise geometry was required in the production
of this chair to make the folding function operate
properly and remain closed when folded. When
open, the chair is a taut and rigid unit. It has been
extensively tested by the Australian Furniture
Research and Development Institute. The use
of marine plywood and stainless steel hardware
and cables reveals the designer's experience as
a boat builder.

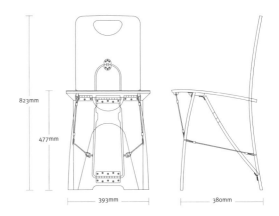

823mm
477mm
393mm
380mm

The parts of the chair in wood are cut out with a CNC router.
The surface is sprayed finished with a nitro-cellulose lacquer.

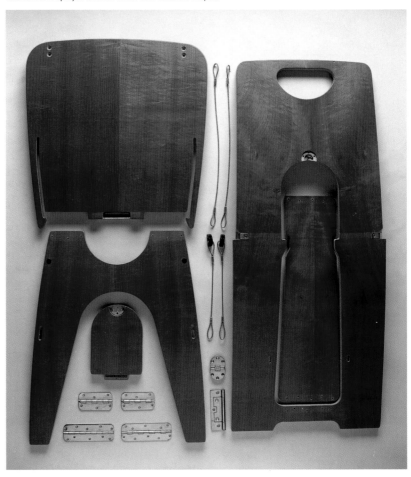

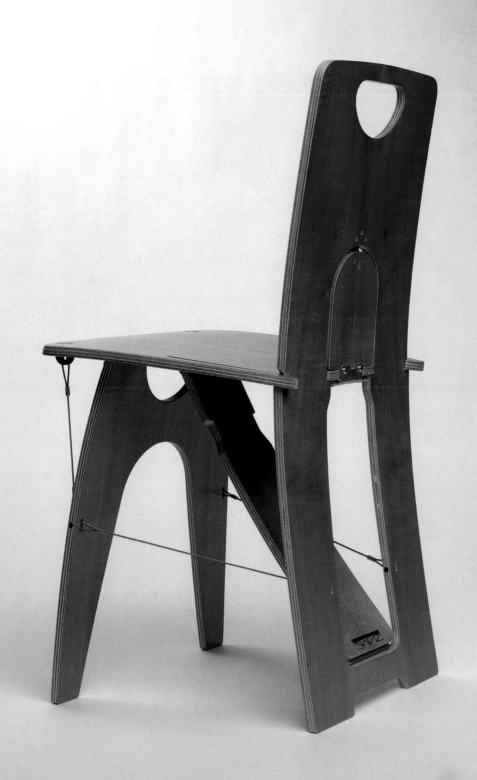

# "Snap" chair

Back right edge of the back
support and seat.

Back left leg view of the 2mm stainless
steel cable and crimper.

Fully folded, hand-
assembled chair.

chairs

# electronics

# "Body Sonic" seat

**Designers:** Interior Team, Design Department,
Mazda Motor Corporation
**Manufacturer:** Mazda Motor Corporation,
Hiroshima, Japan
**Date of design:** 1989

The most intriguing feature of the seat for the
Mazda MX-5 "Miata" sports car is not the head
pillow that is fitted with sound speakers located
near the occupant's ears. Buried within the body
of the upholstery near the occupant's lumbar
region, there is a vibrating frame device,
connected to the sound system, which assists
in creating a complete body experience of the
sound broadcasted from the dashboard amplifier.

Pairs of speakers are located
inside each of the front-seat
headrests.

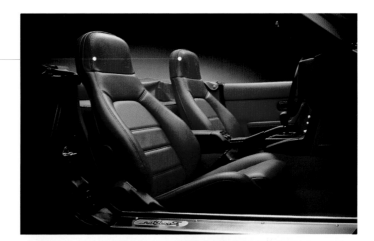

The sound provided by a pair of
speakers and the vibrating unit
housed within the seat is
further augmented by two
woofers (for the bass notes) and
two tweeters (for the high
notes) located in each door.

chairs

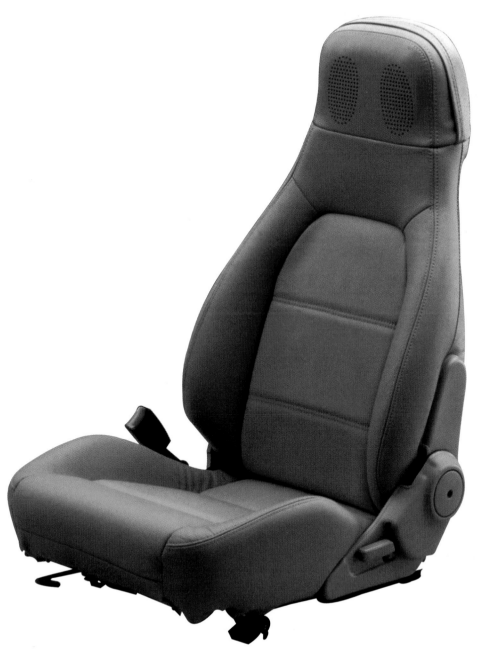

# "Body Sonic" seat

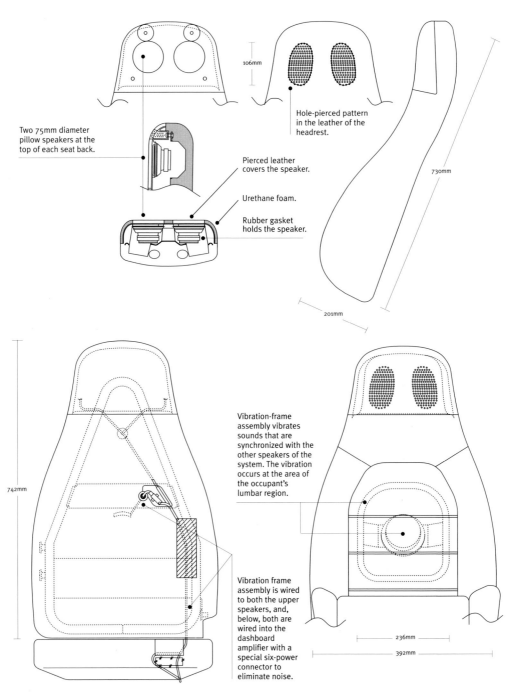

106mm

Two 75mm diameter pillow speakers at the top of each seat back.

Hole-pierced pattern in the leather of the headrest.

Pierced leather covers the speaker.

Urethane foam.

Rubber gasket holds the speaker.

730mm

201mm

742mm

Vibration-frame assembly vibrates sounds that are synchronized with the other speakers of the system. The vibration occurs at the area of the occupant's lumbar region.

Vibration frame assembly is wired to both the upper speakers, and, below, both are wired into the dashboard amplifier with a special six-power connector to eliminate noise.

236mm

392mm

chairs

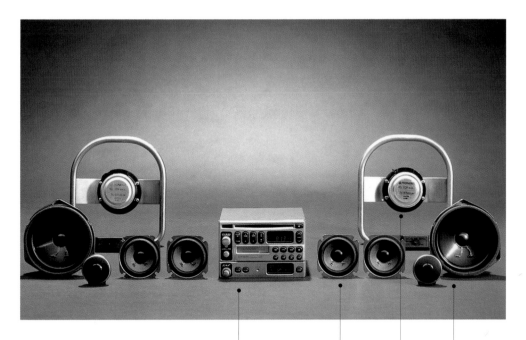

Integrated amplifier is installed in the dashboard and internally wired to vibration frame and speakers in the seats and speakers in the doors.

Two 75mm diameter speakers are installed in the headrest of each seat.

Vibration-frame assembly.

Tweeter speaker (small) and bass speaker (large) are installed in each door.

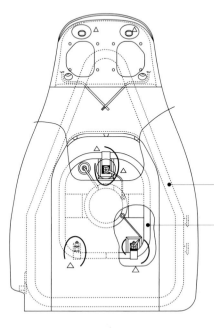

Heavy tubular-steel seat frame to which the speakers and the vibration frame are attached.

Outer ring of the vibration-frame assembly is suspended from the tubular-steel seat frame with rubber bands in three areas.

electronics

Electric lighting design, which is just over a hundred years old, may reveal more about the possibilities of probing human creativity than almost any other artistic effort. As a starting point, little more is needed for illuminating a space than a bare incandescent bulb, possibly a socket, some wiring, and a source of energy. Where accomplished and talented professional designers go from there may well delight, surprise, amuse, educate, or offend you. You will find fixtures in this section that incorporate a wide range of materials: paper, plastics, metals, wood, foam, feathers, and many others. Since lighting fixtures do not rely on the kind of sound structural principles required by other furnishings, such as chairs and tables, the concept and making of an innovative light may depend only on active, or over-active, imagination. In this selection, even traditional table lamps have been reassessed and reinterpreted.

The 50 fixtures here range from the sophisticated, intricate, and expensive to the sensible, minimal and cheap. Some have been seriously conceived while others are merely throwaway aesthetic gestures. They sit on tables, hang from ceilings, mount on walls, and, in one case, do not exist as a tangible object at all.

# lights

# lights: guest introduction

Contemporary designers have found in technology a precious resource for their poetry. Today, technology offers designers access to new materials and techniques that they can change and customize at will, a facility that offers them a new exhilarating freedom. Good contemporary designers, like musicians improvising jazz, have learned to take advantage of this new freedom with an elegant nonchalance acquired only through years of strenuous technical exercise.

Design has been a trade secret for years because too many of its commentators have preferred intellectual distance over communality with the world of things. While good designers struggle to make beautiful things, design critics and historians have felt compelled to elevate these things to the status of well-designed objects. The real world comes back with a vengeance: about a century of industrial design history shows that only a few well-designed objects have graduated to become beautiful things. This shift in status occurs when design objects become universally understood, appreciated, and used every day by everyone.

Dutch designer Gijs Bakker once provocatively observed that bulb manufacturers have already done the difficult job, leaving designers simply to dream up ways to conceal the bulb. Therefore, designing a lamp might seem a redundant task. In women's shoe design, for example, one could similarly assert that footwear manufacturers have already performed the difficult job, leaving designers simply to dream up ways of keeping the sole attached to the foot. But, on the contrary, necessity of function coexists with the pure, sensual delight of form and variation, and together they elevate lamps to the status of design fetishes. Some lamps are as painfully gratifying and as impractical as patent-leather, spike-heeled shoes, while some others are as soothing and embracing as a pair of Air Jordans. People buy lamps, just like shoes, to make a stylistic statement. A useful exercise might be to think of the psychological and sociological implications of a crystal chandelier, the "Tizio" desk lamp, or the small plastic abat-jour by Philippe Starck. Lamps are a very personal, defining choice.

In a designer's hands, light surely gives our world its definition. For this reason, light has for a very long time obsessed architects who have built the world in its religious adoration. Ever since electricity brought the sun and the moon into our homes 24 hours a day, the obsession spread to interior and industrial designers.

Nothing reaches deeper into a designer's soul than the challenge of creating a lighting fixture. A lamp brings a designer's voice to its lyrical extremes—because it does not have to follow the body's physical limitations, because it allows for a subtle play with translucence and shadow, because it has a hot and luminous core, because it can be made of so many different materials. Chairs and tables, with their gross volumes, may disguise the true nature of a passionate neo-baroque or sensitive minimalist spirit, but lamps don't lie.

With these 50 design tales from the past decade, this section encompasses the horizon of design at a time when advanced materials and high technology have required a scrupulous craftsman's approach, and old-fashioned manufacturing processes have found new life in diversified series and unexpected combinations. At last, the adjective "industrial" is an option, permitting things to reveal, through the process of their making, their modern ethic and their post-modern individuality.

**Paola Antonelli**
**Associate Curator**
**Department of Architecture and Design**
**The Museum of Modern Art**
**New York**

# lights: author introduction

Lighting fixtures are strange animals indeed. When they are turned off, they are still objects that make a statement. And we want them to speak; everything we own speaks of who we are, whether we like it or not. Even when we own nothing or very little, a voice makes an announcement.

Unlike other furniture, lamps are not beholden to strict engineering principles. A chair must safely hold its occupant and instill security, even if it is soft or moves, and a table must remain rigid when in use, even if you can see through it, fold it, or roll it away. But a lighting fixture can be ephemeral, evanescent, momentary, transitory, even short-lived, disposable. It can be very, very expensive or very, very cheap. The inventory of usable materials at the designers' fingertips appears to be endless: wood, metal, stone, fabric, paper, and—now that certain others have become respectable—a universe of plastics and a macrocosm of remarkable high-tech composites and ceramics. The Japanese have used paper for centuries, even for flame-type illuminators, and a French lamp recently published in a Japanese magazine featured a sconce whose diffuser is pressed seaweed (see pages 404–405).

The possibilities of lamp design and the materials to make fixtures were vastly extended when Thomas Alva Edison invented the incandescent light bulb almost yesterday, in 1879. And the parameters have essentially remained free (with some regulations governing wiring and transformers) until very recently, when there began to be the problems created by the halogen bulb: a 500-watt filament has proved to be far too hot, creating fires and thus encouraging the passage of governmental laws, rules, and regulations, resulting in the banning of their use in some countries. And even though the 300-watt halogen filament is still acceptable, laws will now govern even their use, limiting designers and directly influencing their forms.

Other advances in bulb technology have included the cooler screw-type fluorescent bulb as a substitute for the incandescent version. But, alas, the desire for a decade-long bulb life is still unfulfilled, no doubt due to the Möbius-strip demand of capitalism whose perpetuity demands obsolescence or, in the case of the light bulb, the death of a product.

With scientific, political, and economic pragmatism aside, this book addresses lighting fixtures as distinct objects, although one example here is merely an illusion (pages 440–441). Therefore, there is no indirect lighting, and few examples concern adjunct lighting systems (like those fitted to tracks or components in open-plan offices). Just as a designer often must create chairs with and without arms, lighting fixtures today are often interpreted in versions of a single design in a configuration for placement on a table, the floor, and the wall and from the ceiling. The samples here serve to illustrate the designers' imagination and conceptual thinking.

Unlike tables, chairs, and some other furniture and furnishings, but more like fabrics, the design community and the public are receptive to lighting forms that express flights of fancy that reject severe abstract geometry, call upon real images (like hearts and birds), and express kitsch metaphors (like the use of paper bags that say "paper bag," and translations of traditional fabric-covered lamp shades into forms that have nothing to do with tradition but are merely post-modernist puns).

As Augusto Morello observes in Plastiche e Design (Milano: Arcadia, 1988): "The illuminating object... is the one where we can best see the possible decorative redundancy connected with formality—while the dominant function of a lighting instrument is not that of 'shedding light' (which is, perhaps, the task of the bulb or its equivalent) but rather that of lending quality to light..."

Thus, this book features lamp designs that Morello suggests are what lighting fixtures are really all about; a lamp is to a bulb as a bridge is to an automobile. Anyone can hang a bare light bulb and socket from a ceiling, just as you can cross a river on any merely adequate bridge.

But hopefully life is enhanced by more than mundane objects; our individual power today may be better or more effectively expressed when we exert control over our own private rooms than when we futilely attempt to effect change over the public environment. Concerning control and choice, the masses have rejected the chastity of 20th-century Modernism time after time; unfortunately, their choice of the opposite or another aesthetic has frequently resulted in the truly dreadful. And they have remained unmoved by the enthusiasm expressed by design historians and journalists for the Modernist idiom. Further, the deliberate vulgarity of some post-modernist retro-expressions has ridiculed the taste of the masses and fostered their resentment, whether they are consciously aware of their enmity or not.

Contrarily, good design with wide appeal does exist in great quantity, if you will excuse my arrogant assumption that I know what is "good" and "bad" while acknowledging the vast amount of published commentary on the subject. An amalgamation of purity and artifice has been nowhere more vivaciously expressed than in Italy, where native and foreign designers have united with manufacturers and technicians in a symbiotic symphony. Even though the result of their coalition has been imaginative, even delightful, the situation handicaps a book like this whose imperative is international in scope. The flow and bulk of good design in Italy has been profuse since the 1950s, although today the paranoid and fiercely nationalist design community there is being unjustly

alarmed by competition, especially from Britain. Nevertheless, worldwide coverage has been assiduously attempted in this section—though the Japanese proved diffident, if not indifferent, and certainly unresponsive, maybe even haughty. This survey is the result of the amenable, generous, and patient manufacturers and designers who furnished the images and information you find here. I was blessed by having Brice d'Antras and Cinzia Anguissola d'Altoé contribute to the gathering of material; they are highly competent independent scholars in their own right and far more knowledgeable and energetic than me.

A concerted effort was made to feature the work of both male and female designers of all races and from all continents, which necessarily and happily includes a range of interpretations expressing various worldviews.

No one remunerated the publisher or author as an incentive for inclusion; the materials were donated free of charge for publication. No special favors were extended. No suggestion is being made that you should purchase any object here, nor that you need any of them; you do not.

To repeat, you can always hang a bare bulb from the ceiling with the cord running down the wall. After all, for millennia people used raw firelight to see in places that were dark. For only a century and a quarter have we used electricity at, it might be noted, a very great price—expensive both in money and to the environment. But, unfortunately, we are addicts.

# metals

# "Marie" table light

**Designer:** Jorge Pensi (Argentine, b. 1946)
**Manufacturer:** B.Lux, Bizbaia, Spain
**Date of design:** 1990
**Bulb:** two halogen, 20w, 12v

In this innovative design, the raising and lowering of the bulb head is made possible by the double-rod pedestal; one rod is wired for the positive pole of electrical and the other for the negative pole. Thus, no matter what the position of the head, an electrical current is provided to the bulb. (For a similar wiring configuration, see pages 392–393.)

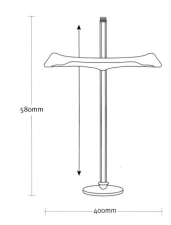

580mm

400mm

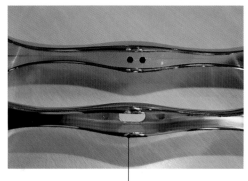

The housing for
the bulb is cast
aluminum.

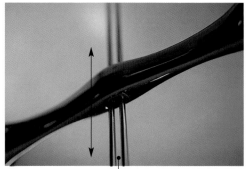

The bulb housing (wired so that
each of the two pedestal rods
serves as either negative or
positive electrical poles) can
be moved up or down.

The base
is cast
aluminum.

The positive and
negative pedestal
rods enter the base.

The underside
view of the
weighted base.

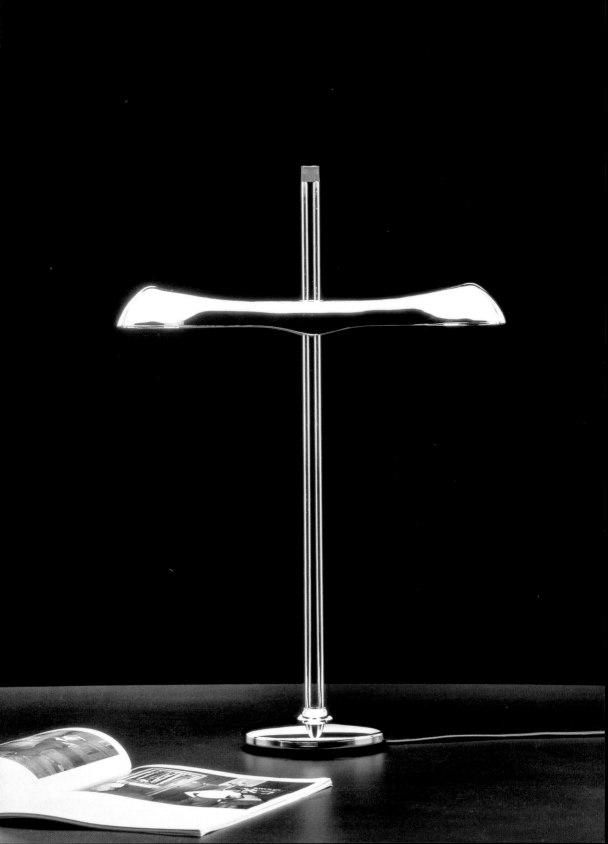

# "Jet" table and wall light

**Designer:** J. Garcia Garay (Argentine, b. 1945)
**Manufacturer:** Garcia Garay S.L., Barcelona, Spain
**Date of design:** 1990
**Bulb:** E14 incandescent, 60w, 220–240v

An example of the work of one of a number of
Argentine designers working and living in Spain,
this fixture was configured to fold, making
shipment cheaper. When a plate is added, wall
mounting is possible. About 1,000 examples
of this lamp are produced annually by the
designer/entrepreneur.

220mm

190mm

190mm

160mm

Stainless steel springs
provide tension while
allowing for 360° rotation
of the bulb housing.

Except for the aluminum
bulb housing and stainless
steel springs, all parts are
chromium-plated brass rods.

The bulb housing is anodized aluminum
to better dissipate the bulb heat.

The axle, attached to the bulb housing
and the legs, allows for 360° rotation with
tension to keep the housing stationary.

# "Au Pair" sconce

**Designer:** Donald Stählin (Swiss, b. 1960)
**Manufacturer:** the designer
**Date of design:** 1989
**Bulb:** halogen, 12v, 50w

The elements of this sconce are essentially unaltered functional objects not ordinarily used in lighting construction. This Dadaistic foray is an exercise more about whimsy than recycling. The name, "Au Pair," is a play on words making reference to the architect-designer's use of a pair of aluminum shoe trees to form a pair of lighting fixtures. Each of the sconces is owned by a different person.

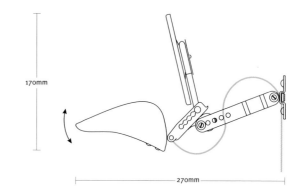

170mm

270mm

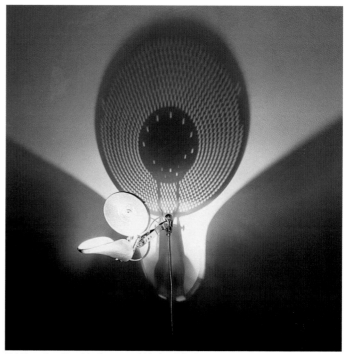

Light from the adjustable shoe tree, which already had a hinge in its original state, produces a dramatic effect on the wall, projected through the diffuser (a vegetable strainer).

lights

306

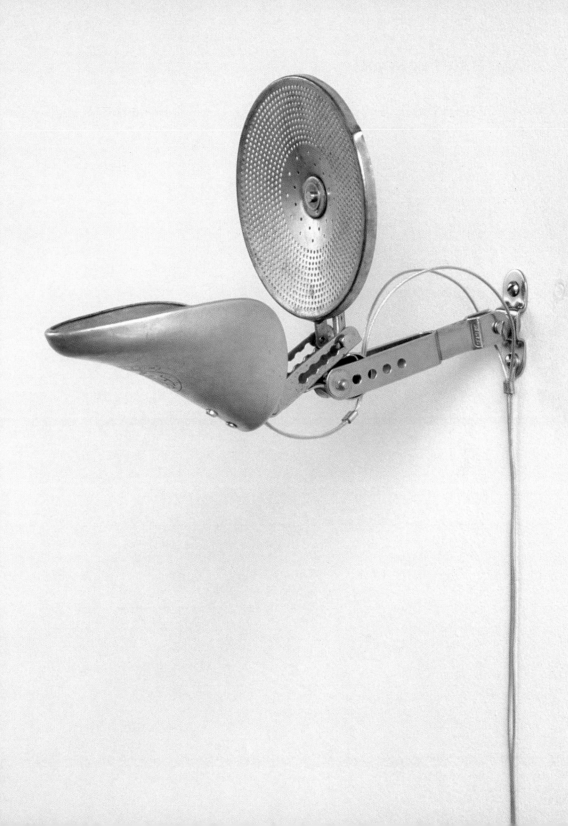

# "Au Pair" sconce

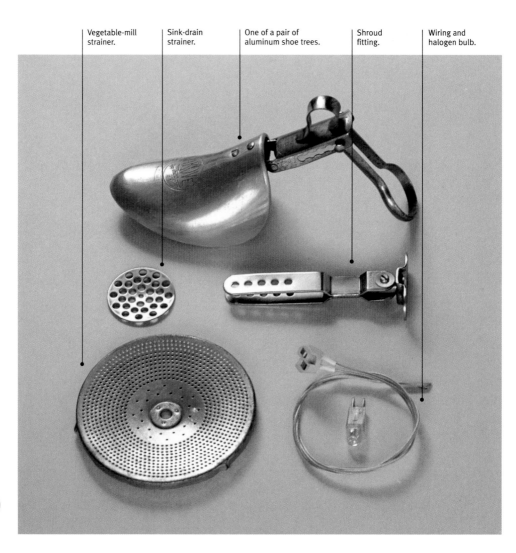

Vegetable-mill strainer.

Sink-drain strainer.

One of a pair of aluminum shoe trees.

Shroud fitting.

Wiring and halogen bulb.

lights

A view exposing the halogen bulb (12v, 50w)
in the downwardly tilted shoe tree.

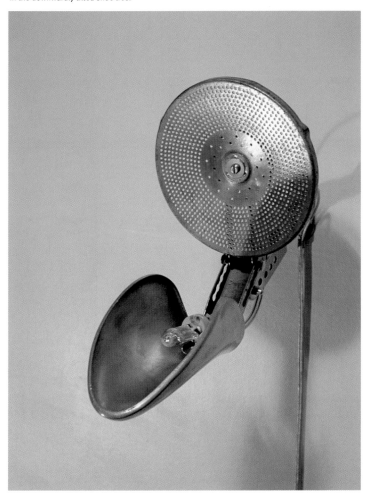

metals

# "Kri" hanging lights

**Designer:** Asahara Sigheaki (Japanese, b. 1948)
**Manufacturer:** Lucitalia S.p.A., Cinisello Bergamo (MI), Italy
**Date of design:** 1994
**Bulbs:** dichroic halogen, 35mm or 50mm diameter; 12v;
20w, 35w, or 50w; toroidal or electronic transformers of
different powers

Different stem lengths and wall and pedestal mounting
lend wide functional possibilities to this lighting system.
Since the accessories (sleeve and diffuser) are on a stem,
dichroic bulbs may be used. The stem can be attached to
rail tracks, ceiling plates (with or without a transformer for
single or three-spot mounting), connectors for linear metal
plank ceiling, wall connectors, and other connectors.

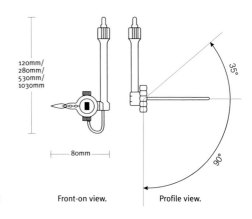

120mm/
280mm/
530mm/
1030mm

80mm

35°

90°

Front-on view.      Profile view.

Extruded aluminum
screen (seven colors).

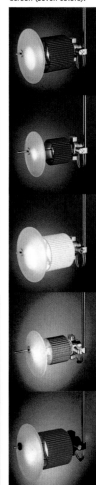

Tubes and rods are in brass.

Sockets in die-cast aluminum
can be rotated through 125°
around its axis and vertically
downward through 35° over
the horizontal line.

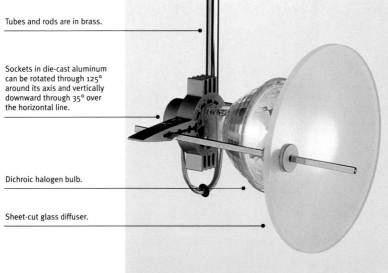

Dichroic halogen bulb.

Sheet-cut glass diffuser.

The system may be fitted with
or without screens or diffusers.

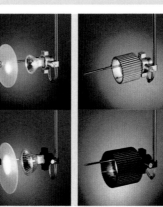

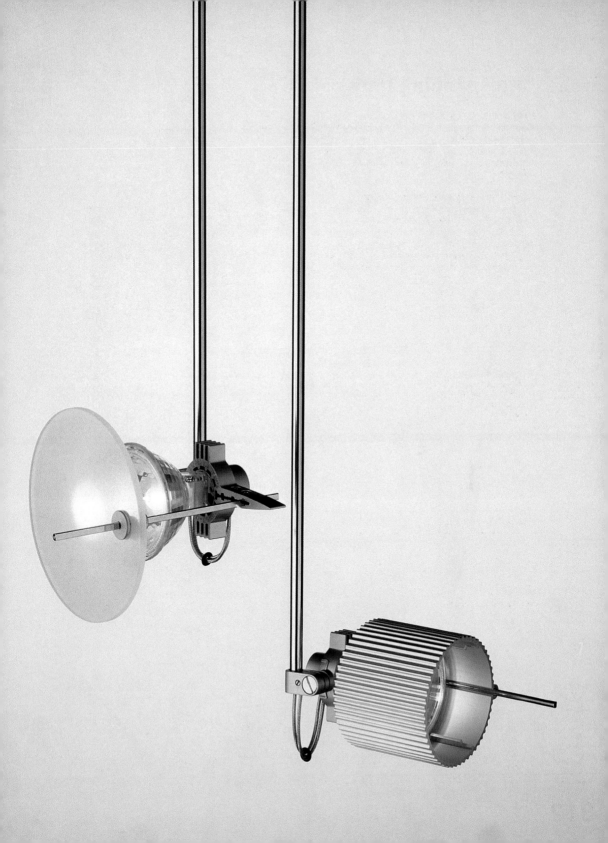

# "X135" table light

**Designer:** Gaspar Glusberg (Argentine, b. 1959)
**Manufacturer:** modulor S.A., Buenos Aires, Argentina
**Date of design:** 1994
**Bulb:** dichroic, 50w, 220–12v, with a standard transformer (50w, 220–12v) in the body

The internal bearing element of this fixture, together with an intermediate acrylic ring, permits the rotation of the bulb housing and thus the projected light. Though different in its essential mechanics, compare this example with the glass-bottomed lamp on pages 396–400.

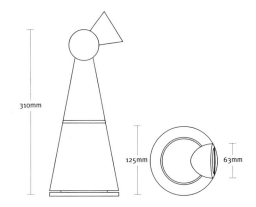

310mm

125mm

63mm

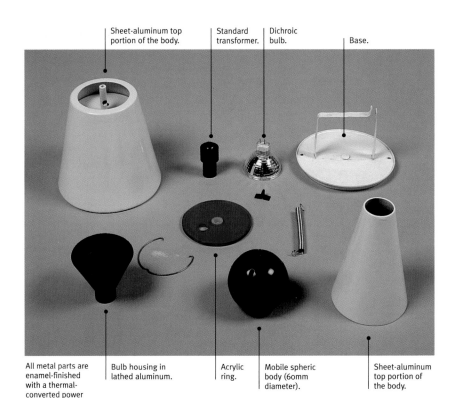

Sheet-aluminum top portion of the body.

Standard transformer.

Dichroic bulb.

Base.

All metal parts are enamel-finished with a thermal-converted power paint.

Bulb housing in lathed aluminum.

Acrylic ring.

Mobile spheric body (60mm diameter).

Sheet-aluminum top portion of the body.

lights

# "Heron" table light

**Designer:** Isao Hosoe (Japanese, b. 1942)
**Manufacturer:** Luxo Italiana S.p.A., Presezzo
(Bergamo), Italy
**Date of design:** 1994
**Bulb:** GY6–35 halogen, 50w, 12v; 50w transformer
in the base

A result of the cooperation of the designer and
the technical staff of the manufacturer, this lamp
features small wheels on the bottom surface that
permit its easy movement on a flat surface. The
reflector, more or less the head of the abstracted
"heron," remains parallel to the work surface
when its height is altered. The body is made of
glass-reinforced PA66 (nylon).

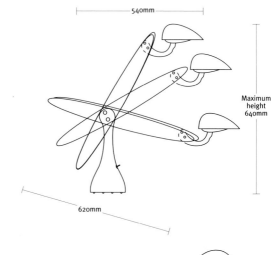

540mm

Maximum
height
640mm

620mm

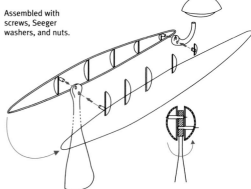

Assembled with
screws, Seeger
washers, and nuts.

Available in black, white,
and metallic colors: silver,
yellow, blue, and red.

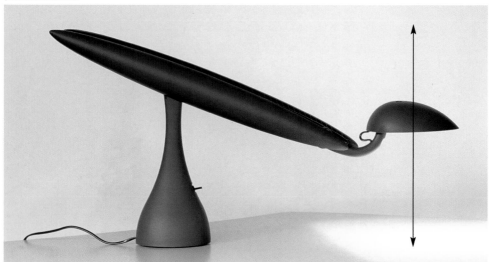

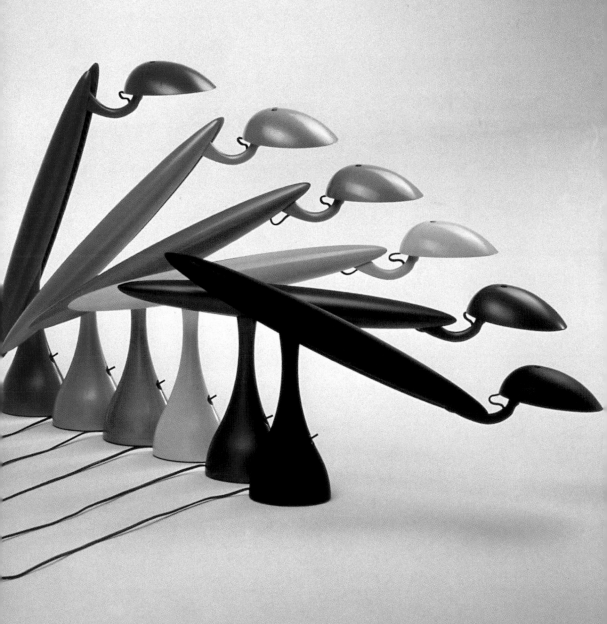

**"Heron" table light**

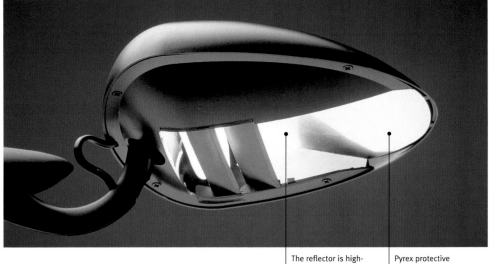

The reflector is high-polished aluminum.

Pyrex protective glass.

lights

The reflector head remains parallel to the work surface when the height is changed.

The arm and body are glass-reinforced PA66 (nylon).

A 50w transformer is built into the base.

Small wheels (polycarbonate, covered with silicon rubber) on the bottom of the base allow for easy surface movement.

metals

# "Heron" table light

A preliminary drawing by the designer.

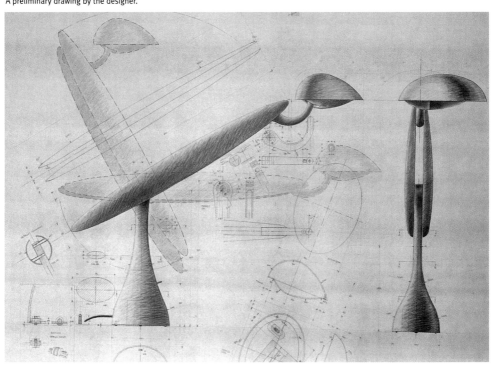

# "Zen" light

**Designers:** Sergi Devesa i Bajet (Spanish,
b. 1961) and Oscar Devesa i Bajet (Spanish, b. 1963)
**Manufacturer:** Metalarte S.A., Barcelona, Spain
**Date of design:** 1989
**Bulb:** E14 incandescent, 25w

More a fetish than a functional lighting fixture,
the name of this lamp reveals its inspirations: the
Orient, Kendo masks, and the Zibalinga of Doctor
Jones. It ignores the demands of arriving at a specific
design solution, providing, as the designers have
suggested, "an effect of warmth and mystery." Using
Zamac metal, this light is heavy for its size and is
weighted at the bottom to prevent its tipping over.

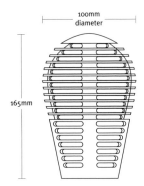

100mm
diameter

165mm

Injection-molded Zamac (an
aluminum-like metal, but much
heavier) is formed into two
equal halves held by small
male fingers on one side that fit
female receptacles on the other.

The metal surface is brushed.

A polycarbonate screen filters
the light and creates an
ethereal effect.

The two equal halves of the body
are connected by the use of Allen
screws and a screwdriver.

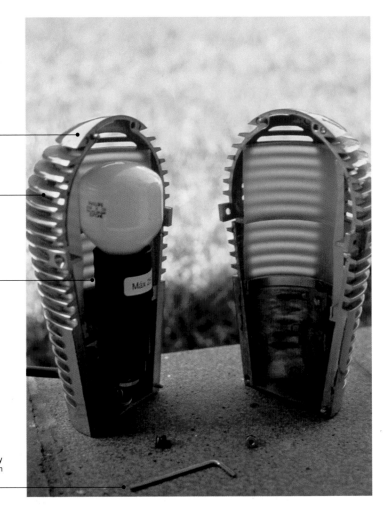

lights

320

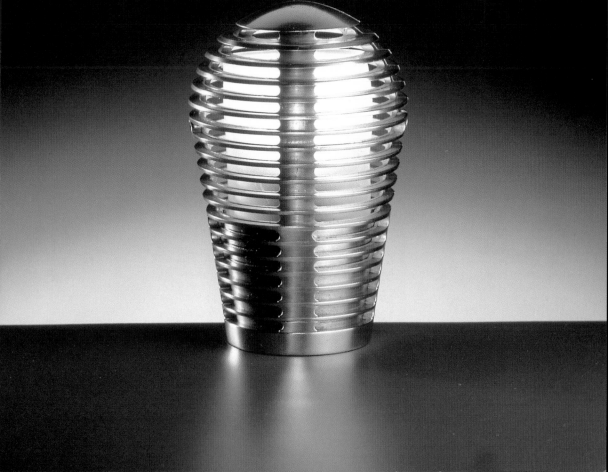

# "Zen" light

The on/off switch is built into the body of the fixture.

The electrical cord enters the body through a rubber gasket.

Molded sides before trimming.

With the appearance of the mysterious object that the designers intended, the fixture glows in the dark.

lights

322

# plastics

# "Loto" floor and table lights

**Designer:** Guglielmo Berchicci (Italian, b. 1957)
**Manufacturer:** Kundalini S.r.l., Milano, Italy
**Date of design:** 1997
**Bulb:** E27 halotube, or E14 incandescent, or 150w energy saving, 110–120v

Two different ovoid-shaped polycarbonate strips are attached onto plastic rings to form a lighted pod, whose shape can be changed by sliding a plastic ring on the lamp's stem. The superstructure is a traditional floor lamp structure to which an imaginative diffuser configuration has been added.

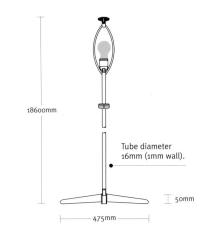

1860omm

Tube diameter 16mm (1mm wall).

50mm

475mm

The three views of the same lamp illustrate how the lighting pod can be reshaped when a polycarbonate ring is slid upward on the main stem.

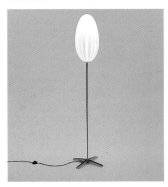
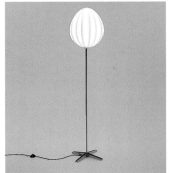
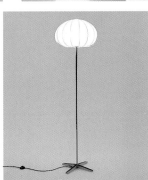

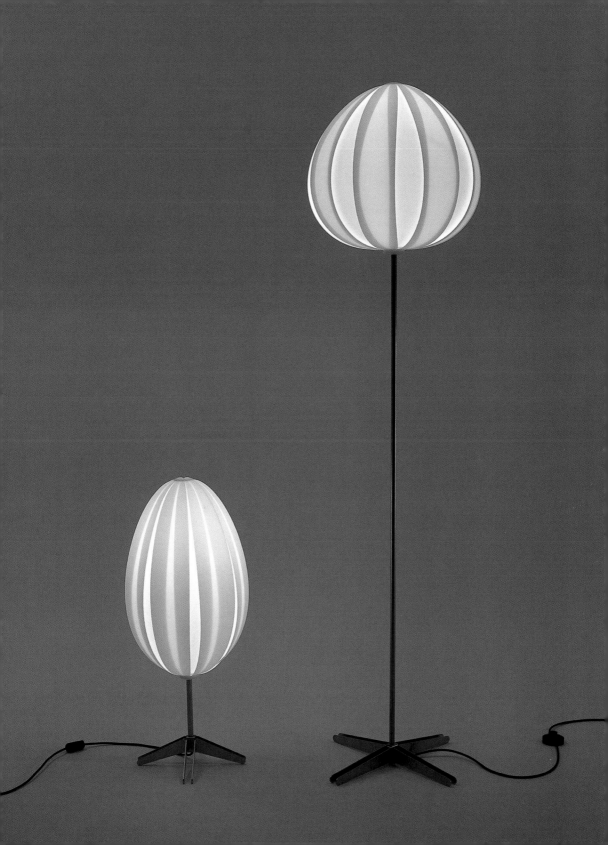

# "Loto" floor and table lights

Alternating eight large serigraphic painted polycarbonate ovoid strips (677mm x 112mm) composing half of the diffuser.

Alternating eight small serigraphic painted polycarbonate ovoid strips (654mm x 101mm) composing the other half of the diffuser.

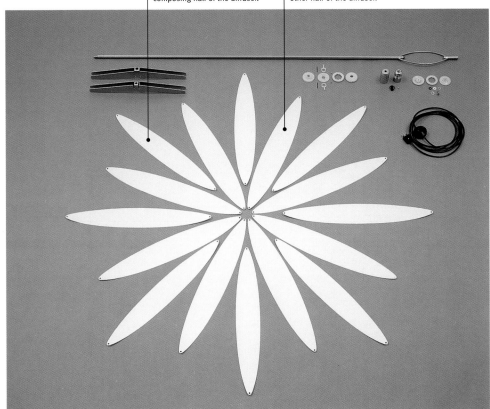

lights

**1**

When all the polycarbonate petals are attached to the die-cast polycarbonate rings (A and B), the pod shape of the petals can be changed when the bottom (B) is slid upward toward the top (A; see photo 3).

The sequence of photographs (numbers 1–5) demonstrates attachment of the petals, first at the bottom (B, left) and next at the top (A, below).

**2**

**3**

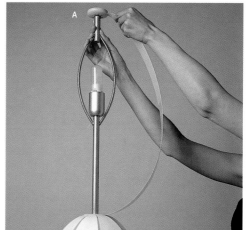

**4**

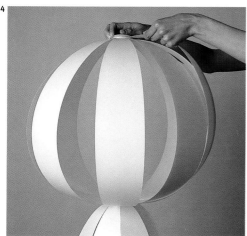

**5**

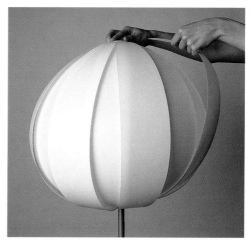

# "Borealis" bollard

**Designers:** Perry King (British, b. 1938)
and Santiago Miranda (Spanish, b. 1947)
**Manufacturer:** Louis Poulsen & Co. A/S,
Copenhagen, Denmark
**Date of design:** 1996
**Bulb:** E27, 50–100w; GX24d-3, 26w

Intended for use in gardens, parks, and other
public areas, the form of this bollard was
inspired by a photograph of the common
comfrey by the German teacher Karl Blossfeldt.
This fixture incorporates a plastic diffuser and
an aluminum base; an aluminum reflector is
housed inside the clear version of the diffuser.

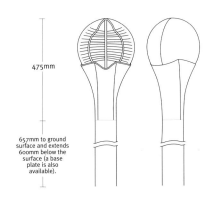

475mm

657mm to ground
surface and extends
600mm below the
surface (a base
plate is also
available).

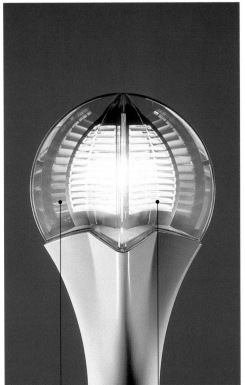

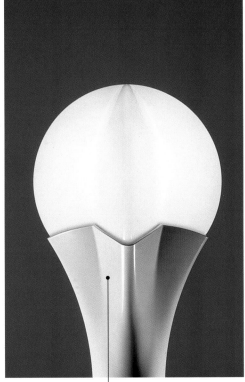

Inside the clear version
of the diffuser are
reflective inner shields
of metal-lacquered
aluminum.

Both clear and
opalescent versions
of the diffuser are
injection-molded
polycarbonate.

The post is white or
gray enamel-painted
extruded aluminum.

lights

**328**

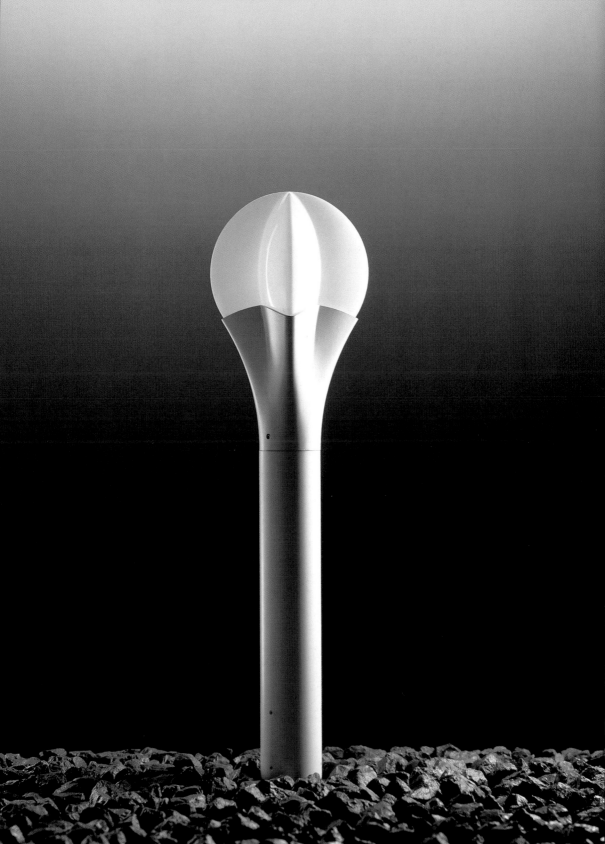

# "Borealis" bollard

The photographs of the flowering maple (Abutilon),
top, and the common comfrey (Symphytum officinale),
bottom right, are two of thousands obsessively taken
by Karl Blossfeldt (1865–1932). The photographer, plant
collector and teacher used his images to demonstrate that
the best human-created industrial forms had already been
accomplished in nature. Notice that the flowering
maple pod (right), when inverted, shows an intentional
likeness to the form of the "Borealis" diffuser.

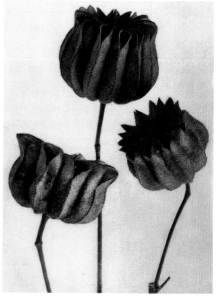

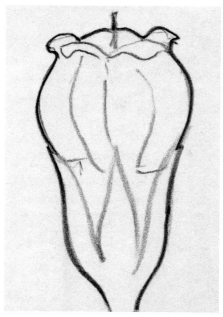

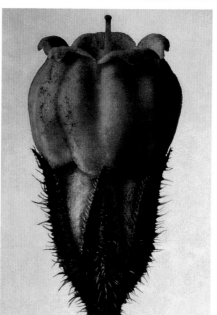

The designers' drawing intreprets the Blossfeldt photograph
of the common comfrey.

Maquettes here inform early developmental stages of
the lamp's diffuser. The example in the upper-right corner
reveals influences of the manufacturer's famous lamps
by Poul Henningensen (1894–1967).

plastics

**"Borealis" bollard**

The fixture has been installed in the plaza of
La Défense in Paris, France (see the top of
the facing page).

A disassembled fixture with a clear diffuser.

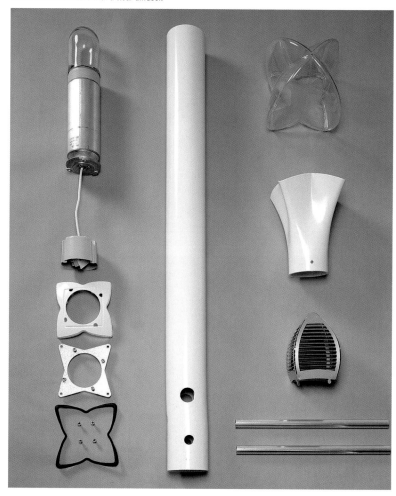

lights

# "Aphid AlluminANT" light

**Designer:** Marc Harrison (New Zealander, b. 1970)
**Manufacturer:** ANTworks, Moorooka, Australia
**Date of design:** 1994
**Bulb:** table version: SBC incandescent 40w, sconce: 75w compact fluorescent

Respecting both traditional and advanced use of materials, this fixture deftly combines wood and plastic. This insect-like lamp was designed in two versions, for the table-top surface and for the wall. It is easily portable, serving what the designer describes as "stationary and nomadic lifestyles."

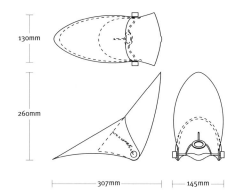

130mm

260mm

307mm    145mm

This lamp is assembled and made with a press and CNC (computer numeric controlled) router. It employs fastenings and fittings in stainless steel—the sconce parts at top and the table version at bottom.

The body is in wood from the locale of the production, Australia.

Compact fluorescent bulb (top) and incandescent bulb (bottom).

The diffuser is in polycarbonate sheeting.

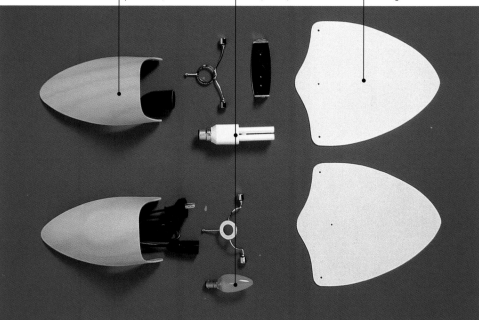

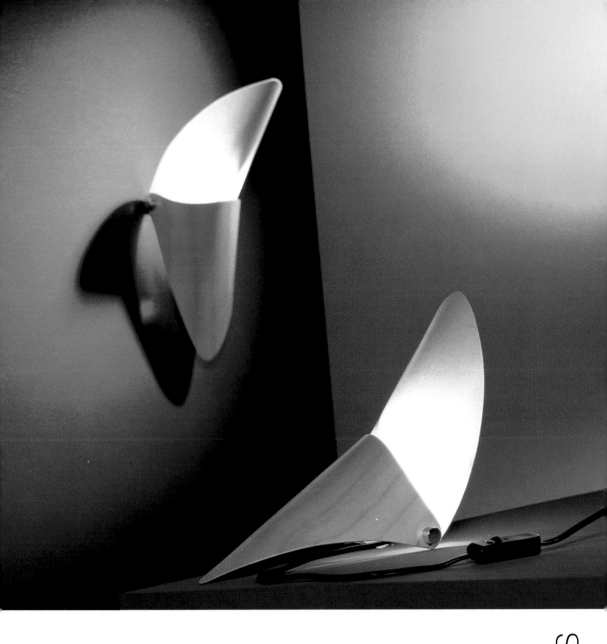

# "Madame Ruby" table light

**Designers:** Celina Clarke (Australian, b. 1967) and Simon Christopher (Australian, b. 1967)
**Manufacturer:** ISM Objects, South Melbourne, Victoria, Australia
**Date of design:** 1994
**Bulb:** incandescent candle, 25w

An industrious essay in recycling, this table lamp uses discarded and reprocessed plastic parts from automobiles and other products.

The percentage of the mixture of polycarbonate and acrylic plastics, like those of discarded automobile tail lights, varies in the composite recycling process.

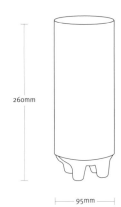

260mm

95mm

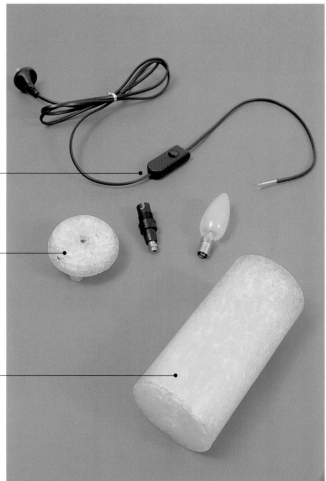

The on/off switch is electrical-line attached.

The base is attached to the body with bolts.

The body, like the base, is made of recycled plastics and has an opening in the top to permit heat escape.

The lamp employs standard electrical parts.

lights

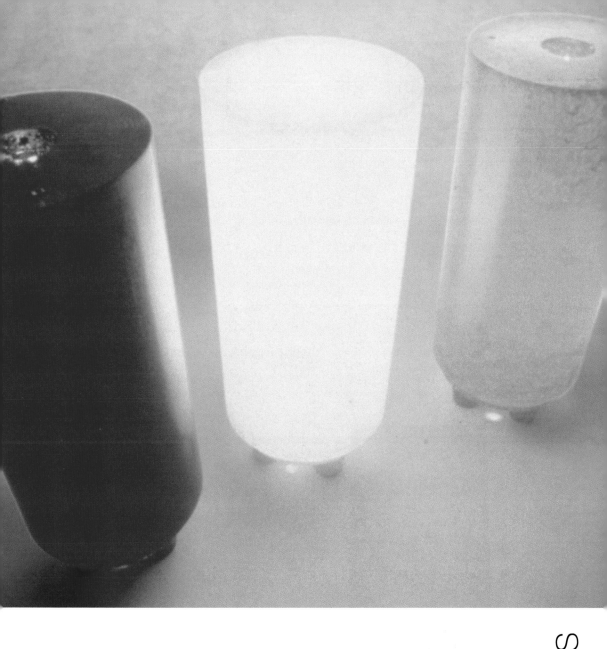

plastics

# "UFO" hanging light

**Designer:** Nick Crosbie (British, b. 1971)
**Manufacturer:** Inflate, London, England
**Date of design:** 1996

This lamp is a particularly intriguing object due to its obvious inflated nature and to its marriage of a hot electrical bulb with a fragile, thin plastic film. The fixture is furnished to the end user in a plastic bag with instructions for assembly. The lamp is available in a range of bright colors that also appear in the design firm/manufacturer's other products. These include egg cups, other lighting fixtures, fruit bowls, chairs, and wine racks.

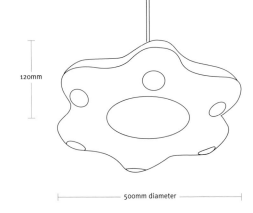

120mm

500mm diameter

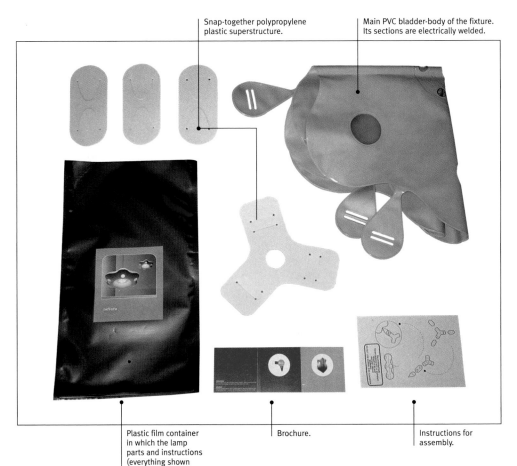

Snap-together polypropylene plastic superstructure.

Main PVC bladder-body of the fixture. Its sections are electrically welded.

Plastic film container in which the lamp parts and instructions (everything shown above) are packed.

Brochure.

Instructions for assembly.

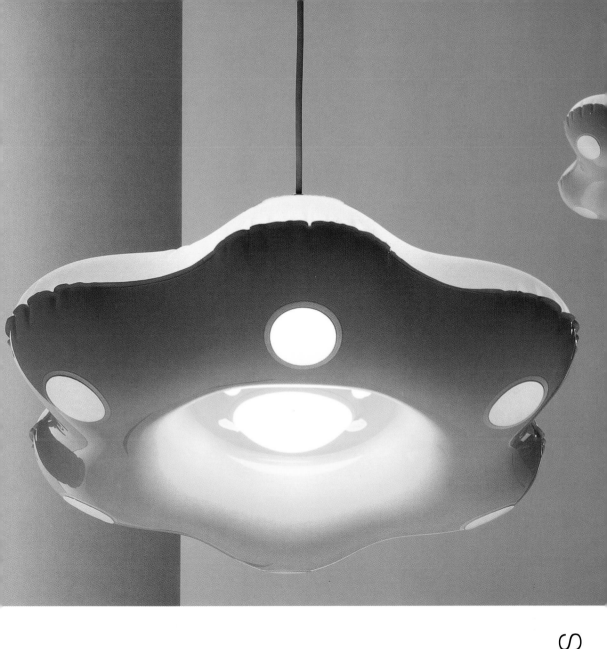

# "Urchin" light

**Designer:** Jonathan Goldman (American, b. 1959)
**Manufacturer:** Goldman Arts, Inc., Belmont, Massachusetts
**Date of design:** 1989
**Bulb:** A19 incandescent, 75w, 110v

The inflated section of this fixture is made of thin rip-stop nylon fabric. Larger than it appears in the photograph, this lamp, if it is indeed a lighting fixture, is both intriguing and whimsical. The fan that expands the spiked diffuser serves both to infuse it with air and to reduce the heat caused by the bulb.

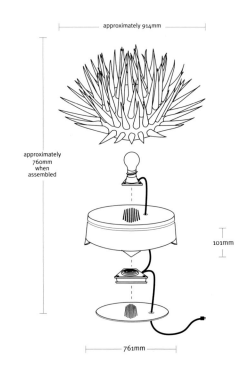

approximately 914mm

approximately 760mm when assembled

101mm

761mm

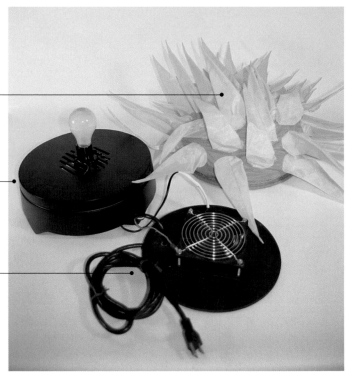

The diffuser, deflated in this view, is made of rip-stop coated nylon.

The particle-board base, supporting the ceramic bulb socket, is slit-perforated to allow air from the fan below to be blown upward.

The axial fan (110CFM AC) blows air through the slits in the light-bulb base into the nylon diffuser and also cools the unit.

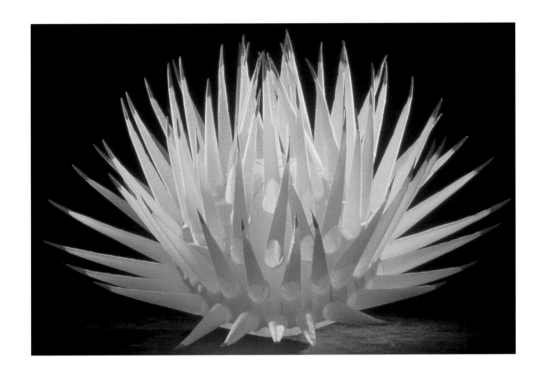

# "Estação da Luz"

**Designers:** Luciana Martins (Brazilian,
b. 1967) and Gerson de Oliveira (Brazilian, b. 1970)
**Manufacturer:** various local small-scale
shops; assembly by the designers
**Date of design:** 1995
**Bulb:** incandescent, 15w

Expandable from three to as many as 20
illuminated units, the most popular configurations
range from three to seven boxes. The designers,
who name their objects using plays on words, call
this fixture, in English, "Station of the Light." The
Portuguese word estação means both station (as in
railroad station) and season (as in the four parts
of a year).

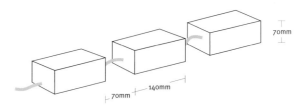

70mm

70mm 140mm

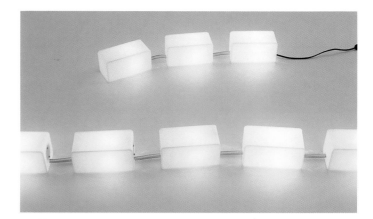

A sheet of acrylic sheeting (4mm
thick) is cut and bent into "U"-
shaped sections. Drilled holes allow
for the insertion of the electrical
wires and also for cooling ventilation.

The bulb socket is screwed into
the end of the acrylic box.

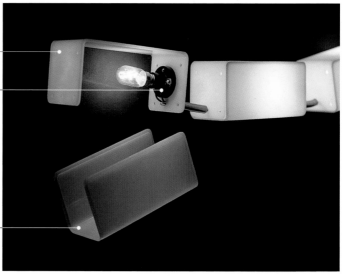

The two sides of the box are
mortised together in a positive/
negative manner but can be
opened for bulb replacement.

lights

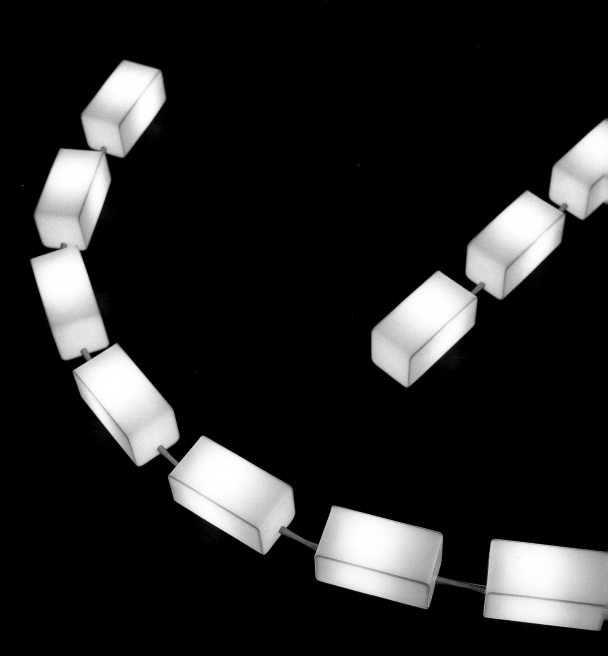

# "Liquid Light"

**Designer:** Jean-Marie Massaud (French, b. 1966)
**Manufacturer:** prototypes (3) sponsored
by V.I.A., Paris, France
**Date of design:** 1995
**Bulb:** compact fluorescent, 11w,
220v; or incandescent, 60w, 220v

Produced in a small quantity as part of the
semi-governmental V.I.A. designer-manufacturer
sponsorship program, this highly imaginative
lamp design features a bulb that floats in a
tinted liquid. It appears to be more of a strange
biological laboratory experiment than a lighting
fixture. The designer describes the lamp as
being the "fluide de vie" ("fluid of life").

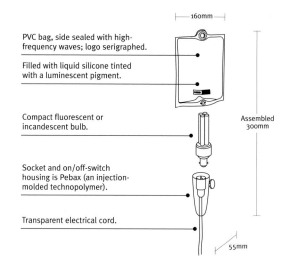

160mm

PVC bag, side sealed with high-
frequency waves; logo serigraphed.

Filled with liquid silicone tinted
with a luminescent pigment.

Compact fluorescent or
incandescent bulb.

Assembled
300mm

Socket and on/off-switch
housing is Pebax (an injection-
molded technopolymer).

Transparent electrical cord.

55mm

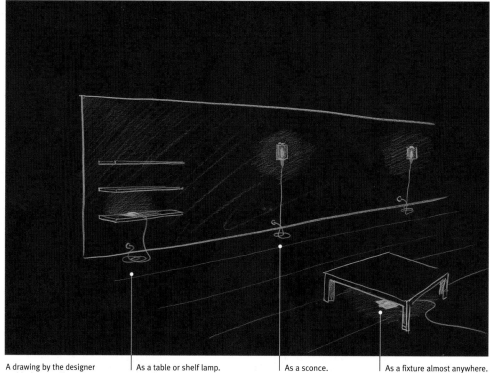

A drawing by the designer
on black paper illustrates
the various applications
of the fixture and its
mobile nature.

As a table or shelf lamp.

As a sconce.

As a fixture almost anywhere.

lights

344

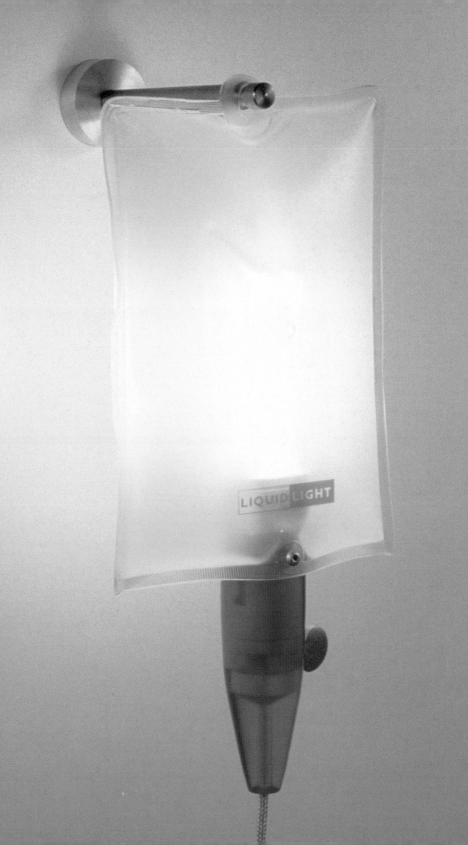

# "Titania" table light

**Designers:** Alberto Meda (Italian, b. 1945) and
Paolo Rizzatto (Italian, b. 1941)
**Manufacturer:** Luceplan S.p.A., Milano, Italy
**Date of design:** 1990
**Bulb:** Osram 250T10 (medium-base double-
envelope frosted halogen), 250w, 115–220v

When someone looks straight on at this lamp from a
distance as close as 1100mm, the numerous blades
of this fixture screen the bulb and its glare from view.
This lamp successfully combines technological
innovation with a certain whimsical lightheartedness,
although its designers may disagree, claiming a far
more serious intent and content.

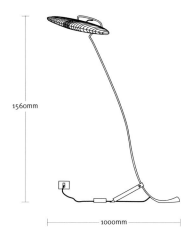

156omm

1000mm

Available as a ceiling
or floor model, the
latter is shown here.
A foot-weighted
stand was designed
to suspend what is
essentially the
ceiling version.

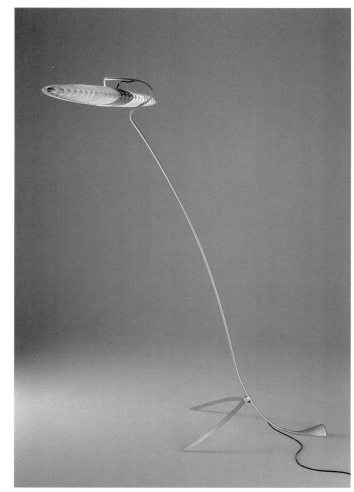

lights

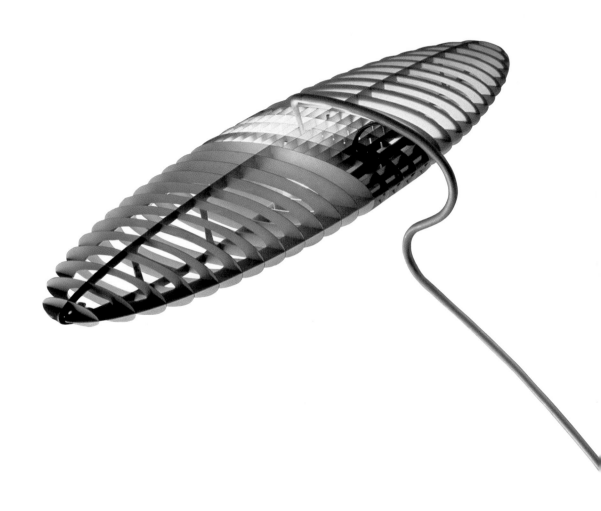

# "Titania" table light

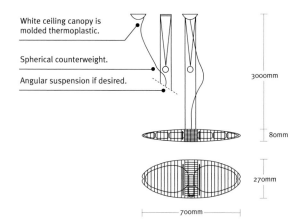

White ceiling canopy is molded thermoplastic.

Spherical counterweight.

Angular suspension if desired.

3000mm

80mm

270mm

700mm

A partially disassembled lamp. The assembly, except that by the end user, is riveted.

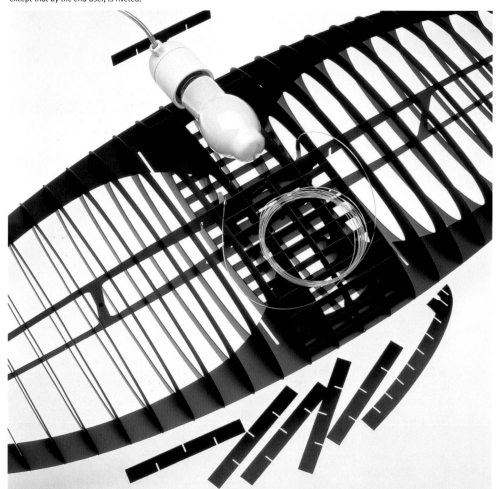

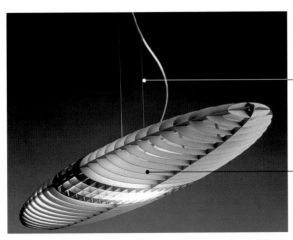

The ceiling model suspends the lamp on two thin nylon strands, separate from the electrical cord. The height is regulated by a ceiling bracket support, balanced by a cast-aluminum counterweight. The two nylon cords permit the fixture to be angled, if desired.

The minor or traversal elliptical ribs range from 270mm x 80mm to 80mm x 25mm in size. They have four slots, at each end and each side, to slide onto the major elliptical ribs (see below).

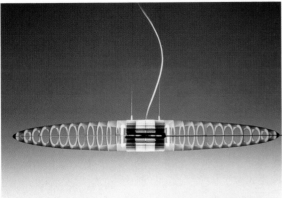

The body is available in a natural or black anodized finish.

Pairs (on each side of the bulb) of interchangeable colored polycarbonate filters (violet, yellow, blue, red, and green) can be employed to create different visual effects at the user's whim.

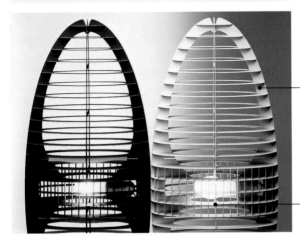

The first set of major elliptical ribs (stamped from aluminum) are placed on the longitudinal plane of the major axis of more than 700mm and minor axis of 270mm. They have numerous slits cut into the sides to accommodate the 24 minor ribs.

The second set of major elliptical ribs are placed on the longitudinal plane of the major axis of more than 700mm and minor axis of 270mm. They also have numerous slits to hold the minor ribs.

plastics

# "Anemone" table light

**Designer:** Ross Tuthill Menuez (American, b. 1965)
**Manufacturer:** Handeye, Inc., Brooklyn, NY, U.S.A.
**Date of design:** 1996
**Bulb:** A19 incandescent, 150w

The designer of this fixture is known for his use of unorthodox materials not normally associated with the production of high-design furnishings. Nevertheless, this striking design is distinctive and, possibly most importantly, emits a pleasant, ambient glow. The overlapping of the nylon strip is purposefully irregular.

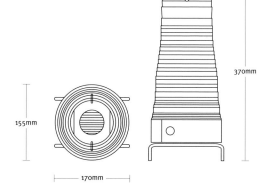

155mm

170mm

370mm

Zytel 42 (nylon) (0.775mm thick x 152m long). The mill finish is retained.

The armature and support plate (hand-brushed nickel-plated steel) are welded together.

lights

plastics

# "Molle" table light

**Designer:** Christophe Pillet (French, b. 1959)
**Manufacturer:** E+Y, Tokyo, Japan
**Date of design:** 1995
**Bulb:** compact fluorescent, 11w, 220v

This lamp incorporates the new application of a technologically interesting, though not necessarily new, material: latex. To draw the comparison between the lamp and a human arm because of its skin and the wrist-like flexing may be too obvious. This fixture, made in Japan, exemplifies the kind of international machinations designers endure today. Its inventiveness was recognized by the awards committee of the 30th Salon du Luminaire in Paris, France.

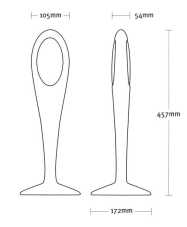

The diffuser lens is opalescent thermoformed polycarbonate.

Compact fluorescent bulb, 11w, 220v.

The structure is deep molded latex.

The arm is a standard flexing tube of wound metal.

To discourage tilting, the base is composed of heavy cast metal.

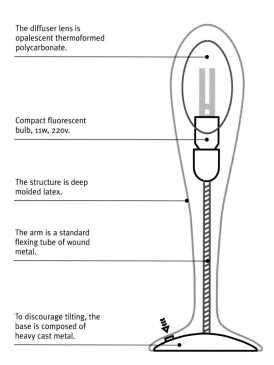

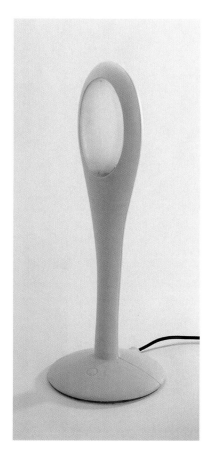

lights

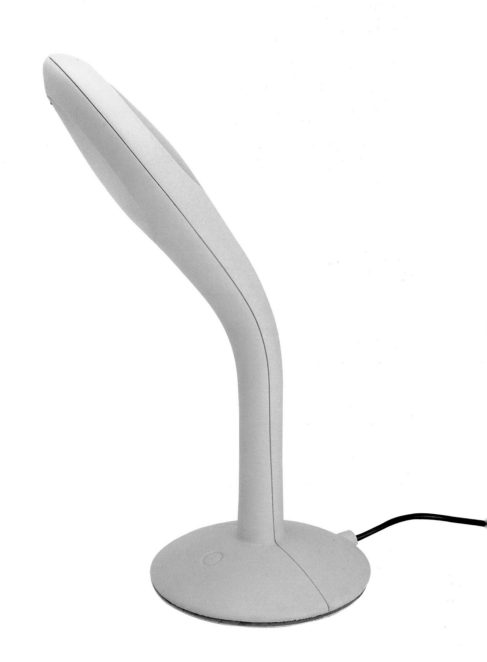

353

# "Clips" table light

**Designer:** Bernard Vuarnesson (French, b. 1935)
**Manufacturer:** Sculptures-Jeux S.A., Paris, France
**Date of design:** 1996
**Bulb:** incandescent frosted golf ball, 40w, 110–220v

While the concept here is lighthearted, the execution is well engineered. The end user may attach any beverage can of his or her choice, although no can is included with the essential components—the attachment device, the socket-and-wiring piece, and the partially recycled shade.

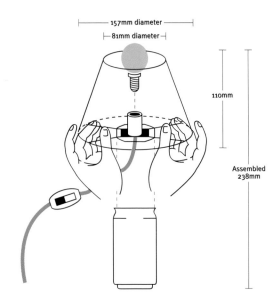

157mm diameter

81mm diameter

110mm

Assembled 238mm

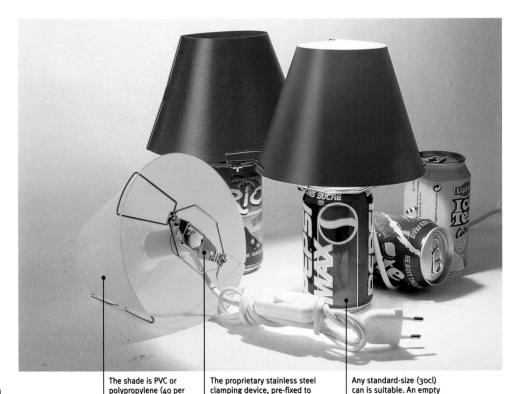

The shade is PVC or polypropylene (40 per cent partially recycled) sheeting (black, yellow, blue, or red).

The proprietary stainless steel clamping device, pre-fixed to the bottom of the shade, is attached to the top edge of a beverage can.

Any standard-size (30cl) can is suitable. An empty can should be washed and, for stability, filled with sand, rice, etc.

lights

354

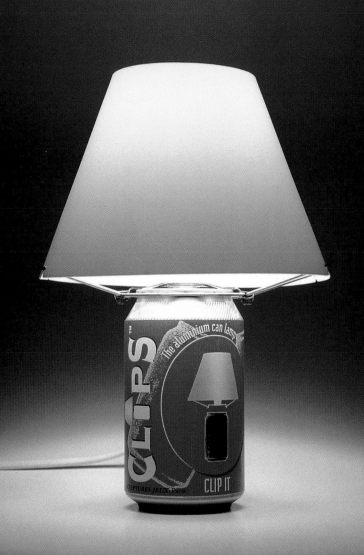

# "Wings" table light

**Designer:** Riccardo Raco (Italian, b. 1952)
**Manufacturer:** Stamp, a product of Samuel
Parker S.r.l., Pomezia (RO), Italy
**Date of design:** 1994–95
**Bulb:** E14 incandescent, 60w, no transformer

This lamp is sold singly and, in order for the
user to create the "wings" effect, in pairs.
Made in a patented plastic material known
as Opalflex, the manufacturer claims that it
has the appearance and some of the features
of opaline glass. Its malleability makes it a
very versatile material. This fixture, which
comes boxed flat, is very expensive.

470mm

260mm

Opalflex, a proprietary plastic-vitreous sheet, does not turn yellow and has
special flexing, modeling, and lighting-diffusing characteristics.

For each lamp, one piece of
Opalflex (cut with a machine
especially for the product) is
wound around 2 1/2 times to
form the shape with its wing-
like extension.

For best results, a 60w milk-
white incandescent or low-
consumption-type bulb is
recommended. Colored bulbs
will create interesting effects.

Three brass screws hold
the one-piece diffuser to
the socket/wiring/base unit.

lights

356

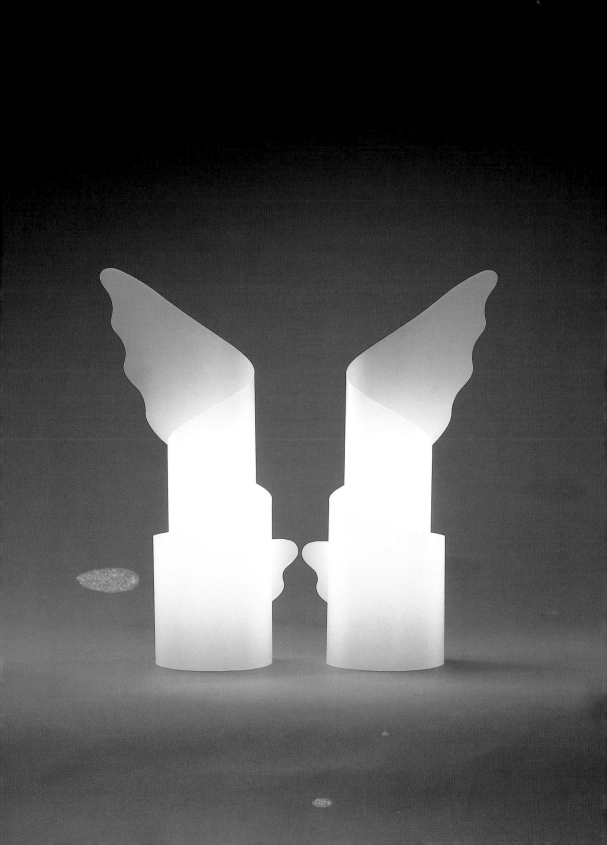

# "Drop 1" and "Drop 2" sconces

**Designer:** Marc Sadler (French, b. 1946)
**Manufacturer:** Flos S.p.A., Bovezzo (BR), Italy
**Date of design:** 1992
**Bulb:** compact fluorescent, 230v (one in "Drop 1" and two in "Drop 2")

The sconce is intriguing to the touch. To maintain the bulb, the diffuser of these lamps can easily be removed by pulling it away from the wall-mounted base. Because the base is transparent (although it does not appear so) light is also projected through the base and onto the wall. Two sizes, each with a different diffuser pattern, are available.

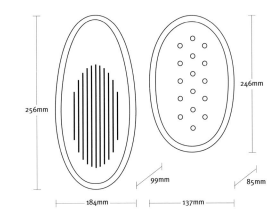

As if it were inflated, the diffuser gives to the touch. Easily removed, the negative track of the diffuser fits into the positive edge of the wall base.

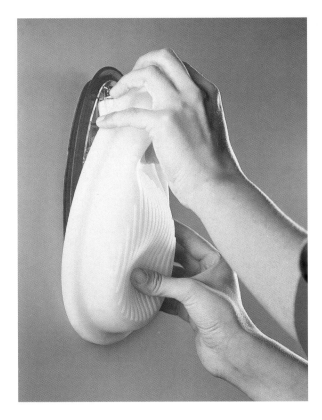

lights

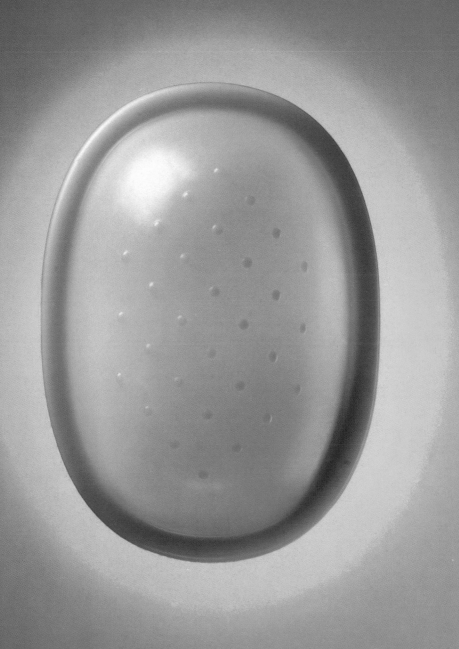

# "Drop 1" and "Drop 2" sconces

The version with a vertically ribbed pattern is the "Drop 1."

The soft, malleable diffuser is an injection-molded silicon elastomer.

The wall-mounted base is Lexan polycarbonate (amber, blue, or green).

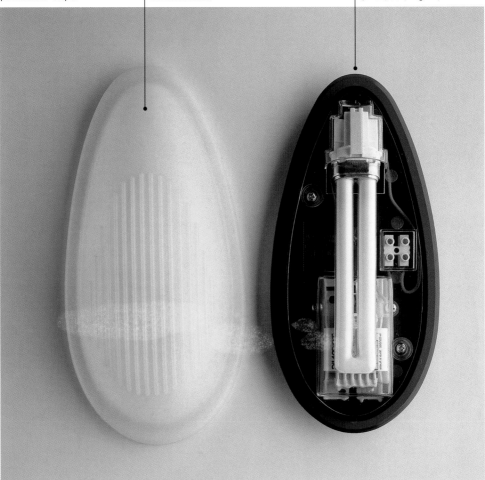

lights

The version with a
pimple pattern is
the "Drop 1."

A soft light is projected through the diffuser and also,
due to the transparent nature of Lexan, through and
around the base onto the wall surface.

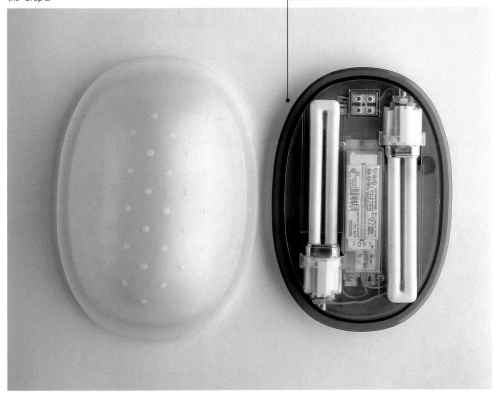

# "Crinkle" table light

**Designers:** Lyn Godley (American, b. 1956)
and Lloyd Schwan (American, b. 1955)
**Manufacturer:** Godley-Schwan, Hamburg, PA, U.S.A.
**Date of design:** 1996
**Bulb:** incandescent candelabra, 40w

This is a visually dynamic design for so simple a
solution. One square sheet of vividly colored vinyl
is heated and made into a somewhat untidy shape,
different for every example made.

305mm

305mm diameter

A vinyl sheet (.015mil) is heated and
hand-shaped into individually different
shapes. Available in white, yellow, pink,
blue, green, red, and purple.

The diffuser is
sandwiched between
heavy steel disks
(127mm diameter).

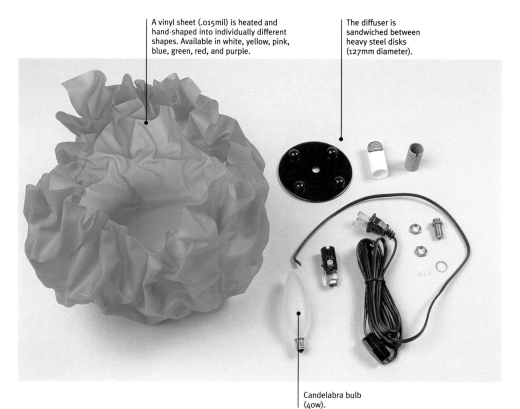

Candelabra bulb
(40w).

plastics

# "Wall-A Wall-A" sconce

**Designer:** Philippe Starck (French, b. 1949)
**Manufacturer:** Flos S.p.A., Bovezzo (BR), Italy
**Date of design:** 1993
**Bulb:** compact fluorescent, 11w, 230v

This fixture reveals the sense of humor for which this designer has become known and surreally interprets a sconce; a traditional, if not corny, lamp with a pleated fabric shade; and lighting in general. The lamp makes use of technologically advanced materials.

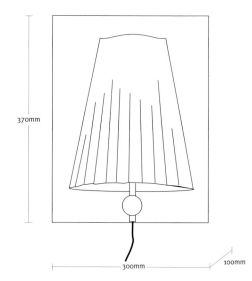

370mm

300mm   100mm

Compact halogen bulb (11w, 220v).

The background is a striated thermoformed technopolymeric sheet (in transparent green, black, or terracotta).

Changeable filters (in amber, azure, striped red, striped green, or transparent) provide various lighting effects.

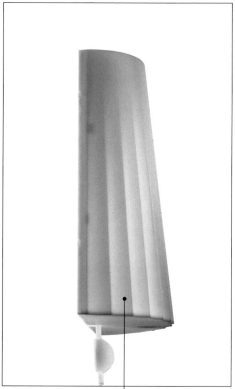

The diffuser, detachable for maintenance and filter changing, is vacuum-formed opaline polycarbonate.

lights

364

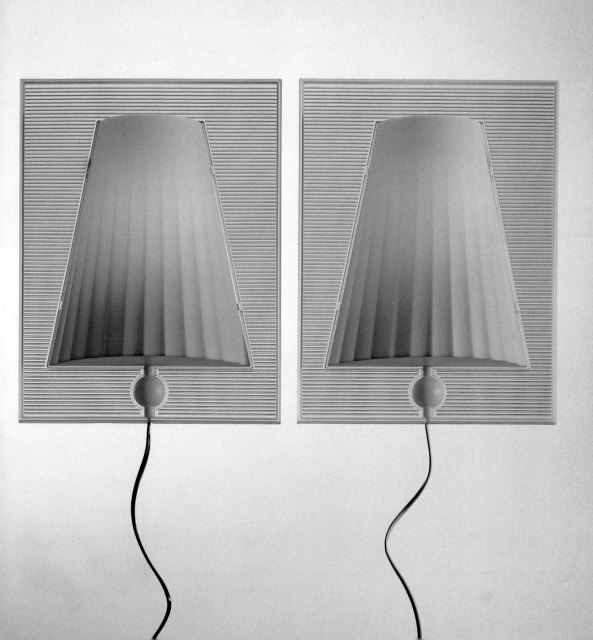

# "Soliel blanc" table light

**Designer:** Didier La Mache (French, b. 1945)
**Manufacturer:** the designer
**Date of design:** 1983
**Bulb:** Sylvania Circline O FC T9 CW, 222

Based on the designer's interest in the highly esoteric aspects of geometry, this fixture, which may be more sculpture than design, is part of his ongoing involvement in symbolism and archetypes which include the circle, triangle, sphere, tetrahedron, pyramid, cube, and convex surface.

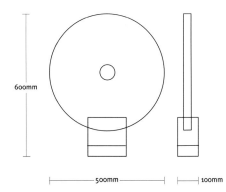

600mm

500mm | 100mm

Three sets of bolts and nuts and nylon washers support the circular fluoresecent bulb between the Plexiglas disks.

Circular fluorescent lighting tube.

Two parallel disks in striped metacrilate (Plexiglas).

Elastomer disks act as shocks to hold the large diffuser disks in place.

Two rectangular glass sections raise the diffuser disks.

Two "U"-shaped bent-steel sheets (zinc-plated) form an open-ended box that houses the transformer and fluorescent-tube socket.

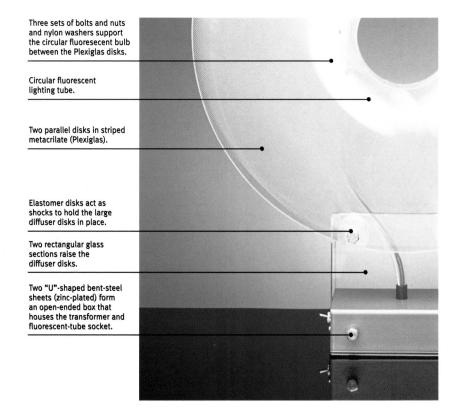

lights

# "Havana" hanging, wall, and floor light

**Designer:** Joseph Forakis (American, b. 1962)
**Manufacturer:** Foscarini Murano S.p.A., Murano (VE), Italy
**Date of design:** 1993
**Bulb:** E27 incandescent, 150w or energy saving 23w, 110/240v

This multipurpose lamp features a diffuser whose top segment is attached to the uppermost point of the central stem, leaving the other three segments to dangle. Of course, this feature is the most effective in the ceiling-hanging and wall models. The diffuser gives off a warm light from a cocoon-like or cigar-like (as the title suggests) container. The segmented design permits easier shipment.

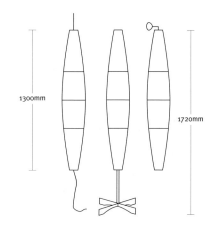

1300mm

1720mm

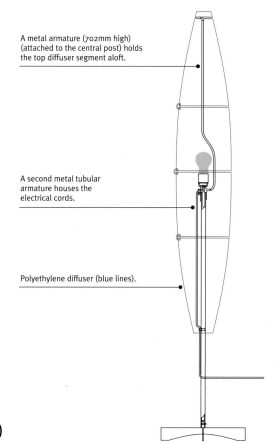

A metal armature (702mm high) (attached to the central post) holds the top diffuser segment aloft.

A second metal tubular armature houses the electrical cords.

Polyethylene diffuser (blue lines).

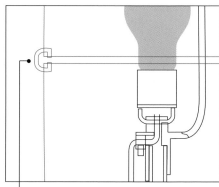

Clamps hold the four segments of the diffuser together, with some open spaces between the segments.

lights

368

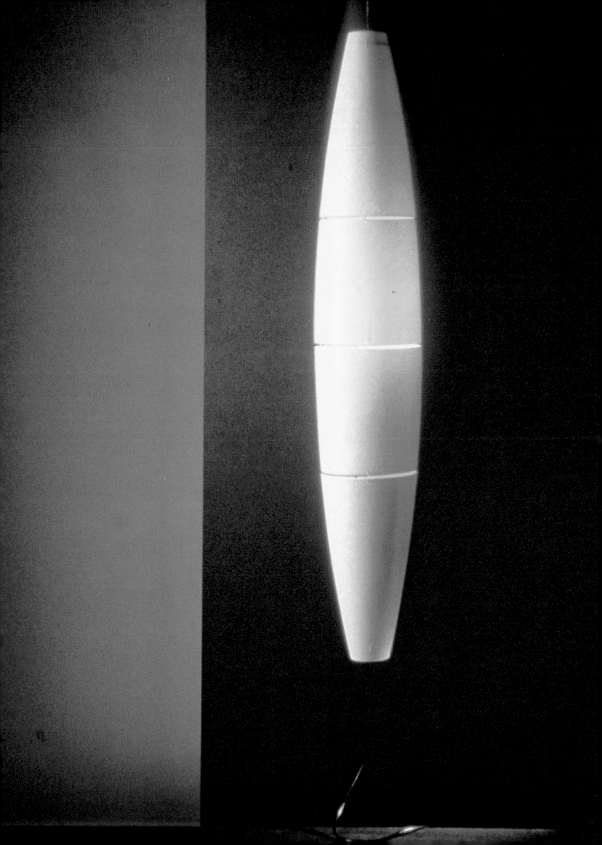

# "Havana" hanging, wall, and floor lamp

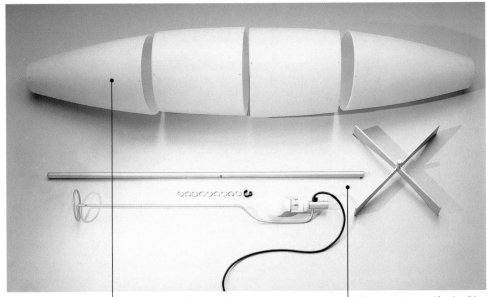

The polyethylene diffuser is injection molded into the cigar shape and sawn into four sections.

Columnar structure and foot in mild steel, painted in an aluminum color. The metal parts are laser-cut.

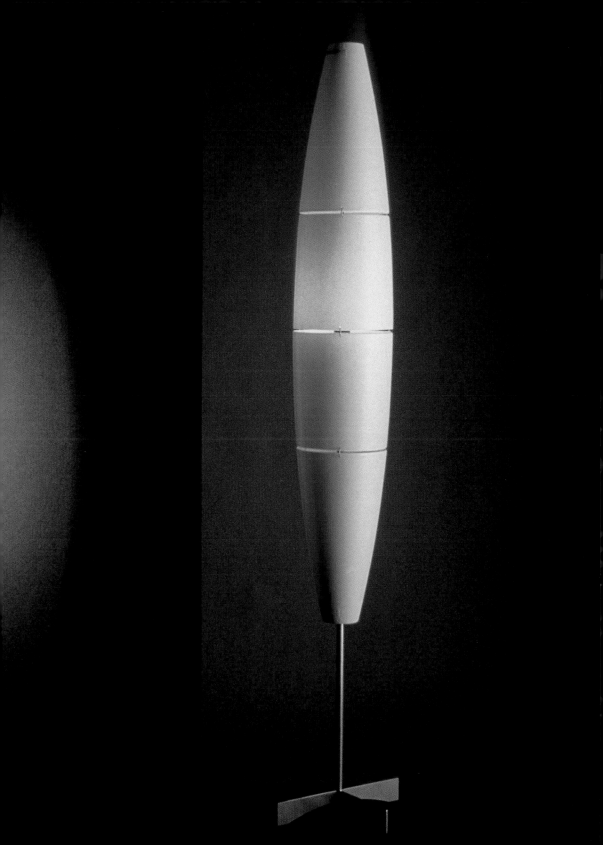

# "Havana" hanging, wall, and floor lamp

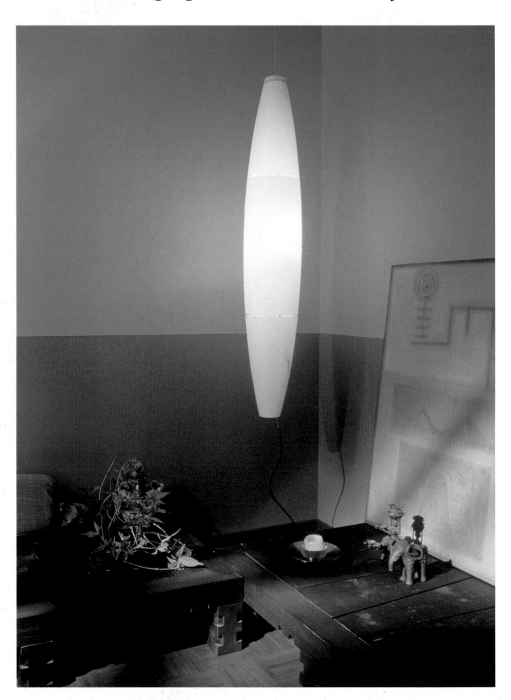

# fibers & composites

# "Sirius Mushroom" hanging light

Designer: Russell D. Barker (British, b. 1972)
Manufacturer: Sirius Designs, High Wycombe,
Buckinghamshire, Great Britain (distributed by SKK
Lighting, London)
Date of design: 1994
Bulb: Spider fitting, E14 (Europe)/E12 (U.S.A./Japan),
60w, 110v, 230v, or 240v

Made by hand by the designer, the diffuser of this
hanging lamp is a one-piece element. The decorative
rubber balls may be removed and, according to the
designer, played with—an intentional design feature.

300mm

240mm

One of the two polyester
resin molds used to form
the diffuser.

A diffuser
removed from
the mold.

Fiberglass matting used
for the reinforcement
of the mold.

A finished
and illuminated
diffuser.

The colored rubber balls are
inserted into holes made
with a drill and may be
removed at will.

The backside of the
rubber balls can be
seen inside the diffuser.

The ceramic socket is held
in place via a
wire armature.

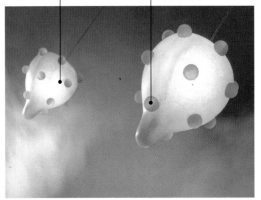

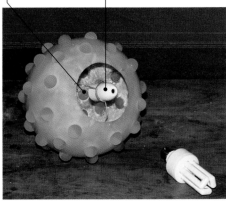

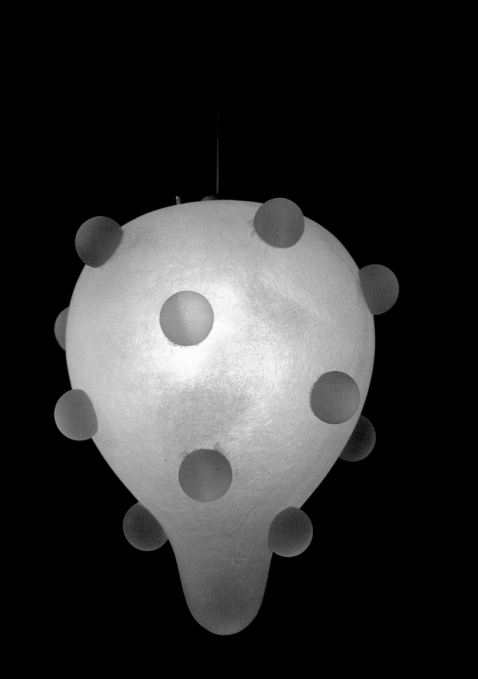

# "E.T.A. Extraterrestrial Angel" floor light

**Designer:** Guglielmo Berchicci (Italian, b. 1957)
**Manufacturer:** Kundalini S.r.l., Milano, Italy
**Date of design:** 1997
**Bulb:** No. 1 Halotube, 150w; or No. 3 E14 incandescent, 40w; 11/220v

Through the use of various hand-driven production methods, this lamp is produced with a resin mold, injection molding, welding, laser cutting, and baking in a kiln. The result is an intriguing, very tall, slender fixture, in a range of bright colors, which features an interesting method for removing the central electrical column for easy maintenance.

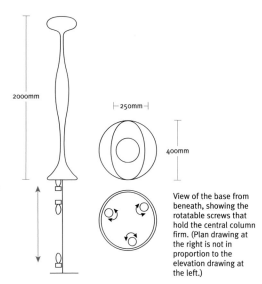

2000mm

250mm

400mm

View of the base from beneath, showing the rotatable screws that hold the central column firm. (Plan drawing at the right is not in proportion to the elevation drawing at the left.)

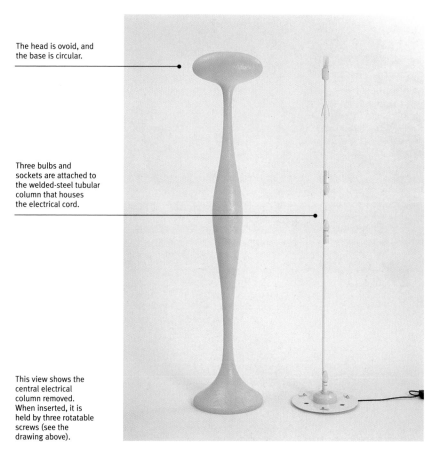

The head is ovoid, and the base is circular.

Three bulbs and sockets are attached to the welded-steel tubular column that houses the electrical cord.

This view shows the central electrical column removed. When inserted, it is held by three rotatable screws (see the drawing above).

lights

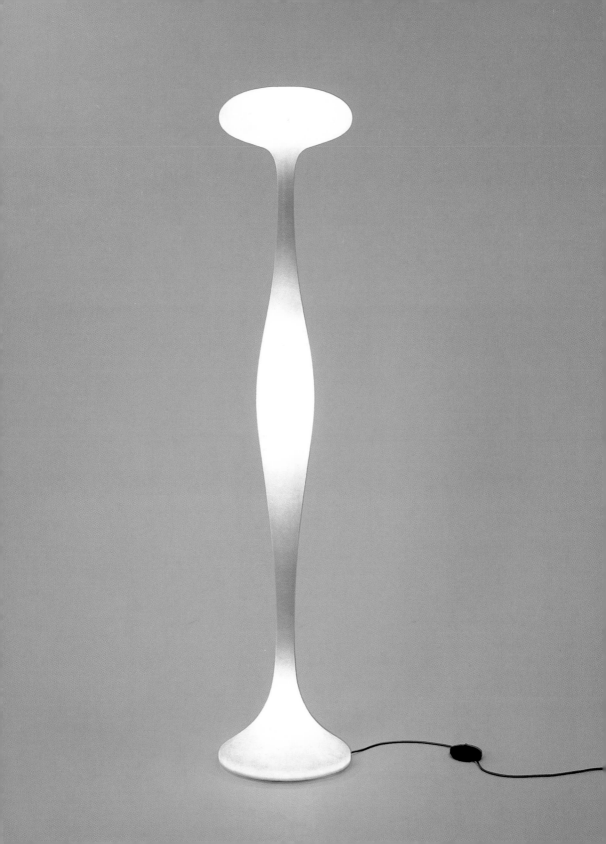

# "E.T.A. Extraterrestrial Angel" floor light

A wooden model from which the mold is cast.

Sealed molds with the contents curing.

A craftsperson trims the polyamide body halves.

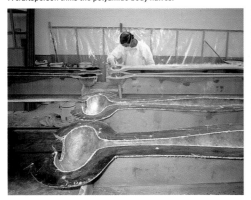

Fiberglass applied to both outside and inside the polyamide body.

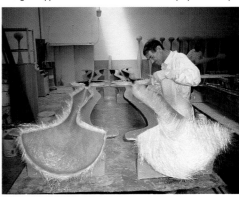

lights

378

The interior, after the fiberglass application, is being sealed.

On an assembled body, the base insert is applied.

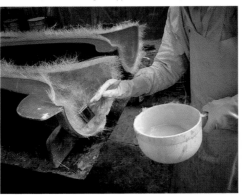

Completed lamps are stored, and a craftsperson applies fiberglass.

The production process:
• The polyamide body is formed in two halves in a resin mold.
• The body is painted with a double protective kiln varnish.
• Special treatment makes the final resin non-toxic.
• The removable base is attached to a welded steel column that supports the electrical cord and the three bulbs.

fibers....

379

# "E.T.A. Extraterrestrial Angel" floor light

A disassembled fixture.

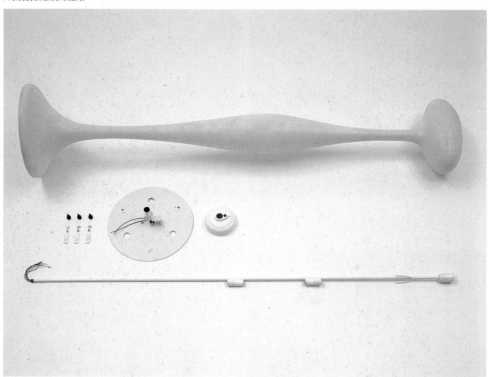

glass

# "Ondi di Luce"

**Designers:** Carlo Moretti (Italian, b. 1934)
with Marion Sterner (German, b. 1963) and
Wolfgang Sojer (German, b. 1962)
**Manufacturer:** Carlo Moretti S.r.l., Murano (VE), Italy
**Date of design:** 1993
**Bulb:** E14 incandescent, 60w, 220v

Created with materials produced by craftspeople in
the renowned glass-making area of Italy, this lamp
was configured in table, sconce, and ceiling versions.
The graceful use of glass tubes is reminiscent of
the best of European lighting of 1920s and 1930s,
especially in France. The form of the lamp has been
compared by the designer to the distant rolling
undulation of the ocean at night.

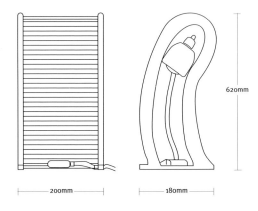

620mm

200mm          180mm

All versions of the frame
(into which the glass tubes
are fed) and the armature
are chromium-plated brass.

The large table lamp incorporates 80
internally etched glass tubes
(300mm long) and the small one
50 tubes (200mm long).

The glass tubes
are fed into the
brass frame.

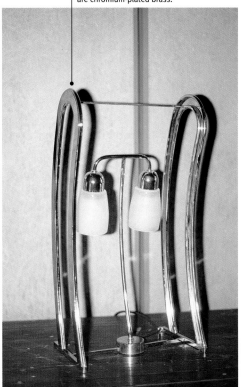

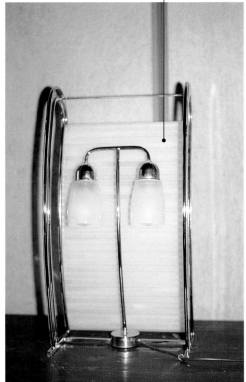

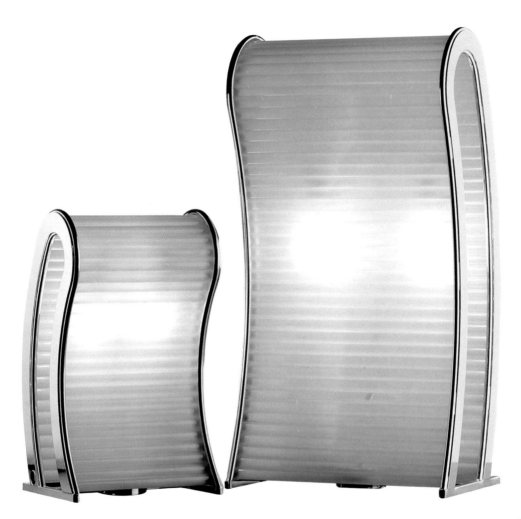

# "Ondi di Luce"

The sconce includes 30 internally
etched glass tubes (200mm long).

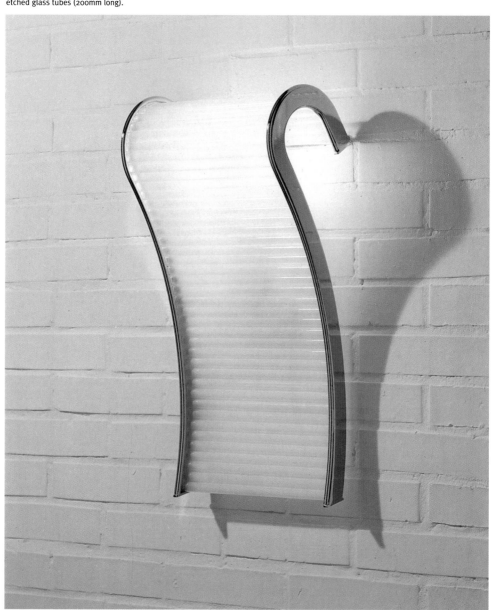

lights

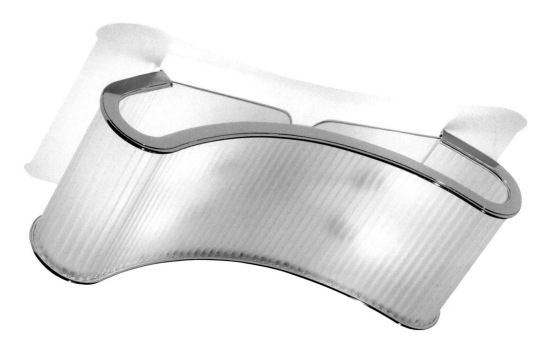

The ceiling-mounted model has 60 internally etched Murano glass tubes (200mm long). In none of the versions of the lamp is glue used to hold the tubes that are fed into the inside track of the frame.

# "Velo" hanging and "Abavelo" table lights

**Designer:** Franco Raggi (Italian, b. 1945)
**Manufacturer:** Fontana Arte, Milano, Italy
**Date of designs:** "Velo" 1988, "Abavelo" 1990
**Bulb:** "Velo" R75 halogen, 150w, with regulation dimmer; "Abavelo" R7S halogen, 300w, class 1

These lamps exploit the flexible nature of glass, resulting in fixtures with the appearance of being as light as air, but, in reality, quite heavy. In hanging, table-top, and wall versions, this light is an exercise manipulating the possibilities of traditional materials (glass and metal). The wall version is not shown.

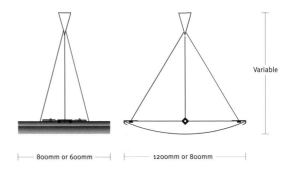

Variable

| 800mm or 600mm | 1200mm or 800mm |

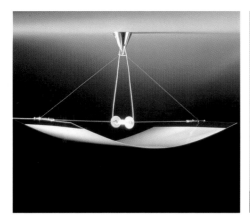

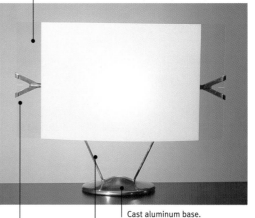

Elastic-like opaline glass is serigraphed in the central portion and bent like a bow. The outer edge is left clear. The table model features two parallel panes of glass.

Cast aluminum base.

Electrical wires are fed through thin stainless-steel supports.

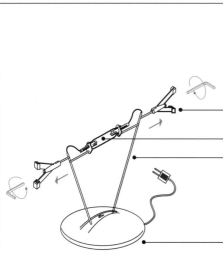

Pairs of metal fingers (two sets on the table model here and single ones on the hanging version above left) are attached with an Allen wrench and hold the glass-plate diffuser(s) in a bowed position.

Placement of the R7S halogen bulb.

Rod in chromium-plated brass or optical black.

The glass sheets (1.1mm thick) are chemically toughened and in the center sections serigraphed white. The table fixture dimensions are 500mm high, 500mm wide, and 200mm deep.

Base is polished die-cast aluminum.

lights

386

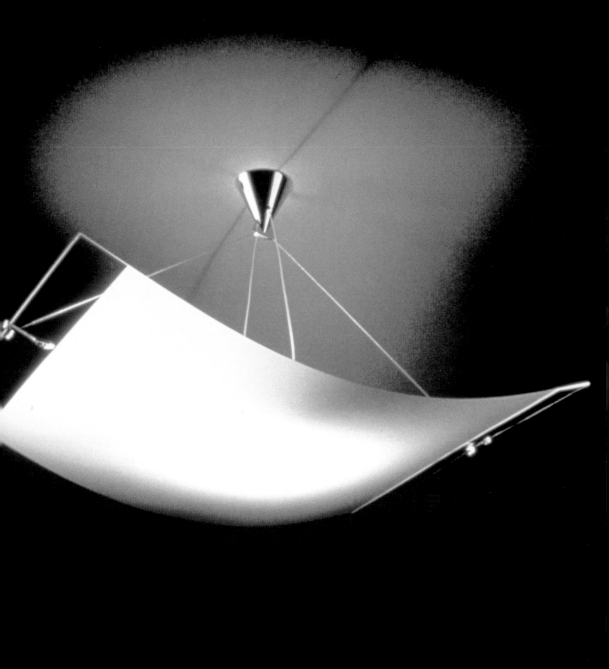

# "Milkbottle" hanging light

**Designer:** Tejo Remy (Dutch, b. 1960)
**Manufacturer:** DMD (Development Manufacturing Distribution Rotterdam BV), Voorburg, The Netherlands
**Date of design:** 1993
**Bulb:** E15, 15w, 220v

The distinctiveness of this fixture lies in the use of a discarded everyday object and the unabashed simplicity of its contrivance. The designer is part of Droog Design, an ad hoc group that accents a crafts approach to materials and the new application of existing techniques.

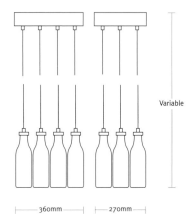

Variable

360mm | 270mm

Standard round plastic-covered elastic wiring.

Special stainless steel caps (not regular milk bottle ones) hold the socket and bulb.

Twelve discarded milk bottles, frosted on the inside, offer ambient lighting.

lights

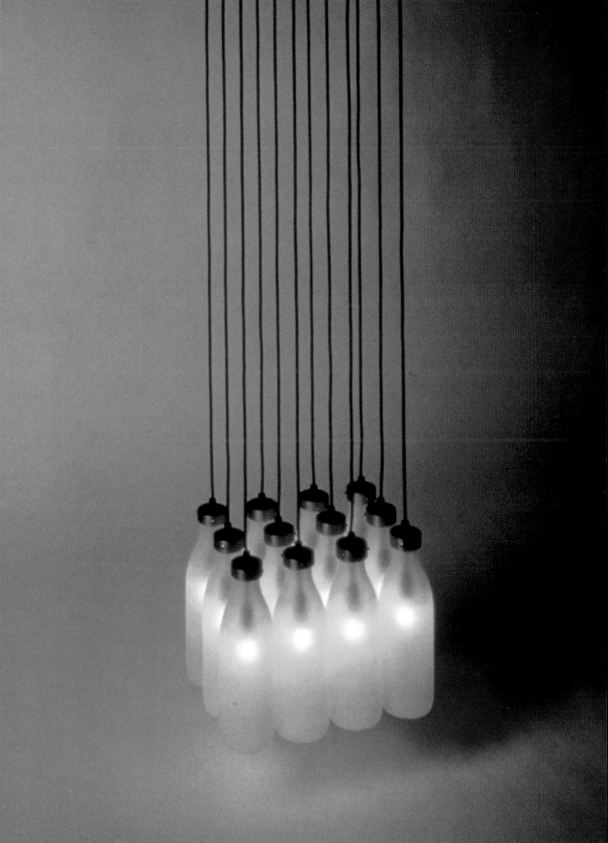

# "Tesa" table light

**Designer:** Umberto Riva (Italian, b. 1928)
**Manufacturer:** Barovier & Toso Vetrerie Artistiche
Riunite S.r.l., Murano (VE), Italy
**Date of design:** 1985
**Bulb:** E27, 100w, 220v

This unusual lamp is more an artistic statement
than a functional object, although it does provide
light. Expensive, precious, and handmade, only
a few examples of this fixture were produced.
All the parts, pieces, and connectors are left
exposed, concealing no constructional secrets.

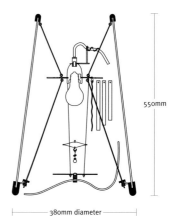

550mm

380mm diameter

The brass disk that holds the socket,
bulb, and glass pendants is suspended
in space within the cone by brass wires.

The dangling glass pendants (125mm,
140mm, and 155mm long) are wired to
the round socket disk through holes in
their tops.

Rubber shocks protect the top and bottom edges of
the glass cone onto which brass hooks and wires hold
the socket/bulb/pendant unit in suspension.

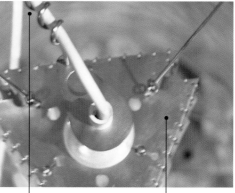

The conical outer
shell is transparent
mouth-blown glass,
cast in a die.

Metal parts
(brass) are
lathe cut.

Brass wire around the electrical
cord firmly holds it in certain bends,
eliminating interference with the
hanging pendants.

The triangular
base is brass.

lights

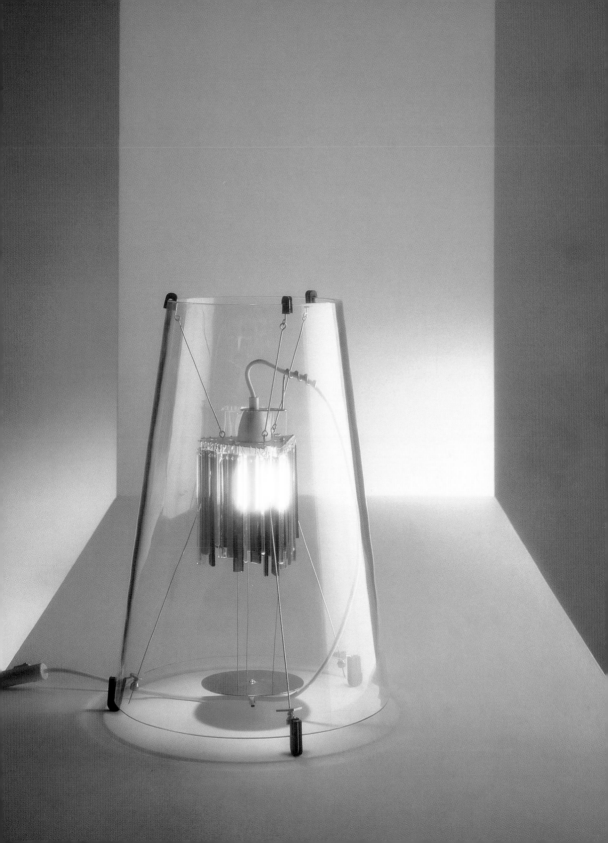

# "Ostrica in Orbita" hanging lights

**Designer:** Pepe Tanzi (Italian, b. 1945)
**Manufacturer:** Album S.r.l., Monza (MI), Italy
**Date of design:** 1996
**Bulb:** low-voltage halogen, 15w, 12v

This lamp features a frosted glass pill-shaped hollow diffuser with a narrow mouth. The diffuser is held in space by positive and negative wiring leads, which are easily removed when slid to the center of the diffuser opening.

Variable

140mm    55mm

Bead stops—attached to the ends of the negative (on one side) and the positive (on the other side) electrical wires—hold the glass diffuser firmly.

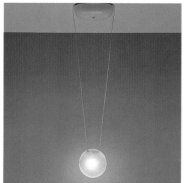

Bead stops slide to the sides of the diffuser slits and hold it securely aloft.

Low-voltage halogen bulb (15w, 12v) is suspended inside the glass diffuser.

Notice the parts of the mouth: wide for inserting the beads and the bulb and narrow for holding the beads.

The diffuser is mouth-blown, handmade, sand-etched borosilicate (high-heat-resistant) glass.

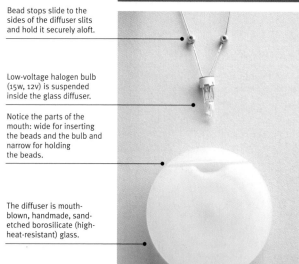

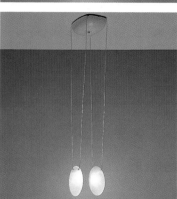

Single or double configurations are possible from a ceiling receptacle. Multiples can also be hung through the use of parallel ceiling wiring.

lights

**392**

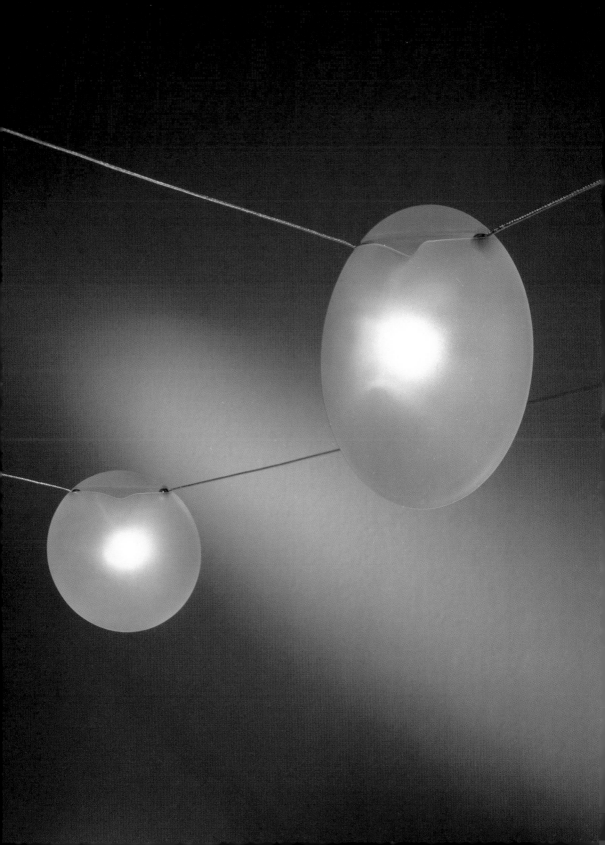

# "Lamp with Switch"

**Designer:** Peter van der Jagt (Dutch, b. 1971)
**Manufacturer:** the designer
**Date of design:** 1996
**Bulb:** custom-blown-glass, halogen,15w, 220v

In a shape reminiscent of a 19th-century light
bulb, this fixture may be far more important than
its simple appearance belies. Revealing a lively
imagination, the mechanics and engineering of
this lamp are highly sophisticated. Except for
the mouth-blown glass, all parts are standard
elements purchased in a retail shop.

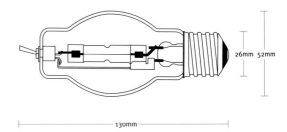

26mm 52mm

130mm

A sealed standard on/off
switch (red vinyl over metal)
protrudes through the glass.

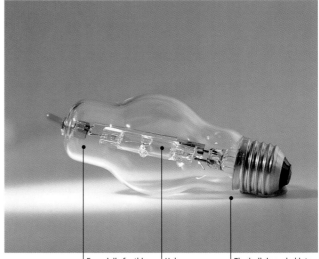

| Especially for this fixture, a mouth-blown glass bulb. | Halogen filament. | The bulb is sealed into the aluminum socket with a ceramic kit. |

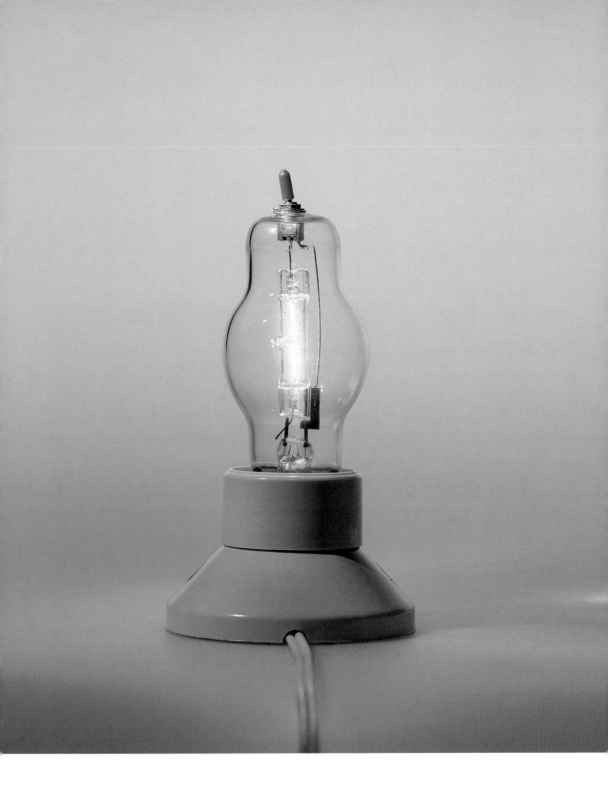

395

# "Bolonia" table light

**Designer:** Josep Lluscá (Spanish, b. 1948)
**Manufacturer:** Metalarte S.A., Sant Joan Despi
(Barna), Spain
**Date of design:** 1987
**Bulb:** dichroic halogen, 20w, 12v

The form of this fixture, the designer suggests, was
inspired by old-fashioned bottles of water capped
with inverted drinking glasses that also served as lids.
The reflector, and thus the direction of the light beam,
swivels. Compare this example with the metal-bodied
lamp on pages 312–313.

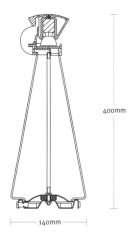

400mm

140mm

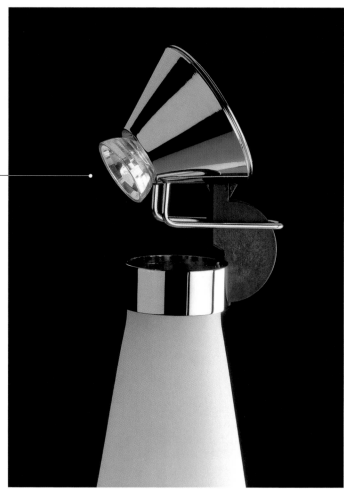

The halogen bulb,
here pointing
downward, in the
holder, which has
the appearance of
a bottle cap.

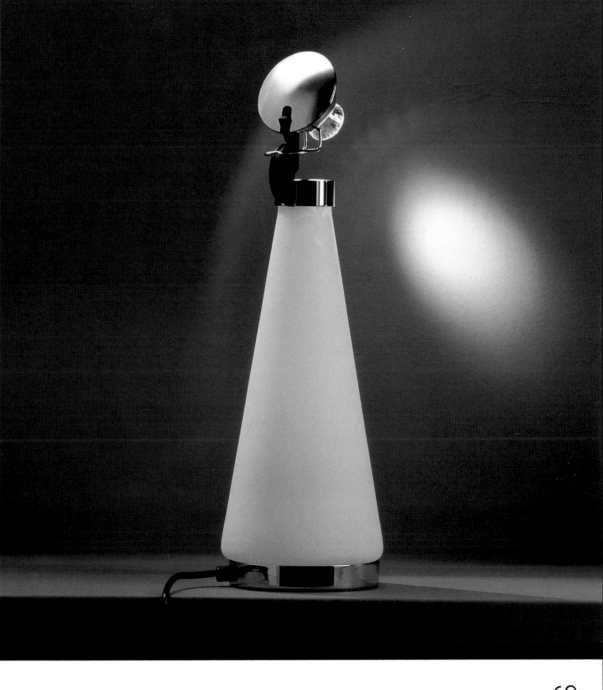

**"Bolonia" table light**

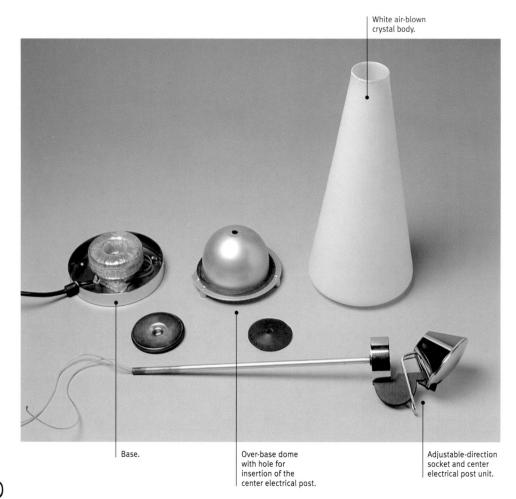

White air-blown crystal body.

Base.

Over-base dome with hole for insertion of the center electrical post.

Adjustable-direction socket and center electrical post unit.

Chrome ABS adjustable socket mounted to the central electrical-wiring post.

White air-blown crystal body.

Aluminum inner over-base element with hole for centerpost.

glass

# "Bolonia" table light

Lamps illustrate the full articulation
of the lighting projection.

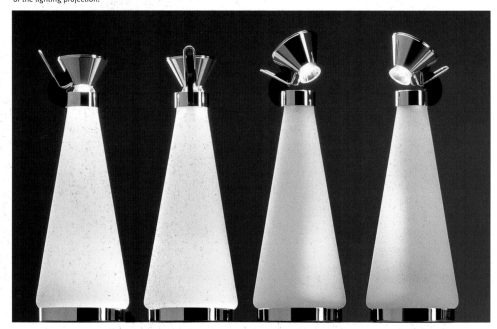

paper

# "Pop Up" light

**Designer:** Feddow Claassen (Dutch, b. 1970)
**Manufacturer:** DMD (Development
Manufacturing Distribution Rotterdam BV),
Voorburg, The Netherlands
**Date of design:** 1995
**Bulb:** E14 (Europe) or E12 (U.S.A., Japan)

Intentionally low-tech and inexpensive, this
fixture features a brown corrugated-paper
carton for its housing. When the carton is
opened, as one would ordinarily do by pulling
on the lid and the flap, the bulb and socket
elements are raised by hand. The bulb does
not actually "pop up," and once raised cannot
be inserted again. The designer is one of the
members of the Droog Design group in Holland,
who have become known for their witty,
irreverent approach (see another Droog fixture
on pages 388–389).

170mm

80mm

80mm

A clear light bulb, furnished
with the carton, would possibly
be more desirable frosted.

Employing
standard electrical
parts, black
plastic gaskets
(above and below
the pop-up inside
lid) hold the
socket firmly.

An ordinary two-sided craft-
paper corrugated cardboard
box houses the bulb and
standard electrical parts.

lights

# "Light in the dark" sconce

**Designer:** Stevan Dohar
(Hungarian, b. 1954)
**Manufacturer:** Adeline André Atelier,
Paris, France
**Date of design:** 1995
**Bulb:** E14

The unusual appearance of the diffuser on this sconce is due to its being formed of a sheet of dried seaweed produced in Japan. The metal diffuser frame is held onto the metal wall frame with magnets, permitting easy detachment.

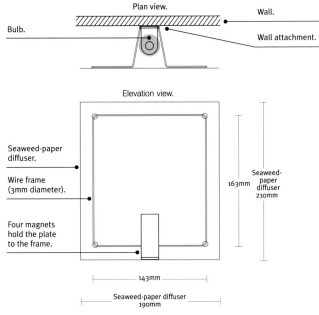

Plan view.

Wall.

Bulb.

Wall attachment.

Elevation view.

Seaweed-paper diffuser.

Wire frame (3mm diameter).

Four magnets hold the plate to the frame.

163mm

Seaweed-paper diffuser 210mm

143mm

Seaweed-paper diffuser 190mm

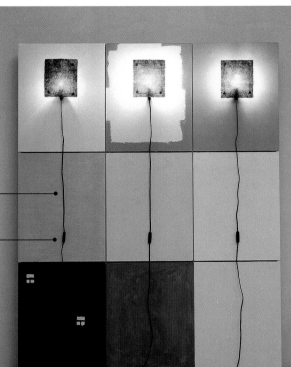

A display unit demonstrates the various reflective light qualities when the sconce is placed on different colored walls.

Electric cord (1000mm long).

The on/off switch is electrical-line attached.

# "Image Light"

**Designer:** Simon Pont (British, b. 1950)
**Manufacturer:** Productivity, Exebridge, Dulverton, Somerset, Great Britain
**Date of design:** 1995
**Bulb:** incandescent, 60W; or compact fluorescent, 11w

This simple lighting fixture may more concern the intellectual messages printed on the bag than the lamp itself. The intensity of the reflected color emitted depends on the bag's color; for example, orange is brighter than blue. This inexpensive lamp, sold in a corrugated box, is to be assembled by the end user following the instructions printed on the box.

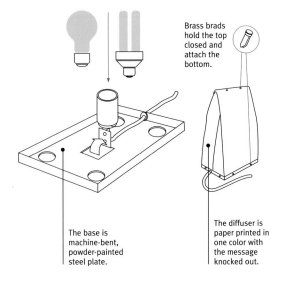

Brass brads hold the top closed and attach the bottom.

The base is machine-bent, powder-painted steel plate.

The diffuser is paper printed in one color with the message knocked out.

In a range of colors, the bag-diffusers are printed with messages that refer to various aspects of light. These range from glib words and phases, for example "Edison" and "Aurora Borealis," to quotations, such as one by the 18th-century English poet, William Blake, known to many English-speaking people:
"Tiger, tiger burning bright
In the forests of the night,
What immortal hand or eye
Could frame thy fearful symmetry?"

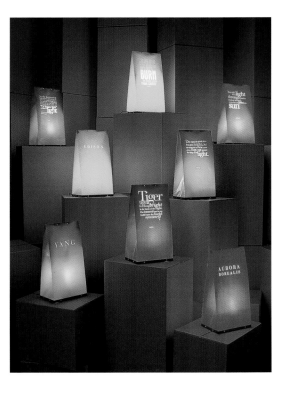

lights

EDISON

# "The Cheapest Light Possible" ceiling light

**Designer:** Constantin Boym (Russian, b. 1955)
**Manufacturer:** Boym Design Studio, New York, N.Y, U.S.A.
**Date of design:** 1985
**Bulb:** E14 (Europe), E12 (U.S.A., Japan)

This particular example of the lamp was made in 1997, though conceived almost a decade earlier. The designer's kitsch, throwaway sense of humor, rather than a concern for green issues, may have been the motivation for this design. As its name reveals, the fixture is very inexpensive and may not offer as much aesthetic appeal as it does a realization of a fecund imagination.

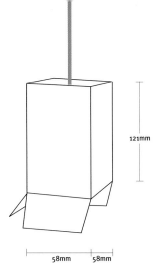

121mm

58mm    58mm

The diffuser is an original paper carton in which light bulbs are sold.

An aluminum foil lining protects the paper carton from the high heat of the bulb.

Electrical cord.

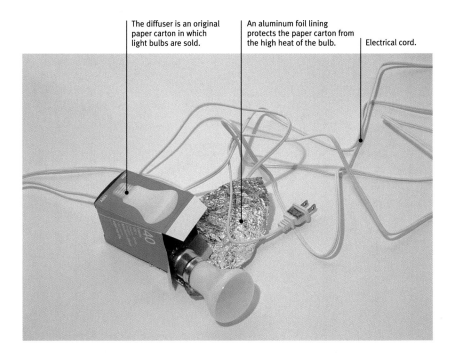

lights

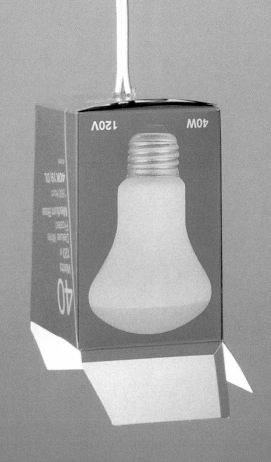

# "Cálida" table and floor lights

**Designer:** Pete Sans (Spanish, b. 1947)
**Manufacturer:** Taller Uno DLC S.A., Camallera, Spain
**Date of design:** 1989
**Bulb:** P.L., 11w for the table version; incandescent,
E27, 60w for the floor version; MEC 75 transformer

Due to the success of the floor version of this lamp,
a table version was designed which employed the
same materials and parts, except for the diffuser
and base heights and the elimination of the bottom
disk. A somewhat valuable material (brass or steel
for the foot) has been combined with one of little
worth (paper for the diffuser).

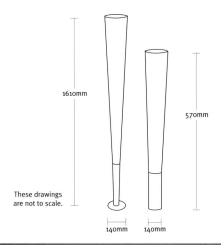

1610mm

570mm

These drawings
are not to scale.

140mm    140mm

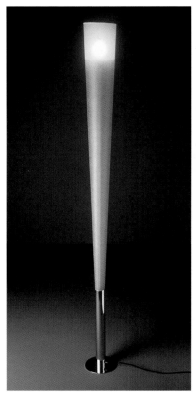

The floor version of "Cálida."

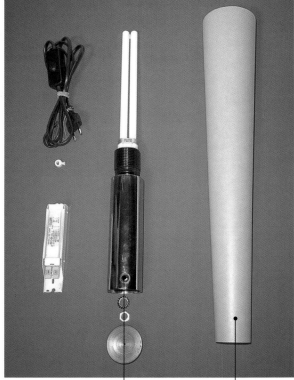

Foot is yellow brass
(shown) or white
chromium-plated steel.

The diffuser
is plasticized
paper.

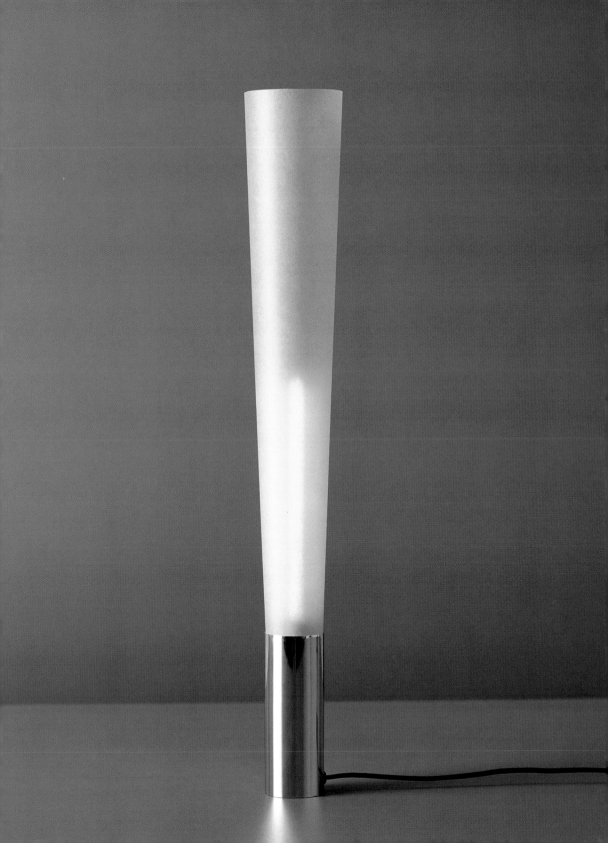

# "Generation Two" lights

**Designer:** Roland Simmons (American, b. 1946)
**Manufacturer:** Interfold, Cowley, WY, U.S.A.
**Date of design:** 1995
**Bulb:** candelabra, 60w, 110/220v

These imposing fixtures, especially the tall models, are made of recycled corrugated paper. The end user assembles them, with a zipper, following the instructions provided with each lamp. They employ one to three bulbs depending on height.

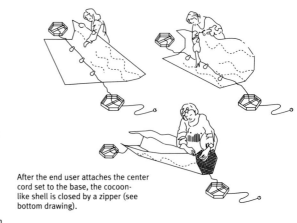

After the end user attaches the center cord set to the base, the cocoon-like shell is closed by a zipper (see bottom drawing).

355mm x 1015mm    355mm x 1930mm    355mm x 2286mm

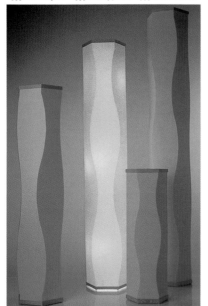

279mm x 915mm

Tall model includes three bulbs.

Center cord set.

Elastic fastener holds the cord set taut.

White pinewood top and base.

# "Lamp Pack"

**Designer:** Tom Tilleul (French, b. 1967)
**Manufacturer:** Axis, Villejuif, France
**Date of design:** 1994
**Bulb:** E14 incandescent flame, 40w,
230/240v

The paper-bag-type body (or diffuser) and
the base stiffener of this lamp are made of
recycled paper products; even the tie on the
packaging is raffia. Created by a member of
a design cooperative, this clever, witty,
economical, and cheap-to-ship fixture is
easily assembled by the end user.

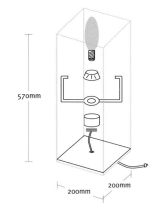

570mm

200mm

200mm

Square corrugated cardboard holds the already-
affixed socket and serves as a base stiffener.

Available in white (left) or
natural recycled paper.

The flat packaging is held together
with a raffia strand.

Socket and gasket.

E14 incandescent flame
bulb, 40w, 230–240v.

This welded brass device, held in
place by the socket and the screw-
on socket gasket, keeps the sides of
the bag-diffuser from touching the
bulb and thereby prevents burning.

lights

PACK

# "W&O" table light

**Designer:** Sasha Ketoff (Italian, b. 1949)
**Manufacturer:** Aluminor S.A., Contes, France
**Date of design:** 1984
**Bulb:** Halogen, 12v

The arm and diffuser of this lamp are rotatable 360°. For the square white reflector, the designer used paper-coated foam core—an inexpensive, non-durable, although easily replaceable, material. The name "W&O" is derived from "Wilbur & Orville," the Wright brothers, suggesting that the thin support structure of the fixture and its flat reflector are structurally akin to the Kitty Hawk airplane.

The artist's pencil sketch illustrates the articulation of the arm and the reflector.

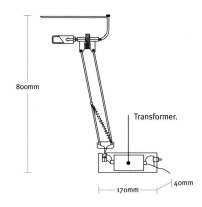

800mm

Transformer.

170mm    40mm

White paper-coated foam core.

The arm and reflector holder are tubular steel (8mm diameter).

The transformer is housed in the base where the on/off switch is also located.

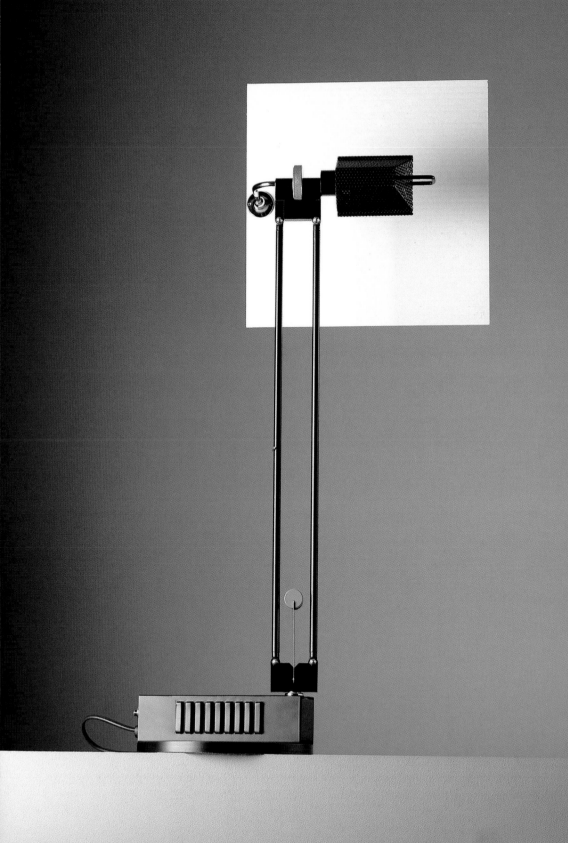

# textiles

# "Lucilla" hanging and floor lights

**Designer:** Paolo Rizzatto (Italian, b. 1941)
**Manufacturer:** Luceplan S.p.A., Milano, Italy
**Date of design:** 1994
**Bulb:** A19 incandescent, 150w; compact fluorescent, 23w

A fixture inspired by traditional Asian lanterns, this lamp features high-tech fabric for the shade. Nomex is a flameproof fabric that can be brightly tinted; here it acts like a skirt hanging from a metal-rod frame. In order to create a stand for what is essentially a ceiling-hanging lamp, the designer conjured an insect-like frame.

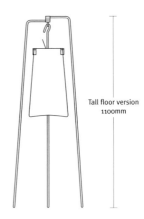

Tall floor version
1100mm

Like a garment, the fireproof Nomex fabric skirt (ecru, yellow, or red) is fitted onto the frame with the electrical cord inserted through a buttonhole-like aperture.

On/off lever.

The wire frame/stand on both the ceiling and floor models is nickel-plated, bead-blasted steel rod (4mm).

lights

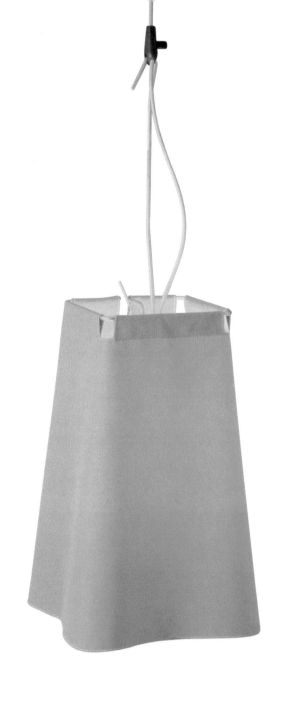

# "Lucilla" hanging and floor lights

2000mm/
4000mm

300mm/
430mm

300mm/
430mm

One of the designer's drawings (above) reveals
his studies for various support solutions for wall
and ceiling mounting and surface placement.
(See the wall-mounted lamp on the facing page.)

In addition to the mounting hardware and
frames, this drawing shows the socket/bulb
cage. The top square rod surrounding the
bulb supports the Nomex shade and the
smaller square rod (below the bulb) holds
the fabric away from the bulb.

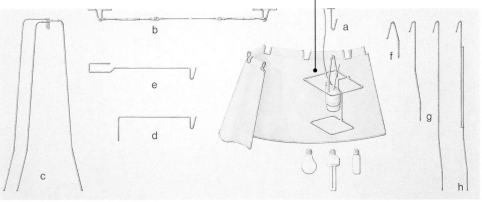

lights

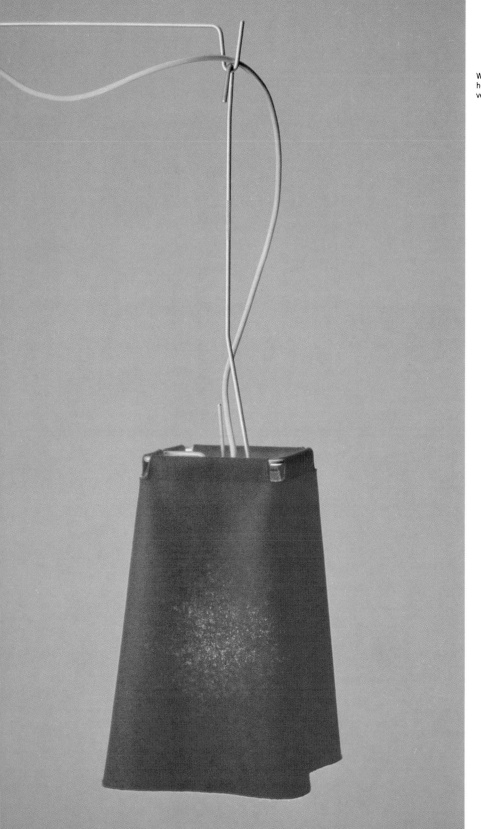

Wall-mounted,
height-adjustable
version.

textiles

# "Bombori" hanging light

**Designer:** Edward van Vliet (Dutch, b. 1965)
**Manufacturer:** Equilibrium, Amsterdam, The Netherlands
**Date of design:** 1996
**Bulb:** E14 incandescent, 75w, 220v

Ribbons and flaps control the light emission on this highly unusual textile lantern. Not only does light project from the sides, it is also cast through two colored or white Plexiglas disks.

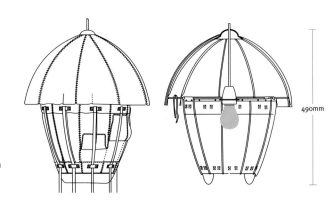

490mm

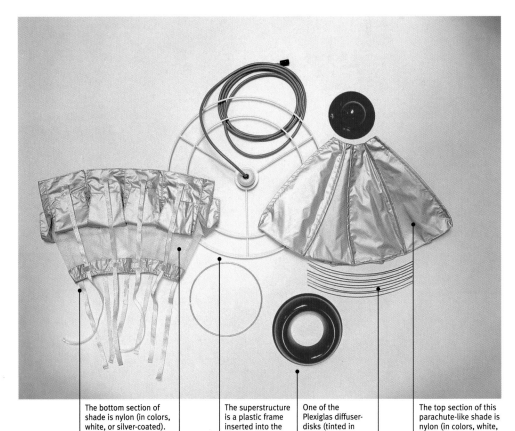

The bottom section of shade is nylon (in colors, white, or silver-coated). The ribbons control the size of the flap openings.

Nylon netting.

The superstructure is a plastic frame inserted into the bottom of the top shade.

One of the Plexiglas diffuser-disks (tinted in a range of colors or white).

The top section of this parachute-like shade is nylon (in colors, white, or silver-coated).

To hold the shape, flexible plastic filaments (like collar stays or thin chopsticks) are inserted into slits in the top and bottom of both nylon shade sections.

lights

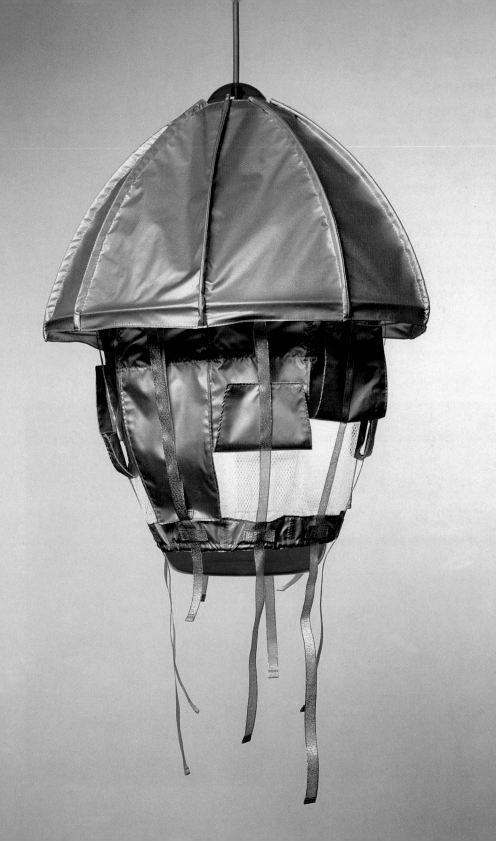

# "Filumena" hanging light

**Designer:** Mark R. Anderson (American, b. 1964)
**Manufacturer:** prototype by Pasquale e Salvatore De Maio S.n.c., Caserta (NA), Italy
**Date of design:** 1996
**Bulb:** 100-150w Halogen frosted E27 socket type, 110 or 220v

Designed to be reminiscent of the laundry hanging over passage ways in small Southern Italian towns, the linen panels on this fixture are furnished with an accessory hook attached to a thin plastic-coated steel line which can pull the drapery aside. This prototype was produced for the occasion of the exhibition "Progetti e Territori '96", held at the Abitare Il Tempo furniture fair in Verona, Italy, where the lamp was hand-wrought by artisans in the area.

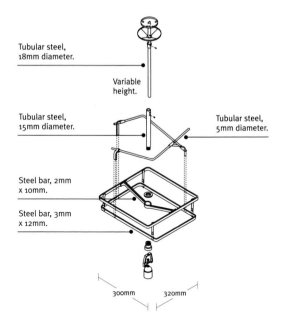

Tubular steel, 18mm diameter.

Variable height.

Tubular steel, 15mm diameter.

Tubular steel, 5mm diameter.

Steel bar, 2mm x 10mm.

Steel bar, 3mm x 12mm.

300mm

320mm

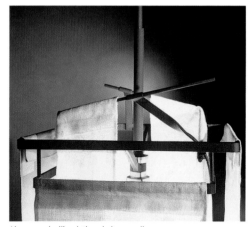

Linen panels, like clothes drying on a line, are fed onto bent steel bars.

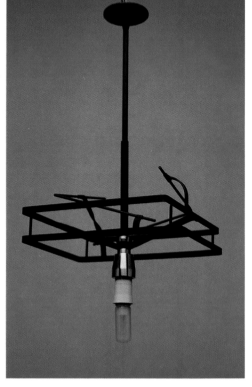

The bare wrought-iron frame, absent of the linen hangings.

lights

426

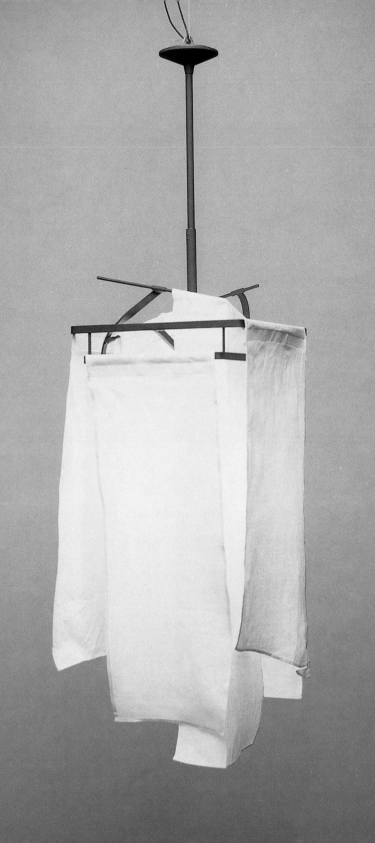

# "Filumena" hanging light

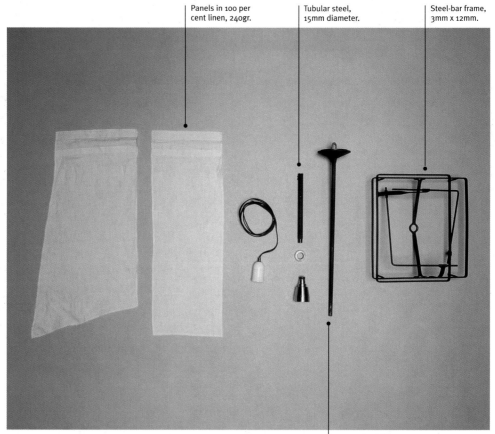

Panels in 100 per cent linen, 240gr.

Tubular steel, 15mm diameter.

Steel-bar frame, 3mm x 12mm.

The center coupling and the bulb holder are nickel plated with a satin finish.

Center support: steel tube.

Metal parts are polyurethane single-coat painted over a tinted primer.

lights

# wood, ceramics, & other materials

# Table light

**Designer:** Theodore S. Abramczyk
(American, b. 1959)
**Manufacturer:** the designer
**Date of design:** 1996
**Bulb:** Satco tubular 40w, 120v

Traditional in concept, the departure here
is the deftly manipulated thin-wood veneer
which gives off a warm light, either in its
natural light color or tinted orange. The
lamp, which floats above the metal plate,
is available in two colors.

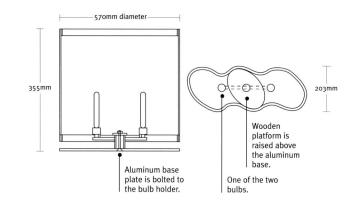

570mm diameter

355mm

203mm

Aluminum base
plate is bolted to
the bulb holder.

Wooden
platform is
raised above
the aluminum
base.

One of the two
bulbs.

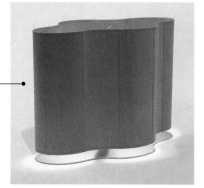

The orange color version;
the natural color is shown
on the facing page.

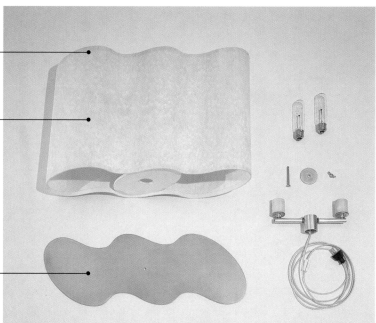

Top and bottom of the
veneer diffuser are glued to
a wooden support ring.

One thickness of wood
veneer (sanded, spray-
painted with varnish, and
polished) forms the diffuser.

Sheet aluminum base
plate conforms to the
silhouette of the diffuser.

lights

wood....

431

# "George" floor light

**Designers:** reflector unit, Tobias Grau (German, b. 1957); tripod, Florian Borkenhagen (German)
**Manufacturer:** Tobias Grau GmbH + Co. Hamburg, Germany
**Date of design:** 1996
**Bulb:** B15d, 100w; without transformer, high-voltage

The tiltable spotlight on this fixture can also be rotated, and the light beam can be dimmed and adjusted from a reflector beam to a narrow spot. The light is projected directly or, with the stretched-cloth screen, indirectly.

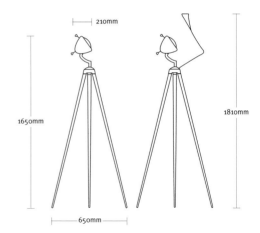

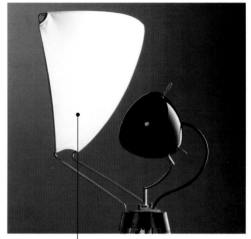

Reflective fabric, to create indirect lighting, is mounted onto a metal-rod frame.

Light-focus adjuster.

PC-glass lens.

Pressure-cast zinc.

Solid lathe-turned oak.

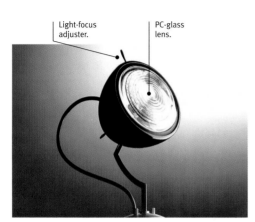

lights

wood...

433

# "Living Lighting"

**Designer:** Harry Allen (American, b. 1964)
**Manufacturer:** Selee Corporation,
Hendersonville, NC, U.S.A.
**Date of design:** 1994
**Bulb:** tubular incandescent, 25–75w, 120v

While working on a lamp project, the
designer discovered that ceramic foam,
when held up to the light, was translucent.
Through the patient cooperation of an
empathetic manufacturer, he was able,
in his own words, "to make such a crazy
idea work."

| 1680mm x 209mm | 1121mm x 347mm | 841mm x 121mm | 341mm x 209mm |
| Tower 1 | Tower 2 | Twist | Tower 3 |

Ceramic foam is fired in a kiln,
drilled or sawn (like marble)
into various shapes at the
industrial ceramics plant, and
then shipped to the designer,
who attaches the porous
ceramic diffuser to the base.

The base is welded sheet
metal, later painted.

The electrical parts are
screwed into the base.

lights

434

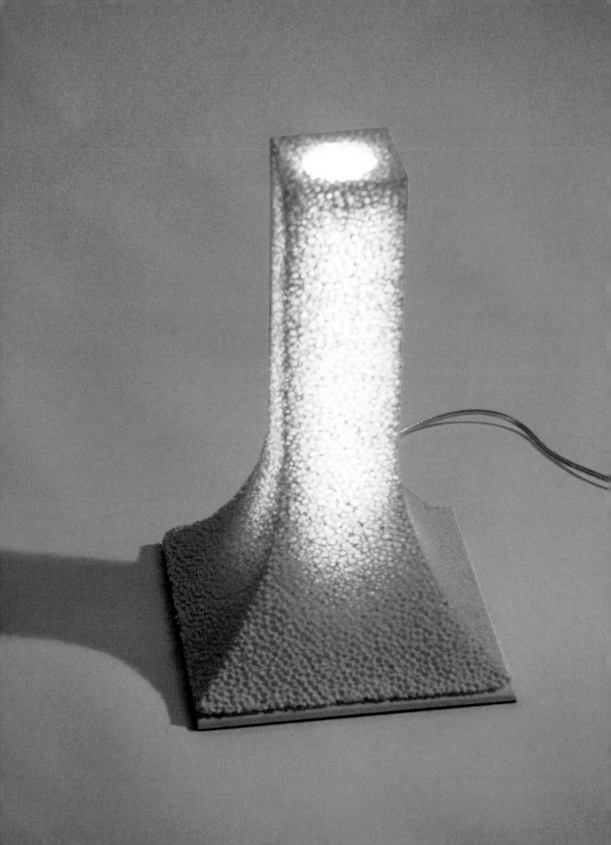

# "Living Lighting"

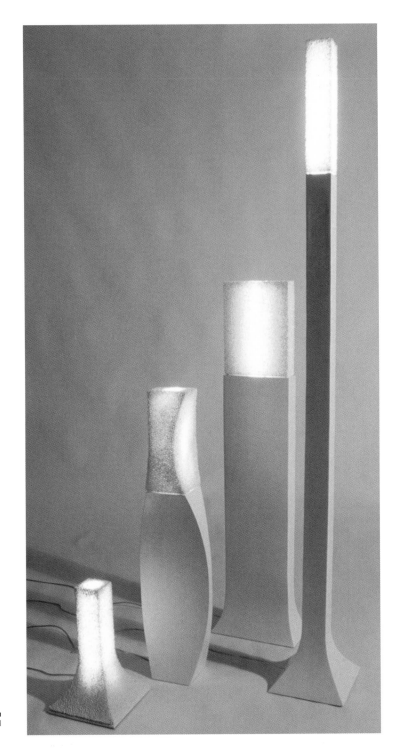

The array of heights and shapes made possible by the manipulation of ceramic foam (for the diffusers) and welded sheet metal (for the bases).

The Selee ceramic material is formed when open-cell polyurethane foam is infused with various oxides, ranging from compounds of yttrium, zirconium, and other materials to alumina. This particular fixture includes Selee A, which contains only aluminum oxide. Baked in a high-temperature kiln, the process eliminates the polyurethane and produces a substance with the appearance of sea coral.

The production process below at the Selee Corporation plant in Hendersonville, NC, does not specifically illustrate the foam forms used in Harry Allen's fixtures but the procedure is the same.

A gloved worker inspects "green" (prior to firing) ceramic foam.

A ceramic foam slab is being trimmed.

Sheets of ceramic foam enter the kiln.

Conveyor belt operation of ceramic foam exiting the kiln.

wood....

437

# "T41" sconce and "T43" hanging light

**Designer:** Luke Gurney (British, b. 1964)
**Manufacturer:** the designer
**Date of design:** 1989
**Bulbs:** E14 incandescent, 240v, round or flame shaped

Here are two lamps that, by utilizing everyday objects, serve both utility and whimsy. Real undecorated cups, saucers, and a teapot were drilled through, and brass tubing was bent into the kind of flowing forms, including the hanging chain and ceiling fitting, found in English and Flemish 17th- and 18th-century candle-fitted lighting fixtures.

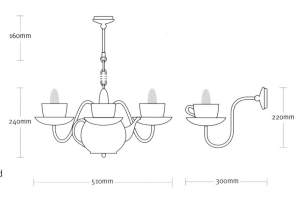

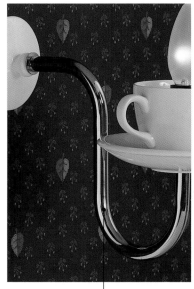

Nickle-plated brass tubing.

Ceramic cups, saucers, and teapots were drilled through to accommodate the fittings. The ceiling finial is the teapot cover.

lights

438

# "The Lamp"

**Designer:** Alexander Gelman (Russian, b. 1967)
**Manufacturer:** 555 Gallery, Jersey City, NJ, U.S.A.
**Date of design:** 1996
**Bulb:** quartz, 250w

Not a lamp at all but rather a metaphor, this image has been created by projecting light over a painted image on a wall. The design was originally drawn by the artist for a poster advertising a poetry reading.

190mm diameter

Flat with yoke 355mm

621mm

Mounted on the ceiling, a 152mm zoom elliptical pattern two framing projector (250w) casts the white shade shape onto the wall. The image is precisely placed to match up with the black "base."

Projection surface: a white-painted brick wall.

The "shade" portion of the image is projected onto the wall.

The "base" is black paint stencilled onto the wall.

lights

# Designers and Manufacturers

## Designers

# Designers and Manufacturers

## Manufacturers

# Index

445

# Acknowledgments and Permissions

## Acknowledgments

Paola Antonelli (Museum of Modern Art); Arlette Barré-Despond; Harriet Bee (Museum of Modern Art); George M. Beylerian (Material Connexion); Dr. Claire Bonney; Judith Brauner (Vitra GmbH); Isabelle Denamur; Ann Dixon (Museum of Modern Art); Olivier Gagnère; Alexander Gelman; Masaaki Gotsubo (Mazda Motor of America, Inc); Arlene Hirst (Metropolitan Home); Gerard Laizé; Ivan Luini (Luceplan USA Inc.); Tom Matano (Mazda Motor of America, Inc); Murray Moss (Moss); Yuki Nishino (Mazda Motors Inc.); Susan Papke (Vitra GmbH); Chee Pearlman; Dianne H. Pilgrim (Cooper-Hewitt National Design Museum); Christa Schumann (Aero); Stephen Van Dyk (Cooper-Hewitt National Design Museum Library);Rémy Vreis (V.I.A); Hideki Yamamoto

## Permissions

15  Axel Kufus
16–17  Stephan Maria Rother (photog.)
18–19  André Haarscheidt and Nicole Zachmann (photog.)
20  Isabelle Millet/Quart de Poil'
22–23  Christian Ghion and Patrick Nadeau/Filluox & Yum (photog.)
24–25  Inredningsform AB
26–27  Carlo Bimbi
28–29  Laura Agnoletto and Marzio Rusconi Clerici
28  Cinzia Anguissola d'Altoé (photog.)
29  Carlo Lavatori (photog.)
30  Katsushi Nagumo
32–33  Vitra AG
34–35  Susanne Papake (photog.)
36–38  Nels Holger Moormann
36–38  Tom Vack (photog.)
40–41  David design ab and Johan Kalén (photog.)
42–43  Alberto Liévora
44–45  David design ab and Johan Kalén (photog.)
46–47  Steel, divisione della Molteni & Molteni S.p.a
48–51  M. Masera (photog.)
52–53  Sergi Devesa and Oscar Devesa
54–55, 57  Pietro Carrieri (photog.)
58–60  Marco Carrieri (photog.)
62–63  Vincenzo Lauriola
64–65  Philippe Chaix and Jean-Paul Morel
66–67  Chérif
68–70  Fiam Italia S.p.A
72–73  IKEA
74–75  Sylvain Dubuisson
76–77  MAP (Merchants of Australian Products)
78  Fernando Campana and Huberto Campana
78–79  Andrés Otero (photog.)
80–81  Wolo (photog.)
82–83  Marc Newson and Tom Vack (photog.)
86–87  Alberto Meda and Sellitto (photog.)
88–89  Marc Harrison/ANTworks
90–93  Anna Castelli Ferrieri
94  Vincent Bécheau and Marie-Laure Bourgeois
95  A. Béguerie (photog.)
96–97  Andrew Tye
98–99  Maarten van Severen
100–102  Moform OY
104–105  Jérôme Gauthier
106  Quart de Poil'
111  Rolan Menegon (photog.)
112–113  Authentics, artipresent GmbH
114–116  Luciana Martins and Gerson de Oliveira
118–121  Michele De Lucchi

122–125  Gebrüder Thonet GmbH
126–127  Alexander Gelman
128–129  Vitra AG
130  Cinzia Anguissola d'Altoé (b)
130–131  Driade S.p.A
132–133  Nels Holger Moormann, Tom Vack (photog.)
134–135  Marino Ramazzotti (photog.)
136–137  Jean-Pierre Caillères
138–141  Atelier Alinea
139, 141  Croci & du Fresne (photog.)
142–144  William Sawaya, Marco Schillaci (photog.)
152–153  Richard A. McGrath (photog.)
154–155  Matrix, divisione della Giorgetti S.p.A
156–157  Quart de Poil'
159  Yellow Diva
160–161  Steinmann & Schmid
162–164  The Gehry Collection, courtesy of Knoll
166–167  Roberto Sellitto (photog.)
168–169  Emilio Tremolada (photog.)
170–171  Schnakenburg & Brahl (photog.)
174–175  Vitra GmbH and Hans Hansen (photog.)
176–177  Marino Ramazzotti (photog.)
178–179  Carlo Forcolini
180–181  Diametrics
182–183  Vitra GmbH and Hans Hansen (photog.)
184–187  King Size by Lasar
188–189  Andrés Otero
190–191  Vitra GmbH and Hans Hansen (photog.)
192–193, 195  Eek en Ruijgrok vog
196–197  Sylvain Dubuisson
198–199  Matteograssi S.p.A
200–202  Paolo Rizzatto and Cassina S.p.A
204–206  Alberto Meda and Alias S.r.l
208–211  Roberto Lucci
212–213  Frans Van Praet
214–215  Hans Hansen (photog.)
217  Vitra GmbH
218–219  Kartell S.p.A
220–221  Oscar Tusquets Blanca and Casas
222–223  Anna Castelli Ferrieri
224–225  Aaron Lown
226–229  MAP (Merchants of Australia) Product Pty
230–231  Andrés Otero (photog.)
232–233  Fabrizio Ballardini and Bernini
234–236  Pod
237  Pod (t), Maverick Recording Company (b)
238  Vitra GmbH
240  Hans Hansen (photog.)
242–245  Alberto Meda
246  William Stumpf (m), Herman Miller Inc. (b)
247–249  Herman Miller Inc.
250–251  Luciana Martins and Gerson de Oliveira
252–255  Vittorio Bonacina & Co.
256–259  Pesce Ltd.
260  Marcel Wanders
261  Hans van der Mars
262  Sears, Roebuck & Co.
263  Constantin Boym
264–266  Andrés Otero (photog.)
268  Alberto Liévore
269  Jordi Sarra (photog.)
270  Alberto Liévore (tl, r), Rafael Vargas (b)
271  Alberto Liévore
272–273  Matteograssi S.p.A
274–275  Quart de Poil'
276–277  Rimadesio
279–280  Fiam Italia S.p.A
282–284  Fly Time S.r.l
286–287  Quart de Poil'

288–290  Witt Design
292–293, 295  Mazda Motor Corporation
302–303  Jorge Pensi/B.Lux
304–305  Garcia Garay
306–309  Donald Stählin
310–311  Lucitalia S.p.A./Studio Azzurro (photog.)
312–313  Gaspar Glusberg
314, 316–319  Luxo Italiana S.p.A./Isao Hosoe
315  Zagnac (photog.)
320–322  Metalarte S.A./Sergi and Oscar Devesa i Bajet
324–327  Kundalini S.r.l.
328–331, 333  Louis Poulsen & Co. A/S
332  Louis Poulsen & Co. A/S; Planet/Bent Ryberg (photog.)
334–335  Marc Harrison
336–337  ISM Objects
338  Inflate
339  Inflate/Jason Tozer (photog.)
340–341  Goldman Arts, Inc.
342–343  Martins and de Oliveira
344  (b) Jean-Marie Massaud (illus.)
345  Jean-Marie Massaud/V.I.A.
346–349  Luceplan/Alberto Meda
350–351  Ross Tuthill Menuez
352–353  Christophe Pillet
354  Sculpture-Jeux S.A./ Christian Horrenberger (photog.)
355  Sculpture-Jeux S.A.
356–357  Samuel Parker S.r.l./Michele Salmi, Mario Tagliabue (photogs.)
358–361  Flos S.p.A.
362–363  Godley-Schwan
364–365  Flos S.p.A.
366–367  Didier La Mache
369, 371, 373  Foscarini Murano S.p.A./ Emilio Tremocada (photog.)
370–372  Foscarini Murano S.p.A./ Roberto Baldassarri (photog.)
374–375  Russell D. Baker
376–377, 380  Kundalini S.r.l./Carlo Lavatori (photog.)
378–379  Kundalini S.r.l.
382–385  Carlo Moretti S.r.l.
386–387  Fontana Arte/Franco Raggi
388–389  DMD/Hans van der Mars (photog.)
390  Cinzia Anguissola d'Altoé
391  Barovier & Roso Vetrerie Artistiche Riunite S.r.l.
392–393  Album S.r.l.
394–395  Peter van der Jagt
396–400  Metalarte S.A./Josep Lluscà
402–403  DMD/Hans van der Mars (photog.)
404  Adeline André Atelier
405  Toshi Fujii (photog.)
406–407  Productivity/Simon Pont
408–409  Boym Design Studio
410–411  Taller Uno DLC S.A./Pete Sans
412–413  Interfold/Roland Simmons
414 (br)–415  Axis
416–417  Sacha Ketoff
420–423  Luceplan S.p.A.
424–425  Equilibrium/Edward van Vliet
426–428  Daniele Piccin (photog.)
430–431  Theodore S. Abramcyk
432–433  Tobias Grau
434–436  Harry Allen
437  Selee Corporation
438–439  Luke Gurney
440–441  Alexander Gelman (photog.)